Matisse

Matisse

Walter Guadagnini

Illustrated
Books

PREFACE

Almost 40 years have passed since Henri Matisse's death, and a few months have gone by since the triumphal retrospective show at the New York Museum of Modern Art that celebrated his greatness. In these moments of commemoration – to which this volume hopes to make a lasting contribution – one of the problems that most naturally arises concerns this artist's heritage and the ways in which his art continues to communicate to us – in some cases, to act as a model – in the present.

By nature Matisse never seems to have worried about creating an immediately recognizable aftermath to his pictorial achievements. Although he is universally considered the loftiest and most legitimate counterpart of Picasso in this century, unlike the Spanish artist he never set himself up as its "voice" and "apostle." He was one of the protagonists of the fiery phase of the early twentieth-century avant-garde movements but always scrupulously avoided proclamations and manifestos. He lived through two world wars, but they left no significant marks on his artistic evolution. During his lifetime this behaviour helped to create the legend of a happy, even "facile" artist – a legend that often implied an unconfessed criticism of Matisse because he represented an outmoded model of the artist – the testament, albeit sublime, of the artist's lack of committment to the burning questions and events of his time.

Very little remains of those controversies, such as the one concerning the decorative character of Matisse's art. What has remained, and is in fact spreading, is the awareness of the artistic and moral value of Matisse's creative experience. For example, there is his legendary obsession with experimentation, always accompanied by intransigent rigour regarding the specific needs of artistic language, which are testified to by his writings – penetrating reflections on the meaning and significance of painting as well as on the painter's "métier." Gradually another aspect of Matisse's art has come to the fore, in a sort of poetic justice: his expressive independence, his capacity to be non-topical, out of step with his own age, and thus to express a topicality that could be called extratemporal, destined to become part of a time different from historical time. Today, with the prevailing disintegration of thought and coherence, Matisse's modern classicism not only emerges as one of the most extraordinary artistic adventures of the twentieth century, but also stands out as an invitation to meditate – free from the bonds of modern mythology and oversimplification – on the basis, significance and effects of a "modernity" which, precisely because of its complexity, has by no means outlived its initial constructive, creative impact.

Walter Guadagnini

CONTENTS

9 **THINKING IN COLOUR**

9 The Apprenticeship Years

13 The Postman of Collioure

18 A Table in Eden

22 Variations

27 Drawing in Colour

33 **THE WORKS**

34 Biography

36 The Beginnings

64 From Divisionism to Fauvism

110 From *The Dance* to *The Moorish Café*

142 The Confrontation with Avant-Garde Art

179 The Period Between the Two Wars: From Nice to Vence

262 Sculpture

284 BIBLIOGRAPHY

285 INDEX

THINKING IN COLOUR

The Apprenticeship Years

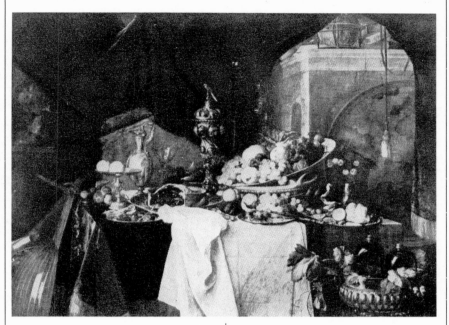

"I belong to a generation for whom everything had to arise from feeling, observed from nature and rendered immediately, hence without memory." Matisse was a world-famous artist when he wrote these lines to his life-long friend André Rouveyre from his gilded exile in Vence, retracing the crucial moments of his artistic formation and recalling most of all the influence worked on the young artists of the late nineteenth century by the triumphant poetics of Impressionism. Yet his statement is meaningful only if taken in a general sense, as a sort of evocation of a cultural climate. For on closer scrutiny, this artist's years of apprenticeship – which lasted up to the beginning of the twentieth century – reveal the complexity of his interests, the various stimuli taken in by his eyes and his intelligence, and his difficulty in finding his own path, the highroad, as it were, to artistic creation.

What really took place in the art world in that period bridging two centuries – from 1891 when the young Matisse began his painting career in Paris to the autumn of 1905 when his works and those of his artist friends earned them the epithet of Fauves (wild beasts) at a historic Paris Salon – is not easy to summarize, and gives full measure of the many difficulties a mere novice

♦ *Above: Jan Davidsz de Heem,* The Dessert, *1640; oil on canvas; 147 × 203 cm (58 × 80 in); Musée du Louvre, Paris. Matisse did a copy of this painting at the beginning of his career, in 1893, and took up the same*

motif in 1915, re-elaborating it along the lines of a compositional structure that shows the influence of Cubism, in particular the form evolved by Juan Gris.

would have had in getting oriented in that world. Two schools shared the favour of both the public and critics of the time and imposed their taste. The first, already in decline but firmly anchored to the powerful academies, Salons and public commissions, defended the conventional values of "good" drawing, composition and decorum both in the choice of subjects and in their rendering. The second, which itself would soon become academic, upheld the primacy of retinal sense perception, of capturing the fleeting moments of reality, which were rendered through rapid execution and dabs and touches of colour that gradually led to the dissolution of form. In brief, the Impressionists were about to win their battle, but had already spawned young artists who questioned the very bases of Impressionist research and were ready to foster certain aspects of figurative art such as memory, symbols, evocation and duration.

The last Impressionist exhibition in 1886 was quite revealing in this sense. Alongside the "impressions" of Berthe Morisot, Mary Cassatt and Jean-Louis Forain were the paintings of Gauguin, who was about to initiate his own research based on the values of the "noble savage" and on a new vision of painting, first in Brittany and then in Polynesia. More important still were the revolutionary works of two young painters and an old-time Impressionist, who transformed their canvases into an intemperate web of tiny dots of pure colour that at a certain distance could be recognized as compositions with an Impressionist subject conceived and executed with classical poise. One of these paintings in particular marked a turning-point in the art of the time:

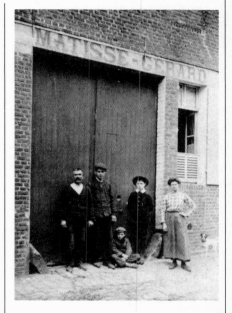

♦ *Above: the entrance to the general store opened by Matisse's father at Bohain, northern France; Matisse Archives. Matisse's parents ran this store, which dealt*

mostly in seeds and grain. The letterheads of the establishment's paper had the following caption: "Fodder and garden seeds. Cattle-cake and manure."

♦ *Below: Henri Matisse,* Dead Christ, *after Philippe de Champaigne, 1895; oil on canvas; 67 × 194 cm (26½ × 76 in); Musée Matisse, Nice. This is one of the many copies of*

"classical" art that Matisse executed in his youth; some of them were purchased by the French government, which was common practice at the time.

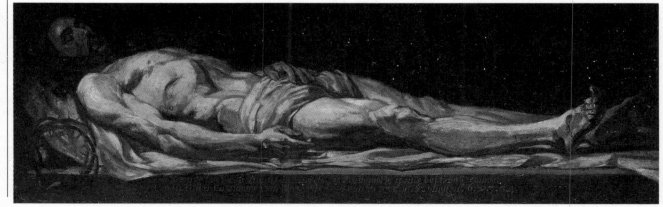

The Golden Age

♦ *Gustave Moreau,*
The Life of Humanity
(detail): The Golden
Age. Sleep. Adam;
*Musée Gustave
Moreau, Paris.*

Of the numerous references to classic culture in the imaginary world of the Symbolist generation, without a doubt one of the most recurrent and significant is the mythical Golden Age. Sung by such poets as Virgil and Ovid, but also evoked in the poetry of Baudelaire and Mallarmé, the Golden Age represents the vision of a still innocent humanity, far from the cares of everyday life, living an existence of idle pleasure spent in harmony with a kindly nature. The reference to this mythical age in human history grew out of the sheer contrast with the social and artistic reality of the time, which was characterized by the urbanization of the masses, by inevitable industrialization and by a thoroughly materialistic vision of life, the artistic counterpart of which was the rise of the realist aesthetic.

With the emergence of the many contradictions inherent in this world view and the mistrust in the very notion of progress that had played such an important role in the formation of nineteenth-century values, the new Symbolist generation came to the fore, which set against this reality the eternity of myth, the discovery of "other" worlds and ways of life, and the rediscovery of the deepest roots of Western culture and thought. This movement might be construed as an escape from reality, but it arose from the need to reestablish certain values that had been discredited or even abandoned by a society dominated by the senses and by a material existence that had made people forget the ideal, imaginary dimension of true artistic creation.

It was only natural that the myth of the Golden Age should inspire dissimilar artists – from Puvis de Cha-

vannes to Moreau, and from Signac to Gauguin, Denis and Matisse – thus generating a general atmosphere to which each painter contributed his own quite distinct artistic vision. In Puvis de Chavannes' *The Happy Land,* for example, the pastoral scene is set in a barren landscape outside of time, and the figures have an almost hieratic bearing based on classical poise, while in Moreau myth is decked out in the vestments of redundant imagination in which the time and motifs of disparate cultural milieus are fused and where a decisive part is played by luxuriant nature that still prevails over Man.

Gauguin set his scenes in the exotic landscapes of Polynesia, "updating" myth by transferring it to a sort of Garden of Eden outside contemporary Western society. Signac tried to convey this Paradise within time and space, lending a mythical, sacred aura to scenes of everyday life.

In *Luxe, calme et volupté* Matisse embarked on more or less the same path, referring in the title to an image created by Baudelaire, one of the undisputed fathers of this generation, while in *La joie de vivre* he sets aside all topical references and draws from an extra-temporal dimension, giving rise to a series of symbolic compositions that evolved in the following years.

Sunday Afternoon on the Island of the Grande Jatte, an outdoor scene whose figures seem to have stepped out of a fresco by Piero della Francesca, painted by the 25-year-old Georges Seurat, who died in 1891. His artistic "heir" would be the other young artist exhibiting at this exhibition – Paul Signac, destined to become the main theoretician and leading exponent of Neo-Impressionism. Signac's ideas, together with those of the old and converted Impressionist Camille Pissarro, were to have a strong influence on the young Matisse. The Neo-Impressionists were not the only artists in this period to blaze new trails that rejected the Naturalist aesthetic. At the same 1886 Impressionist exhibition another voice defended the rights of the imagination, of dreams, of painting so immersed in the origins of nature that it transcended it and became pure vision; the works of Odilon Redon – *The Secret, Intelligence, Temptation* and *Salomé* – represented ancient symbols and new myths in a continuous transfiguration of the object and "reality." By the same token, at 14 rue de la Rochefoucauld, in voluntary seclusion, an artist was creating a world of dreams and legends, populated by gold and turquoise, by Salomé and Sphinxes, a pictorial language based on a precept that Delacroix had uttered years before: "Even before nature, it is our imagination that makes the painting." This was Gustave Moreau, who was Matisse's first and only acknowledged teacher at the Ecole des Beaux-Arts from 1891 on. Moreau taught his pupils to visit and love museums but also to observe reality, as Matisse himself recalled many years later: "He, at least, was capable of enthusiasm and even of being carried away. One day he would state his admiration for Raphael,

♦ *Above: Albert Marquet,* Matisse Painting in Manguin's Atelier, *1904–05; oil on canvas; 100 × 73 cm (39 × 28¾ in); Musée National d'Art Moderne, Centre Georges Pompidou, Paris. Fellow artists from the time they were pupils in Gustave Moreau's studio, Matisse and Marquet formed a work companionship in the early*

nineteenth century similar to that of Picasso and Braque. Their closeness can be seen by many biographical details (as well as their similar artistic styles, of course): their studios were close to each other at 19 Quai Saint-Michel, they often exchanged canvases, and painted many portraits of each other.

♦ *Below: Henri Matisse,* Henri Matisse Engraving, *1900–03; drypoint; 14.8 × 19.6 cm (5¾ × 7¾ in); Musée Matisse, Nice. "Often, when I had no more resources, I thought of Rembrandt [...] I told myself that Rembrandt did not*

need to touch up his sheet in order to give it quality: the first state of his etchings are quite interesting also for his indications regarding the quality of the paper collected and used."

another day for Veronese. He arrived one morning proclaiming that there had never been a master greater than Chardin." His pupils often went to the Louvre, but Moreau would tell them: "Don't be content with going to the museum, go out into the streets."
There was yet another important influence in this period. In 1895, 500 of the leading personalities in French culture attended a banquet to celebrate the 70th birthday of Puvis de Chavannes who, like Moreau, was to die three years later, leaving an indelible mark on the post-Impressionist generation. Puvis was the artist who had redeemed the decorative function of art through his huge compositions, which were also filled with symbolic allusions, from the yearning for the Golden Age in *The Happy Land* to the timeless grace of *Girls by the Seashore*. Inspired by classical painting, he created a style that rose above the mere everyday and maintained the essentiality and sobriety of expressive means so dear to the classic masters, in utter contrast with both Moreau's richly adorned canvases and with the resplendent Impressionist palette. His essential grace, together with a highly personal colour scheme that was totally removed from sense-data, and his bold use of flattened figures, pale colours and uncluttered spaces were elements that the artists of the time saw in Japanese prints, the aesthetic value of which had first been discovered by the Impressionists and which had become an acknowledged source of inspiration that the eye could use to free itself from the limitations and constraint of traditional Western perspective.
At the end of the nineteenth century the extraordinary pictorial adventure of Paul Cézanne was attracting more and more interest and admiration in Paris, albeit among a restricted circle of artists and intellectuals: the epic attempt to "redo Poussin in nature," to reconcile feelings and ideas, the eye and the mind, and to reconstruct reality by bearing in mind most of all the rigour of art, the total commitment it requires. Matisse, who later called Cézanne "a sort of god of painting," bought a small work of his in 1899, *Three Bathers*, which, as he himself said, "has sustained me morally in the critical moments of my venture as an artist: I have drawn from it my faith and my perseverance [...]" This was the lesson the younger generation learned from Cézanne: perhaps even more than the pictorial lesson, it was the moral one they took in, the awareness that painting deserved total dedication, to the point of becoming a sort of mission, and was by no means the shortest route

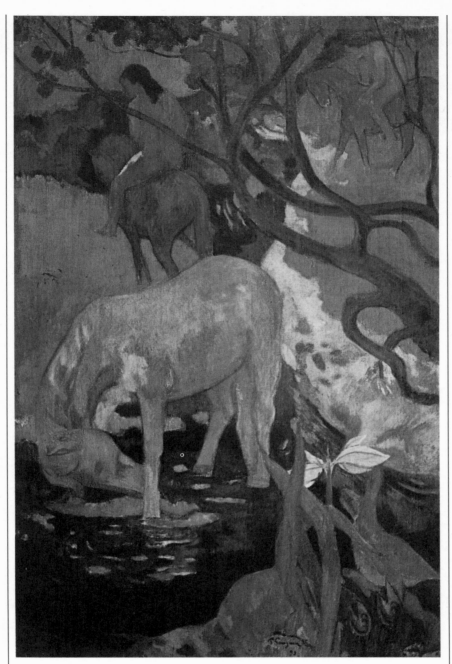

to fame, academic honours or teaching posts.
This was the situation that presented itself to the son of grain merchants who had moved to Saint Quentin, where he began to study law, and then went to Paris with the aim of developing a vocation for art that he had discovered during a long convalescence in 1890. It is not surprising, therefore, that he should have had such a long and at times contradictory apprenticeship; this testifies to a heightened curiosity, to be sure, but also to his uneasiness in having to choose his own artistic path and avoid slavishly imitating the many possibilities offered by the art of the time. As Matisse himself stated so aptly, referring to the towering figure of Gauguin: "I never saw Gauguin. I instinctively shrank from his already codified theory, because I was a student at the Louvre and was well aware of the complexity of the problem I had to solve in relation to myself, and I was afraid of doctrines, which are like passwords." The one truly stable

♦ *Above: Paul Gauguin,* The White Horse, *1889; oil on canvas; 141 × 91 cm (55½ × 36 in); Musée d'Orsay, Paris. Matisse always refused to be influenced by Gauguin, since he seemed to him to represent a sort of "preconceived*
notion" of artistic procedure. Despite this, Gauguin's influence in helping Matisse to break free from the bonds of Neo-Impressionism cannot be underestimated, as is shown in particular in the rendering of the vegetation in this painting.

♦ *Right: Matisse at Belle-Ile, 1896; photograph by Emile Wéry. The artist went to Brittany in 1896 and 1897, partly because he was attracted by the fame enjoyed by Pont-Aven, and partly because he wanted to try en plein-air*
painting after having done so many museum copies and still lifes. During his second sojourn there Matisse "discovered" Impressionist colour, although some of this was certainly due to the influence of Emile Wéry's painting.

element in Matisse's youthful experience was the centrality of museums. It was in museums that he took his first steps in painting. It is here that, at least until 1896, he faithfully copied the masters, which, besides affording him a certain income since the government purchased some of the copies, gave him his awareness of "the complexity of the problem" of painting. It was museums that made him understand that he had to grapple with tradition and use it as a touchstone for his own art, a task from which he never shirked; it afforded him the images, techniques and compositional values that even in the moments of his greatest experimentation were to remain the breeding ground for his pictorial experiments.
The centrality of the museum is clearly in evidence in Matisse's first works, which were mostly still lifes: Moreau's young pupil shows obvious elements borrowed from the Flemish masters and the more veiled but ever-present influence of Chardin, while at the same time drawing on the two fathers of nineteenth-century realism, Courbet and Manet (artists who just a few years before had been considered avant-garde but were now assimilated into "mainstream" art). This is the genre – which later came to be a favourite of Matisse's – that combines two of the basic elements of the artist's aesthetic: the need to find in perceptive reality the prime stimulus of creative inspiration and the awareness that pictorial language is self-contained, independent with respect to the rendering of that very reality. This autonomy is quite evident, in the still life, in the

The Importance of Drawing

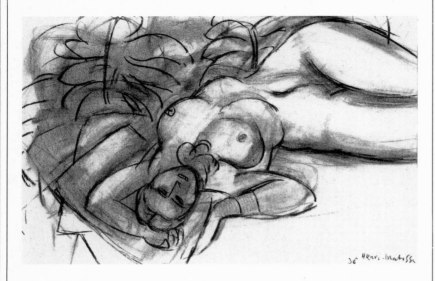

♦ *Above: Henri Matisse,* Reclining Nude with Large Foliage, *1936; charcoal; 32.9 × 50.2 cm (13 × 19¾ in); Musée Matisse, Nice.*

Drawing is a fundamental part of Matisse's art. Like sculpture, it has a dual role, acting both as a support, a confirmation, or as a moment of pause in relation to painting, and as a fully autonomous expressive means that abides by its own laws and whose evolution can be traced even without precise pictorial references.

This duality is understandable, as Matisse was an artist firmly rooted in tradition and at the same time a leading exponent of modernity. His first approach to drawing consisted in his numerous academic studies and those that later accompanied the works which, due to their dimensions and compositional difficulty, were the most complex – from *The Dance*, executed in 1933, to the decoration of the Chapel of the Rosary in Vence. Here the drawings acted as studies, sketches, progressive approaches to the definitive version, and as such can still be placed in the classical category of drawings.

The second approach is to be seen in all those drawings in which the primary impulse was to explore the relationship between the various elements that form the image, to dominate the surface space by means of the sign and to establish that rapport of empathy between the motif and the artist which Matisse himself

often said was an essential trait of his pictorial procedure. Hence he began with drawing from life and little by little freed this art form from the constrictions of rigid academic canons, at the same time basing the freedom of this line on clearly defined rules and measures. It was this initial discipline that allowed Matisse to achieve that dominion of space and essential line, that capacity to render "the luminosity and differences of values in colour" through drawing that characterize his graphic art from the beginning of the century, and especially in the last two decades of his career. Of his drawings, particular mention should be made of the series *Themes and Variations*, which takes up the comparison Matisse loved to make between figurative art and music by making numerous variations on a theme in which he exhibits a virtuosity that is at times redundant. As elsewhere, Matisse fully exploits the inherent characteristics of every graphic means by drawing on an exceptional variety of strokes, from the utmost linear essentiality of the pen to the infinite nuances of charcoal which breathe life into ever changing forms, space and light.

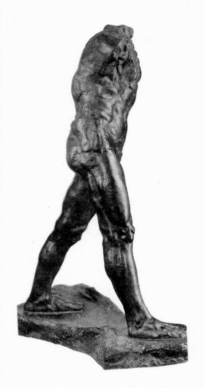

♦ *Below: Auguste Rodin,* Walking Man, *1875–78; bronze; Musée Rodin, Paris. This work inspired Matisse's first important sculpture,* The Slave *(1900).*

Curiously enough, the same model, Bevilacqua, posed for both works, and he was probably also the model for the Nude *painted by Matisse in the same year.*

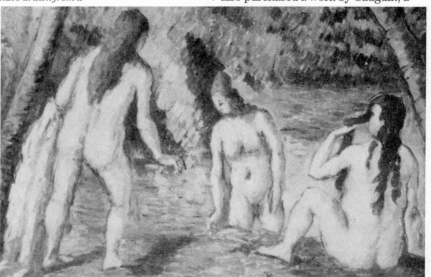

♦ *Below: Paul Cézanne,* Three Bathers, *1879–82: oil on canvas; 60.6 × 54.6 cm (23⅞ × 21½ in); Musée du Petit Palais, Paris. Matisse purchased this canvas from Vollard in 1899, and donated it to the Petit Palais in 1936. In the accompanying letter he wrote: "[…] it has sustained me morally in the critical moments of my venture as an artist: I have drawn from it* *my faith and perseverance." The influence Cézanne exercised on Matisse was decisive for his artistic formation, and the latter once even went so far as to say that "there were so many possibilities in him [Cézanne] that, more than anyone else, he was obliged to organize his thoughts. Cézanne, you see, is a sort of god of painting."*

artificiality and symbolic value of the subject.

But not even Matisse could avoid becoming involved in the pictorial practices of his generation, at least in that period. Between 1896 and 1897, he roamed around Brittany with his friend Emile Wéry, an Impressionist painter, intent on painting on the spot and on brightening his palette, as Renoir and Monet's newly accepted tradition taught. According to Henri Evenepoël, a fellow pupil in Moreau's studio, after returning to Paris from these outings Matisse "used to practice Impressionism and think through Claude Monet." And this was no transient, superficial experience. *The Dinner Table*, painted in 1897, was accepted at the Société Nationale des Beaux-Arts Salon. Matisse had been elected an associate member the previous year thanks to the good offices of his enlightened teacher Moreau, who, although disagreeing with the new path taken by his pupil, was nevertheless quick to recognize his talent.

The journeys to Brittany were immediately followed by others to London – to become acquainted with the painting of Turner, whom Pissarro had spoken of – and then to more southerly locations, to Corsica, Toulouse and Perpignan, where he underwent the "revelation of light" and where the conflict between museum and nature was momentarily resolved in favour of the latter.

The sequence of works Matisse painted in the last years of the nineteenth century bears the marks of what was perhaps the most doubt-stricken period in his career. This uncertainty also extended to which models the fledgling artist should follow in order to overcome it. Two events that occurred in 1899 are quite indicative in this regard. As we have already seen, Matisse bought Cézanne's *Three Bathers* from Ambroise Vollard; but he also purchased a work by Gauguin, a

The Postman of Collioure

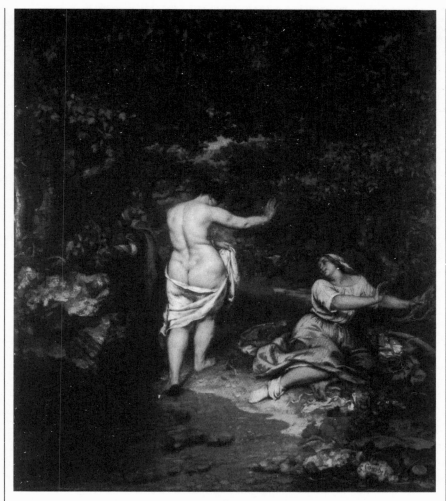

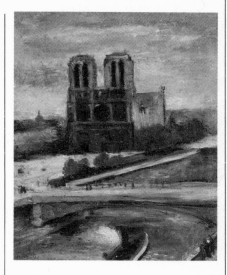

"Thus Fauvism, as defined by Matisse's procedure between 1905 and 1907, appears both as a homogeneous phenomenon and as a conjunction of two irreconcilable phases. On the one hand, landscapes (sometimes still lifes): anarchy, exuberance, uneven execution; an assault on the perspective system, which fights back inch by inch; line, abstract in essence, banished as had always been the case in the realistic tradition, or since the subject has to be established, recovered and torn to bits by the furious tide of colour. On the other hand, figures or landscapes organized around figures; carefully weighed compositions rather than observed motifs; order, coherence, style; colour calmly taking possession of the areas assigned to it by linear drawings. Here, an art of representation in its last gasp. There, the sudden appearance of an art of the "image," unconnected to the painter's experience or practice. Rupture and continuity, as between water and steam. Just as a steadily rising temperature produces a transformation at a given point, the intensification of colour, once local tones have been brought to their pitch, slips over the brink into the unrealistic." Pierre Schneider, in his monumental work on Matisse, thus synthesizes in exemplary fashion the two-year period that marked a turning point between the young and mature Matisse. These two years witnessed his *succès de scandale* at the 1905 Salon d'Automne and his definitive entry into the restricted circle of artists who were loved and protected

♦ *Left: Gustave Courbet,* The Bathers, *1853; oil on canvas; 227 × 193 cm (89½ × 76 in); Musée Fabre, Montpellier. The pose of the central figure clearly reminds one of* The Back I *sculpted by Matisse in 1909, which shows this artist's capacity to draw inspiration from the most disparate sources.*

♦ *Above: Henri Matisse,* Notre-Dame with Tugboat, *circa 1900; oil on canvas; 73 × 60 cm (28¾ × 23½ in); Private Collection. The motif was painted on the spot from the window of the studio at number 19 Quai Saint-Michel, where Matisse worked from*

1900 to 1908. The studio was then taken over by his friend and fellow artist Albert Marquet. In 1913, Matisse returned for brief periods to this building, this time on the lower floor, and painted the well-known Notre-Dame in 1914.

♦ *Below: a page from the 4 November 1905 issue of "L'illustration," which has reproductions of some of the paintings the so-called Fauves exhibited at the Salon d'Automne. The captions under the paintings were taken from the reviews that appeared in various newspapers of the time.*

plaster sculpture by Rodin and a Van Gogh drawing. And he read Signac's essay *D'Eugène Delacroix au néo-impressionisme*, the theoretical *summa* of the leading exponent of Divisionism. With the benefit of hindsight it is easy to say that the only lasting influence on Matisse was Cézanne. But a closer look at his work dating from this time shows that all the artists mentioned above were equally decisive in Matisse's artistic development at the beginning of the century. His almost Divisionist work, *Sideboard and Table* (1899) was painted only a year before the clearly Cézannesque *Male Model*, which in turn is reminiscent of Matisse's first sculpture piece, *The Slave*, in which the influence of Rodin is evident. *The Slave* was finished a year before *Luxe, calme et volupté* (1904), the famous painting that adheres, albeit in a rather unorthodox manner, to the Neo-Impressionist aesthetic, so much so that Signac bought the work. Matisse's Fauve palette owed a great deal to Van Gogh, as he himself confirmed: "At that time there was also the influence of Gauguin and Van Gogh"; "A great modern accomplishment is to have found the secret to expression by means of colour, to which has been added, with what is called Fauvism and with the movements that followed, expression through drawing; outline, lines and their direction."

These were the different lessons that

Matisse learned and set beside those he had acquired in museums and at Moreau's studio. A few months later these lessons would all be channelled into a totally autonomous pictorial language thanks to the contribution made by two new revelations: the liberation of colour and the "discovery" of the Orient.

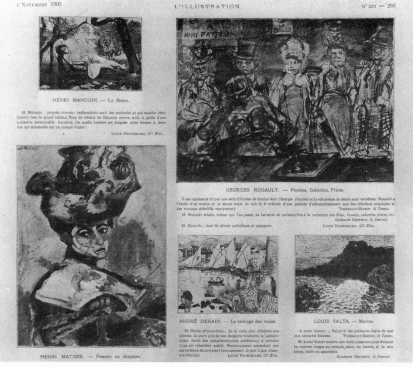

14

♦ Above: Henri Matisse, Seated Nude, 1906: woodcut; 41 × 27.5 cm (16¼ × 10⅞ in). Matisse did a series of woodcuts in 1906, probably urged to do so by Vollard. These works are in line with the atmosphere of the "Die Brücke" (The Bridge) German Expressionist movement and of the most radical Fauves such as Vlaminck, although they may also have been influenced by Vallotton's woodcuts, which were quite popular at the time.

♦ Below: Henri Matisse, Portrait of Mme Matisse, 1905; oil on canvas; 38 × 46 cm (15 × 18⅛ in); Musée Matisse, Nice. Matisse's wife was one of his favourite subjects and he painted her in different poses and clothing. Matisse had this to say about portraits: "I've come to discover that the similarity of a portrait derives from the opposition between the model's face and other faces, that is, from its very own asymmetry."

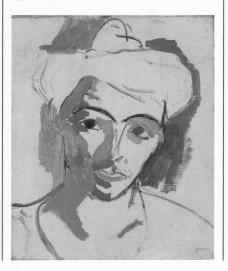

by a cosmopolitan array of intellectuals, from the American Stein family to the Russian Shchukin whose activities, including art collecting, helped to perpetuate the glory of Paris, the capital of the nineteenth century. As Schneider points out, Matisse was at this time still in an evolutionary phase that had unquestionably reached its final stage – so much so that some of the canvases executed in this period, such as *Portrait of Madame Matisse, The Green Line* (1905), can be considered consummate masterpieces of twentieth-century art – but that was still marked by doubts, uncertainty and hesitation which already by 1908, had been overcome for good. Certain paintings, executed with the Neo-Impressionist technique as late as 1906, bear witness to this state of things; but a painting such as *La joie de vivre* (1906) irradiates its magnificent light more on the canvases done in the 1908–10 period than on those executed at the same time or immediately afterwards. Just as *Pink Onions* (1906) stands out as a curiously unique work that would be brought to fruition only many years later. The two versions (and the anecdote that accompanies them) of *The Young Sailor* (1906) are cases in point: the first version fundamentally belongs to the most destructive, paroxysmal, anti-conventional moment of the Fauve experience, the moment that Schneider detects in the landscapes and still lifes; the second version, which is more synthetic, with the colour constrained within the outline of the figure and applied in a much more homogeneous manner, can be linked with the following artistic experiences and seems to represent a "step forward" in Matisse's pictorial research. Gertrude Stein's account of the presentation of these works is extremely significant in this context: "One summer he brought down from the country a study of a young fisherman, together with a free copy of it with radical deformations. At first he tried to pass off the second painting as a work by the postman at Collioure, but in the end he admitted that it was an experiment of his. It was the first thing he had done with deliberate deformations." Now this account shows that Matisse was quite conscious of the revolutionary significance this painting was taking on for his art – so aware that he drew back from it and metaphorically disowned it. This attitude (a similar anecdote concerning *Pink Onions* was narrated by Jean Puy) felicitously exemplifies the experimental nature of those years and the delicate turning point in the development of Matisse's

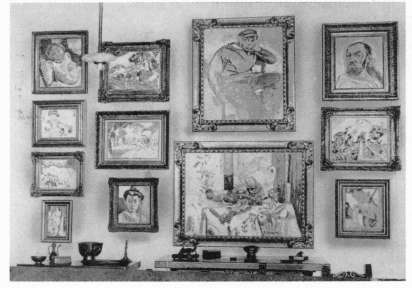

♦ The wall given over to Matisse paintings in Michael and Sarah Stein's Paris home around 1907.

The 1905 Salon, with its *succès de scandale*, marked the beginning of Matisse's fortune with art collectors. It was on this occasion that Michael and Sarah Stein bought his *Woman with the Hat*, thus giving birth to a group of collectors – including Leo and Gertrude Stein and Marcel Sembat – that in a few years' time were responsible for the increase in value of the artist's works. This Parisian group was flanked by a pair of Russian art collectors, Sergei Shchukin and Ivan Morosov, who bought Matisse's most important paintings up to 1913. The following descriptions of these two collectors are by Matisse himself.

"Shchukin, an importer of Oriental textiles from Moscow, was about fifty [...] came one day to the Quai Saint-Michel to see the paintings. He noticed a still life hanging on the wall and said: 'I'll buy it, but first I must keep it for several days in my house, and if I can bear it and if it continues to interest me, I'll keep it.' Fortunately for me, he managed to bear this ordeal without harm and my still life did not tire him to an unwarranted degree. So he came back and ordered a series of large canvases that were to decorate his house in Moscow – the old palace of the Troubetzkoi princes built during the reign of Catherine II. After that he asked me to do two decorations for the staircase in his palace, and it was

then that I painted *Music* and *The Dance* [...]

"Morosov, a colossal Russian, twenty years younger than Shchukin, owner of a factory with three thousand workers, had married a ballet dancer. He had commissioned decorations for his music room from Maurice Denis who painted *The Loves of Psyche*. In the same room he had six large Maillol sculptures. He bought from me, among other works, *Window at Tangier, Moroccans on the Terrace* [*Zorah on the Terrace*] and *Entrance to the Kasbah*."

After the war and the Russian Revolution, these extraordinary people disappeared, but their role was soon filled by another famous art collector, Dr Albert C. Barnes. Here too Matisse himself gives us a key to interpreting this legendary figure who was known for his "sharp eye" and bad temper. "One of the most striking things in America is the Barnes Collection, which is exhibited in a spirit very beneficial for the formation of American artists. There, the old masters' canvases are set beside the modern painters, a Rousseau next to a primitive: this grouping helps students to understand many things they never teach at the academies." And on another occasion he said: "You know, he has 340 Renoirs, more than anyone else in the world. And 80 Cézannes, very important works, and some lovely Seurats, which are rare, and a marvellous El Greco."

pictorial experimentation.

We must now look into other passages that led the artist on to this road, the practical and intellectual tools Matisse adopted to this end. First and foremost, without a doubt, was the absolute expressive freedom given to colour. "[…] Fauvism derived from the fact that we placed ourselves at a total distance from imitative colours and with pure colours obtained stronger reactions – more evident simultaneous reactions; and there was also the luminous intensity of the colours." Matisse stressed the expressive nature of his colours all his life, but what mattered most at this particular moment was freeing himself from the concept of painting as representation, and the predominance of colour over drawing. In this sense, the use that Matisse and his "fellow travellers" (some of whom, such as Marquet, Manguin and Rouault, had been his close friends since they had studied

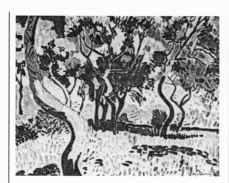

♦ *Above: André Derain,* Trees, Collioure, 1905; *oil on canvas; Musée National d'Art Moderne, Paris. In 1905 Derain and Matisse worked side by side in this fishing port in southern France, creating works that gave rise to Fauvism. Derain described their mood* at Collioure in a letter: "This place has people with sunburned faces; chrome, orange, seasoned skin; bluish black beards [...] then red, green, or grey earthenware [...] donkeys, boats, white sails, multicoloured fishing boats."

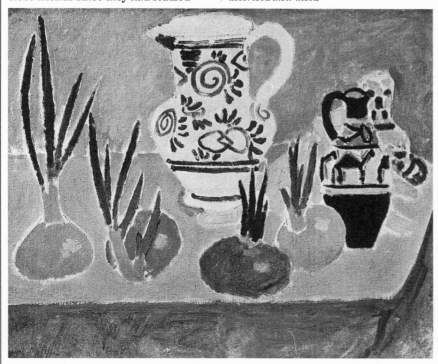

with Moreau) made of pure colours during this period took on the meaning of a rupture with tradition that in a short time became a more complex basis of a new aesthetic. That this moment of heightened expression was of brief duration was due to many factors, the most important of which was the crystallizing of Cézanne's influence and all this implied in terms of the compositional and spatial organization of the painting. The use of pure colour could only strengthen this and take Matisse even farther and irrevocably away from the aesthetic off-shoots of nineteenth-century naturalism. But in order for that rupture to become more deep-seated, a new element, a reassessment, had to make its way into Matisse's visual and intellectual horizon. The concept of

♦ *Above: Henri Matisse,* Pink Onions, Collioure, 1906; *oil on canvas; 46 × 55 cm (18⅛ × 21⅝ in); Statens Museum for Kunst, Copenhagen.*

pictorial space, which had since the Renaissance been part of Western painting, had been taken to its extreme consequences by Cézanne, while still remaining within the bounds of this tradition. From that point of view Cézanne was insuperable, and Matisse understood this early on. The only possible solution lay in changing the

rules of the game.

Accounts of this given by Matisse and some of his fellow artists such as Derain and Vlaminck are not particularly clear in this regard and do not always correspond; but certain facts are undeniable. In 1903 at the Pavillon de Marsan in Paris, there was an important exhibition of Islamic art; in 1906 Matisse made a journey to Algeria and brought back ceramics and textiles; in 1907 he went to Italy, where he paid particular attention to the Italian "primitives," especially Fra Angelico; again in 1906, according to several sources, Matisse "revealed" African sculpture to Picasso, probably at the same time that Vlaminck and Derain made the same discovery.

In order to modify the rules of perspective, Matisse looked at the non-Western, or in any case pre-Renaissance tradition for the solution he was seeking and, once this influence was totally assimilated, he produced *Harmony in Red, The Dance* and *Music,* an extraordinary sequence of masterpieces that made an indelible mark, as veritable thresholds, on much of twentieth-century painting. In this light one can grasp the meaning of the episode of the second version of *The Young Sailor*: the metaphorical figure of the postman is Matisse himself deviating from post-Renaissance figurative culture and pretending not to realize this, putting himself in the guise of a "primitive." Matisse's greatness, however, resides in his very capacity to reconcile the influence of the Louvre with that of Islamic art and so-called primitive art.

In this period sculpture became a much more important factor in Matisse's output than in the past, both quantitatively and qualitatively: *Torso with Head (La Vie)* (1906), *Reclining Nude I* (1907), *Two Women* (1908), *La Serpentine* (1909), *The Back I* (1909), and *Jeannette I* (1910). "I

♦ *Above: Henri Matisse,* Landscape at Saint-Tropez, 1904; *pencil on tissue paper; 31 × 20 cm (12¼ × 7⅞ in); Musée Matisse, Nice. This drawing executed in the countryside of Saint-Tropez has a* particular field of view that is underscored by the presence of the artist's hand and foot in the composition, which makes the beholder participate in the painter's activity.

♦ *Below: Henri Matisse,* Study for "The Dance," 1909; *charcoal; 48 × 65 cm (19 × 25⅝ in); Musée de Peinture et de Sculpture, Grenoble. According to Matisse himself, the subject of* The Dance *came to him from some sardana dances he saw at Collioure and from the farandole* dances he saw at the Moulin de la Galette. Besides the inspiration afforded by the movement of these popular dances, Matisse was certainly also influenced by the symbolic implications of this motif, which was used by many artists in this period.

15

16

would take some clay and take a break from painting," Matisse later recalled, thus placing this art in a sort of secondary position. Yet sculpture played a different role in this period, similar in some ways to the one played by the second version of *The Young Sailor*. The most striking aspect of these works are the "deliberate deformations" mentioned by Gertrude Stein, as if Matisse were seeking confirmation of his creative conquests in the art form that was most closely related to and caught up in the realist, representative tradition. It is no accident that the influence of African art, interpreted by Matisse by "following invented proportions and planes," should be assimilated much more in depth in *Reclining Nude I* than in its corresponding pictorial version, *Blue Nude*, which has a much more exotic subtitle: *Memory of Biskra*. Matisse's definitive liberation from the dominance of perception over emotional invention is to be found in the earlier work, *La joie de vivre*. The theme here is the Golden Age, hence a subject placed outside of realistic time and space. Even though this subject plunges Matisse into the Symbolist atmosphere which, from Moreau to Puvis and Gauguin, had already produced various versions of this theme, its appearance in the midst of a series of paintings given over mostly to landscape and figures is indicative of its anticipatory nature – like a premonition of a precise creative choice that would soon be carried out to the full. This was confirmed by his repetition of certain details in this painting that became the main, or even sole, subjects of the decorative works of the following years. The round dance in the background became *The Dance*; the reclining nude with one arm behind her head became the monumental *Memory of Biskra* (painted in 1907, the same year as the sculpture *Reclining Nude I*); the crouching figure on the left picking a flower is repeated in the person feeding the turtle (perhaps a subtle homage to his teacher Moreau, who painted two turtles in his 1865 work *Orpheus*) in *Bathers with a Turtle* (1908) and its mirror image is seen in *Luxe* (1907); the aulos player in the foreground and a similar figure in *Music* (1910).
The enormous difference between *La joie de vivre* and successive canvases is on two levels which refer to the problems Matisse confronted at this time. After the Fauve experience he was able to liberate colour: "My picture *La musique* was composed with a fine blue for the sky, the bluest of blues. The surface was coloured to saturation, to the point where blue, the idea of absolute blue, was conclusively

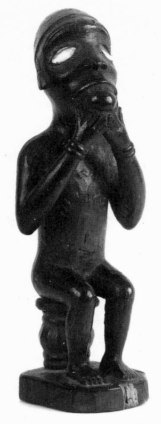

• A nineteenth-century Bagonko statuette that belonged to Matisse. The influence of primitive art was decisive in the development of this artist's aesthetic from 1905 to 1910, as is shown by the breaking up of the planes in a sculpture piece such as his Reclining Nude I (1907).

present. A bright green for the earth and a vibrant vermilion for the bodies. With these three colours I had my harmony of light and also purity of tone. Notice that the colour was proportionate to the form. Form was modified according to the interaction of neighbouring colours. The expression came from the coloured surface, which struck the spectator as a whole." Here one intuits his kinship with the poetics of colour from then on that informed his entire pictorial language. Also, by placing primary importance on certain individual elements of the composition and investing them with absolute value, Matisse broke away from the last fundamental conceptual heritage of Western tradition, the narrative element, even the symbolic narration of his latest works. Beginning with his works of 1908, Matisse can consider himself an "abstract" painter not because he repudiates recognizable forms and objects in his works, but because he totally abandons narration and concentrates solely on the pictorial

rendering of emotion, leaving to the tools of painting the task of conferring a new secular sacredness to his canvases. It was this religious sense which, after 1907, enveloped both the symbolic compositions and the interiors and figures that Matisse continued to paint, and that led him to declare on the one hand the attainment of a pictorial language ready to respond to the most disparate stimuli, and on the other the ability to make this "new" language part of a continuous flow of inspiration that would never veer off its course.
The still lifes and landscapes, however, resisted this wave of spiritual feeling; it is tempting to view this as inevitable, since these works did not possess the same degree and intensity of abstraction inherent in the very formulation of the images that grew out of *La joie de vivre*, nor could they be transformed into icons like the various portraits of his wife or of his son Pierre. Yet this is no reason to consider these works less evolved than the others;

• Right: Gustave Moreau, Orpheus, 1865; oil on canvas; 54 × 99.5 cm (21¼ × 39¼ in); Musée du Louvre, Paris. This is one of the rare paintings by Moreau that was exhibited before his death and the opening of the Paris museum dedicated to his works. It was therefore rather well known, and may have been seen by his pupil Matisse, who took up the motif of the turtle in his 1908 painting Bathers with a Turtle. Among other things, the turtle is the symbol of music, one of Matisse's favourite themes.

◆ Left: Edward Steichen, Matisse Sculpting "La Serpentine," 1909. Taken by the famous photographer Steichen in Matisse's studio at Issy-les-Moulineaux, this photograph was printed in 1913 in the contemporary art and photography magazine "Camera Work," run by Alfred Stieglitz in New York. The previous year Matisse had exhibited his sculpture pieces in Stieglitz's gallery.

◆ Right: Pablo Picasso, Les demoiselles d'Avignon, 1907; oil on canvas; 244 × 233.7 cm (96 × 92 in); Museum of Modern Art, New York. Matisse and Picasso met in 1907 and, while they were never close friends, they regarded each other with mutual respect, took note of each other's artistic experiments, and even exchanged some paintings. Despite their great difference, Les demoiselles d'Avignon and La joie de vivre can be considered equally important central works in the evolution of twentieth-century art.

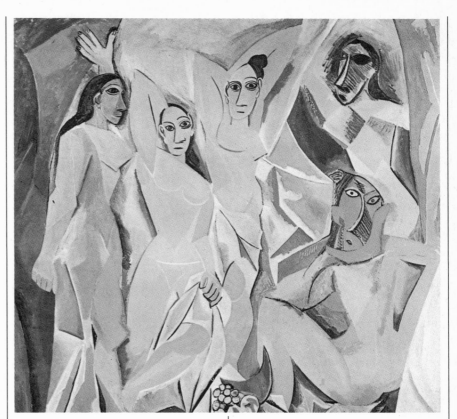

◆ Above: Matisse with his pupils in his studio at the Sacré Coeur convent, 1909. Matisse opened his own academy for a brief spell but abandoned it, giving the following explanation: "The most depressing thing was they did not understand how desperate I was to see them doing "Matisses." So I understood I had to choose between a painting career and a teaching career."

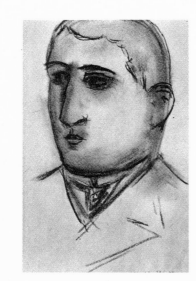

◆ Right: Henri Matisse, Guillaume Apollinaire, 1914; charcoal. The French poet was one of the first to recognize Matisse's greatness, writing an article on him in 1907. Later he was more attracted to Picasso and Cubist pictorial research, but he continued to follow Matisse's works with great interest.

their primary task was to continue the analysis of form and space, as is the case for example of the first canvas with a theme central to Matisse's creative imagination, *Goldfish*, in which there converge the subject of the title, a vase with flowers and a statuette of *Reclining Nude*. But it is especially through these works that Matisse tests the possibility of a new approach to the theme of decoration, which was already present in his symbolic paintings. If in those works there prevails a synthetic conception obtained by reducing to the core all the elements that make up the work, in the still lifes those very elements are exaggerated through a play of lines, colours and light that transform the canvas into a single continuous arabesque, as is the case with *View of Collioure* (1908) and in *Still Life with Blue Tablecloth* (1909). Different subject, different pictorial solutions, and an identical result: an unreal spatiality, the accentuation of the role colour and line play as bearers of emotion and of the very meaning of the works, and the exaltation of the decorative element understood in a more or less symbolic key. When in 1908 Matisse used words to reveal his aspirations, he did nothing else but describe the canvases he would paint a few months hence and that, with some brief intervals, he would continue to paint for the rest of his life: "What I dream of is an art of balance, of purity and serenity devoid of troubling or disturbing subject-matter. An art which could be [...], for the businessman as well as for man of letters, for example, like a comforting influence, a mental balm, something like a good armchair in which one rests from fatigue."

A Table in Eden

"But whom should one follow, Matisse or Picasso? Oh heroic days!" André Salmon's predicament takes us straight into the atmosphere of the first decade of this century, the already mythical season of the avant-garde movements. The intellectual salons of the two nuclei of the Stein family; Apollinaire's art criticism; the extraordinary Russian art collectors who adorned their Moscow residences with the works of young Parisian artists; the cafés and the different clans and cliques; the discovery of modern art in the United States thanks to the pioneering efforts of Stieglitz and the rather chaotic yet grandiose Armory Show in 1913; the web of relationships between painters and intellectuals, actors and theater personalities; the discovery of Diaghilev's Ballets Russes; the rise of the great gallery owners Kahnweiler, Bernheim-Jeune, and Guillaume – this was a period of artistic ferment unique in the entire twentieth century, interrupted only by the outbreak of the First World War.

Matisse lived in this atmosphere with mixed feelings. He was one of the major protagonists of this artistic efflorescence, reaping glory as well as acrimonious criticism and ridicule. However, he shied away from this pivotal position. From 1909 to 1914 he travelled rather frequently. He moved his studio to Issy-les-Moulineaux in 1909; in 1910 he visited Spain; the following year he went first to Moscow to oversee the installation of *The Dance* and *Music* commissioned by Sergei Shchukin, then to Morocco, where he was to return in the winter of 1912 and the spring of 1913; on his return he set up a studio in Paris, at 19 Quai Saint-Michel, and divided his time between Paris, Issy-les-Moulineaux and Collioure, where he and his family took

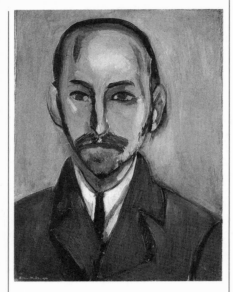

♦ *Above: Henri Matisse*, Portrait of Michael Stein, *1916; oil on canvas; 67.3 × 50.5 cm (26½ × 19⅞ in); Museum of Modern Art, San Francisco. Michael and Sarah* *Stein were among the first and most important collectors of Matisse's works, replacing Leo and Gertrude Stein, who became more interested in Picasso around 1910.*

♦ *Below: Hokusai,* View of Mt Fuji during a Storm; *woodcut; Musée Guimet, Paris. The influence of Japanese art on nineteenth- and twentieth-century European painting can be seen in the work of many artists from Impressionism on. Matisse himself once said: "Colour* *exists in itself, has its own beauty. We were made to realize this by the Japanese prints and drawings we bought for a few centimes on the Rue de Seine. Once my eye was unclogged [...] I was capable of really absorbing the colours because of their emotive power."*

refuge when war broke out.

These were years of intense creative activity in which Matisse developed the central themes of his own inner vision, at the same time particularly from 1914 to 1917, dabbling with Cubism. His pictorial experimentation led Matisse to the creation of absolute masterpieces such as *The Red Studio* and *The Pink Studio* (both 1911), *Still Life with Aubergines* (1911–12), the Algerian canvases of 1912–13, and *French Window at Collioure* and *The Branch of Lilac* (both 1914).

There was still a certain ambivalence in Matisse's approach to different themes and in the various ways in which they could be usually expressed depending on whether he had to paint, for example, a composition of figures or of objects. But in the paintings mentioned above even this contradiction disappears, and there was now total unity in his vision.

"I do not paint things, but only their relationships"; "A colour is alive only in virtue of the interaction with its neighbouring colour." These words by Matisse reveal the meaning his had taken on. When these relationships are

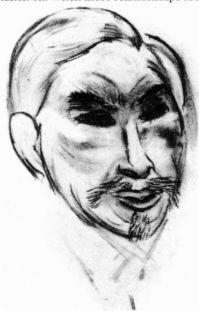

fully achieved on the canvas, the subject and the figurative impetus that gave rise to the composition no longer matter. Examples of paintings created wholly out of relationships are *The Red Studio* and *Still Life with Aubergines*, which were created in different but equally definitive manners. *The Red Studio* is almost a metaphorical self-portrait. It contains relationships between the painter and his studio, the painter and his oeuvre, between the individual paintings and the paintings and sculptures, between the actual space of the studio and the fictitious space of the works, between a suggested perspective and a marked perspective that spills the entire composition on to the surface,

♦ *Above: Coptic fabric. Matisse's decorative art drew inspiration from different expressive forms, especially the great Middle and Far* *Eastern traditions, certain motifs of which, such as those in the fabrics and carpets, he reproduced "to the letter."*

♦ *Left: Henri Matisse,* Portrait of Shchukin, *1912; charcoal; 49.4 × 30.5 cm (19½ × 12 in). The Baltimore Museum of Art, Walters Collection. The Russian art collector, who was also a great* *supporter and patron of Picasso, not only purchased many of Matisse's most important works, but also commissioned two historic panels,* The Dance *and* Music, *as decorations for his Moscow home.*

♦ *Below: detail of Persian ceramic tile that once belonged to Matisse. The tile appears in a drawing he did in 1915.* *Matisse himself also worked in ceramics, further evidence of his love for Oriental art.*

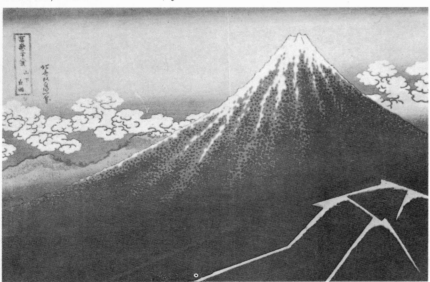

18

The Influence of "Orientalism"

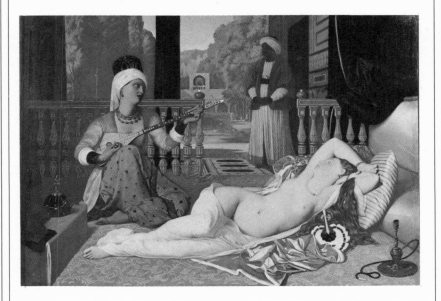

Throughout the nineteenth century Western culture sought inspiration from other cultures. At first this was merely a generic sort of "Orientalism"; then, in the second half of the century, it shifted towards a search for a deeper knowledge of Far Eastern art, especially Japanese art. The first manifestation of this impulse was partly a consequence of Napoleon's expedition to North Africa, leading to an "Orientalist" artistic movement that combined the desire for knowledge with a predominant taste for the exotic. The many artists, mostly French, who specialized in this field were in fact academic painters whose interest in Middle and Far Eastern cities and people lay only in finding heretofore unknown subjects which were then depicted according to the canons of purely academic tradition. These painters did little more than create a fashion, as their activity in this direction was superficial and had virtually no practical effect on the work being produced at the time.

Things were quite different in the case of an artist who during his stay in North Africa found not only new subjects, but colours and light foreign to his artistic formation. This was Eugène Delacroix, who returned to Paris with a rich and luminous palette. He was followed in this by another great colourist, August Renoir, who was also fascinated by the pictorial potential of the clothes, fabrics and carpets of an extraordinary decorative tradition. However good their quality, the "Oriental" paintings of Delacroix and Renoir are still part of a purely Western vision of this exotic world and did not

♦ *Jean-Auguste-Dominique Ingres,* Odalisque with Slave, *1839; oil on canvas; The Fogg Art Museum, Cambridge, Massachusetts. Matisse always regarded Ingres's art, especially his precise*

drawing, as a model whose influence was inexhaustible. Both in La joie de vivre *and in some figures Matisse painted in the late 1920s, the influence of Ingres is clearly to be seen.*

really mark any significant change in their aesthetic, which was firmly anchored to the post-Renaissance principle of art as the representation of reality.

Matisse followed in these artists' tracks, but very soon made a radical change in the approach to so-called Oriental art, totally immersing himself in it. He was the first artist to succeed in merging two such distant cultures, and the irruption of the Islamic concept of art as pure decoration in his works called into question the very values of Western artistic tradition.

between the painting within a painting represented by the still life in the foreground and between the canvases hanging on the wall, between the painting executed in 1911 and the others painted previously, and lastly, between the different tones that communicate with the red that overwhelms the studio and invest it with a visionary character, a task which in other periods would have fallen to the subject-matter. *Still Life with Aubergines* is more obscure. Here the play of space is worked out in an even more complex way. Not only is everything thrown on to a single surface, but the descriptive element, realistic and yet decorative, represented by the wallpaper, also invades the floor; there is a total assimilation between the table with the aubergines and the screen; the dizzying play of the painting within a painting is expressed by means of the mirror on the left and the open window on the right which indicates the irruption of a wild, untamed nature into a still life. The triumph of the decorative element is parallel with a reaffirmation of the centrality of the relationship between objects and between colours, between interior and exterior, between painting and reality. *Still Life with Aubergines* was apparently painted in the wake of Matisse's visit to the exhibition of Islamic art in Munich in 1910, which made a deep impression on him. The exhibition further confirmed for Matisse the possibility of transforming the canvas into an uninterrupted continuum of signs and colours that invade the entire space of the work, and the need to subordinate the still realistic truth of the individual details to the pictorial balance of the whole. The Algerian canvases address this in a consistent manner, particularly *Entrance to the Kasbah* and *Zorah on the Terrace*, about which Matisse expressed some doubts in a letter to Camoin: "I wanted to do a decorative painting and actually I think it is one; but I would have liked it to be even more so." This aim was fully achieved in *The Moorish Café* (1913), arranged along the lines of *Music* but now definitively pacified in an atmosphere of total ease, in which the figures with their abstracted faces, fuse the different formal and symbolic elements that had followed one another in Matisse's oeuvre from the time of *La joie de vivre.*

It is not surprising that the ultimate aim of these artistic experiments, which was achieved between Paris and Collioure in 1914, is represented by Matisse's most "abstract" paintings – *French Window* at *Collioure, Notre-Dame* and *The Yellow Curtain.* These

♦ *Above: Henri Matisse,* View of the Kasbah, *1911–12; pencil; 34.6 × 24.6 cm (13 × 9 in); Private Collection. Matisse's trip to North Africa was of fundamental importance to his "discovery of light" and bore its best fruit in the canvases executed between 1910 and 1915.*

♦ *Below: Henri Matisse,* Irene Vignier, *1944; etching; 8.2 × 5.6 cm (3 × 2 in). This portrait of the daughter of Mme Vignier is part of a series of etchings Matisse produced during the Second World War. The subjects were taken from among his family and friends and were executed with great confidence and speed.*

works mark the extreme to which Matisse took his artistic vision and open up perspectives he would develop in the following years. The immediate impression of these works is how they are constructed in chromatic and spatial relationships, a structure which ends up transforming the motif – which is always present – into pure form and colour and, as in the left-hand section of *The Yellow Curtain*, into pure arabesque, while the motif of the window once again takes us to a duality favoured by Matisse, that between interior and exterior, which is here resolved in a purely cerebral composition. Matisse once again

20

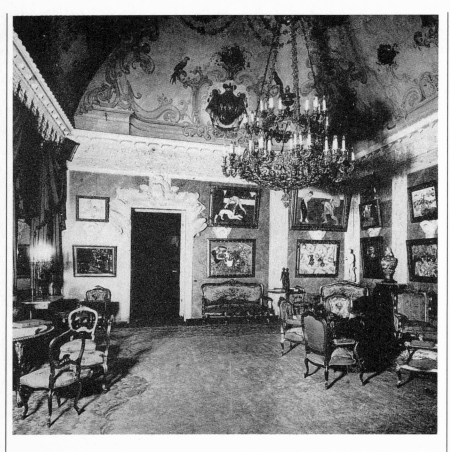

♦ *Below: Henri Matisse, Sketch, 1906; 9 × 11.5 cm (3½ × 4½ in); Private Collection. One of Matisse's favourite subjects was his own family. Portraits, family scenes, conversations and the various themes of classical painting are reinterpreted by Matisse in a domestic key, thus lending a sort of secular sacredness to this subject.*

starting point in Cézanne, whose art and influence Matisse had by no means forgotten. As he himself said, it was a matter of adding "the magic of colour" to Cézanne, and in order to do this it was necessary to remove oneself momentarily from the most direct consequences of the master's oeuvre; once this dimension had been achieved, Cézanne's teachings could come to the surface again, just as Matisse had formulated them in 1908: "Now look at a canvas by Cézanne: everything is so well arranged that no matter how many figures are represented or where you stand, you will always be able to distinguish each figure clearly and know which limbs belong to each body. If in the painting there is much order and clarity, this is because they existed in the spirit of the artist, or because the artist was aware of their necessity. Limbs may cross and mingle, but still in the eyes of the beholder they will remain attached to the right body. All confusion will have disappeared." We need only observe two large

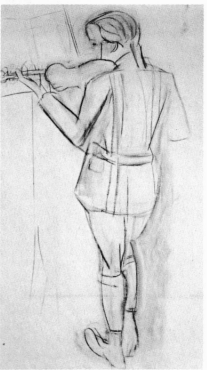

♦ *Above; the Matisse room in Sergei Shchukin's home in Moscow, 1912. At least two of the artist's works can be recognized: Nymph and Satyr and Game of Bowls.*

♦ *Below: Henri Matisse, The Violinist, c. 1917; charcoal; 194 × 114 cm (76½ × 44⅞ in); Musée Matisse, Le Cateau-Cambrésis. Matisse often made use of musical metaphors to define painting and was himself an amateur musician. In the figure of the violinist, Pierre Schneider sees Matisse's homage to one of his favourite artists, Manet, the creator of The Old Musician.*

reaches an extreme on the edge of the world of pure ideas. Once again his study of the paintings in galleries and museums (together with his extraordinary mastery of such a complex, solid and highly evolved pictorial language) that enabled him to create a new style without any break in continuity. Much has been said about the relationship between Matisse and Cubism, and Picasso in particular, both from the art-historical and biographical viewpoints. A cultural exchange of ideas certainly took place but, since it involved artists and ideas that were by then already famous, such an exchange could only result in mutual support rather than create any influence. What mostly differentiates Matisse's work and the direction it was taking from work of the Cubists is without question their different conception of pictorial space, which is directly involved with the perception and rendering of reality on the canvas, hence a fundamental artistic principle. Matisse's space is continuous, infinite rather than indefinite, always an invention of the imagination developed entirely on the surface. Cubist space, on the other hand, is still realistic space, dissected and broken down and yet reconstructible, the result of rigorous analysis, a space that never draws from the imaginary or symbolic but is always firmly anchored to reality, of which it sets out to offer a more complete vision than that of conventional imitative representation. Even the nature and role of colour are inspired by and respond to antithetical principles.

In Matisse colour is applied in large background areas, enclosed within clearly defined outlines, and it is evocative and symbolic, heraldic and exaggerated in its purity. In Picasso and Braque (from 1908 to 1913) colour is still connected to the chiaroscuro tradition; it is extremely sober and yet quite rich in the variation of tones, and respects the chromatic appearance of real objects. It is this very rapport with reality and the capacity to offer a "modern" interpretation of it that so attracted Matisse, after his radical experiments with the decorative and abstract, to the work of those artists. In any case, despite their differences they were all engaged in a common battle to renew pictorial language. For, although the results of their experiments were at opposite poles, they had a common

compositions Matisse executed in 1916, *The Moroccans* and *Bathers by a River*, to understand how the syntax of space responds to this category of problems which are so superbly assimilated in Matisse's vision, which perhaps achieves the height of fusion of constructive and decorative mastery in *The Piano Lesson* (1916). Two other works, painted between the end of 1915 and early 1917, clarify this phase of Matisse's artistic experience and set his relationship with Cubism in a broader perspective: *Variations on a Still Life by De Heem* and *The Rose Marble Table*. The former in particular is considered proof of the influence of Cubism on Matisse during this period, especially by comparing it to some works by Juan Gris, who was a close friend of Matisse during the war. As in

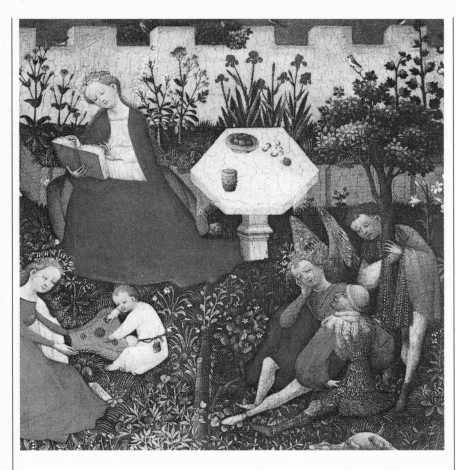

♦ *Left: Master of the Middle Rhine, The Garden of Paradise, c. 1410; oil on panel; 26.3 × 33.4 cm (10⅜ × 13⅛ in); Städelches Kunstinstitut, Frankfurt. Not only does the theme of this work bring to mind such symbolic works of Matisse as The* Dance *and* La joie de vivre, *but the table in the middle could be considered a source of inspiration for his 1917 painting,* The Rose Marble Table, *reproduced below. This is yet another demonstration of how Matisse was an attentive observer of the art of the past.*

♦ *Right: Alberto Giacometti,* Matisse in His Studio, *undated; pencil; 65 × 50 cm (25⅝ × 19¾ in); Private Collection, Milan. Like Matisse, Giacometti also participated in one of the crucial periods of avant-garde art and* then went on his way, creating his highly personal, inimitable style. The encounter between Matisse and Giacometti is therefore one of two central figures of the "tradition of the new and modern."

♦ *Below: Henri Matisse,* The Rose Marble Table, *1917; oil on canvas; 146 × 97 cm* (57½ × 38¼ in); *Museum of Modern Art, New York, Mrs Guggenheim Fund.*

The Rose Marble Table, Matisse was once again directly inspired by the old masters, quite explicitly in the case of the still life, and implicitly but equally clearly in the other work, in which there is a quotation of a small table in the middle of an "Eden" painted in the early fifteenth century, here laid flat on the surface by Matisse in a composition with a motif, Eden, that was very close to his heart.

This is where Matisse's link with Cubism lies. In this period of transition he worked in a direction apparently very remote from the one he had taken ten years before. Paradoxically, the Cubist pictorial language remained much more bound to the post-Renaissance painting tradition than Matisse was, and in order to channel this tradition into his own vision, in order to return to his roots and the museum works to which he would always refer, Matisse had to pass through his most recent and innovative interpretation, which was the same one formulated by Picasso and Braque in the wake of Cézanne's art and influence.

Cubism was therefore an indispensable support to which Matisse could turn in order to solve an inner conflict between reality and imagination. This also demonstrates the analysis that lay at the base of Matisse's felicitous and seemingly instinctive art.

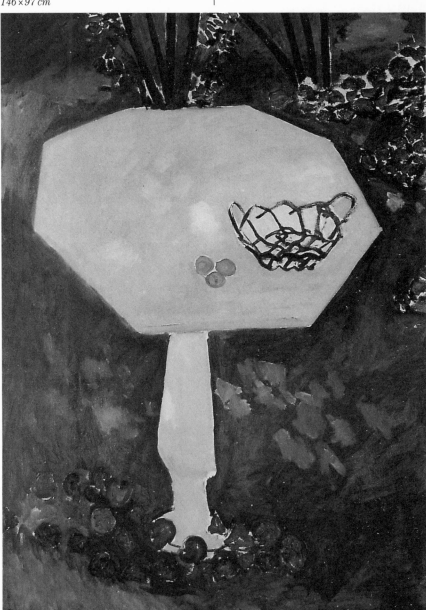

Variations

22

"Note that the classic painters have always done the same work, and always in a different way. From a certain time on, Cézanne always painted the same canvas of *Three Bathers*. Although the master from Aix continuously redid the same picture, don't we always come upon a new Cézanne with the greatest curiosity?" The same could be said for Matisse, and it is a judgement which is most applicable in the years between the two world wars, by which time Matisse was considered a classic by public and critics alike, and he himself was also probably aware of being so. This certainly does not imply a decrease in creative urgency in Matisse, but rather greater concentration on a limited number of themes and the ability to address the pictorial problems arising from this more limited range of figurative impressions. These could be summed up by the central role played by the female figure, almost always set in an interior, and by the still life – themes that follow one another with

♦ *Above: Henri Matisse*, Study after the Tomb of Lorenzo de' Medici, *c. 1918–20; charcoal; 53.4 × 72 cm (21 × 28⅜ in); Private Collection. As we have already seen, Matisse was certainly not an artist who* repudiated the past; he carefully studied and drew inspiration from the classical Italian tradition, such as the pose of this Michelangelo sculpture, which he used in numerous works.

♦ *Below: Henri Matisse*, Study for "Antaeus" after Pollaiuolo, *1935; pencil; 28.7 × 38.5 cm (11⅜ × 15⅛ in); Matisse Archives. Although his favourite Italian artists were the* "primitives," Matisse incorporated many Renaissance models into his art. This drawing was a study for one of his papiers découpés *in 1938 that was to be used for the ballet* The Strange Farandole.

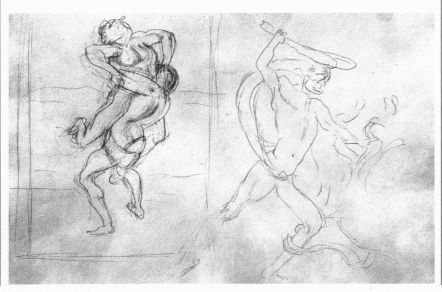

obsessive frequency, interrupted only by the occasional landscape, from 1919 until well into the 1940s. In 1925 Matisse said: "Painting is a means of expression, and the same thing could be expressed in different ways." His art had already adapted to this principle. But we must move backwards in time in order to understand the transitions Matisse made from the extreme experimentation of the war years to achieve what has been called his "classical" phase, which corresponds to the 1918–28 period. The two versions of *The Young Sailor* are admirable examples of a fundamental transition in Matisse's art, and echo elements found in *The Piano Lesson* and *The Music Lesson*, executed in 1916 and 1917 respectively. *The Piano Lesson* belongs to the moment of greatest contact with the avant-garde aesthetic, while *The Music Lesson* heralds the later paintings that, as often with Matisse, were executed before the preceding phase had been fully exhausted. *The Piano Lesson* displays a rigorous synthetic composition, the spaces are widened excessively in an abstract rhythm based on the relationship between the geometric forms and between the colours, and the scene becomes an unreal, almost oneiric, vision. In *The Music Lesson* the configuration is surprisingly realistic; whereas before the exterior was an ideal triangular form, it now becomes a garden depicted in its individual elements and the dream-like setting is here transformed into a family portrait, a genre scene comparable to the one Matisse had copied from Fragonard at the Louvre many years earlier. In short, this is much richer painting, marking the advent of a new phase in which the decorative dimension once again works its influence on reality, no longer seeking to reach the vertiginous heights of the symbol; this is a tamed reality set on to a stage, as it were, that lives and exists only for painting and in order to be painted. Matisse's so-called classicism thus seems to respond to his own inner needs rather than those of an external climate, even though once again his path runs parallel to the major artistic movements of the time.

This was the period of the discovery of classicism by Picasso, Derain and Severini, the period of the German New Objectivity movement, the years in which the experimentation of the avant-garde movements came to an end and there was a return to the supremacy of drawing, of compositional balance, and of tradition. None of this was new to Matisse, but it constituted further confirmation of the development of his own artistic language. His classicism

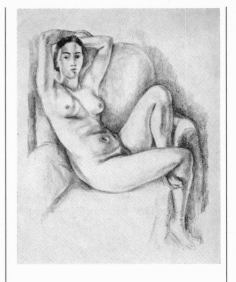

♦ *Above: Henri Matisse*, Nude Seated on a Blue Cushion, *1924; lithograph; 61.7 × 47.8 cm (24¼ × 18¾ in). In the early 1920s Matisse produced a series of lithographs based on one of his favourite themes, which was taken up in many paintings and* sculptures in this period. These lithographs bear witness to the popularity of Matisse's art at the time, which induced such famous art gallery owners as Frapier and Vollard to commission works from him in this medium.

♦ *Below: Henri Matisse*, Self-portrait, *1934–35; brush and ink; 10.4 × 7.8 cm (4⅛ × 3⅛ in); Private Collection. "I have always considered drawing not the exercise of a particular skill, but above all a means for expressing intimate* feelings or for describing moods: simplified means, however, in order to convey simplicity and greater spontaneity to the expression, which must speak to the mind of the beholder without heaviness."

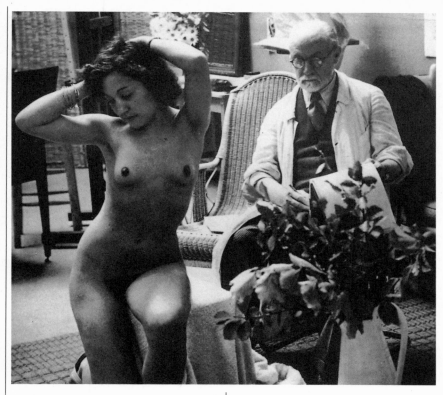

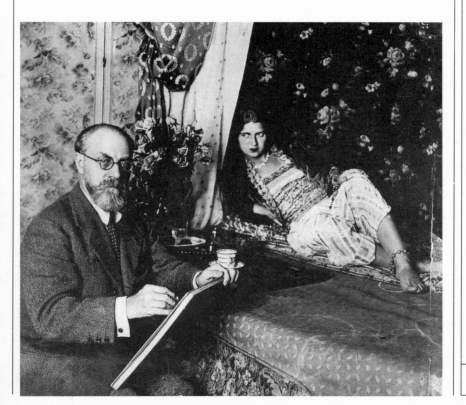

can be interpreted only as a more balanced and more intimate dimension of an ongoing, uninterrupted artistic adventure characterized by progressive shifts, "different ways" of expressing "the same thing." We need only observe *The Moorish Screen* or one of the *Odalisques* executed during this period to see how the realization of decorated space and the primacy of colour over every other element in the composition were by then consolidated practice in Matisse's art and how, as with the classic painters, the motif was a mere pretext, a "pointer" paving the way for innumerable pictorial variations.

The term "variation," which Matisse deliberately used to describe a series of

♦ *Above: Brassaï, Matisse in His Studio, 1939. The female nude is one of the most recurrent in Matisse's production. "I often keep these girls [his models] for many years, until all interest has been exhausted [...] The emotional interest they inspire in me is* revealed *not so much in the representation of their bodies, but is often manifested in the lines or special values scattered throughout the canvas or over the drawing paper, so as to form its orchestration, its architecture [...]"*

♦ *Below: Matisse painting in his studio in Place Charles-Félix in Nice, c. 1928. Matisse constantly re-elaborated his* Oriental motifs in his studio, creating veritable stage sets in which to set his models in typical Oriental clothes.

Matisse's Books

♦ *Henri Matisse,* The Blinding of Polyphemus, *illustration for James Joyce's* Ulysses, *1935. Matisse met with the author in order to discuss the execution of the illustrations but admitted he had never read Joyce's masterpiece.*

Among the many masterpieces created by Matisse, we can include the graphic works that accompanied certain classics of literature, especially contemporary ones, published by such prestigious firms as Skira and Tériade.

Matisse began this activity relatively late in his career, when he had already taken his place among the great masters of the twentieth century, and he first reacted to the idea of book illustration with scepticism, as if this were a purely marginal part of his creative work; but gradually his interest in this activity grew. From 1932, when Skira published Mallarmé's *Poésies* accompanied by 29 plates by Matisse, to 1950, when the *Poèmes* of Charles d'Orléans came out, Matisse illustrated nine books: James Joyce's *Ulysses, Pasiphaé: Chant de Minos* by Henry de Montherlant, Pierre Reverdy's *Visages, Repli* by André Rouveyre, *Letters of a Portuguese Nun* by Mariana Alcoforado, and Pierre de Ronsard's *Florilège des amours*; there was also *Jazz*, a book entirely by Matisse himself and published by Tériade in 1947, the drawings and etchings inserted in books written by friends of his, and the many book, catalogue and magazine covers he illustrated.

But the term "illustration" is not really appropriate if we consider Matisse's attitude to this branch of his creative work. He never restricted himself to a mere literal and descriptive transposition of the texts he illustrated, but always sought to translate into his artistic language what the words suggested to him, thus trying to make the two expressive modes complementary. The artist's own words are quite indicative: "Illustrating a text does not mean completing it. If a writer needs an artist to explain what he has said, it is because the writer is inadequate. I have found authors with whom nothing could be done: they had already said everything. Book illustration can also be embellishment, enrichment of the book with arabesques, conformity to the writer's viewpoint. One can also execute illustrations with decorative means: beautiful paper. The illustration is useful, but it does not lend much to the literary substance. Writers do not need painters to explain what they want to say. They must possess the resources they need to express themselves." On other occasions Matisse used a musical metaphor that clarifies his attitude to texts quite effectively: "It is a bit like the role of the second violin in a string quartet, except that the second violin responds to the first violin, while in my case I do work that is parallel to that of the writer but is in a sense a bit more decorative." The decorative element, central to all of Matisse's oeuvre, plays its role in this field as well, as can be seen in the illustrations of Charles d'Orléans' *Poèmes*, in which the lily motif is repeated in each plate, in adherence to the principle of variations on a theme that immediately leads to the idea of ornament, which was so much a part of Matisse's art.

24

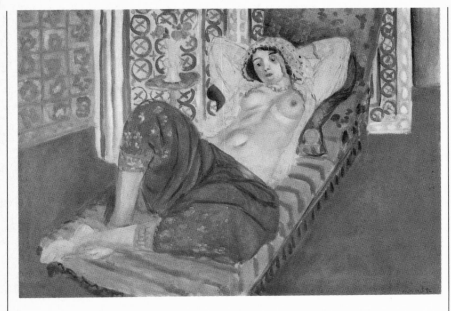

drawings executed in the 1940s, is an extremely faithful description of Matisse's language, coming as it does from the domain of music, which was an essential part of the artist's life (he was a passionate amateur violinist) and which he often declared was the reflection and "sister" of painting. It would be wrong to think that Matisse was intent only on developing this one theme to the exclusion of all others; although this is what his "chamber" works of the 1920s and 1930s reveal, there is no doubt that in this period he was still willing to experiment with new or only partly explored pictorial languages.

Often these experiments grew out of Matisse's leading position in the contemporary art scene as an undisputed master of modern art, whose alter ego was the equally renowned Picasso. This partly explains why Matisse embarked on certain artistic sidelines, such as scenery and costume design, first in 1920 for Stravinsky's *Le chant du rossignol* (The Song of the Nightingale) produced by Diaghilev's Ballets Russes, and then in 1939 for Shostakovich's ballet *Rouge et noir* (Red and Black) produced in Monte Carlo; a series of lithographs in 1925 with the odalisque motif, which had by then become synonymous with Matisse in the eyes of the public; book illustration, especially

♦ *Above: Henri Matisse,* Odalisque with Red Culottes, *1921; oil on canvas; 67×84 cm (26⅜×33⅛ in); Musée National d'Art Moderne, Centre Georges Pompidou, Paris.
Left: Henri Matisse,* Odalisque with a Moorish Chair, *1928; The Museum of Modern Art, New York. Even the models who posed for Matisse have become part of the public image of this artist. One of the most important was Henriette Darricarrère, his favourite model in his Nice period who often sat for his odalisque paintings. Other recurring names are Lydia Delktorskaja and Wilma Javor, who were the subjects of Matisse's paintings of the 1930s and of his Theme and Variations engravings.*

♦ *Below: Henri Matisse, costume design for the ballet* Red and Black, *Monte-Carlo, 1939. Matisse did the scenery and costumes for this ballet, which was set to music by Shostakovich and performed by Diaghilev's Ballets Russes. The artist's passion for dance is also shown by his many drawings of ballet dancers.*

poetry, which began in 1932 with Skira's publication of an edition of Mallarmé's *Poésies*; and lastly, a masterpiece such as the three decorative panels for the Barnes Foundation in Merion, Pennsylvania that were commissioned by his long-time collector and were completed in 1933 after three years of study. There is also his sculpture production, which he continued on a regular basis up to the early 1930s, first taking up the theme of *The Back*, three versions of which dated from 1909, 1913 and 1917, and then returning to the *Reclining Nude* motif, which in this period took on the value of a plastic equivalent of the figures that populated his interiors. Therefore, whether they were apparently minor accomplishments such as the book illustrations, notable feats such as the Barnes panels, or continuations of prior initiatives such as sculpture, these works bear witness to Matisse's inexhaustible activity which was destined to have repercussions on his painting as well. After *The Dance*, executed for the Barnes Foundation, Matisse created compositions such as *Pink Nude* (1935) and the various versions of *The Dream* and *The Rumanian Blouse* that underscore the primacy of the search for a formal and compositional synthesis. In preceding years this search had given way to the arabesque plenitude of the cloth and curtains used as a backdrop against which the figures stood out or with which the objects were fused. The return to the prerogative of line fully corresponds to Matisse's vision of drawing and etching, art forms that precisely in this period grew in intensity and importance and that would later lead to the invention of the *papier découpé*, the drawing in space and colour *par excellence*.
Thus on the one hand there is the studio with its familiar, but always different objects, the intimacy of a space recreated by a sumptuous style of painting that almost verges on baroque redundancy; on the other hand there is the imagination, an architectural style of painting based on an extreme synthesis of form and colour, an essential decorative conception reduced in its principal elements to the point of pure rhythm. From the 1930s on Matisse developed, along parallel lines, the two main aspects of his entire visual universe, supported in this by his technical mastery and the unquenchable thirst for experimentation that allowed him to find in every field the medium suitable for his expressive needs. At this stage of his artistic development the technical procedures and the tools of his trade played a primary role in the creation of

the image, demonstrating once again how the artist's roots in tradition went hand in hand with his ability to refashion it and make it part of the process of discovery of unknown expressive horizons based on experience and not on the adaptation to pre-established artistic canons, an attitude that originated in his youthful refusal to adhere to the spirit of the Ecole des Beaux-Arts. The intellectual pleasure of experimentation for the sake of it or as an act of provocation, which played such an important part in the course of events of twentieth-century art, including a good deal of Picasso's oeuvre, does not belong to Matisse's expressive repertoire. What is part of his creation is the need to adapt his artistic means to his own ends; and

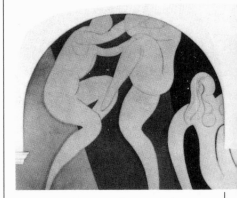

♦ *Above: Henri Matisse,* The Dance, *1931–32; oil on canvas; three panels: 385×475 cm (152×187 in), 400×500 cm (157½×197 in), 375×470 cm (147½×185 in); The Barnes Foundation, Merion, Pennsylvania. "I had the honour of being chosen by Dr Barnes to decorate the lunettes in the large staircase of his foundation, the part in shadow of the ceiling, set against the dazzling light of an immense glassed-in area consisting of three doors set on the same level and quite close to one another, each six meters high and about two meters wide [...]"*

♦ *Below: Henri Matisse,* The Head of Hair, *1932; etching; illustration for Mallarmé's* Poésies, *Skira, Lausanne. This was the first book illustrated by Matisse.*

in following this principle Matisse worked with the utmost freedom, even going so far as to repudiate conventions when necessary, but always without ideological prejudices of any sort. This was partly because he was keenly aware of the rapid involution the very concept of avant-garde was undergoing, and of the damage done to the interpretation of a work by a reading based on preconceived notions that were not to be verified in the very core of painting. Already in 1920 he had stated: "The mood [at the time of Fauvism] was one of defending painters against the Salons and against official painting. Whereas nowadays the masters are the Indépendants. In order to exist, one must wear an "Indépendant" armband. That is the current madness of the

Matisse's desire to meet Renoir in 1918 and show him some of his paintings was of great significance, as was his friendship from the 1920s on, with artists with whom he felt closest and collaborated with such as Pierre Bonnard, Aristide Maillol, his old friends Marquet and Camoin – all representatives of a generation that had been blooded by the avant-garde movements and had in the end evolved a pictorial language that was apparently no longer topical. (The same can be said of Matisse's friendships in the literary world, from Aragon to Rouveyre and Char, which are preserved for posterity in a voluminous correspondence that is fascinating and very useful for anyone interested in Matisse. In fact, his letters are

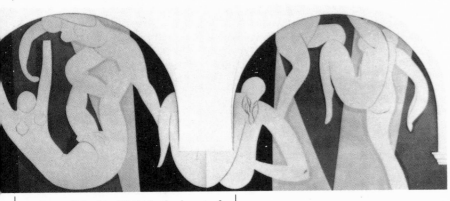

moderns." And in 1947, in the heart of the specious dispute between exponents of the "abstract" and the "figurative," he wrote to André Rouveyre: "I feel the need to keep my distance from all conventions, from all theoretical ideas, in order to liberate myself thoroughly and totally, placing myself outside the moment and this fashion of distinguishing between figurative and non-figurative."

Only by bearing this position in mind can we approach Matisse's work from the 1920s on in the right frame of mind and understand its basic inner consistency. From this point on what he strove for above all was to explore his inner self more deeply than he had done in his earlier works.

♦ *Below: Henri Matisse beside his* Rape of Europa, *1928. The violent subjects taken from mythology are not frequent in Matisse's production, but they mark an* *important stage in his career, as is demonstrated by other works such as* The Blinding of Polyphemus, Nymph and Satyr *and* Jupiter and Leda.

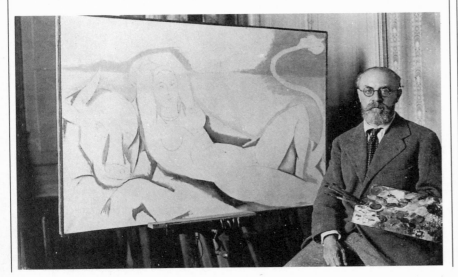

"The Dance" at the Barnes Foundation

After the round dance in his *La joie de vivre* and *The Dance* executed in 1910, Matisse returned to this motif in 1930, once again because of a commission on the part of an art collector, the American Dr Albert C. Barnes, who already had *La joie de vivre* in his large collection of old and modern paintings. This is how Matisse described the work in 1934, one year after it was installed at the Barnes castle: "[...] it is a panel 13 meters by 3.5 meters, set above three 6-meter high, entirely glassed-in doors [...] The painting almost forms a pediment over these three doors – like the elevated part of a cathedral porch – a pediment placed in shadow and yet, by extending the large mural surface that was perforated by these three large luminous openings, would also retain all its luminosity and hence its plastic eloquence (a surface in shadow set against a strongly lit bay without destroying the continuity of the surface) deriving from modern achievements regarding the properties of colours [...] The panels are painted in flat colours. The surfaces between the doors acquire a continuity in the decoration of the black surfaces and give unity of surface from the floor up to the top of the vault: 6 m + 3.5 m = 9.5 m; which, associated with the pendentives that press down on these black surfaces, gives the illusion of a monumental support for the vault. The other colours: pink, blue and the nudes in a uniform pearl grey, which create the entire musical harmony of the work. Their open contrasts and distinct relationships offer an equivalent of the hardness of the stone and of the sharp ribbing of

♦ *Henri Matisse, right-hand panel of the first version of* The Dance; *Matisse Archives. "Having carefully examined the particular lighting conditions, I returned to Nice and started work on the painting, 13 meters long by 3 meters high [...] For three years I* *worked like this, constantly rearranging eleven flat tinted shapes, rather like moving counters in a game of checkers, and changing them with the scissors, until I found an arrangement that fully satisfied me."*

the vault, thus lending a great mural quality to the work – a very important factor, because the panel is in the upper part of the Foundation gallery, filled with easel paintings – so it was logical to make a clear-cut distinction between this and my work of architectural painting."

This passage manifests the complexity of the problems Matisse had to tackle and above all his consciousness of the role his work would play in the architectural setting: not a mere image amongst other painted images, but a sort of activator of space able to extend the actual dimensions of the wall and become a hinge between the interior and exterior.

The long gestation period of this work was partly due to a technical "mishap" that obliged Matisse to execute two versions of *The Dance*. He had been misinformed about the size of the space available for the panels and so had to abandon the already finished first version, which was purchased in 1937 by the city of Paris and is now kept in the Musée d'Art Moderne de la Ville.

25

26

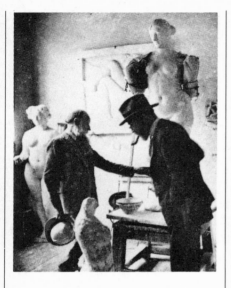

♦ *Above: Matisse and Aristide Maillol in Maillol's studio. The friendship between the two artists dated from 1905, when they first met in Banyuls, and lasted all their life. Although their conception of sculpture was markedly different, Matisse and Maillol were united by a common striving after a mythological-poetic dimension in art.*

characterized by the continuous alteration of the biographic and creative sides of his life and reveal his total, near-obsessive devotion to his art.) These artists were often accused of perpetuating a pictorial procedure and an artistic ideal whose vitality had long been sapped and of being the heirs of academic art. In reality they were developing an artistic style that was free from the obsessive need for novelty at all costs, placing in a different dimension of time from that of everyday life, and even from historical time. These artists had matured in the heyday of Symbolism, an artistic movement in which the idea usurped the dominating role of sensation, and the eternal nature of myths replaced the transient nature of daily existence; their connection to the museum was reinforced as a sort of vision of ideal continuity with the entire history of painting. All this left an indelible mark on this generation of artists, and meant they were misunderstood by the succeeding generation, which grew up in the fiery and iconoclastic years of the early twentieth-century avant-garde movements.

The period between the two world wars was considered a time of blissful isolation, which Matisse spent between Nice and Paris with numerous trips to the United States, Italy and Tahiti. He was awarded first prize at the Carnegie International Exhibition in Pittsburgh in 1927, held many one-man shows at Bernheim-Jeune's gallery and his first retrospective exhibitions at the Copenhagen Statens Museum for Kunst, at the Galerie Georges Petit in Paris, the Basle Kunsthalle and the New York Museum of Modern Art, achieving world-wide recognition for a career that in a few years' time would once again startle the art world.

♦ *Above: Matisse with Joan Miró, c. 1938. Although Surrealist art did not appeal to him, Matisse liked Miró's art, and even asked his son Pierre, who owned a gallery, to bring him one of the Spanish artist's paintings.*

♦ *Below: various stages of* Music, *1939. Matisse laid great importance on the birth and evolution of this work, so much so that he kept a photographic documention of its various stages.*

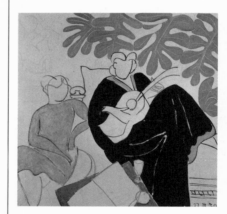
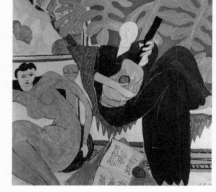

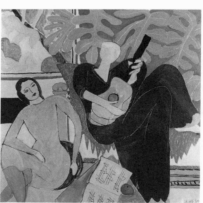
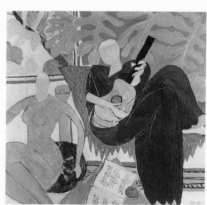

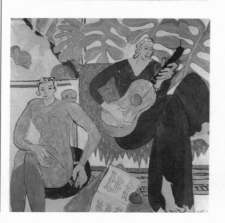

♦ *Below: Papeete, Polynesia, in a photograph taken by Matisse. His trip to Oceania in 1930 did not have an immediate effect on his production, but later gave rise to some of the last papiers découpés and tapestries with Polynesian motifs.*

Drawing in Colour

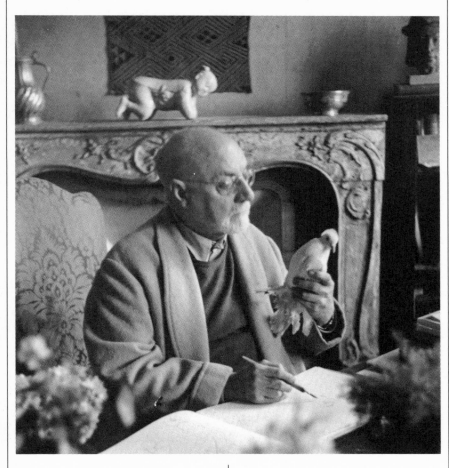

♦ *Above: Henri Cartier-Bresson, photograph of Matisse in Vence in 1944.*

♦ *Below: objects that belonged to Matisse, gathered together in his suite at the Hôtel Régina after his death.*

"My research does not seem to be limited yet. The cut-out is what I now find to be the simplest and most direct to express myself. One must study an object for some time in order to know its exact sign. Yet in a composition the object becomes a new sign which helps to maintain the force of the whole. In a word, each work is an assemblage of signs invented during the execution to suit the needs of their position. Taken out of the composition for which they were created, those same signs have no further use [...] There is no rupture between my old paintings and the cut-

outs except that with greater completeness and abstraction I have attained a form filtered to its essence, and I have retained of the object – which I used to present in its spatial complexity – the sign that is sufficient and necessary to make that object exist in its very own form and in the totality for which I conceived it." The 82-year-old Matisse felt that his pictorial experimentation did not "seem to be limited." This statement explains, from a point of view that is much more than merely biographical, the extraordinary results he attained in the last decade of his life. Of all the twentieth-century artists, Matisse, a few years after Monet, represents the continuity of a tradition, of a veritable myth of artistic literature, that of the creative fecundity of some artists in the last years of their existence, a myth that was incarnated in the figures of Titian, Rembrandt and Goya. However, while these artists' expressive tension and striving was the fruit of a dramatic, often tragic vision of the world, in Matisse one witnesses the advent of a joyous dimension, a happiness perhaps definitively attained through the unbridled song of colour, at so many years' distance from the legendary and literary yearnings of *La joie de vivre*. This utter serenity in painting – the most successful achievement of the wish

♦ *Above: a photograph of Matisse in the garden of his publisher friend*

Tériade at Saint-Jean-Cap-Ferrat in 1952.

♦ *Below: the dining room in Emmanuel Tériade's Villa Natasha at Saint-Jean-Cap-Ferrat, 1951–52. Matisse did the ceramic tile panel of* The Tree *and the*

stained-glass window, Chinese Fish, *for his publisher friend. Pierre Schneider calls the dining room "a second chapel – but a purely secular one."*

he expressed in 1908: "What I dream of is an art of balance, of purity and serenity [...]" – corresponds to an equally serene person. We need only look at one of the many photographs taken of Matisse in this period, such as those in the garden of his publisher friend Tériade at Saint-Jean-Cap-Ferrat, to note in the expressions of the artist the same spirit that emanates from his last works.

And yet, despite all the recognition he

received, the 1940s were difficult years for Matisse the man, marked as they were by family problems and illness. In 1944, his wife was arrested and his daughter tortured and deported for having taken part in the Resistance; and from 1941 on several operations had kept him bed-ridden for long periods. Matisse reacted to all this by immersing himself in his work, devoting his energies most of all to drawing when he was immobilized and totally given over

HM

28

reasons why he adopted this technique which is totally extraneous to tradition, even the contemporary tradition of collages, as it responds to wholly different needs. The texts of *Jazz* are actually connected more to an overall definition of poetics, and Matisse's dissatisfaction with the book in itself shows how the extreme simplicity of these works took their cue from a total review of his own artistic experience in order to arrive at the definition of his present needs. A few months after *Jazz* was published, he asked himself: "When I do these cut-outs, when I see them on the wall, why do they seem so pleasing to me and without that jigsaw puzzle aspect that I find in *Jazz*?" He answered this question a few years later: "*Jazz* did arouse a lot of interest, and I felt I should continue, because until then the work was rendered futile by the lack of coordination between the various elements functioning as total sensations. Sometimes difficulties cropped up: lines, volumes, colours, and when I put them together everything collapsed, the one destroyed the other. I had to start afresh, strive for

♦ *Above: Henri Matisse*, The Lagoon *(maquette for* Jazz*), 1944; gouache on paper cut-out; 40.5 × 60.5 cm (16 × 23¾ in); Private Collection. "The* papier découpé *allows me to draw in colour. For me this means simplification. Instead of drawing the outline and*

applying the colour inside it – the one modifying the other – I draw directly in the colour, which is all the more measured in that it is not transposed. This simplification guarantees precision in the merging of the means, which become one only."

♦ *Below left: interior of Matisse's apartment at 132, Boulevard du Montparnasse during the execution of* Oceania. *Note how,*

even when he is caught up in his large decorative works, his drawings play a fundamental role in working out the basic ideas.

to finishing the last ambitious work of his long artistic career, the decoration of the Chapel of the Rosary at Vence, which was the ideal crowning of the project he had pursued all his life – an art in which decoration and expression were "one and the same."

The *papiers découpés* and the chapel at Vence are without a doubt the salient moments of this last phase of Matisse's production and once again mirror the two cornerstones of his art: on the one hand the study of the principles and elements of painting and of the possibility of settling what Matisse himself called "the eternal conflict between drawing and colour"; on the other hand the desire to overcome mere formal rendering with that expression of emotion that sometimes flows out of the familiar objects and faces of his studio, and at other times takes on the guise of a symbol, of an unearthly imagination. The birth of the gouache paper cut-outs may be traced to the end of the 1930s, to the genesis of the volume *Jazz*, which was finally published in 1947 after a series of mishaps. A decade thus separates Matisse's first cut-outs from their systematic presentation, which was accompanied by notes from the artist who never fully clarified the

♦ *Above: Henri Matisse*, Acrobat, *1952; brush and India ink; 100 × 75 cm (39 × 29½ in); Private Collection. Matisse often compared an artist's work with that of the acrobat: "[…] I am the ballet dancer and*

tightrope walker who begins his day with many hours of various warm-up exercises so that all parts of the body will obey him when he wants to translate his emotions into a succession of dance movements."

music and dance, find the right equilibrium and avoid the conventional. A new start, new exercises, other discoveries." And in the same period he again explained the rationale for this expressive medium: "Personally at this moment I am directed toward more opaque, more immediate materials, which leads me to seek a new means of expression. The *gouache découpé* allows me to draw in colour. For me this means simplification. Instead of drawing the outline and applying the colour inside it – the one modifying the other – I draw directly in the colour, which is all the more measured in that it is not transposed. This simplification guarantees precision in the merging of the means, which become one only." The concepts Matisse expresses so lucidly lead to some particular considerations. First of all, we should

underscore the singular capacity for self-analysis and self-criticism revealed in a work such as *Jazz* which, from the time it first appeared, unanimously considered a masterpiece, destined to leave an indelible mark on post-war art. As for the character of these works and in particular of the gouache cut-outs, Matisse's recourse to the terms "dance" and "music" as keys to finding his way out of an impasse are significant: what strikes one here is the meaning taken on by these terms in this context, a metaphysical meaning as it were, without any figurative or thematic references, transferred to an absolute dimension to designate the rhythm, harmony and balance of the composition. *The Swimming Pool* and *The Wave* are the pictorial equivalents of this conception, the noblest and most authentic heirs (while being totally new in their formulation) of the *Dances* painted in 1910 and 1933, taken to the height of possible abstraction without losing sight of its original starting point – the world of sensations and objects. There are traces of continuity, therefore, that are confirmed in another way by Matisse's persistence in traditional painting procedures, which in some cases, such as the ingenious invention of *The Rocaille Armchair* (1946), responds to the same needs of rhythmic and dance-like transfiguration by means of essential painting that is also "drawn in colour."

Another consideration concerns the lack of any specific references in the above quotations to the other key word in Matisse's poetics: decoration. Most probably at the time he thought he had already found the solution to this in painting, while his work in the chapel at Vence raised this problem in a wider context. Here the relationship between the pictorial and architectural dimensions obliged Matisse to deal with a highly symbolic subject such as the religious one and with a tradition, both Western and Oriental, which he had always considered a model (we need only think of his admiration for Giotto's frescoes in the Scrovegni chapel in Padua). Perhaps this is the reason for the lack of references to decoration. But this should not lead us to neglect an important aspect of the last *gouaches découpés* – their physical extension, their monumental scale: *The Swimming Pool* is over 15 meters (49 feet) long, *Decoration. Flowers and Fruit* is over 8 meters (26 feet) long, and *Large Decoration with Masks* is almost 10 meters (32 feet) long. Matisse's ultimate challenge seems to be lightening the painting to such a degree as to enable it to support the dimensions usually used for more noble subjects, historical and religious

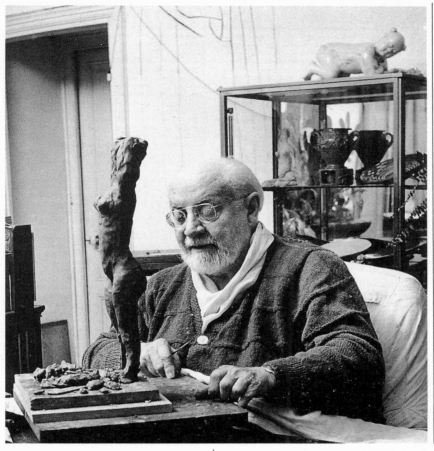

♦ *Left: Matisse sculpting* Standing Nude (Katia) *in 1950. He continued sculpting up to the last years of his life, and although from 1930 he sculpted much less than before, the few works he created were still important parts of his production.*

♦ *Below: Henri Matisse,* The Tree, *1952. This motif became quite important in the final phase of Matisse's oeuvre, and in this regard he said to Aragon: "I must be patient about understanding how the mass of a tree is formed, then the tree itself, the trunk, the branches, the leaves. First how the branches are arranged symmetrically on a single plane. Then the way they turn and cross in front of the trunk […] Don't get me wrong: I do not mean to say that when I see a tree from my window I try to copy it faithfully. The tree … is also the totality of its effects upon me […] I must first identify myself with it."*

HM.52

♦ *Below: Henri Matisse,* Nude – Back View, *1950; brush and India ink; 52 × 40 cm (20½ × 15¾ in); Private Collection. In the final phase of his career Matisse was caught up in the decoration of the Vence chapel, and drawing took on primary importance for him in establishing the relationship between pictorial space and what he called "plastic signs."*

painting, by removing all those rhetorical and official attributes that such scale and subject-matter inevitably bear. In order to achieve this, Matisse overturns the terms of the question and gives the decorative element – that is to say, the element that in Western tradition is used at most as a support or as a picturesque complement of the subject represented – the main role, the entire weight of the composition. This is the most radical reversal of conventions that Matisse ever achieved, as can also be seen in the sheer size of these works, which reveal a poise and confidence never before achieved. Matisse reaches these heights also by means of a technical expedient, setting himself, through the "discovery" of cut-outs, beyond painting, in a place that is conceptually extraneous to the tradition of Western painting. From his decision to draw inside the material and in the colour, to the typographical

origin itself of this procedure, and then to the extreme compositional freedom employed in the layout of the work by means of cut-out forms, the novelty of Matisse's approach to the theory and practice of painting is evident. These works are thus the conclusive fruit of an inexhaustible meditation on the two themes that were the most persistent in Matisse's thought: colour and its true expressive autonomy, and decoration and its true expressive capacity. The definition of the interior feeling of colour is translated in Matisse's final works into the total superficiality of the backgrounds, into their heraldic clarity, and into their desire to be transformed into pure light and emotional quality. As for decoration, the realization that painting in a decorative key implies not only the possibility, but the need to develop *ad infinitum*, is of decisive importance, because by definition it has neither

beginning nor end in space and time. The extraordinary quality these works convey is their capacity to address the senses, to expand the sensory experience through an elementary and highly synthetic language. Once again Matisse has to withdraw from the pure and abstract domain of ideas and return to the concrete experience of the world, which in this case means light, without forgoing the autonomy of pictorial language. This is the basis of Matisse's victory over the presumed dichotomy of the abstract and the figurative, the attainment of a course in which painting sums up an excess and lack of

consummately achieved.

The light in the stained-glass windows at Vence is at once colour and space, or rather, a colour and a space that become light, losing their physical consistency in order to become pure evocation, almost painting sublimated in light. There were many factors that contributed to this achievement: the very function of the chapel; the evocation of the stained-glass windows in Gothic cathedrals; the direction Matisse was taking with his cut-outs; and the practical need to lend greater emotional breadth to a rather confined physical space. Because of this

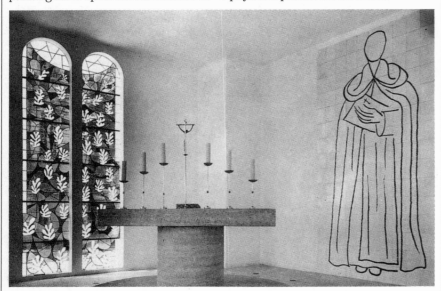

restraint that is both emotional and visual.

Parallel with this essential experience was the decoration of the Chapel of the Rosary in Vence, the apotheosis of Matisse's art, a visual testament of extraordinary grace and intensity. The symbolic vocation of Matisse's art reappears in this work; it permeates every detail of the composition, from the stately faceless figures of St Dominic and the Virgin Mary to the stained-glass windows, which may be seen as the focal point of the entire work. In these windows the idea of luminosity that pervaded Matisse's research from the very beginning is

♦ *Above: Henri Matisse, interior of the Chapel of the Rosary, Vence. Matisse considered this work "the culmination of an*

♦ *Below: Henri Matisse:* Stations of the Cross, *compositional study, 1949–50; ink and pencil. The final version of* Stations of the Cross *does not follow the plan of the preparatory study. As Matisse said: "The* Stations of the Cross *is finished [...] It is no longer the*

entire life of work and the fruit of an enormous, sincere and difficult effort" and had no qualms about calling it his masterpiece.

processional narrative of the study, but a kind of great drama in which the scenes, though they are identified by a number, are interwoven around the Christ on the Cross who has taken on a dream dimension – as has the rest of the panel."

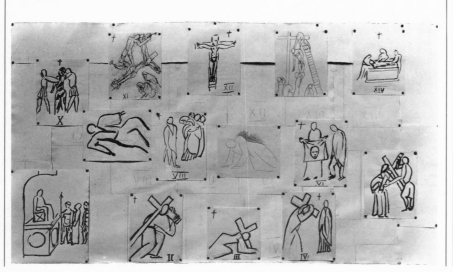

The Chapel of the Rosary in Venice

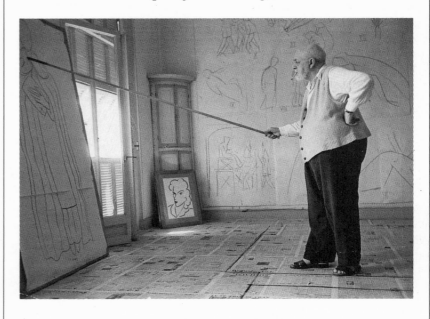

"Why have you decorated the chapel at Vence?" "Because for quite some time I wanted to synthesize my contribution. And so this occasion presented itself. I was able to do architecture, stained-glass windows and large mural drawings on tile at the same time and bring together all these elements, fuse them into one perfect unity." This is what Matisse had to say about the last and most ambitious work of his life, the Chapel of the Rosary at Vence, which he began in 1948 and finished in 1951. The commission for this project sprang from the interest shown by Brother Rayyssiguier, a young novice and architect who was then convalescing at the Dominican monastery in Saint-Paul de Vence. The work took up almost all of Matisse's energy and interest in this three-year period, as is shown by the artist's many letters and preliminary sketches and studies, and also led to some vivacious disagreement with those artists, such as Picasso, who did not approve of his decision to lend his art to a religious subject rather than to a social cause.

Matisse saw to every detail in the chapel work in the context of the overall project, whose goal was to give visitors "[...] a lightening of the spirit. So that, even without being believers, they sense a milieu [...] where thought is clarified, and feeling itself becomes lighter." He even went so far as to decide to replace the traditional organ with "[...] the sweetness of female voices able, through Gregorian chant, to penetrate the tremulous and coloured light of the stained-glass windows."

♦ *Matisse at the Hôtel Régina in Nice, observing a figure he drew for the Chapel of* *the Rosary in Vence, c. 1950. Photo Robert Capa – Magnum.*

The chapel, small and extremely simple in structure, comes alive through the relationship between the stained-glass windows (consisting of ultramarine, bottle green and frosted lemon yellow) and the ceramic panels facing them, with their drawings in black on white tile representing the *Virgin and Child* and *St Dominic*. The lightness and graphic essentiality of these two isolated figures is counterbalanced by the "tempestuous" (as Matisse described it) *Stations of the Cross*, in which the individual episodes do not follow the traditional temporal order of the biblical events but rotate around the core of the work, the crucifixion. Here too Matisse avoided giving a narrative character to his work by aiming at an overall evocation of feeling that flows from the lines, the colours, the forms and their balanced rapport. As in *The Dance* at the Barnes Foundation, Matisse had to address a spatial problem, which he wanted to solve with pictorial means, without forcing the architectural structure. But if at Merion the solution still lay in the painted surface, at Vence it was the light filtered by the stained-glass windows that played the main role, giving what is perhaps the greatest example of that transmutation of colour into pure luminosity that Matisse had sought throughout his artistic career.

30

safeguards the balance between art and the world and presupposes the possibility of dialogue between the two. Those artists who arrived after him and followed in his tracks – Rothko with his colour-light mystique, Newman and his chromatic absoluteness, Accardi and his emotional hyperdecorativess or Stella with his unemotional decorativeness, to name only the most important – bore witness, in their greatness, to the loss of this balance and the impossibility of restoring the bond that had kept the artist and his world united. This bond Matisse had found in the solar splendour of the Golden Age and which had permeated all his oeuvre, the myth of universal harmony that no one after him would be able to draw from with such conscious purity and in whose feasibility, above all artistic, no one would believe in any longer.

condensation of motifs in a single place, these stained-glass windows are an exemplary summing up of Matisse's creative experience, encompassing his relationship with tradition and the inclination towards experimentation, his attachment to the sensory experience and the quest for a fantastic and symbolic dimension, the total correspondence between expressive needs and technical means, and lastly a deep faith in the communicative nature of painting and art in general and the awareness that it cannot be reduced to mere function but must above all obey the rigorous laws that govern form. Once again, it was basically classical measure that guided Matisse through more than 60 years of trials and conquests, a sense of measure that still

♦ Above: Henri Matisse, White Chasuble, *maquettes for the chasubles in the Vence chapel, 1950–52; papiers découpés; 190 × 200 cm (75 × 79 in); Musée Matisse, Nice. Matisse saw to every* detail of the Chapel of the Rosary in Vence, *including the liturgical garments, so that he could invest the work with total unity. The motifs of this chasuble are also inspired by Oriental tradition.*

♦ Below: Matisse at the Hôtel Régina, working on the maquette for the Chapel of the Rosary in Vence, c. 1950. Photo Robert Capa – Magnum.

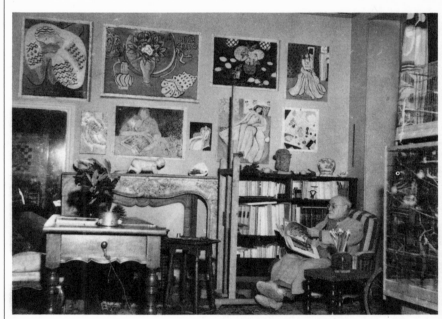

♦ Above: Matisse reading in his studio at the villa La Rêve in Vence. On the wall, The Dream and Still Life with Magnolia *can be recognized among the other paintings.*

THE WORKS

Biography

34 | Henri Matisse was born in Le Cateau-Cambrésis on 31 December 1869. His parents, Emile Matisse and Héloïse Matisse (née Gérard), were seed and grain merchants. Henri's father opened a general store in Bohain that over the years expanded and became a flourishing business in the fodder seed and manure line. After obtaining a classical education at the *lycée* in Saint-Quentin, young Henri began to read law in Paris in 1887 and 1888. The following year he returned to Saint-Quentin and became a clerk in a law office.

It seems that his artistic vocation came to the fore during a long convalescence in which he began to paint. A year later, in 1891, he was in Paris; here he first enrolled at the Académie Julian, where he studied with one of the standard-bearers of late nineteenth-century academic art, Adolphe William Bouguereau, and then went to Gustave Moreau's studio at the Ecole des Beaux-Arts.

The lessons with Moreau proved to be of fundamental importance for Matisse's artistic formation, first of all because his new teacher – at odds with academic teaching which had become decadent – was open-minded and encouraged his pupils to carry out their pictorial research critically and with the utmost freedom; and then because he became acquainted with Rouault, Marquet, Manguin, Wéry and Evenepoël, young artists who shared his early experiences and, as in the case of Marquet, his entire creative and human existence. During his apprenticeship years Matisse made many copies of the old masters at the Louvre, some of which were purchased by the French state in order to help young artists to pay their tuition, as was the custom in those days. In 1895 he began living in 19 Quai Saint-Michel, in a building in which Marquet would also set up his studio and where Matisse would paint his numerous views of Notre-Dame. In the same year, attracted by the Impressionist aesthetic, he began to paint *en plein air*, first in the surroundings of Paris and then in Brittany, which he visited with his friend Wéry. A second trip to Brittany and the success he enjoyed at the Salon de la Société Nationale des Beaux-Arts, of which he was elected associate member, were the high points of the following year. In this period his palette, influenced by the direct contact with nature and by the works of the Impressionists exhibited at the Caillebotte Bequest in the Musée du Luxembourg, became brighter, so much so that the series of canvases he executed, including *The Dinner Table*, caused a stir among the same members of the Société Nationale who the year before had so warmly received him as one of their own.

After marrying Amélie Parayre in 1898, Matisse travelled to London to view Turner's paintings, as Pissarro had spoken so highly of them to him. Then he began to travel south, going to Corsica, Toulouse and the Perpignan area. These trips marked his discovery of Mediterranean light, the light that would play such an important role in his future work.

On returning to Paris he enrolled in the Académie Carrière, where he met Puy and Derain, who would share his Fauvist adventure. This period (1899) was marked by another significant event: Matisse bought from the Vollard gallery Cézanne's *Three Bathers*, a Rodin plaster bust, a Van Gogh drawing and Gauguin's *Head of a Boy*, works that clearly show what direction his pictorial research was taking. They also testify to his total commitment to this research, since this purchase was made when his first son Jean was about to be born and the Matisse family's economic situation was at one of its lowest ebbs. In fact his new painting style was not at all appreciated by the art collectors and, after the birth of his second son Pierre in 1900, financial hardship forced him to decorate friezes at the Grand Palais to support his family and then, in 1902, to take the family to Bohain.

This was the most difficult moment in his artistic career, so adverse that he even considered abandoning painting. And his art also seemed to be at a stalemate, since the influences of his early years had not yet evolved into a truly organic and independent pictorial language. Between 1903 and 1904, thanks mostly to the good offices of Signac, the leading exponent of Neo-Impressionism, Matisse found his way back into the Paris art scene. He drew up a contract with Berthe Weil, his first art dealer, held his first one-man show at Vollard's gallery, and participated in the 1905 editions of the Salon d'Automne and the Salon des Indépendants, where he exhibited *Luxe, calme et volupté*. The recognition these exhibitions gave him paved the way for the first period of true fame for Matisse. This coincided with the 1905 Salon d'Automne, in which he exhibited together with his group of friends who were later dubbed "fauves" (wild beasts). The *succès de scandale* their paintings sparked was immediately followed by the Stein family's purchase of some of them; this marked the beginning of art collectors' interest that in only a few years sharply increased the market value of Matisse's works and made him one of the most prominent contemporary artists. Matisse took to travelling once again, going first to Algeria in 1906 and to Italy in 1907; he often stayed in the fishing port of Collioure to paint together with his friends Marquet and Derain. His participation in the Salons always triggered a scandal among the more traditional circles and ever increasing interest on the part of the most vivacious and discriminating cultural milieu, from Apollinaire to Gertrude Stein. In 1907 Matisse had his first and only teaching experience; he would give it up two years later because he realized he was simply not interested in it.

Matisse's dazzling rise to fame in this period is shown by the one-man shows he held at the Stieglitz Gallery in New York in 1909 and at Paul Cassirer's gallery in Berlin, even though, economically, these shows were failures. The following year marked another important stage in Matisse's career: Sergei Shchukin, the Russian art collector, commissioned the decorative panels *The Dance* and *Music* for his Moscow home, and Bernheim-Jeune, who would later be his dealer for a long time, signed his first contract with the artist, thus marking the definitive consecration of Matisse as one of the few masters of contemporary art.

The years before the First World War were characterized by the creation of some of his greatest masterpieces – from *The Red Studio*, *The Pink Studio*, and *Interior with Aubergines*

to the so-called Moorish triptych purchased by the Russian art collector Morosov in 1913 – as well as by trips to Moscow, Spain and Morocco (where he went several times from 1911 to 1913). On his return Matisse stayed at Issy-les-Moulineaux, where in 1909 he had built a studio, and at Collioure. Major influences in the development of his art were the direct contact he made with Islamic culture in Morocco and the Islamic art exhibits he saw in Munich in 1910 and in Paris in 1912 – although he had already begun to use certain basic elements of this artistic language in his work before this time.

When war broke out Matisse moved with his family from Issy to Collioure; and during the war years he spent his time between these two localities and Paris, where he returned to his former studio at 19 Quai Saint-Michel. In 1916 he also began to visit Nice.

Of particular interest in this period were his new friendships in art circles, including Juan Gris, whom he met in Collioure, and Renoir, whom he met for the first time in Nice in 1917, and the patronage of new and important art collectors – the Danes Lund and Rump (whose bequests so greatly enriched the Copenhagen Statens Museum for Kunst) and the American Albert Barnes, whose Foundation is one of the most prestigious art collections, for quality and quantity alike, in the world.

Among the most significant paintings done in this period are *French Window at Collioure, The Yellow Curtain*, those in which Matisse compares and contrasts himself with Cubism (from the *Portrait of Mademoiselle Yvonne Landsberg* to *The Piano Lesson*), and the first approaches to his new, less experimental style that would dominate the so-called Nice period of his production. In 1918 the Matisse-Picasso exhibition held at the Paul Guillaume Gallery, with a presentation by Apollinaire, marked a confrontation between the two figures the public considered the most representative artists of the first two decades of this century.

After the end of the First World War Matisse's journeys become more infrequent. From 1921 on he spent six months a year in Nice, where he rented an apartment in Place Charles-Félix, and six months in Paris. In the meantime public institutions made purchases and held retrospective shows of his works. In 1921 the Musée du Luxembourg bought, for the first time in France, a Matisse painting: *Odalisque with Red Culottes*; the following year *Interior with Aubergines* was donated by his wife to the Grenoble Museum and two years later Marcel Sembat, one of the first collectors of Matisse's work, donated his collection to the same museum; in 1924 the Statens Museum for Kunst in Copenhagen organized the first really large public Matisse exhibition, and in 1927 the artist won first prize at the Carnegie International Exhibition in Pittsburgh.

Matisse's contact with the United States increased in this period; in 1930 he went there twice, first passing through on his way to Tahiti, and then to be part of the jury for the Carnegie Prize. On this latter occasion Albert Barnes asked him to decorate the gallery of his Foundation; Matisse spent three years working on this project, up to the installation of the murals in 1933. Once again the subject was *The Dance*, which the artist rendered in a synthetic manner that would characterize the last phase of his production. Matisse's dedication to other areas of artistic creation at this time was significant: engraving, drawing, and especially book illustration, which all increased his fame.

Among the principal events of the pre-war period were the retrospective shows at the Galerie Georges Petit in Paris, the Basle Kunsthalle, and the Museum of Modern Art in New York in 1931; the scenery and costume design for *Red and Black* (originally entitled *The Strange Farandole*) for the Ballets Russes; the acquisition of the first version of the Barnes Foundation *Dance* on the part of the Paris Musée de la Ville; and lastly, Matisse's moving to the Hôtel Régina at Cimiez, near Nice, in 1938.

The Second World War was among the most dramatic periods in Matisse's life. At first he considered moving to Brazil but, feeling this would be an act of "treason," he decided to remain in France. In 1941 he underwent surgery for an intestinal illness and was confined to bed for long periods, even some time after the operations, so that he concentrated mostly on drawing and book illustration. After Cimiez was bombed in 1943 Matisse moved to Vence where he settled, with frequent visits to Paris, until 1949. In 1944 Mme Matisse was arrested and their daughter Marguerite was deported for having taken part in the Resistance. This is Matisse's description of one of the saddest moments of this period to his friend Charles Camion in 1944: "As you probably know, Mme Matisse was condemned to six months' imprisonment [...] For my part, I thought I had been through everything, physical and moral suffering. But no! I had to have this trial as well. I can't bear to think of Marguerite, about whom we know nothing, not even where she is. I'm totally disheartened. For three months, in order to bear my troubles, I have worked as much as possible. I'm exhausted [...] I've been in bed for nearly a week with a liver ailment and fear further complications with gallstones that a year ago brought me a hair's breadth from the operating table, which I certainly would not have survived. So there you have it, my dear friend: one must paint serenely with all this, or better, despite all this."

Matisse spent the last decade of his life between Paris, Vence and Nice, where he settled in 1949, once again in the apartment-studio in the Hôtel Régina. The decoration of the Chapel of the Rosary in Vence, begun in 1949 and finished in 1951, and the large paper cut-outs, are the final achievements of his art – an oeuvre that was continuously celebrated, from the retrospective shows in Philadelphia and Lucerne in 1948 and 1949 to the donation of the Cone Collection to the Museum of Art in Baltimore, the prize awarded at the 1950 Venice Biennale, the imposing retrospective show curated by Alfred Barr Jr. at the Museum of Modern Art in New York, and the inauguration of the Musée Matisse at Le Cateau-Cambrésis in 1952. Active to the last – "I'm still working a bit and I realize that the quality has not decreased thanks to my good discipline. But one must be modest," he wrote to his friend Rouveyre on 19 September 1954 – Matisse died in Nice on 3 November 1954 and was buried in the Cimiez cemetery.

The Beginnings

36 The works painted by Matisse in the first decade of his artistic career testify to the wide spectrum of expressive possibilities he experimented with during his apprenticeship and at the same time demonstrate that already in this early stage he had laid the bases for his future pictorial research, especially as regards the thematic aspect, the choice of subjects and genres with which he could work. Side by side with the copies he made of the masters in the Louvre, from 1890 to 1896 Matisse almost exclusively painted still lifes and interiors with figures, the two genres that even later on would make up the bulk of his *catalogue raisonné*. In these first works, especially *Interior with a Top Hat* and *Lemons and Bottle of Dutch Gin* (both executed in 1896), it is rather easy to detect the sources of inspiration around which Matisse's art was maturing: on the one hand, the great Dutch still life tradition, and on the other an eminently French influence, particularly Chardin and Manet.

This "genealogy" is evinced by certain images (the knife sticking out over one side of the table in *Lemons*, which is a primary rhetorical figure in this genre, and the top hat which was by then identified with Manet) and also by Matisse's use of a palette dominated by somber tones ranging from brown to black, while the light is diffused over the entire composition, thus eliminating dramatic effects, and brightening only in some reflections on smooth objects – in brief, a palette in line with the dictates of northern realism. These were therefore approaches to a genre and attempts to link the tradition of the new with that of the museum through direct visual sensations, breaking free from the academic shackles of historical subjects or literary compositions. It was also the first sign of the conception of painting as a balance of different relationships – between the objects and the various components of the work – after which Matisse's pictorial research would always strive; and an ideal testing ground of this vision was the still life, a genre based on the definition of the various elements of the composition in relation to space and light.

The still life, which belongs at once to the domains of reality and of the symbol, was a natural choice for the expressive needs of Matisse, who was seeking to define his aesthetic by drawing inspiration from the Impressionist poetics of the real as well as the ever more popular Symbolist vision.

A determining factor in this process was the teaching of Gustave Moreau who, although a leading exponent of an exaggeratedly symbolic and literary type of painting, did not hesitate to encourage his pupils to study reality. A work that bears witness to Matisse's apprenticeship with Moreau and the atmosphere of his studio is *Gustave Moreau's Studio*, which the burgeoning artist painted in 1894–95; the composition here seems to revolve more around the relationship between the model in the foreground and the plaster statue in the background than on the figures of the students caught up in their painting. As in the still lifes he produced in the same period, here too Matisse seems to dwell on the nature of painting and on the fundamentals of artistic language. What seems to matter is not so much the result obtained, as the need to clarify, above all for himself, the relationships between painting and reality, between the painted image and the retinal sensation; and he did this by filtering these problems through the indispensable lesson of tradition, a past he considered still able to influence contemporary art. However, there is no trace in these works of any direct influence of Moreau, nor would there be any such influence in the future. What this artist transmitted to the young Matisse was the reassessment of the symbolic value of a work of art. But for Matisse even this aspect was to develop later on, after a long immersion, which lasted up to the first years of the twentieth century, into the heart of the other horn of the pictorial dilemma – reality. In 1895 Matisse made his first trip to Brittany together with his friend and fellow painter Emile Wéry and had his first experience of painting *en plein-air* – directly from nature – a by now common pictorial procedure thanks to the rising wave of Impressionism and that was beginning to show signs of becoming mannered imitation rather than true expression. However, the young artist did not hurl himself headlong into this new enterprise, discarding all the experience, knowledge and convictions he had gained both in Moreau's studio and in museums. The first Brittany paintings show how Matisse's palette still consisted, as he later said, "only of bistres and earth colours," and even the organization of the picture is influenced less by the fleeting sensations of Impressionism than by the language of an artist like Corot – an essential link between Romanticism and Realism in the second half of the nineteenth century. In this period Corot as well as Manet had become representatives of a modernism that was by then sanctified in the museums and could thus allow Matisse to approach landscapes in the manner most congenial to his temperament – gradually and with the aid of a recognized "guide."

It was in the following year, 1896, with his second trip to Brittany, that Matisse's works began to reveal a clearly Impressionistic palette that made his friend Henri Evenepoël speak of his infatuation with Monet. The best example of this phase is an interior, *The Dinner Table* (1897). It is the first "summa" of his oeuvre at the beginning of his career: the already large-scale composition and its complexity, the desire to merge the human figure and still life in the same picture, the adoption of a palette that still lies halfway between the original "seventeenth-century" tonalities and the recent discovery of Impressionist colours – all these elements make this

painting the emblematic conclusion of the first cycle of Matisse's pictorial quest. Significantly enough, it was the elderly teacher Moreau who took it upon himself to defend his pupil's painting from the criticism of the more traditional members of the Société Nationale des Beaux-Arts; according to Matisse, Moreau declared: "Let it be, his decanters are solidly on the table and I could hang my hat on their stoppers. That's what is essential." This also shows to what degree Matisse's painting was still connected to a tradition that was, broadly speaking, academic even though thoroughly up-dated, and how superficial his Impressionist procedure was – still not yet able to bring its weight to bear on the very structure of the artist's vision, something which would occur in only a few months' time.

Another trip, this time to Corsica, in the summer of 1898, was the last stage of Matisse's evolution in this period which he called "the revelation of the South." The paintings in this phase reveal Matisse's awareness of the central role played by colour in the definition of the image, or rather, in its rendering of expression. In Corsica Matisse seemed to realize that the use of colour and light in the style of Monet implied a new attitude towards form, which could no longer be the one marked out by contours as in his preceding works. Together with this atmospheric dissolution of form, the new centrality of colour bears in itself an accentuation of the materiality of objects, as can be

seen in *Still Life with a Pewter Jug* (1898). The convergence of these two elements in the works executed that year explicitly manifests for the first time an approach that was to be a pivotal part of Matisse's future evolution – the basic expressive autonomy of pictorial means, first of all colour. Matisse was aware of this problem right from the outset of his artistic career and solved it by favouring the still life over other genres. Now, however, after careful consideration of the most radical consequences of Impressionist practice, a totally unexplored horizon opened up for him, one that required new stylistic tools, among other things. This was an intuition on Matisse's part in this period, as attested by various factors. First of all, the progression of his oeuvre – which was anything but linear – especially his production in 1899 and 1900; in the second place, the continuous research into the principal artistic figures of the time, almost as if to indicate the need to examine the various possible solutions offered for every aspect of the problem. This explains his forays into Neo-Impressionism with *Sideboard and Table* (1899) and *Vase of Flowers* (1900), which are utterly different; the former faithfully adheres to the laws of the most orthodox scientific pointillism, while the latter displays a much more forced Expressionist bent, in which the separated brush-strokes seem most of all to respond to an emotional impulse that is quite distant from the objective

Neo-Impressionistic restructuring of light. Then there is the chromatic invention of *Still Life against the Light* (1900), which is another example of the experimental phase that continued until 1905, after the addition of other contributions had clarified the needs and aims of Gustave Moreau's former pupil.

Among these, the most significant was certainly the influence of Cézanne, which began to make itself felt in Matisse's oeuvre in 1900, a year after he had bought *Three Bathers*, which Cézanne had executed in 1882. In fact, the two fundamental works Matisse produced that year, *Male Model* and *Interior with Harmonium*, clearly reveal that he was caught up in scrutinizing certain aspects of Cézanne's aesthetic, especially those concerning the construction of the painting and the role of colour. If the oeuvre of the master from Aix was still considered difficult to understand at that time, respected but certainly partly misinterpreted, for Matisse's generation it nonetheless represented an obligatory proving ground because it was a point of departure from Impressionism that, unlike Symbolism, was not based on the imagination but on an analysis of reality. And Cézanne had effected this analysis with extreme intellectual rigour, bringing into play every element of artistic creation, both mental and practical. His conception of space, which was shaped anew by means of a mental elaboration of sensations, and the structural value that

colour took on, were the factors that first attracted Matisse's attention, as they represented a further and intellectually more meaningful confirmation of the potentiality of painting to represent itself and be self-sufficient, while still maintaining its relation with the world of objects, and to find its source of inspiration in reality.

Therefore, both in *Male Model* and in *Interior with Harmonium*, it is not only the palette that reveals Cézanne's influence, but also the structural deformations of the model, and the heightened, upsetting perspective of the objects in the *Interior* (especially the harmonium) that foreshadow, albeit in an embryonic form, the huge and entirely two-dimensional surfaces of the mature Matisse. Certainly in the last two years of the nineteenth century the evolution of Matisse's pictorial procedure took such a "modern" turn that even the enlightened and tolerant Moreau had a hard time defending him from the accusation of having betrayed what was presumed to be his natural inclination; this criticism, levelled at Matisse in the first years of the twentieth century, prompted the onset of the most difficult phases of his career, both on an economic and moral plane.

Above: Still Life with Books, *Bohain-en-Vermandois, 1890; oil on canvas; 38 × 45 cm (15 × 17¾ in); Private Collection. This is one of Matisse's first known paintings, and is clearly influenced by the nineteenth-century Naturalist tradition.*

Opposite: Woman Reading, *Paris, autumn-winter 1895; oil on canvas, 61.5 × 48 cm (24¼ × 18⅞ in); Musée National d'Art Moderne, Centre Georges Pompidou, Paris.*

40

Gustave Moreau's
Studio, *Paris,
1894–95; oil on
canvas; 65 × 81 cm
(25⅝ × 31⅞); Private
Collection.*

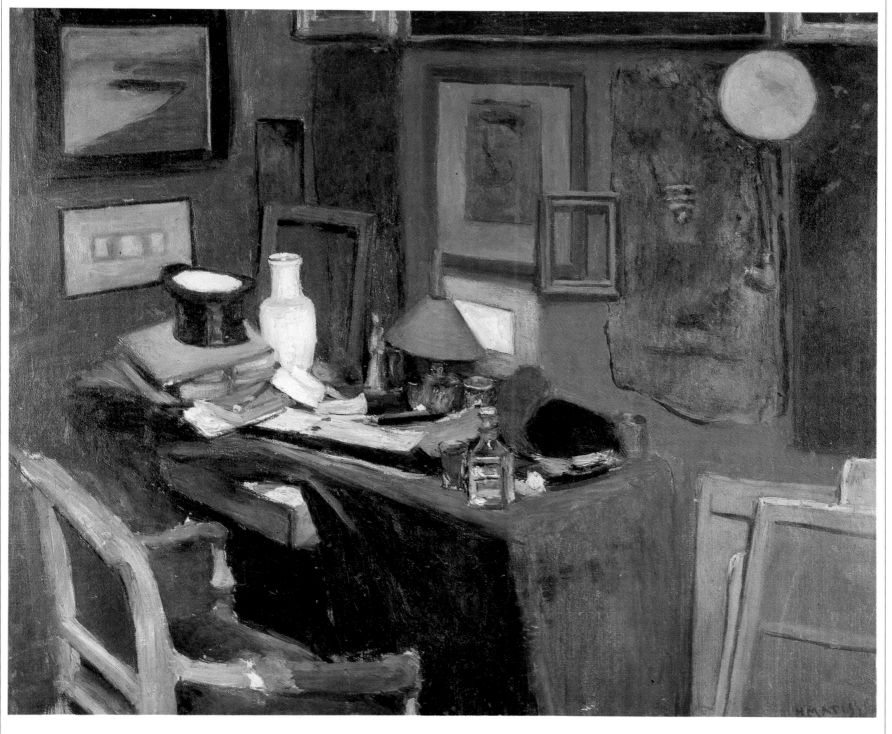

Interior with a Top Hat,
*Paris, autumn-winter
1896; oil on canvas;
80 × 95 cm (31½ × 37½
in); Private
Collection. Interiors
were among the most
recurrent motifs in
Matisse's long career.*

42

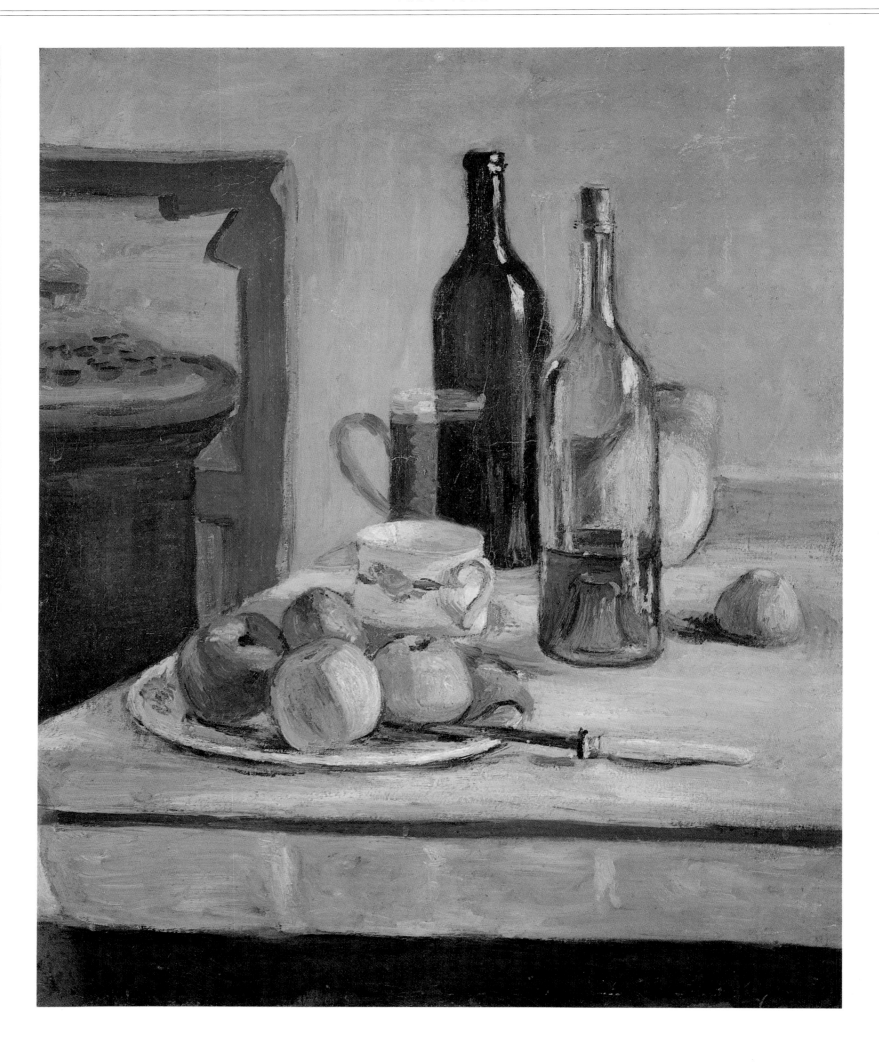

Still Life with Two canvas; 73 × 60 cm
Bottles, *Paris or* *(28½ × 23½ in);*
Brittany 1896; oil on *Private Collection.*

Lemons and a Bottle of Dutch Gin, *Paris or Brittany 1896; oil on canvas; 31.2 × 29.3 cm (12¼ × 11½ in);* *Museum of Modern Art, New York, gift of Mr and Mrs Warren Brandt.*

44

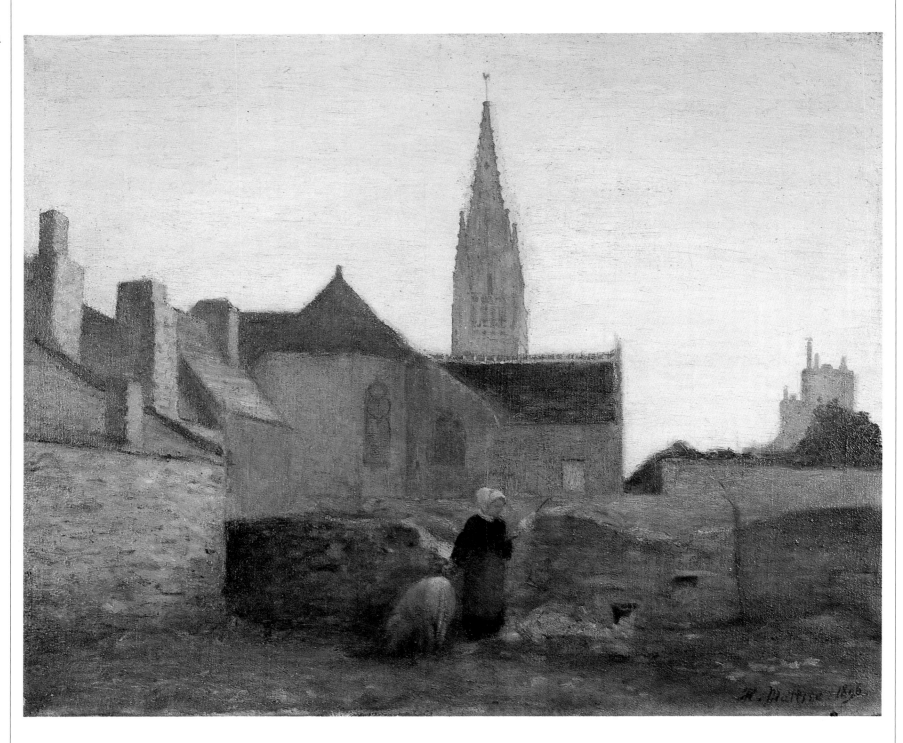

Village in Brittany,
Brittany 1896; oil on
canvas; 59.5 × 73 cm
(23¼ × 28½ in);
Musée Matisse, Nice.
The visit to Brittany
and the discovery of
en plein-air painting
were crucial to
Matisse's artistic
formation.

Rocks at Belle-Ile,
*Belle-Ile, 1896; oil on
canvas; 55 × 45 cm
(21½ × 17½ in);
collection unknown.*

46

The Stack of Gorse,
Brittany, 1896;
32 × 38 cm (12½ × 14¾
in); Private
Collection. This work,
as well as the one
reproduced on the
preceding page,
reveals how Matisse,
for the first time in
contact with natural
light and now
influenced by the
Impressionists, has
altered his brush-
strokes.

The Dinner Table,
Paris, autumn
1896-spring 1897; oil
on canvas; 100 × 131
cm (39⅜ × 51½ in);
Private Collection.
Moreau was forced to
defend this painting
by his pupil Matisse,
as the exponents of
the academic
tradition criticized it
for being too
"modern."

48

The Olive Tree,
Corsica, 1898; oil on
canvas; 38 × 46 cm
(14¾ × 17¾ in);
Private Collection.

This is one of
Matisse's first works
after his "discovery
of the South."

Still Life with Pewter
Jug, *1898; oil on
canvas; 23 × 33 cm
(8¾ × 12¾ in);
collection unknown.
The substance and
light here* disintegrate the
solidity of the forms,
thus creating a kind
of "gestural"
expressiveness that is
rare in Matisse's
oeuvre.

50

Above: The Courtyard of the Mill, *Ajaccio, 1898; oil on canvas; 38 × 46 cm (15⅛ × 18⅛ in); Musée Matisse, Nice.*

Opposite: Woman Reading in a Purple Dress, *1898; oil on canvas; 38.1 × 46.4 cm (14¾ × 18 in); Musée des Beaux-Arts, Reims.*

52

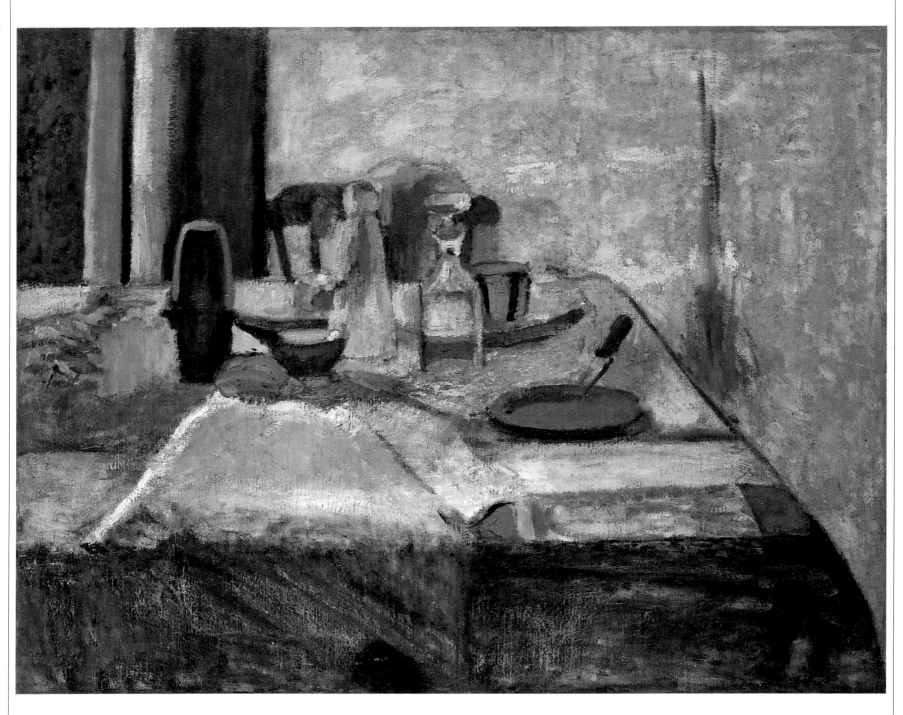

Above: Still Life
against the Light,
Paris, autumn-winter
1899; oil on canvas;
74 × 93.5 cm
(29⅛ × 36⅞ in);
Private Collection.
During his

apprenticeship years
Matisse paid much
attention to the effects
of light falling on
objects until he was
able to achieve results
such as those seen in
this still life.

Opposite: The Invalid,
1899; oil on canvas;
46 × 38 cm (17¾ × 14¾
in); Baltimore
Museum of Art, Cone
Collection.

54

Sideboard and Table,
Toulouse, 1899; oil on
canvas; 67.5 × 82.5
cm (26½ × 32½ in);
Private Collection.
This work is the first
to show the influence
of the Neo-
Impressionist
aesthetic, which
Matisse drew on more
intensively from 1904
to 1906.

The Hare, *Paris, 1900;*
oil on canvas;
32 × 24.5 cm
(12½ × 9½ in);
Private Collection.

56

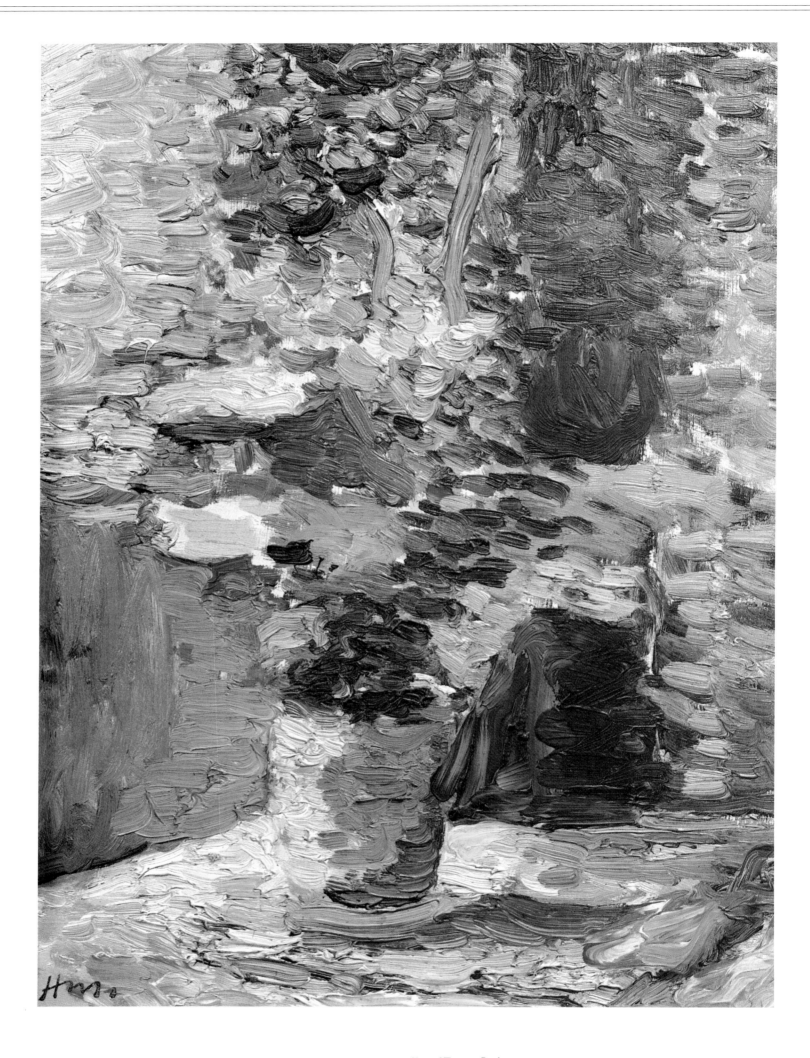

Vase of Flowers, *Paris,*
1900; oil on canvas;
31 × 23 cm (12 × 8¾
in); Private
Collection.

57

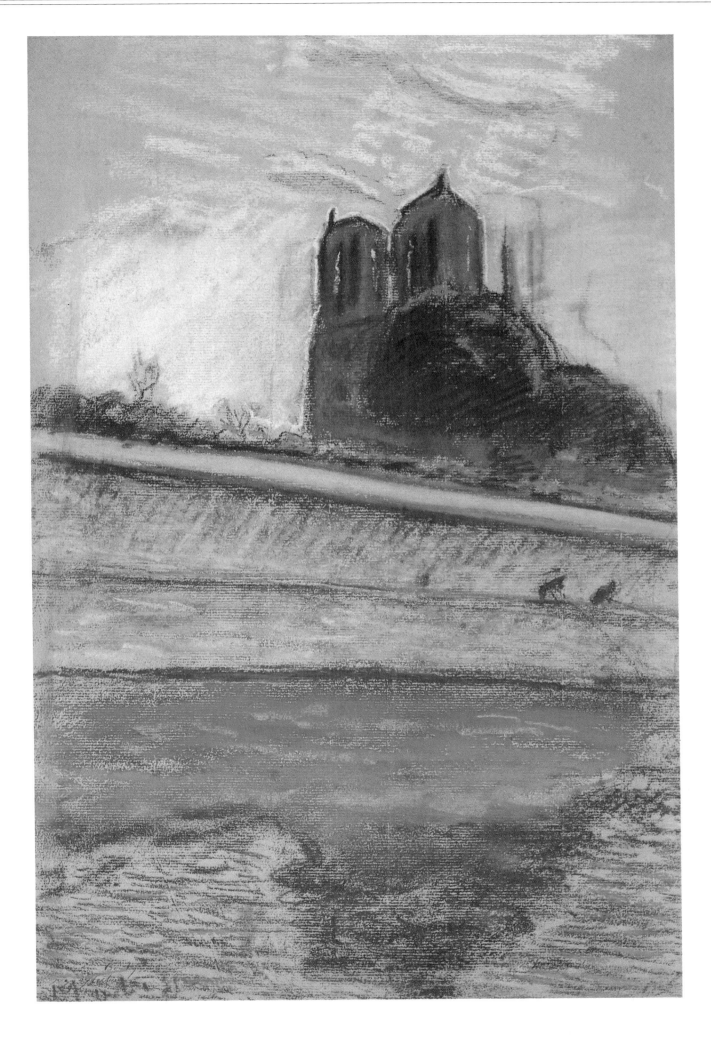

Notre-Dame de Paris,
*Paris, 1900; pastel;
46 × 31 cm (17¾ × 12
in); Private
Collection. This view*
*of Notre-Dame was
executed from the
window of Matisse's
studio in 19 quai
Saint-Michel.*

58

Above: Landscape at
Arcueil, *Arcueil, 1900;
oil on cardboard;
24 × 36 cm (9 × 14 in);
Musée Matisse, Nice.*

Opposite: Interior with
Harmonium, *Paris,
1900; oil on
cardboard; 73 × 55.5
cm (28½ × 21½ in);
Musée Matisse, Nice.
The influence of
Cézanne became*

*more evident in
Matisse's interiors,
whereas in his
landscapes he
continued to work in
the Impressionist* en
plein-air *vein.*

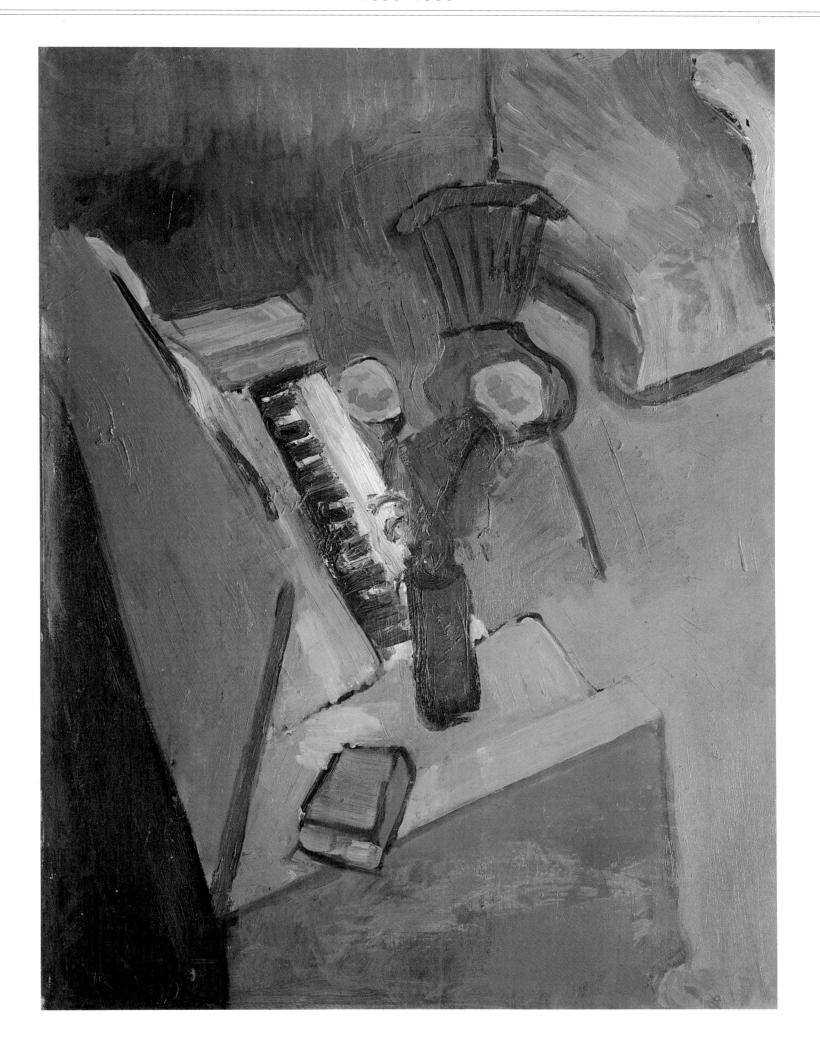

60

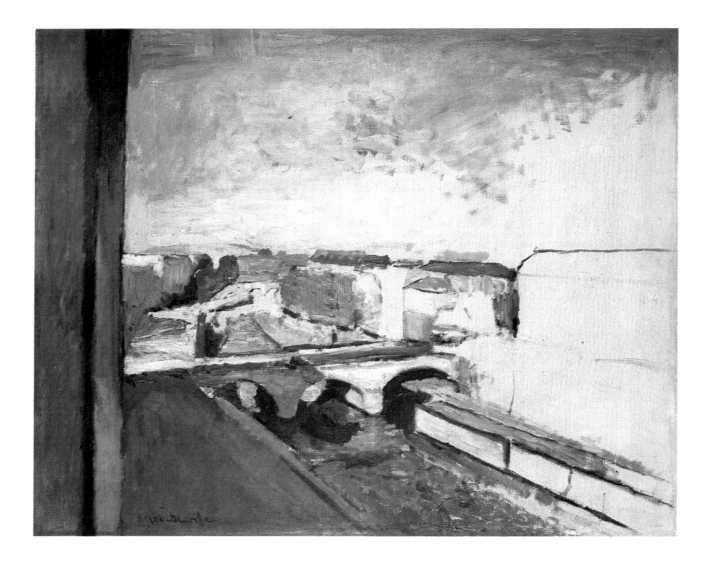

Pont Saint-Michel,
Paris, 19 quai Saint-
Michel, 1900; oil on
canvas; 58 × 71 cm
(22⅞ × 28 in); Private
Collection. This work
was painted from one
of the windows of
Matisse's studio at 19
quai Saint-Michel.
Marquet, who took
over this studio when
Matisse left it,
painted a similar
subject.

Self-portrait, *Paris,*
1900; oil on canvas;
55×46 cm (21⅝×18⅛
in); Musée National
d'Art Moderne,
Centre Georges
Pompidou, Paris.

Above: Still Life with Blue Jug, *Paris (?), 1900; oil on canvas; 60 × 65 cm (23½ × 25¼ in); Wilbur Brayton Jr. Collection.*

Opposite: Male Model, *Paris, 1900; oil on canvas; 99.3 × 72.7 cm (39⅛ × 28⅝ in); Museum of Modern Art, New York. Cézanne's influence, discernible here, was elaborated on by*

Matisse long before the master from Aix was "discovered" by Parisian art circles. This work presents certain similarities with the sculpture The Serf, *produced in the same year.*

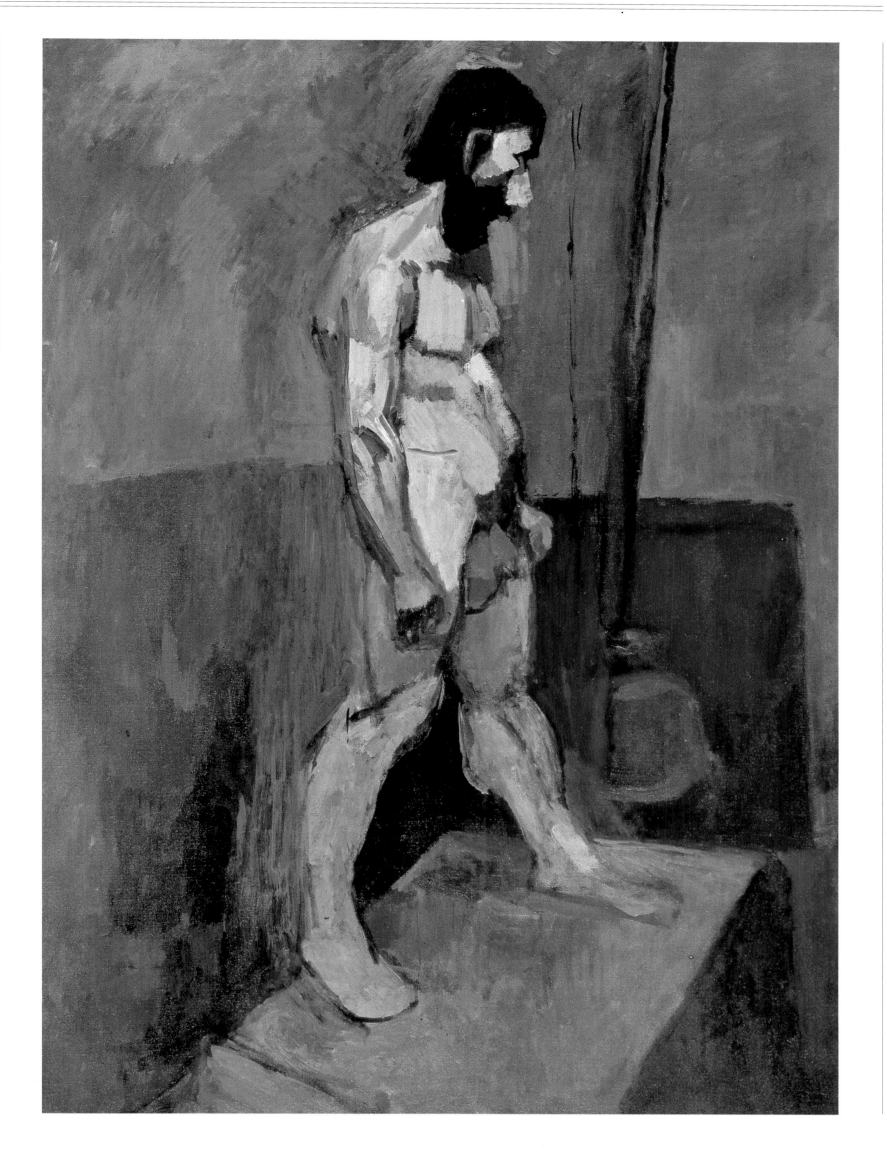

From Divisionism to Fauvism

64

The works Matisse executed from 1901 to 1904 represent the most problematical and uncertain moment in his entire production. The flush of enthusiasm over his new discoveries was soon replaced by the practical difficulties involved in finding his own path to artistic creation, the momentary incapacity to merge and channel all the stimuli taken in and then fashion an original and finished pictorial language. Besides his constant meditation on Cézanne's aesthetic, Matisse seemed to be turning back to a revision of realist models; but he did so with less naturalness – and one might even say with less conviction – than he had evinced only five years earlier, as can be seen in *The Path in the Bois de Boulogne* (1902) and *Mme Matisse in a Japanese Robe* (1901). These stylistic uncertainties were accompanied by others stemming from the artist's financial straits which in turn resulted from the loss of his patrons, who had supported him at the outset of his career but had abandoned him in his period of experimentation from 1898 to 1900.

This crisis reached its peak in 1903, a year that witnessed the creation of anomalous but very intense works such as *Studio under the Eaves* and *Bouquet on a Bamboo Table*, after which Matisse removed his doubts by returning to a procedure he had already practised and soon afterwards abandoned a few years before – Neo-Impressionism, in particular the most up-dated and accepted version championed by Paul Signac. But whereas in 1898 Matisse interpreted this procedure as little more than a

variation of the Impressionist "method," now, thanks to his study of Cézanne which had matured in the meantime, it took on a much more precise meaning as a decisive step in the process of freeing his painting from the heritage of nineteenth-century realism, especially from its Impressionist connotations. And though in 1904 Matisse was still wavering between total adherence to the pointillist theories and a resumption of naturalism, one cannot ignore the fact that a work such as *Luxe, calme et volupté* was a fundamental crossroads in his attainment of artistic maturity that would manifest itself the following year with the sensation caused by the Fauve paintings exhibited at the Salon d'Automne in Paris.

The pictorial technique of the work shows how Matisse does not follow the dictates of the Neo-Impressionist aesthetic to the letter but tends to lend the greatest possible strength and self-sufficiency to the colour, refusing, for the first time with such determination, to be even slightly faithful to "natural" colour. On a conceptual level this painting paves the way for the Fauve works and for compositions he painted from 1905 to 1910. The transformation of an everyday scene – a picnic at the seaside – into a symbolic composition marks the other step Matisse took to free himself from the realist aesthetic – the emergence of the monumental and sacred aspect of his pictorial quest. *La joie de vivre*, painted between 1905 and 1906, represents both a moment of continuity and a break with the poetics he had initiated with *Luxe, calme et volupté*. The structure of this

work is in a similar symbolic key, which is emphasized by the absence of realistic elements in the landscape and by the explicit reference to a literary theme – the Golden Age. But the pictorial procedure is different, as Matisse abandons the mechanical pointillist system in favour of a style characterized by broad chromatic areas and backgrounds and exaggerated linearity.

At all events, these two works are veritable hinges connecting the young and the mature Matisse, as is testified by the stylistic uncertainties recognizable in both of them, and by the adoption of a theme and an attitude towards the meaning of painting that would become central to Matisse's later production. As with *The Dinner Table* years before, these works were quite ambitious, both in their choice of subject-matter and in their physical scale, so ambitious they could be considered true manifestos, courageous stands of an artist still searching for his true expressive dimension.

As occurred throughout Matisse's career, these paintings had their counterparts in apparently different works that sought to explore other aspects of artistic creation; these works reveal the complex course of Matisse's pictorial development and his determination to exploit all the possibilities underlying any given aspect of pictorial procedure that had arisen. This need seems to have been met by the Fauve paintings that characterized the years 1905 and 1906. Together with the controversy they triggered at the 1905 Salon d'Automne,

these works placed Matisse in the center of the artistic debate raging at the time and also gave rise to avant-garde art patronage that continued to support him to the end of his career. Alongside the works executed in a symbolist key, *Portrait of Mme Matisse – The Green Line*, *The Woman with a Hat* and the various landscapes he painted at Collioure together with his friend Marquet continue the "realist" approach in Matisse's oeuvre; but they undermine it from within through the irruption of a totally anti-naturalist, violently expressive colour scheme.

These works offer us a much clearer idea of the key role played by the brief Neo-Impressionist period in what Matisse himself called the "liberation of colour." In his symbolic compositions this liberation was in some way justified by the unreal quality of the subject but in his portraits, still lifes and landscapes it was undoubtedly a more traumatic rupture, going so far as to neutralize one of the few certainties that still remained in the relationship between painting and the outside world – the conventional correspondence in colour between the objects of nature and their translation on to the painting surface.

In this period all the store of knowledge, studies and even uncertainty that characterized Matisse's long and complex artistic formation attained its first, sublime synthesis. *Interior with Young Girl* or *The Open Window* clearly evince reminiscences of Matisse's re-evaluation of the pointillist-inspired break-down of colours; *The Woman with a Hat*, *The*

Green Line and *The Young Sailor I* reveal how the influence of Van Gogh's extreme expressiveness and of Cézanne, structural conception of colour are still at work and recognizable within the fabric of the painting. Matisse also left his own original mark on these works, an amalgam of the complexity of the above influences and his absolute love for colour.

The "discovery" of pure colour was flanked by his meditation on the nature of pictorial space. The space defined by colour is fragmented and certainly not three-dimensional, entirely developed on the surface of the painting and essentially symbolic. It is therefore a mental space that is in contrast with reality and with the physicality of the subjects painted, and above all it prevents the composition from achieving the unity that Matisse had seen both in classical painting and, in another sense, in Cézanne's art. The space created by the Fauves in this period is characterized by the absence of drawing, of linear continuity: "the eternal conflict between drawing and colour" is clearly manifested for the first time in these works and it led Matisse to seek new solutions, the first result of which was *La joie de vivre*. This burst of expressionism in the true sense of the word faded away roughly at the end of 1906. A new phase began, heralded by the elaborate gestation of *La joie de vivre*: the first stage of Matisse's true artistic maturity, dating from 1906–7, with such works as *Blue Nude (Memory of Biskra)*, *Still Life with a Red Rug*, *Le luxe I*, *Le luxe II*, and *Portrait of Nono*. In order to

understand the evolution of Matisse's art during these few months we need only look at these works.

In *Blue Nude* (1906), for example, there is a deformation in the anatomy of the figure and in the perspective that has no precedent in Matisse's earlier works; and this becomes even more evident when one considers the large scale of this work. Matisse achieved this result through his acquaintance with so-called primitive art, a tradition totally foreign to Western art and hence able to offer him further confirmation of the possibility and need to abandon post-Renaissance conventions, not only in the use of colour (a problem he had already solved in his Fauve period), but also in the treatment of the figure.

In *Still Life with a Red Rug* (also executed in 1906) a new, decisive contribution is made by the Oriental decorative tradition. Once again, Matisse's affinity for "another" culture allows him to wed reality and invention, faithfulness to the initial objective sensation and the assertion of the autonomy of pictorial language. In this specific case the endeavour was perhaps not totally successful, since Cézanne's compositional structure still prevails, thus nullifying the basic characteristic of decoration – its continuous flowing over the surface; nevertheless, his influence gave Matisse's poetics the elements necessary for its evolution in a decorative and symbolic key.

The two versions of *Le luxe* represent the natural continuation of the direction Matisse had taken in *La joie de vivre* and, at the same time, show signs of the new influences at work. These are

therefore transitionary works, whose main interest lies in the attention Matisse paid to drawing, to the definition of form through line. Colour, which at the height of Matisse's expressionist fervour had been free to spread out and shatter the figure, is now enclosed in the clear-cut spaces marked out by the outlines, thus lending to the entire composition a sense of immobility and temporal suspension reminiscent of the intensely symbolic works of Puvis de Chavannes, an artist in whom Matisse was particularly interested at this time. His attitude towards portraits was similar; if we compare *Portrait of Nono* with *André Derain*, which was executed only two years earlier, we will see how in the former the abstract quality of the composition is accentuated and every element reduced to its essence, thus achieving an absoluteness comparable to that found in Byzantine icons.

A careful reading of these works reveals the extreme complexity of this period of Matisse's output and the wide gamut of pictorial problems he addressed in order to take the decisive step towards total mastery of his operative and conceptual means. Matisse himself gave the following succinct description of those years and the ones immediately afterwards, recreating an atmosphere that was clearly felt in his paintings: "Fauvism, the exaltation of colour; precise drawing due to Cubism; visits to the Louvre and exotic influences filtered through the ethnographic museum of the old Trocadéro: all things that shaped the landscape in which we lived, where we travelled and from which we have all departed." To filter

these influences and assimilate them into one's own poetics, thus revitalizing Western artistic language in a decisive manner – this was the wager of the avant-garde at the beginning of this century, in which Matisse played a leading role, together with his friend and rival Picasso.

The greatest achievement of this period – perhaps the first time in which Matisse expressed to the full the revolutionary significance of his painting and his independence from all previous models – is *Harmony in Red, La Desserte*, executed in 1908. In this canvas Matisse combines the two principal elements governing his inspiration – the level of reality and that of pictorial invention – by means of an amazing chromatic web that transforms the entire composition into a model of dazzling decorative painting. Still life, composition with figures, landscape, all the components of the realist tradition remain recognizable and physically present but are transfigured by the invasion of the decorative element, which occupies every part of the surface, with even the trees entering into this scheme. Note how the overall two-dimensional character of this work – underscored by the repetition of the same figurative motif on the wall and tablecloth as well as by the uniform red background – does not contrast at all with the perspective suggested by the table or with the break created by the window. Matisse lends a meaning to the idea of decoration that was previously unknown in Western painting. To use his own words: "Expression and decoration are one and the same, since the latter is condensed in the former."

66

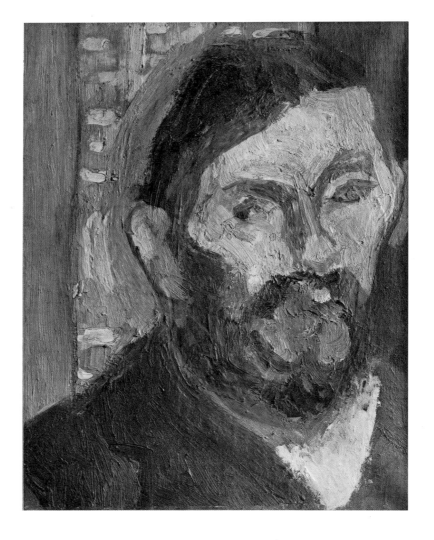

Above: Portrait of Bevilacqua, *Paris, 1901; oil on canvas; 35 × 27 cm (13³/₄ × 10⁵/₈ in); Musée des Beaux-Arts, Nantes. Bevilacqua was famous in the art world at the turn of* the century, as he was one of Rodin's favourite models. He is also the subject of Matisse's *Male Model* and the sculpture *The Serf, both executed in 1900.*

Opposite: Mme Matisse in a Japanese Robe, *Paris or Bohain-en-Vermandois, 1901; oil on canvas; 116.8 × 80 cm (46 × 31¹/₂ in); Private Collection.*

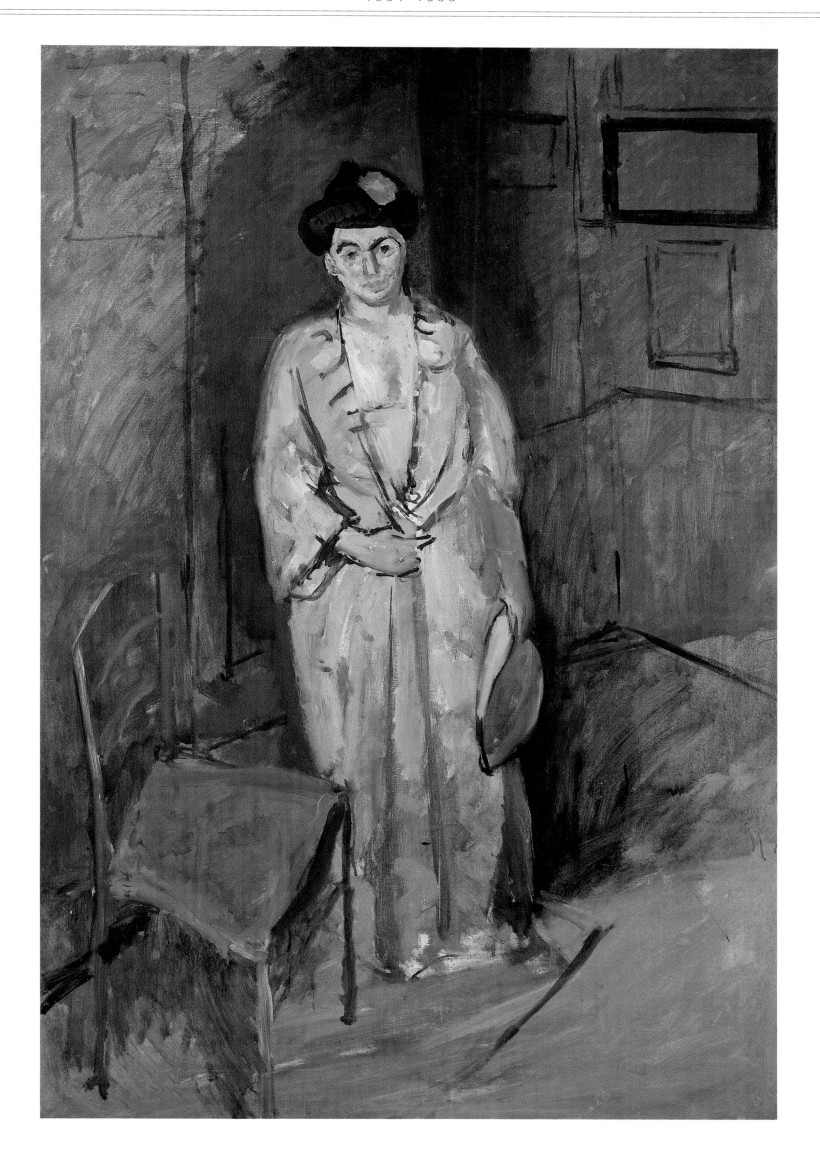

68

The Path in the Bois de
Boulogne, *Paris,*
1902; oil on canvas;
65 × 81.5 cm

(25¹⁄₄ × 31³⁄₄ in);
Pushkin Museum of
Fine Arts, Moscow.

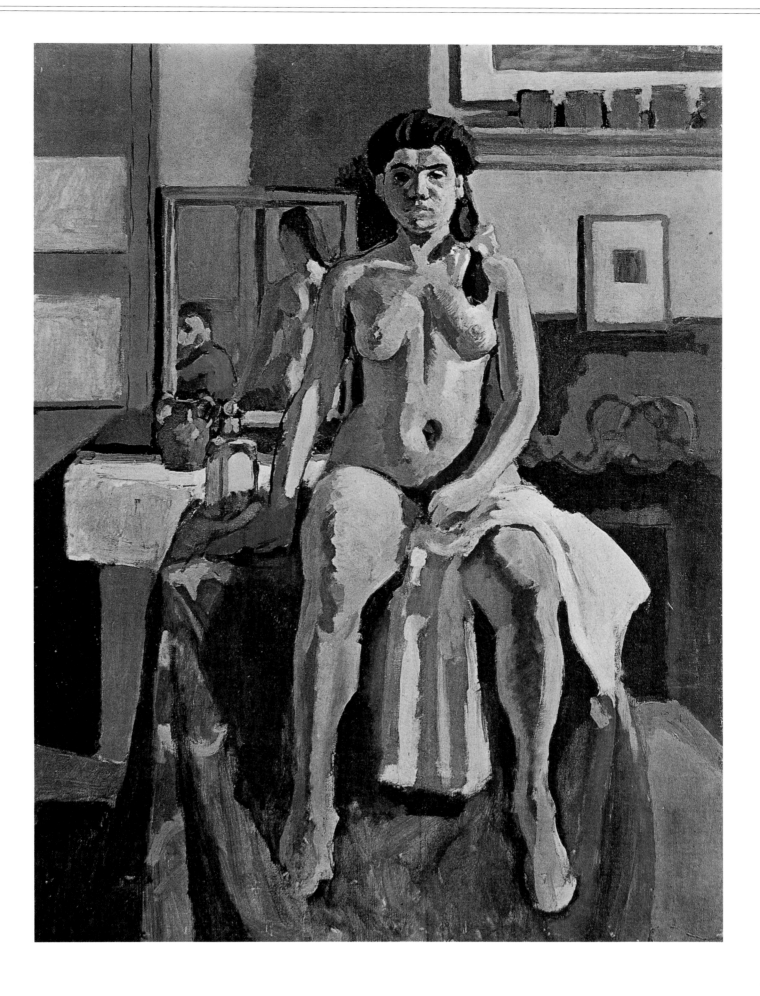

Carmelina, *Paris, 19 quai Saint-Michel, 1903–04; oil on canvas; 81.3 × 59 cm (32 × 23¹/₄ in); Museum of Fine Arts, Boston, Tomkins Collection. From this period, the female nude became one of Matisse's recurring and best loved subjects.*

70

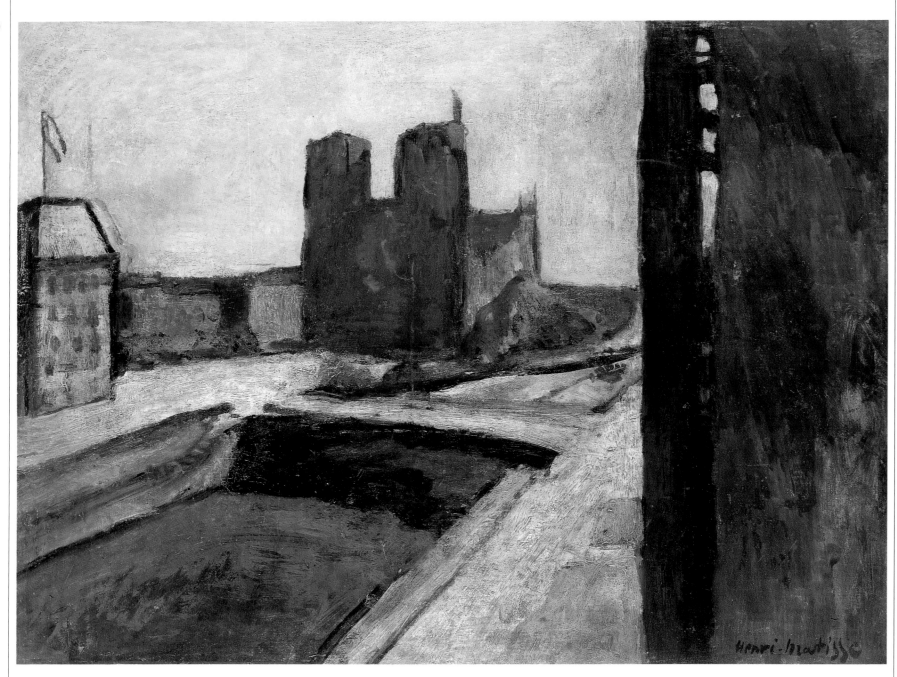

Notre-Dame with Violet
Wall, *Paris, 1903; oil
on canvas; 50 × 65 cm
(19½ × 24¼ in);
Private Collection.
The theme of a
window view recurs*
almost obsessively in
Matisse's oeuvre,
almost as if he were
seeking a "frame" for
the natural scenes in
his paintings.

Studio under the Eaves, *Bohain-en-Vermandois, autumn-winter 1901–2; oil on canvas; 55 × 44.5 cm (21½ × 17½ in); The Fitzwilliam Museum, Cambridge, Massachusetts. Some critics have interpreted this work as a metaphor for the difficult period Matisse was experiencing at this time.*

72

Bouquet on a Bamboo
Table, *Bohain-en-
Vermandois, 1903;
oil on canvas;
54.6 × 45 cm
(21¼ × 17½ in); Jan*

*Krugier Gallery,
Geneva. This is one of
the most frequently
recurring motifs in
Matisse's artistic
universe.*

The Door to Signac's Studio, *Saint-Tropez, 1904; oil on canvas; 30 × 24.5 cm (11¾ × 9½ in); Private Collection. Signac's support and* *influence were of crucial importance to Matisse's rise to fame and to the definition of his style in the early years of this century.*

74

Above: Study for Luxe, calme et volupté, *Paris or Saint-Tropez, 1904; charcoal on paper; 22.2×27 cm (8½×10½ in); Private Collection.*

Opposite: Luxe, calme et volupté, *Paris, 1904–05; oil on canvas; 98.5×118 cm (38½×46½ in); Musée National d'Art Moderne, Centre Georges Pompidou, Paris. Purchased by Paul Signac, this canvas condenses the* motifs of Matisse's first mature oeuvre, while at the same time taking in the symbolic aspects of his pictorial experimentation, which would lead to the masterpieces that were painted soon afterwards.

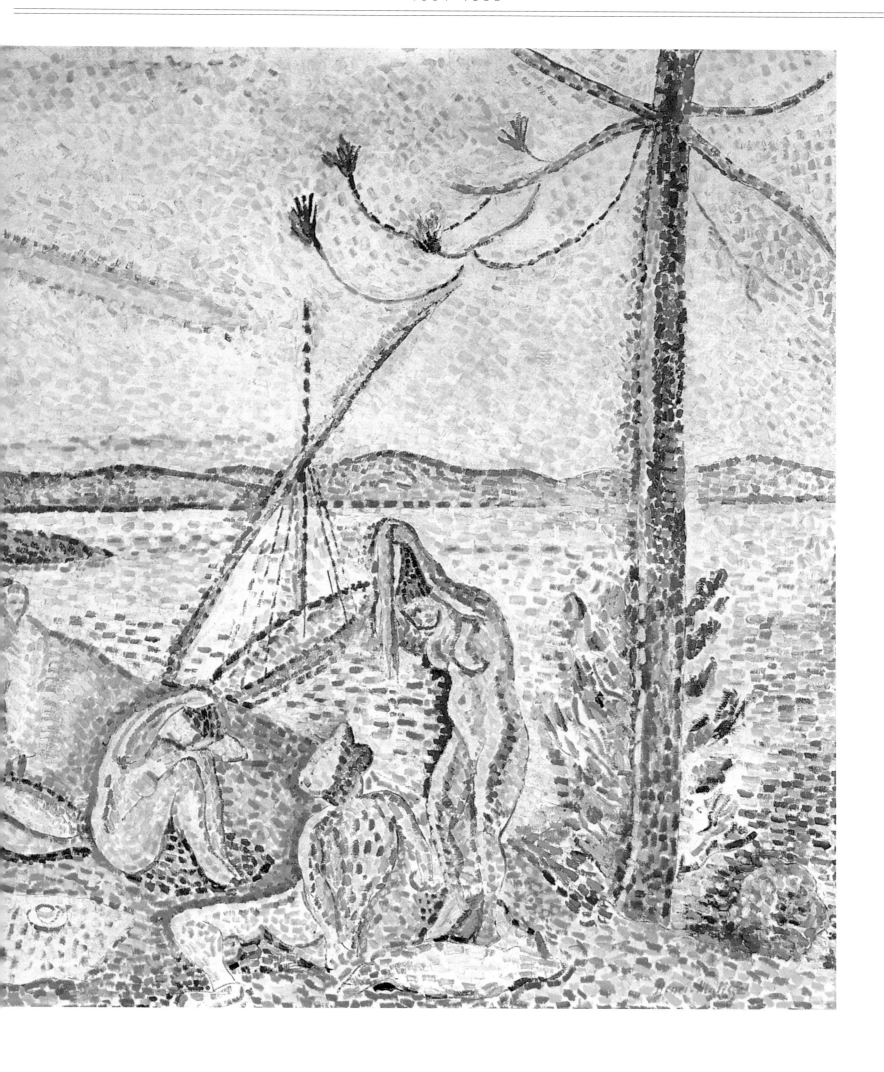

76

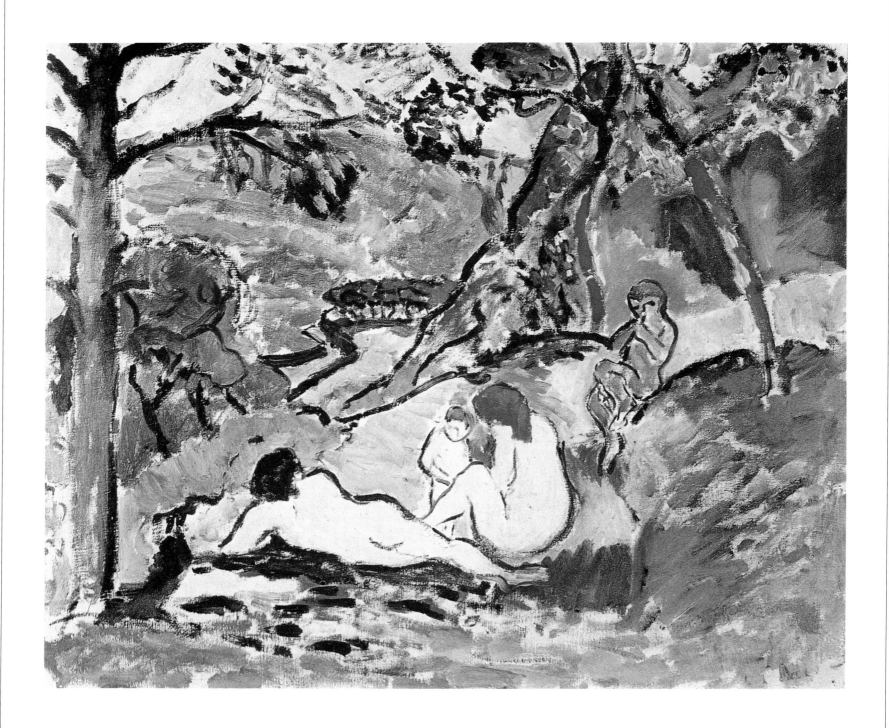

Pastoral, *Collioure, summer 1906; oil on canvas; 45 × 55 cm (18¹/₈ × 21⁵/₈ in); Musée d'Art Moderne de la Ville, Paris. The references to the Golden Age are quite explicit in this work;* on a pictorial level *Matisse is still trying to reconcile the immediate expressiveness of colour with the form typical of Cézanne's Bathers.*

By the Sea (Gulf of
Saint-Tropez), *Saint-
Tropez, summer
1904; oil on canvas;
65 × 50.5 cm
(25½ × 19⅞ in);
Kunstsammlung
Nordrhein-* *Westfalen,
Düsseldorf. The
transformation of this
subject into a
mythical scene was
the starting point for*
Luxe, calme et volupté.

78

Rue de Soleil, *1905; oil
on canvas; 46 × 55 cm
(18 × 21½ in); Private
Collection. Arcueil,
Collioure and the gulf
of Saint-Tropez, the
legendary sites in the
French Midi that
gave birth to Fauvism
played an important
role in Matisse's
"discovery of light".*

La Moulade, Collioure,
*Collioure, 1905; oil
on canvas; 24.2 × 32.3
cm (9½ × 12½ in);
Private Collection.*

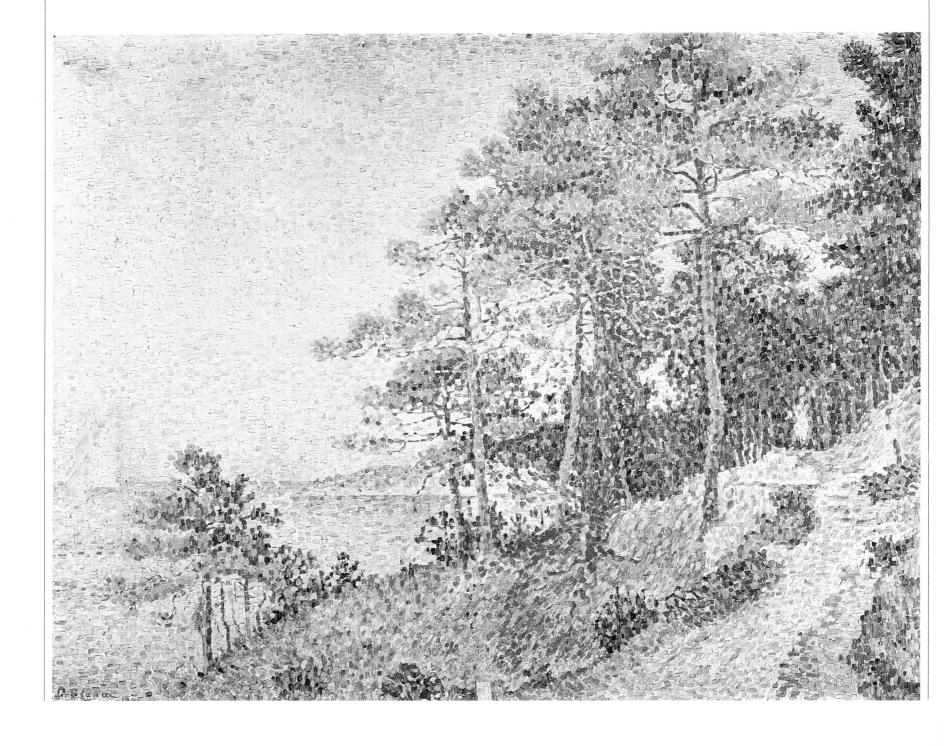

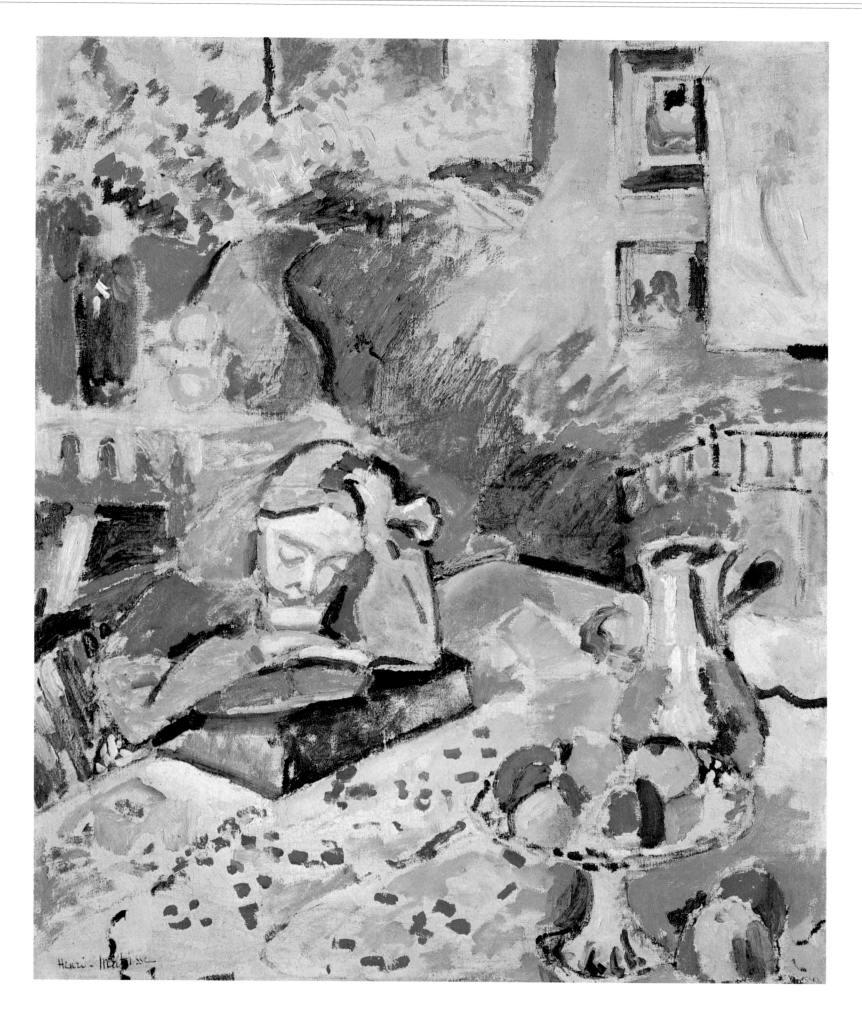

Opposite above: The Port of Abaill, *Paris, 1905–06; oil on canvas; 60 × 148 cm (23⅝ × 58¼ in); Private Collection.*

Opposite below: Paul Signac, Saint-Tropez, 1905; oil on canvas; Musée des Beaux-Arts, Grenoble.

Above: Interior with Young Girl, *Paris, autumn-winter 1905–06; oil on canvas; 72.2 × 59.4 cm (28 × 23 in); Private Collection.*

This is one of the first of Matisse's clearly Fauve paintings, as can be seen by his free use of colour as a means of expression.

82

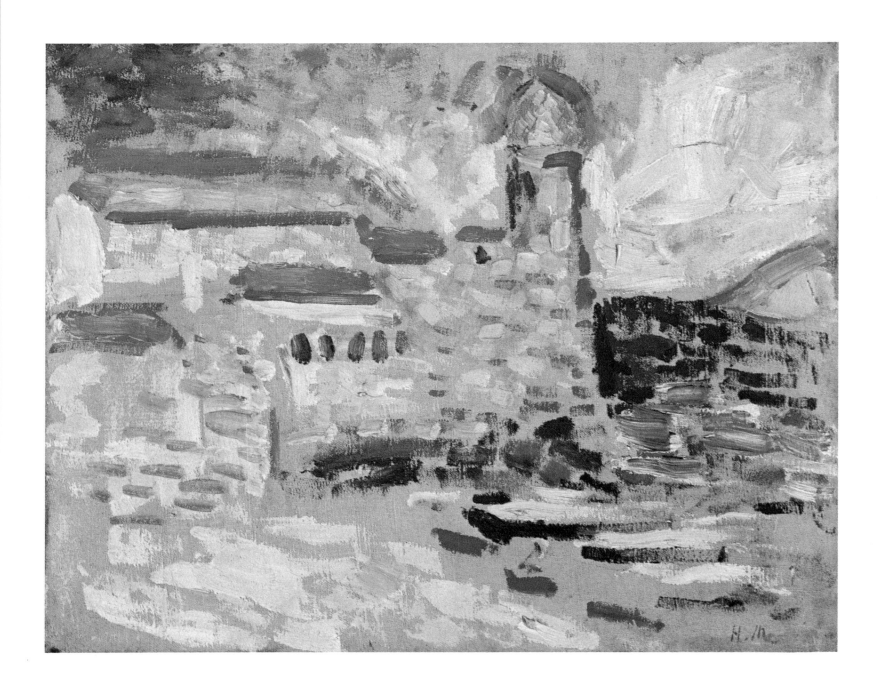

View of Collioure (The Bell Tower), *Collioure, summer 1905; oil on canvas; 32.9 × 41.3 cm (12¾ × 16 in); Kate Steichen Collection. The southern light was a decisive factor* *in the birth of Fauvism. Matisse, Marquet, Vlaminck and Derain went to Collioure with the express aim of laying the foundation for their new aesthetic.*

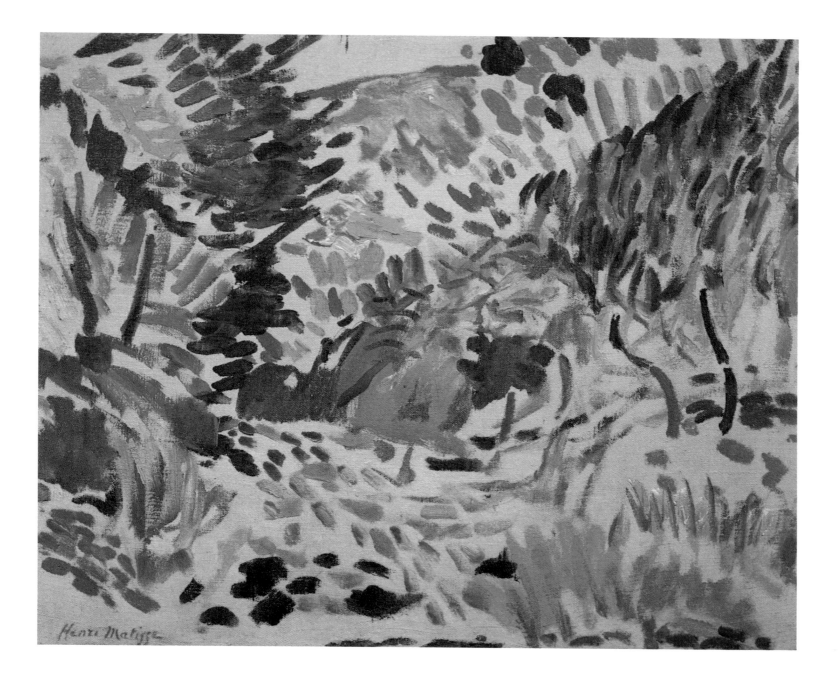

Landscape at Collioure, *Collioure, summer 1905; oil on canvas; 39 × 46.2 cm (15⅜ × 18¼ in); Museum of Modern Art, New York, fractional gift of Mrs Bertram Smith. The use of colour to create an anti-naturalistic effect and the* abandonment of *Renaissance perspective are the major innovations in Matisse's Fauve style, while for the most part the other elements in his pictorial procedure still adhered to the canons of nineteenth-century painting.*

84

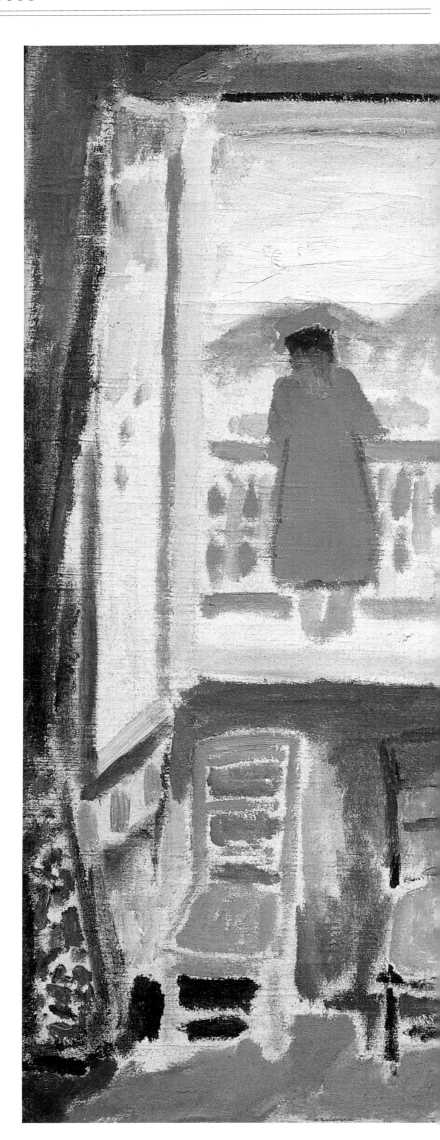

Above: Collioure, *Collioure, summer 1905; reed pen and India ink; 25 × 19 cm (9¾ × 7½ in); Private Collection.*

Opposite: Interior at Collioure, The Siesta, *Collioure, summer 1905; oil on canvas; 59 × 72 cm (23¼ × 28⅜ in); Private Collection. The relationship between interior and exterior is a recurring theme in Matisse's oeuvre that is to be interpreted as the relationship between the space created by the artist and nature's space.*

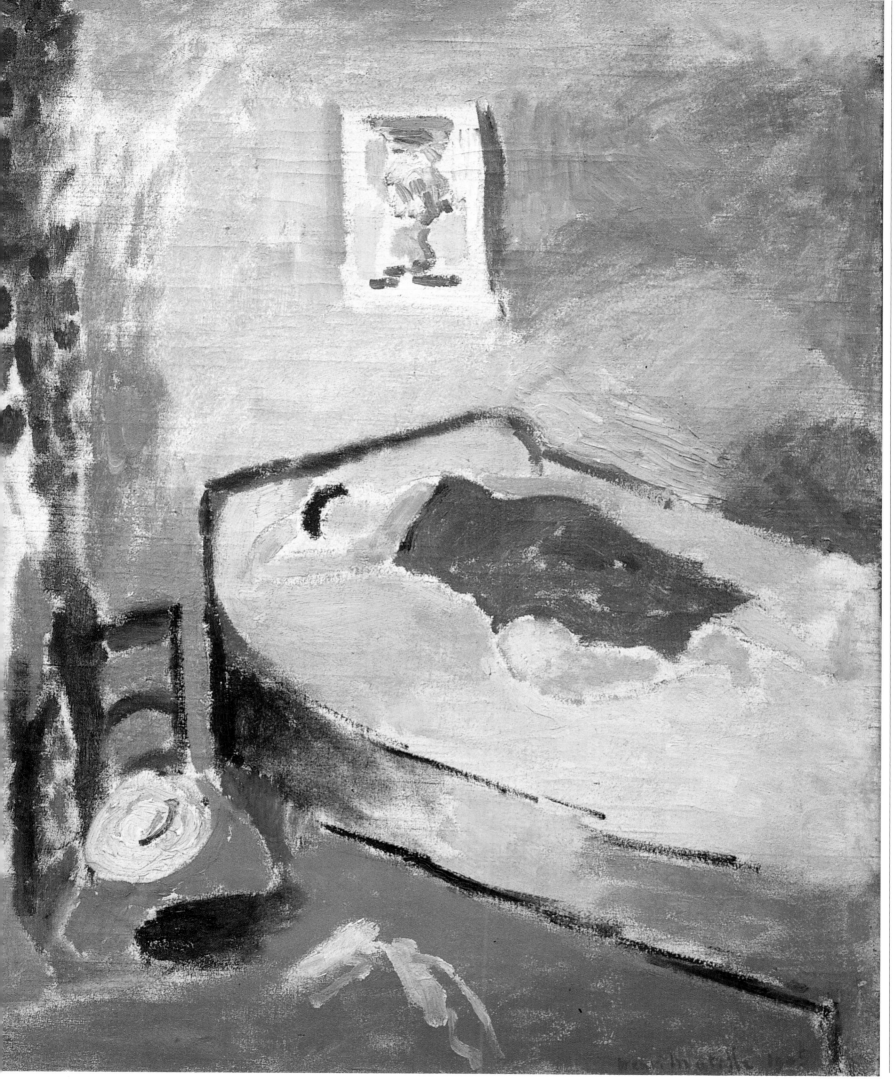

86

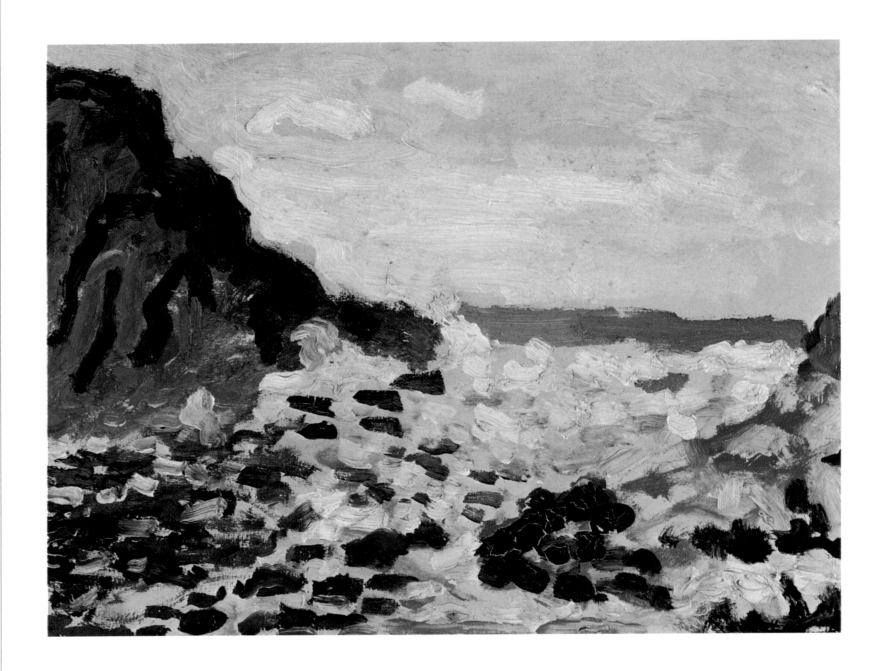

Above: Seascape, *Collioure, summer 1905; oil on cardboard; 24.5 × 32.4 cm (9⅝ × 12¾ in); San Francisco Museum of Modern Art, bequest* of Mildred B. Bliss. As can be seen in this work, it is now colour, not drawing, that constructs the image in this phase of Matisse's pictorial research.

Opposite: The Open Window, Collioure, *Collioure, summer 1905; oil on canvas; 55.2 × 46 cm (22¾ × 18⅛ in); Mrs John Hay Whitney Collection, New York.*

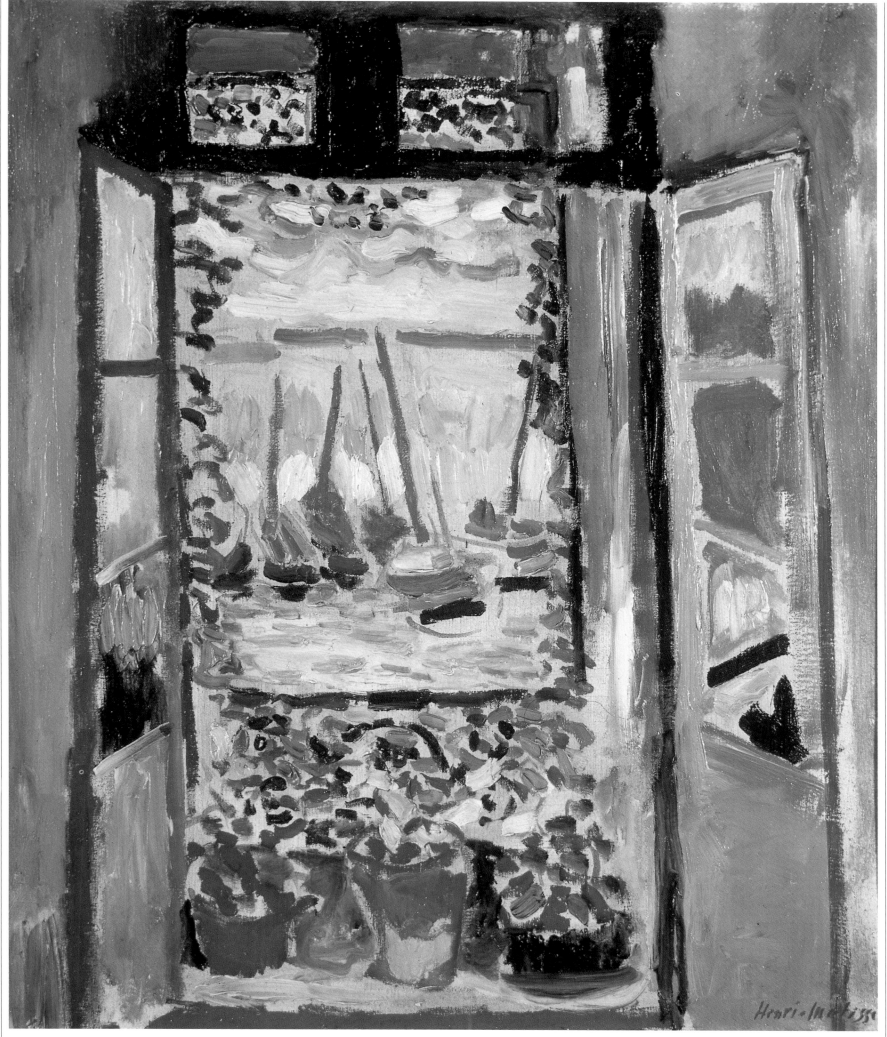

88

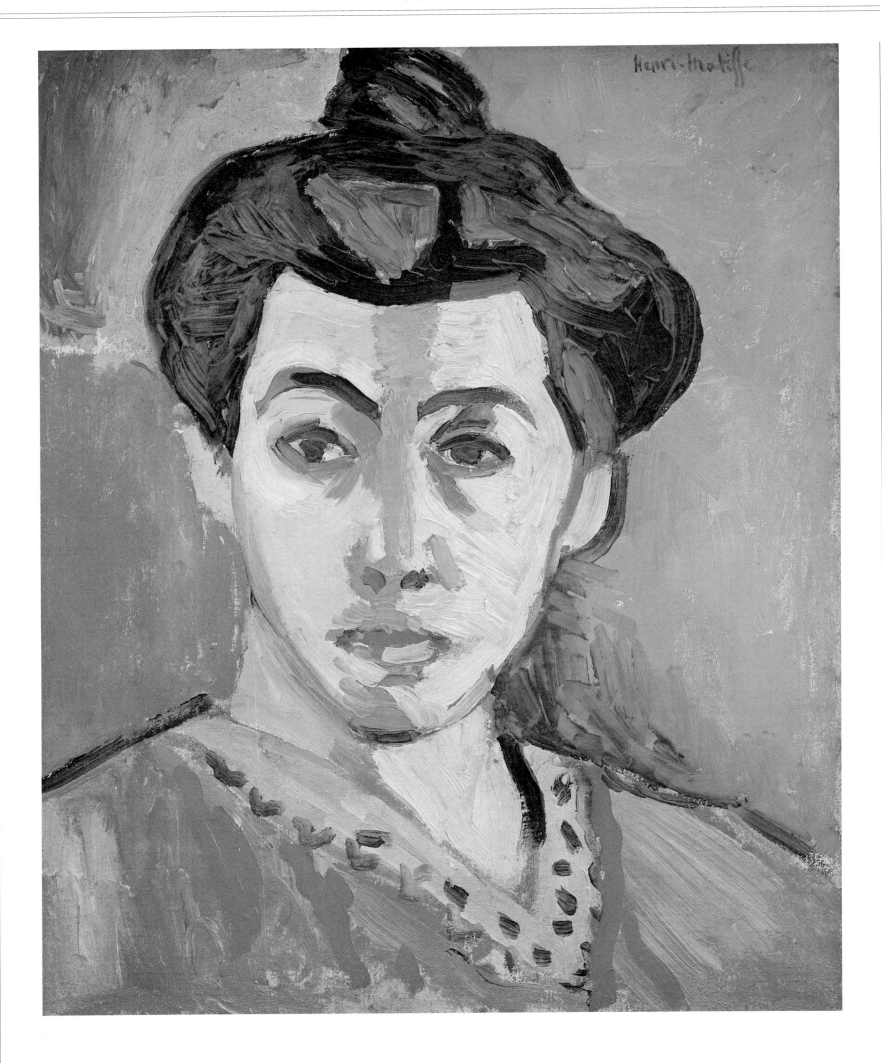

Portrait of Mme Matisse – The Green Line, *Paris, autumn-winter 1905; oil on* canvas; 40.5 × 32.5 cm (16 × 12⅞ in); *Statens Museum for Kunst, Copenhagen.* *This work, which once belonged to Gertrude Stein, was one of the Fauve paintings that* caused such a sensation at the historic 1905 Salon d'Automne.

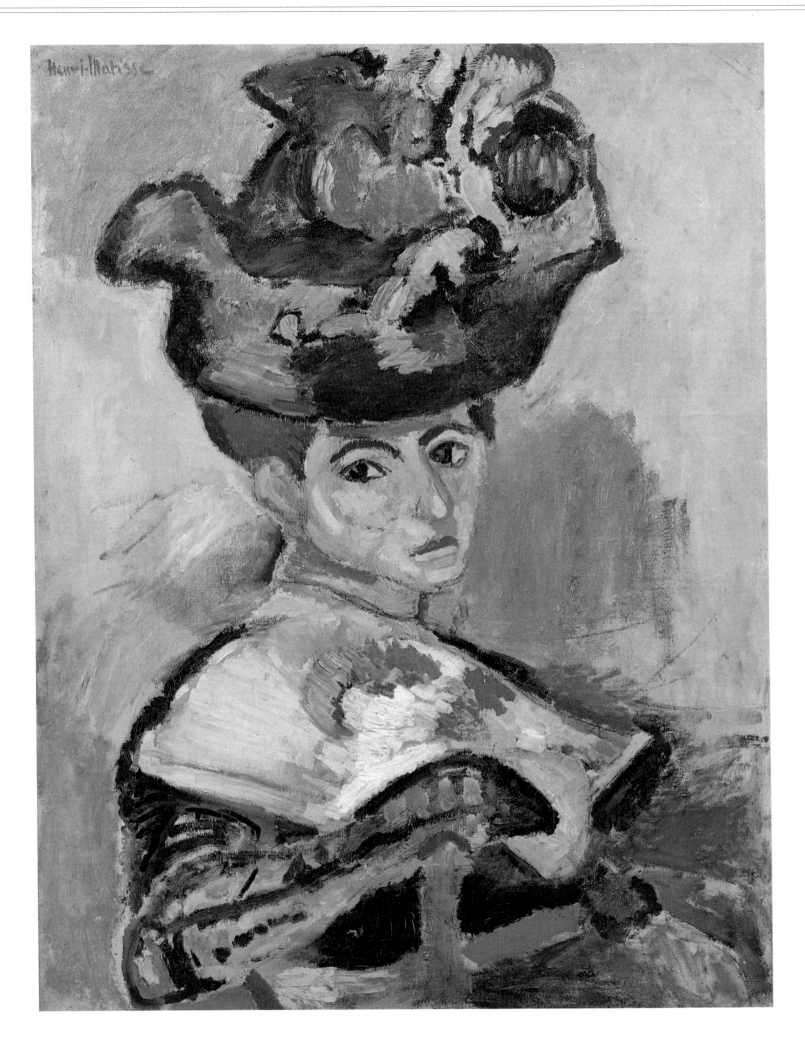

The Woman with the Hat, Paris, autumn 1905; oil on canvas; 80.6 × 59.7 cm (31¾ × 23½ in); San Francisco Museum of Modern Art, bequest of Elise S. Haas. This painting was bought by Sarah Stein on the last day of the 1905 Salon. The purchases on the part of the Stein family marked the beginning of Matisse's good fortune with art collectors.

90

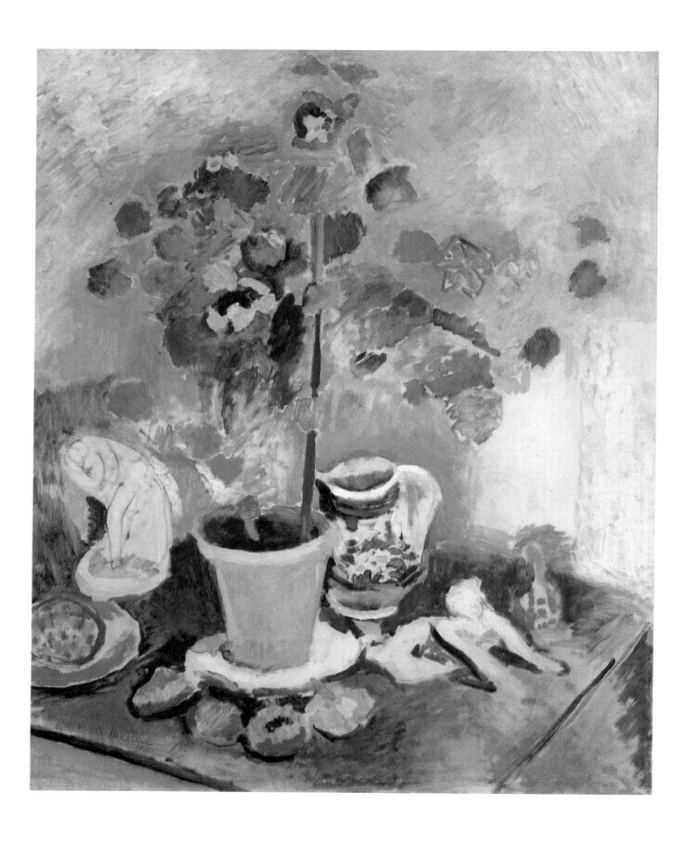

Still Life with a
Geranium, *Collioure,
summer 1906; oil on
canvas; 97.9 × 80.2
cm (38½ × 31½ in);
Art Institute of
Chicago, Joseph
Winterbotham
Collection.*

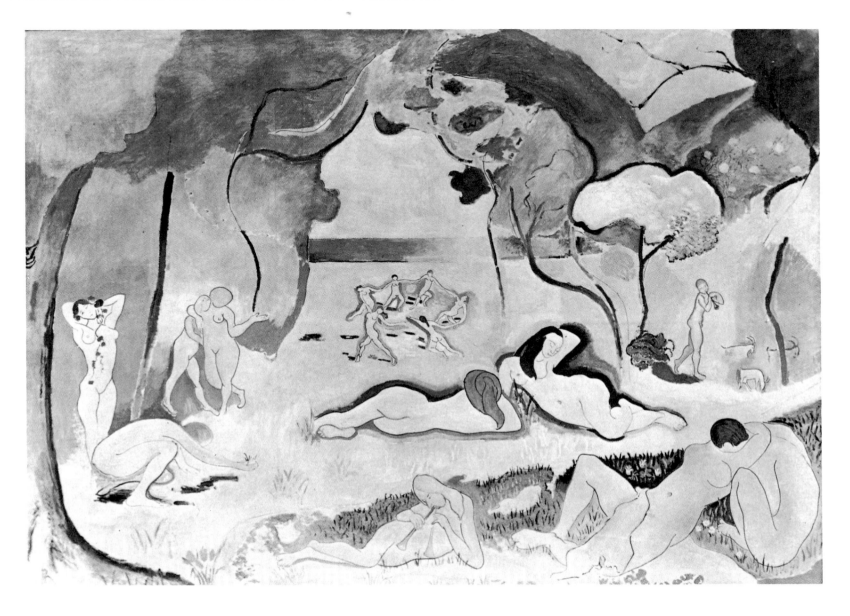

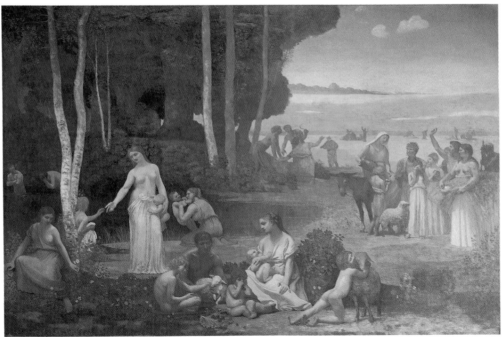

Top: La joie de vivre, *Paris, Couvent des Oiseaux, autumn-winter 1905–06; oil on canvas; 174 × 238 cm (68½ × 93¾ in); The Barnes Foundation, Merion, Pennsylvania.*

Above: Puvis de Chavannes, Summer, *1891; oil on canvas. The influence of this artist was of fundamental importance for the entire post-Impressionist generation. One need only observe the compositional structure and setting of this work to see how Matisse studied this artist quite carefully.*

92

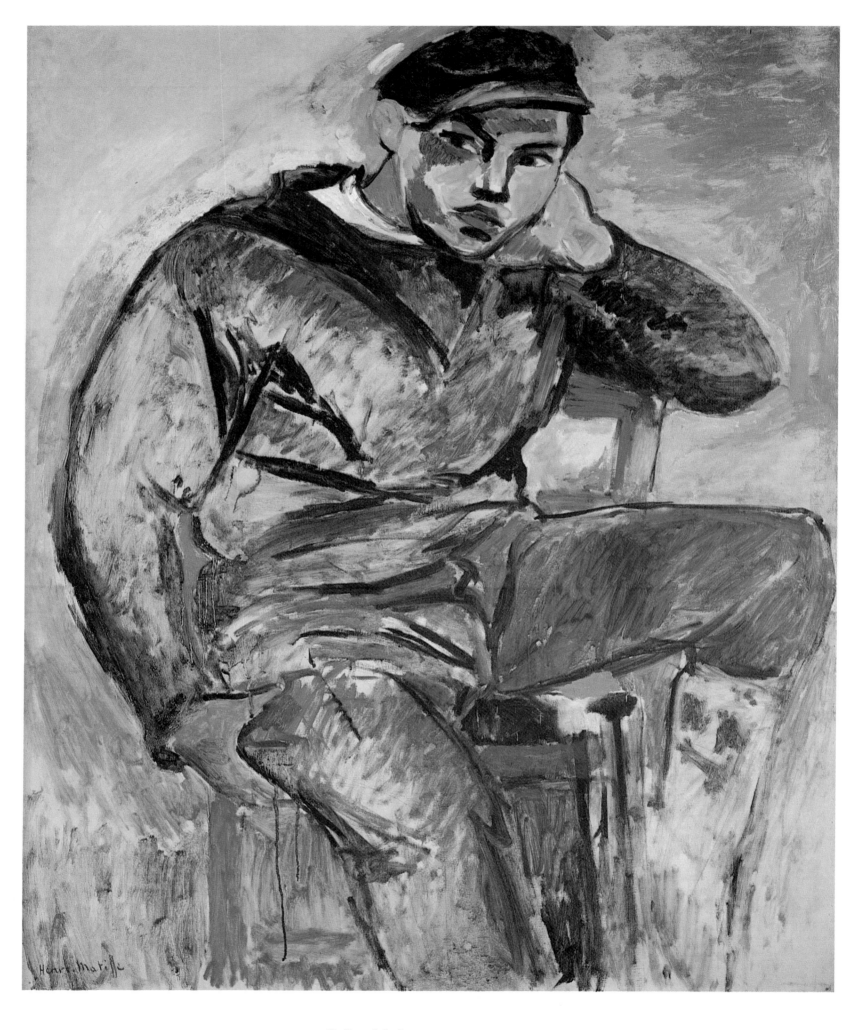

The Young Sailor I,
Collioure, summer
1906; oil on canvas;
100 × 82 cm
(39¼ × 32¼ in);
Private Collection.

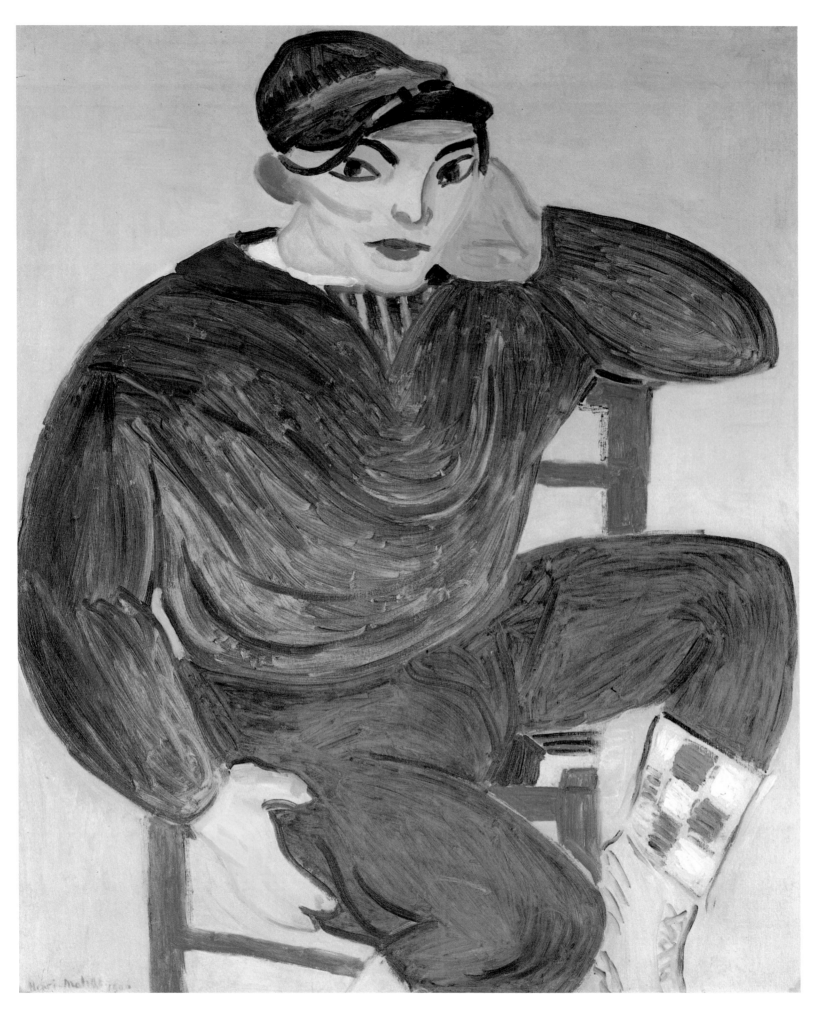

The Young Sailor II,
*Collioure or Paris,
summer-winter 1906;
oil on canvas;
101.5 × 83 cm
(40 × 32¾ in); Private*
*Collection. These two
works mark the
transition from a
markedly Fauve
aesthetic to the more
synthetic style*
*Matisse used from
1906 on. Note, in the
second version, the
clear-cut linear
definition of the out-
lines, the flat colours,*
*and how the facial
features are pared
down to their most
essential elements.*

94

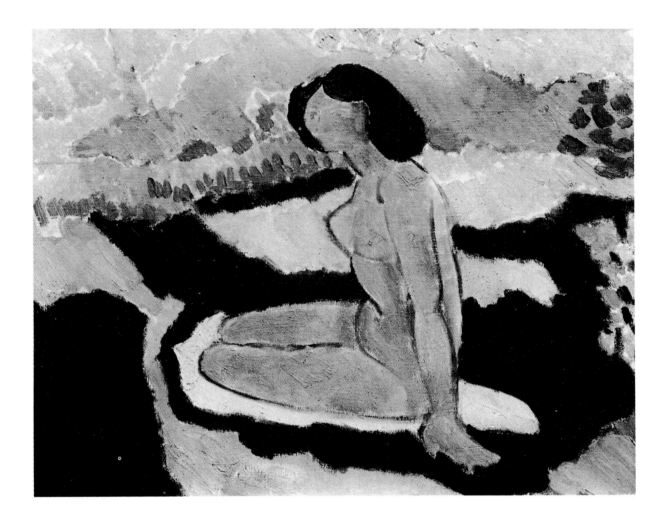

Opposite above:
Seaside, Collioure,
Collioure, 1905;
watercolour;
20.5 × 27 cm (8 × 10½
in); Private
Collection.

Opposite below:
Mountains, Collioure,
Collioure, 1905;
watercolour;
20.6 × 26.2 cm
(8 × 10¼ in); Private
Collection.

Above: Pink Nude,
1906; oil on canvas;
33 × 41 cm (12¾ × 15¾
in); Musée des Beaux-
Arts, Grenoble. The
nudes Matisse

painted in this period
can all be ideally
linked with the
pictorial aims
revealed in his La joie
de vivre.

96

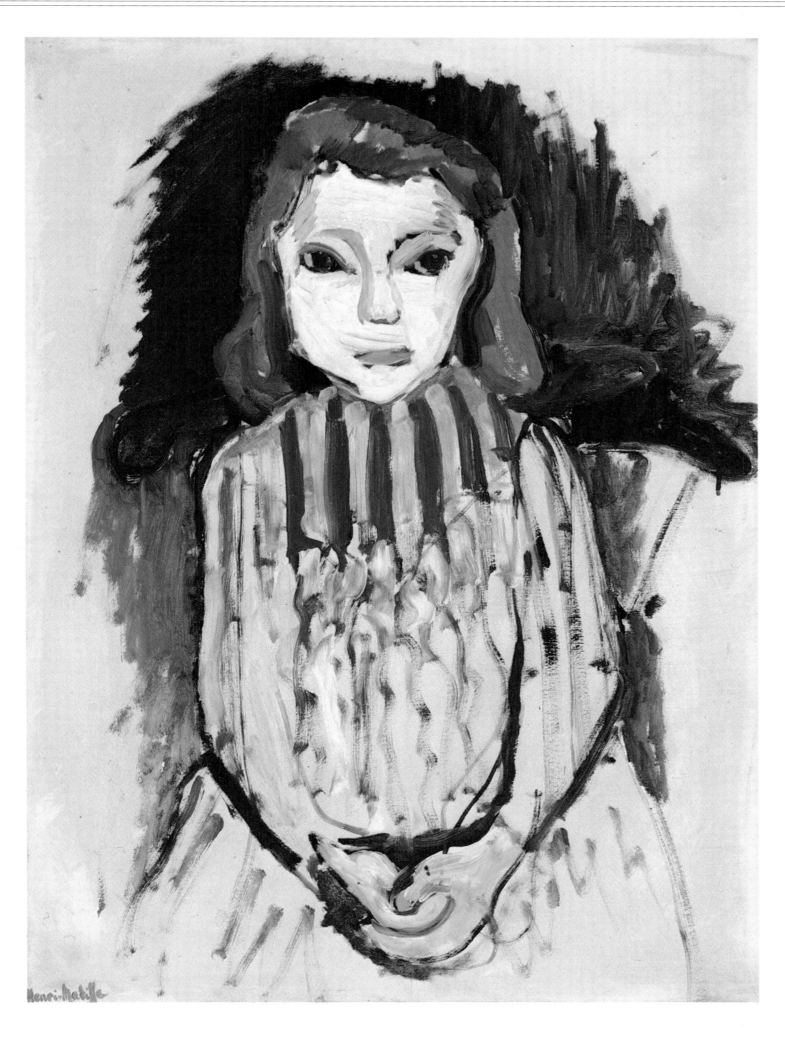

Opposite: Woman by a Stream, *Collioure, 1906; oil on canvas; 35 × 28 cm (13½ × 10¾ in); Galerie Artel. The* "coexistence" *of synthetic works and others such as this with the sharp, fragmentary brush-* strokes typical of Fauvism, is characteristic of Matisse in this period.

Above: Marguerite, *1906; oil on wood; 71.1 × 53.5 cm (27¾ × 20¾ in); Private Collection. This is one of the first portraits Matisse painted of his daughter, who was born in 1901.*

98

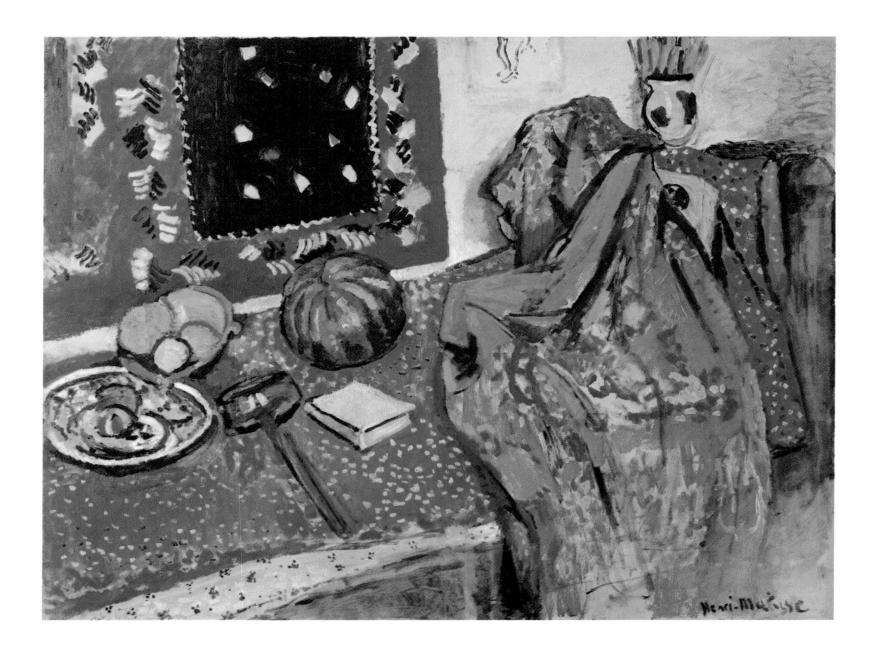

Still Life with a Red Rug, *Collioure, summer 1906; oil on canvas; 89 × 116.5 cm (35 × 45⅞ in); Musée des Beaux-Arts, Grenoble. This is a difficult work to interpret in that* *Matisse is trying to reconcile Cézanne's perspective with the decorative procedure that was becoming increasingly important in his oeuvre.*

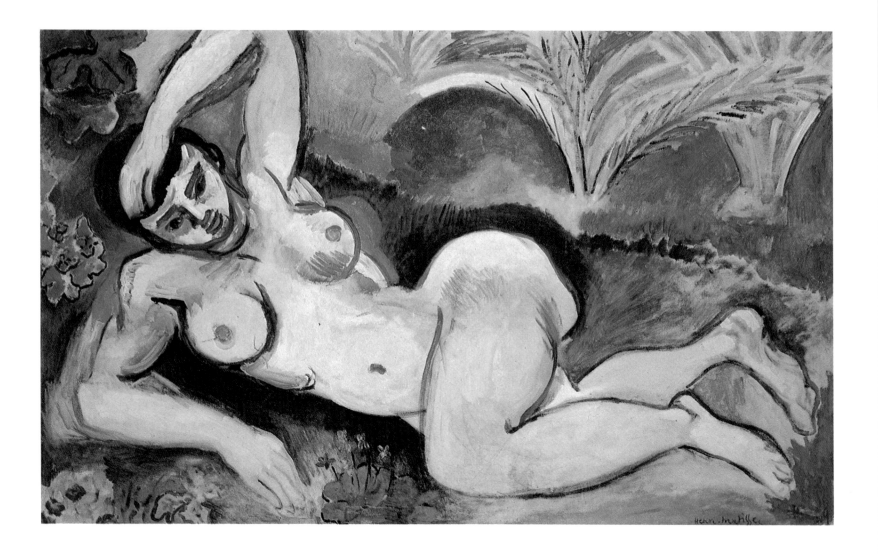

Blue Nude (Memory of Biskra), *Collioure, 1906; oil on canvas; 92.1 × 140 cm (36¼ × 55¼ in); The Baltimore Museum of Art, Cone Collection. Called a "Black Venus," this work merges the* *monumentality of primitive art with the free chromatic play of Fauvism, as well as the decorative vein so characteristic of Matisse that can be seen in the vegetation in the background.*

100

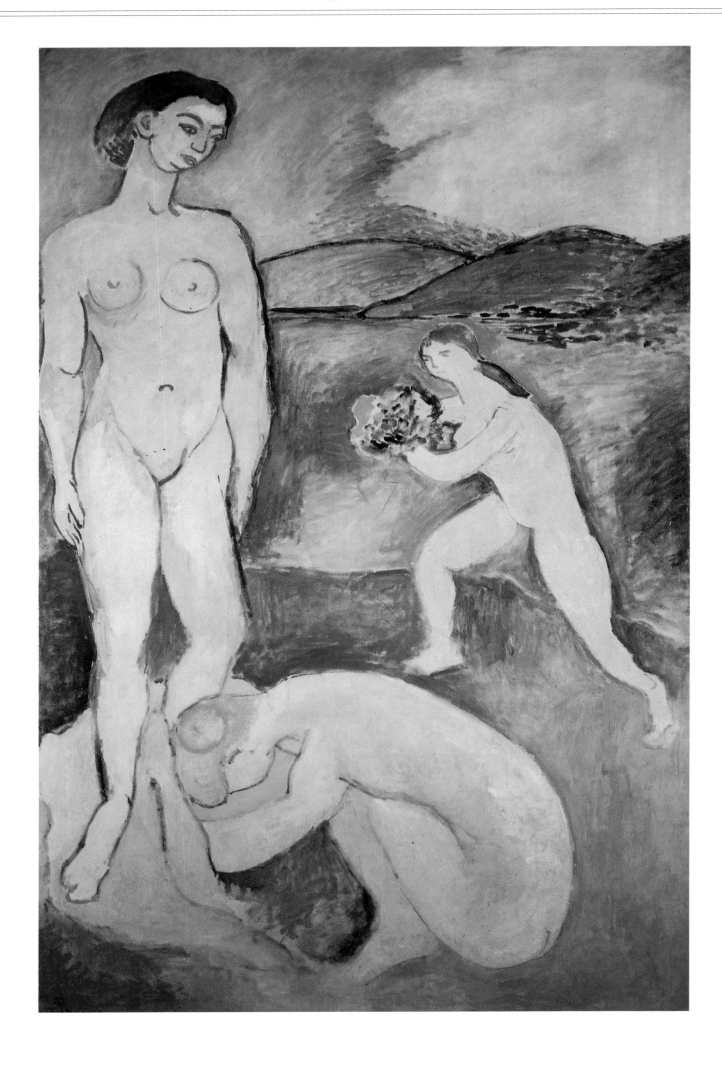

Le luxe I, Collioure,
summer 1907; oil on
canvas; 210 × 138 cm
(82⅝ × 54⅜ in);

Musée National d'Art
Moderne, Centre
Georges Pompidou,
Paris. The synthetic

treatment of the
bodies is
accompanied by
more discontinuous

brushwork – an
example of the
artist's different
pictorial procedures.

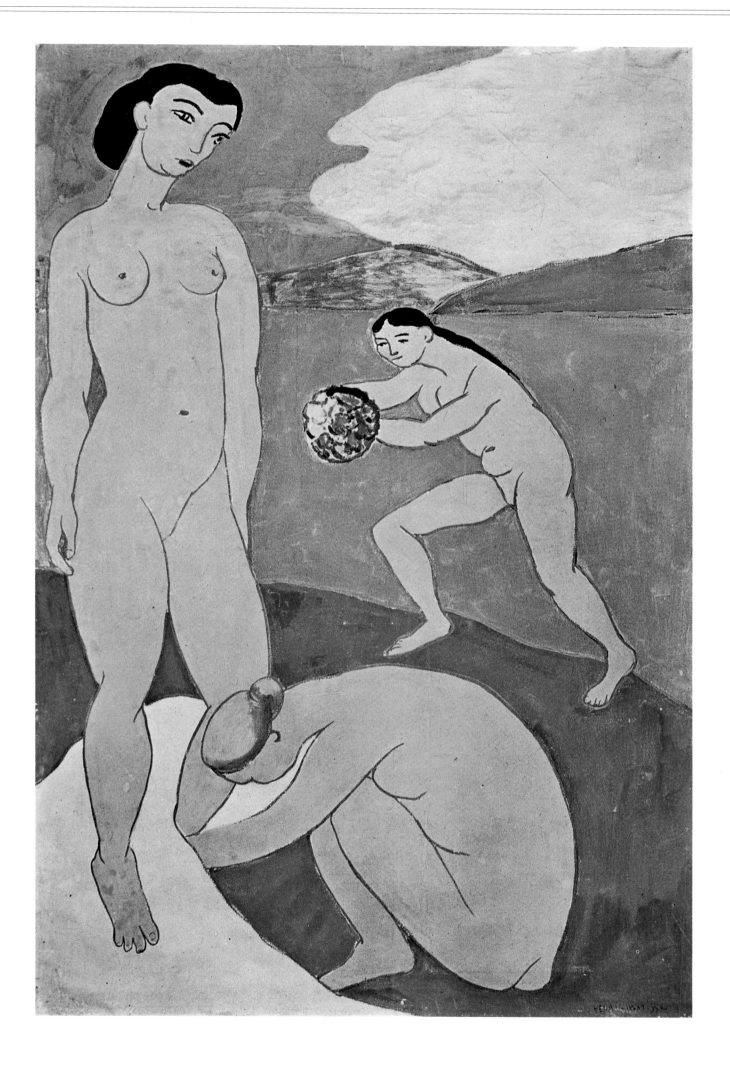

Le luxe II, *Collioure or Paris, 1907; oil on canvas; 209.5 × 138 cm (82½ × 54⅜ in);* *Statens Museum for Kunst, Copenhagen. As was the case with* The Young Sailor, *the* *second version of this work is much more linear and the colours are flat, which* *emphasizes the two-dimensionality of the canvas.*

102

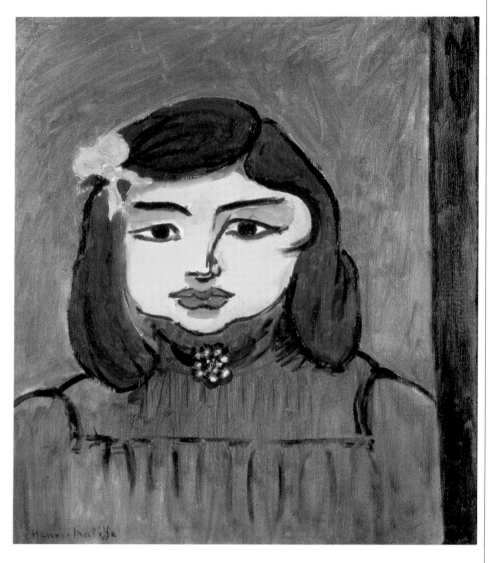

Above left: Standing Nude, *Collioure, 1907; oil on canvas; 92.1 × 64.8 cm (36¼ × 25½ in); The Tate Gallery, London.*

Above right: Portrait of Nono, *Collioure, 1907; oil on canvas; Metropolitan Museum of Art, New York, bequest of Miss Adelaide Milton de Groot. The stylizations of the* facial features and the body in these two works adheres to Matisse's desire to lend the utmost solemnity to the subject by underscoring its salient characteristics, and to heighten the expressive potential of the colour and, in the case of the sculpture, of the Cézannesque volumes of the figure.

Opposite: Nude, Black and Gold, *Paris, Hôtel Biron, summer-autumn 1908; 100 × 65 cm (39⅜ × 25⅝ in); Hermitage Museum, St Petersburg.*

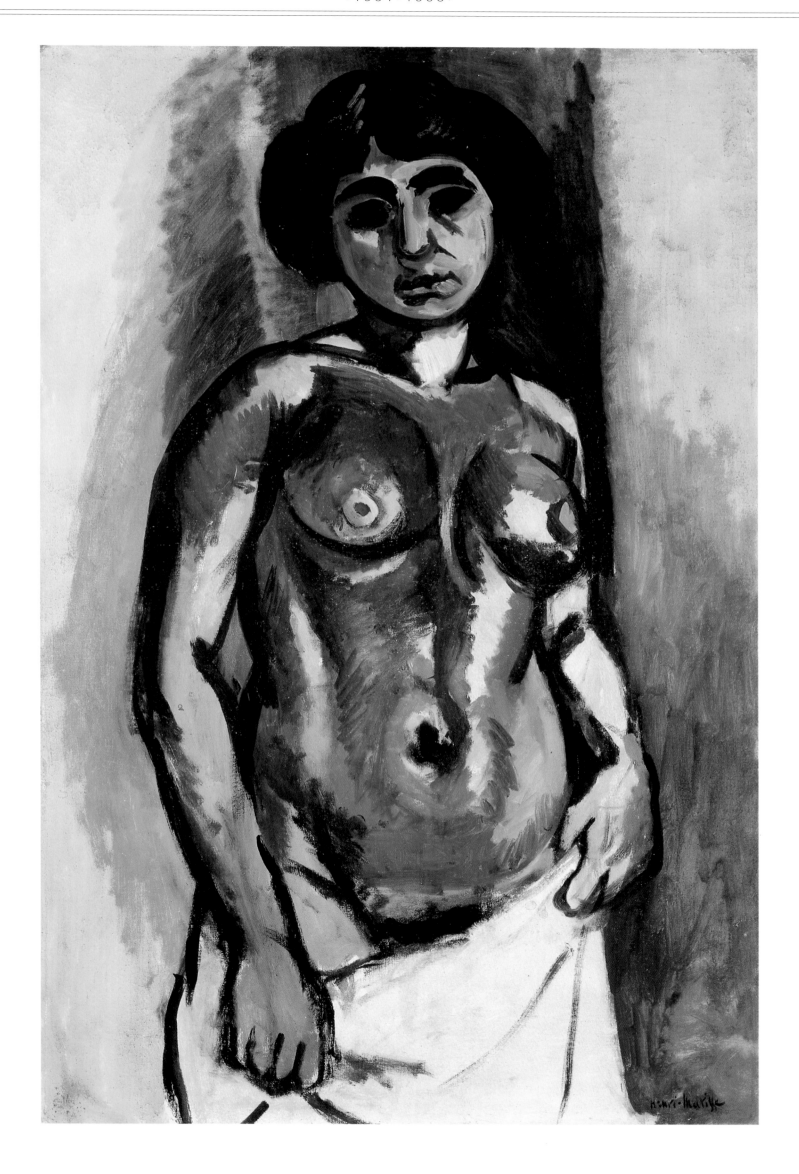

104

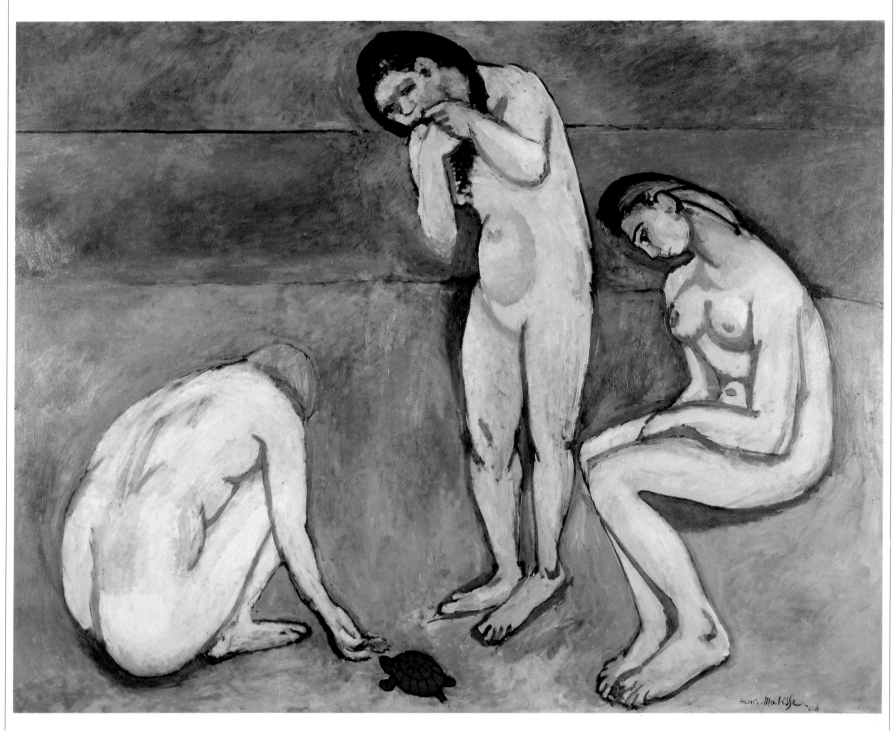

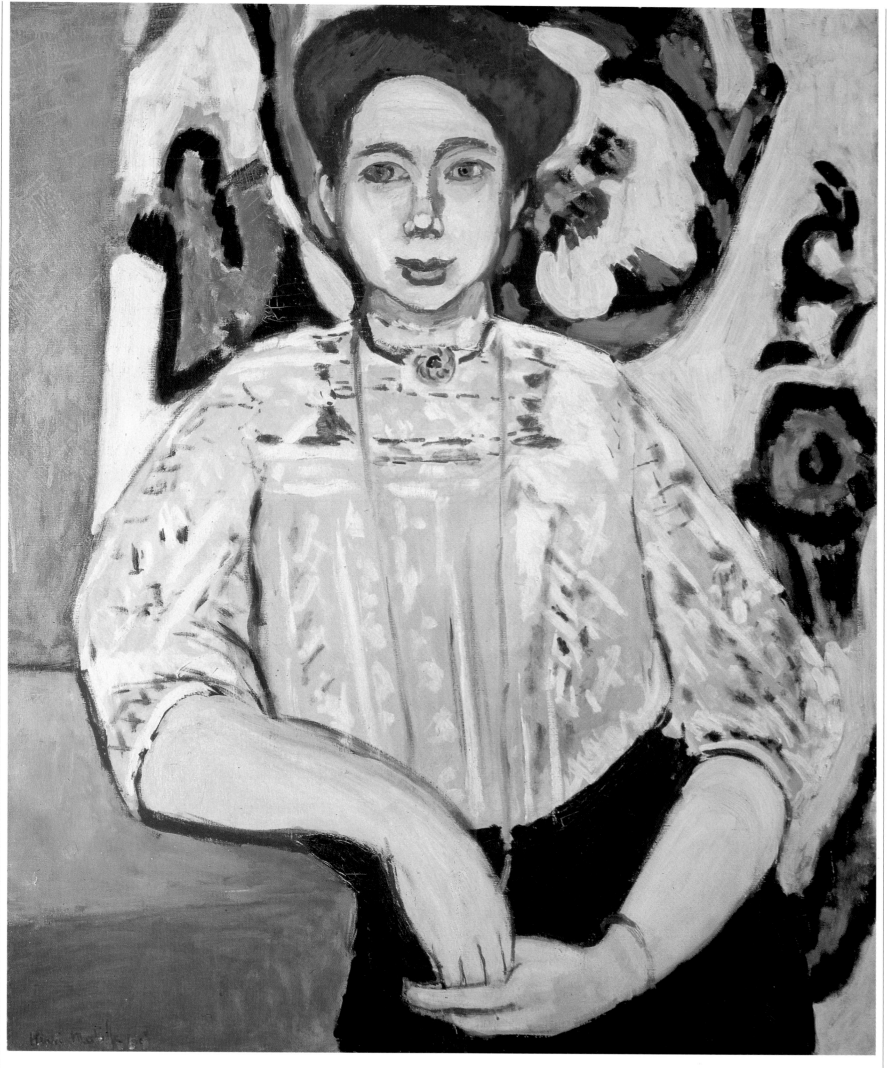

106

Still Life in Venetian Red, 1908; oil on canvas; 89 × 105 cm (35 × 41⅜ in); Pushkin Museum of Fine Arts, Moscow. The decorative dimension of Matisse's oeuvre begins to make itself felt more and more, while the title of this work underscores the importance he attaches to colour, which he uses to create a sense of depth as opposed to the surface.

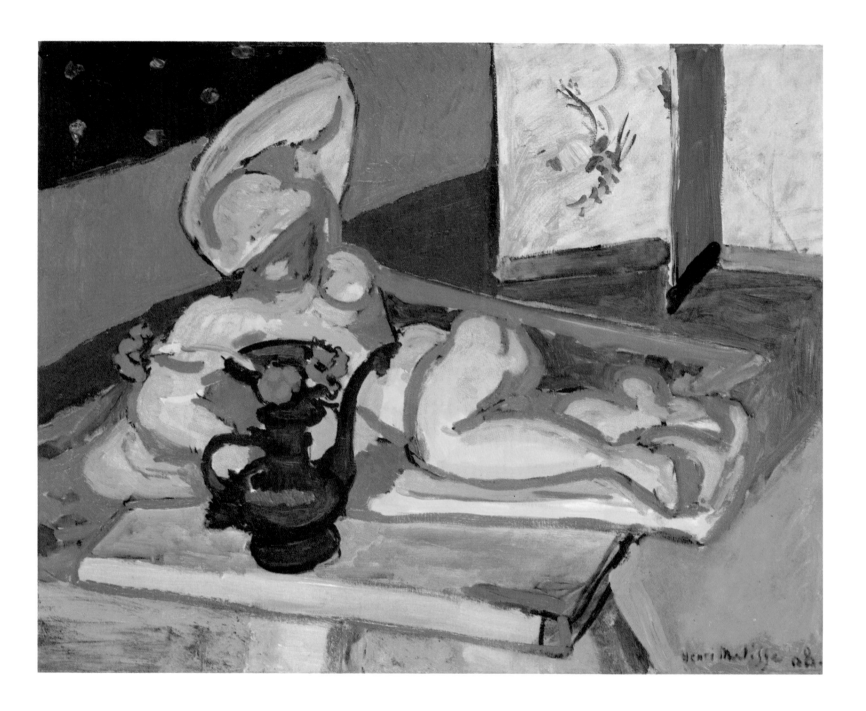

Sculpture and Persian Vase, *Paris, winter-summer 1908; oil on canvas; 60.5 × 73.5 cm (23⅞ × 29 in); Masjonalgalleriet, Oslo. Matisse often adopted his own sculpture pieces as subjects for his* paintings. *In this case it is* Reclining Nude I, *which he executed in 1907. The reference to his* Blue Nude, *painted in 1906, is evident in the circularity so typical of Matisse's pictorial procedure.*

108

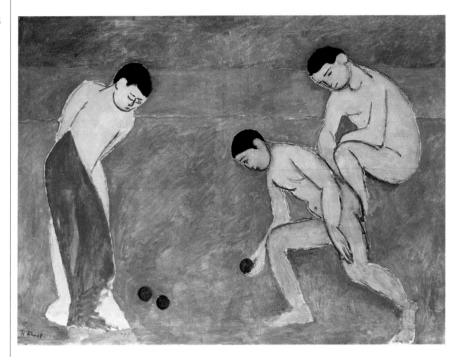

Above: Game of Bowls,
*Paris, autumn-winter
1908; oil on canvas;
113.5 × 145 cm
(45⅝ × 57 in);
Hermitage Museum,
St Petersburg.*

Opposite: Harmony in
Red, La Desserte,
*Paris, Hôtel Biron,
1908; oil on canvas;
180 × 220 cm
(70⅞ × 86⅝ in);
Hermitage Museum,
St Petersburg. One of
the consummate*

*masterpieces of
Matisse's first
creative phase, this
work had a long
gestation period: at
first it was dominated
by a sky-blue colour,
and was then
transformed into the*

*painting reproduced
here. The work was
purchased by the
Russian art collector
Shchukin while
Matisse was still
working on it.*

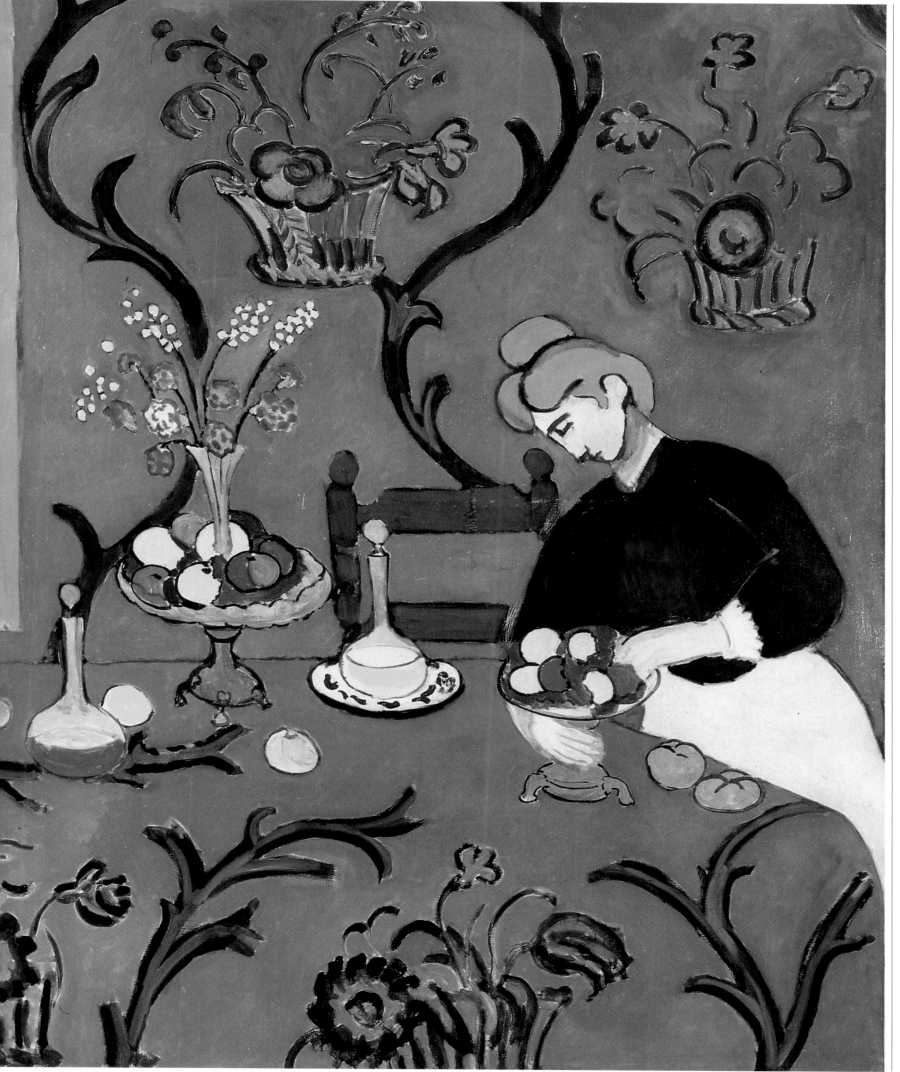

From *The Dance* to *The Moorish Café*

110

The series of paintings Matisse executed from 1909 and 1913 constitute his most famous period, during which he brought to fruition the numerous influences of his apprenticeship years and forged an autonomous pictorial language, creating many masterpieces and addressing a number of fundamental artistic issues.

This period, is characterized by non-linear works with an explicitly symbolic tone alongside others with a more conventional subject-matter, and where European tradition is flanked by Oriental influences in a network of motifs and meanings whose common denominator is the central role played by colour.

It is best to leave aside any chronological treatment of these works and concentrate on the emergence of certain stylistic or thematic constants that will reveal the essential unity of Matisse's oeuvre.

As we have already seen with *Portrait of Nono*, one of the salient features of this phase in Matisse's work is the essentiality of form, the determination to simplify the elements of the composition with the converse aim of accentuating the expressive power of his pictorial means – particularly line and colour – as well as the symbolic value of the entire painting. The exemplary achievement in this sense was obtained in the two panels Matisse painted for the Russian art collector Shchukin in 1910, *The Dance* and *Music*. He used only three colours, for expression and symbolic abstraction (red for the bodies, green for the earth and blue for the sky). The figures are rendered in essential outlines and are characterized mostly by the abstract, vacant quality of the faces, which lack realistic features; the space lies flat over the entire surface and helps to lend an ultra-terrestrial feeling to the scene, thus setting it in the timeless dimension already evoked in *La joie de vivre*, but this time without the artist having to recur to extra-pictorial and literary devices to achieve this effect. The only aspect that substantially differentiates *The Dance* from *Music* is the movement. It is a vital feature of the former work, not only because of the motif, but also because it is emphasized by the imbalance arising from the gap between the hands of the dancer on the left and the other one in the center foreground with her back to the beholder, as well as by the configuration of the earth, which seems to follow the dancers' movement. In *Music* there is a total lack of movement, partly due to the sacred, hieratic, monumental character of the figures without instruments whose song accompanies the two musicians.

The nature of these two works is undoubtedly sacred; they are invested with a sacredness that is secular but no less intense than the religious form, and they emanate a cosmic sense of the pictorial experience – the attempt to transform the obscure and sometimes deceptive allegories of late nineteenth-century Symbolist painting into deeply emotional images by means of the utmost simplicity and concentration of pictorial means.

Later works such as *Conversation* (1911), *The Painter's Family* (1912) and the Algerian canvases executed in 1913 all reveal how Matisse sought to rediscover and regenerate the sacred dimension of painting. The first two works are particularly important in that they introduce a "lofty" theme into a genre – the domestic scene – that belongs to the worldly, bourgeois tradition. The transformation Matisse effected is evident above all in *Conversation*, in which the everyday character of the scene is elevated, once again thanks to the solemnity of the figures and the severity and essentiality of the composition, to the level of an Annunciation. Matisse had written, in 1908, about "the so-called religious feeling I have for life," declaring that among the numerous paintings of the masters he had seen during his journey to Italy, his favourites were those by Fra Angelico and the Giotto frescoes in the Scrovegni chapel in Padua – the former exuding serene transcendental grace, and the latter an example of the fusion of religious feeling and terrestrial physicality, both with an expressive and operative essentiality that, in Matisse's opinion, was surpassed only by the Byzantine icons he saw in 1911.

The portraits Matisse painted in this period can also be interpreted in this key. They emphasize the persistence of the everyday imaginary world that Matisse subjects to continuous inventive re-elaboration. They also demonstrate how Matisse was moving away from Western artistic conventions through his rejection of one of the central aspects of post-Renaissance portraiture – the almost photographic realism of the representation, the recognition of the psychological and social condition of the person portrayed, and the exaltation of the person's individuality by revealing the impulses of their soul. Now this "absence" must not be interpreted as a loss on Matisse's part: his rejection of photographic precision meets his need to single out and underscore, among the various features in a face, those that are indispensable to the expression of the emotion not only of the model, but also of the artist and of the rapport established between the two. Once he had found these essential features, Matisse left a lot of space to memory or to what he himself called "the almost unconscious registration of the model," and it is these initial moments that set the tone for the entire work, in which the absence of psychology is thus replaced by the quest for expression, a procedure that is, significantly enough, similar to the one he followed in his great symbolic paintings. Matisse's "betrayal" of the real is always effected in the name of greater expressive depth and of meditation on the *raisons d'être* of painting and on the link between the exterior world and the world he re-creates on the surface of the canvas, through the decisive intervention of memory and imagination.

The Moorish Café, painted in 1913 after Matisse's trips to Tangier from 1911 on, represents the highest realization of the intuitions and influences that in 1910 had led to the creation of *Music*, to which this work is clearly connected both in its compositional structure and the overall

emotional tone employed. What differentiates the two canvases is the level of feeling and tension arising from the surface. The two most highly charged elements in *Music* are lacking in *The Moorish Café*: the violent contrast between the colours and the expressive intensity on the faces of the singers. The Moorish painting revolves totally around the play of tonalities that creates a sort of chromatic identification between the figures and the floor they are sitting on, an identification fortified by the colour of the bodies alluding to that of the vase in the foreground, and the transparency of the fish bowl which does not interrupt the chromatic unity of the floor. The sense of quiet idleness and suspension that pervades the entire surface is made possible most of all by the extraordinary invention of the absence of details that could in some way identify the figures; Matisse not only leaves out the features in the faces, but also renders the hands and feet (as well as the fish and flowers) as pure geometric form and chromatic quality. Such serenity and perfect harmony will be found again in his last paper cut-outs. What makes *The Moorish Café* unique is the fusion of the feeling of reality and pure pictorial invention, and Matisse's capacity – by means of a pictorial language that verges on decorative abstraction – to recreate the actual atmosphere, both physical and emotional, of a place, perhaps even of an entire culture.

Parallel to this, Matisse also developed the other main component of his research, which revolved around the theme of still lifes, an inexhaustible source of inspiration for him from the outset of his career. Decoration had come to play an increasingly central role in the still lifes, leaving its imprint on the realist genre *par excellence*, reaching the point of the literal invasion of space in *Harmony in Red*. Works such as *Still Life with Blue Tablecloth* (1909), *The Pink Studio*, *The Red Studio*, *Spanish Still Life* and *Interior with Aubergines* (all executed in 1911), *Calla Lilies, Irises and Mimosa* (1913), and, in another sense, the landscapes painted in Morocco in 1912, all confirm this tendency and their superb pictorial quality demonstrates that Matisse had reached full artistic maturity.

What immediately strikes one in these canvases is the wealth of forms and colours and the unending string of motifs that actually saturate the surface. This aspect appears even more evident, and alienating, when compared to the essentiality, the utter compositional parsimony of the coeval paintings of figures already discussed. Matisse takes two different, even antithetical, paths in order to achieve the same objective, to free painting once and for all from its imitative nature. The paths he took were the abstract, symbolic synthesis of forms and colours, and the profusion, or even exasperating overabundance, of the same elements, once again with the aim of making them almost nonrepresentational. Whereas the human figure can lend itself to being transformed into a decorative motif only through the gradual linear reduction of the body, the same ornamental motif is already present in the very nature of the objects Matisse has chosen to depict and hence must be accentuated in order to reach the level of abstraction he is trying to achieve. What these canvases have in common, besides the subject, is their development on the surface, Matisse's explicit rejection of three-dimensionality; this is the crucial transition from realist poetics to a decorative aim. The masterpiece of this period, *Interior with Aubergines*, is exemplary in this regard as it not only treats a realistic object in a decorative key, but is a veritable *tour de force* of the theme of analogies. Only two examples will suffice to clarify this procedure. There is the echo between the wallpaper and the floor, the "stamped" fabric on the screen and the flowers in the corner of the fireplace; then there is the chromatic analogy between the vase with flowers, the pears, the stems of the aubergines and a part of the landscape seen through the window. These analogies, together with other less obvious ones between the different elements in the painting, are the pictorial achievement of a thought that always inspired Matisse's oeuvre, which he described as follows: "There are two ways of expressing things. One is to show them crudely, and the other is to evoke them through art. By removing oneself from the literal representation of movement one attains greater beauty and grandeur. In order to succeed in this, I try to come close to these objects, define their specific character and the interrelations of their components; these interrelations exist both among the combinations of colours and among the combinations of forms."

The Pink Studio and *The Red Studio* (both executed in 1911), can be placed at the meeting point of the two above-mentioned approaches to eliminate the imitative in art. These canvases belong to the category of interiors and, broadly speaking, of still lifes. They are so charged with weighty symbolic significance as to be precise declarations of poetics: the very image of the studio, which is a metaphor of the personality and existence of the painter through the place in which he creates; the replicas of Matisse's works, which are a sort of catalogue of beloved objects and at the same time figures of passing time; the mirror effect created by the same paintings within a painting – which frequently recurs in Matisse to reaffirm that the canvas belongs to the real world and is an object among objects; the "real" still life at left in *The Red Studio* and the composition in the middle of *The Pink Studio*, which are other, more ambiguous examples of paintings within a painting; and lastly, the unifying element of these two works – the colour, which, beginning with the very title, is the true all-embracing protagonist that sets the tone for the entire surface.

If one accepts this interpretation of these works as declarations of an aesthetic, the position colour occupies in a hypothetical scale of values of this artist is evident. All the works Matisse executed in this period confirm the supremacy of colour.

112

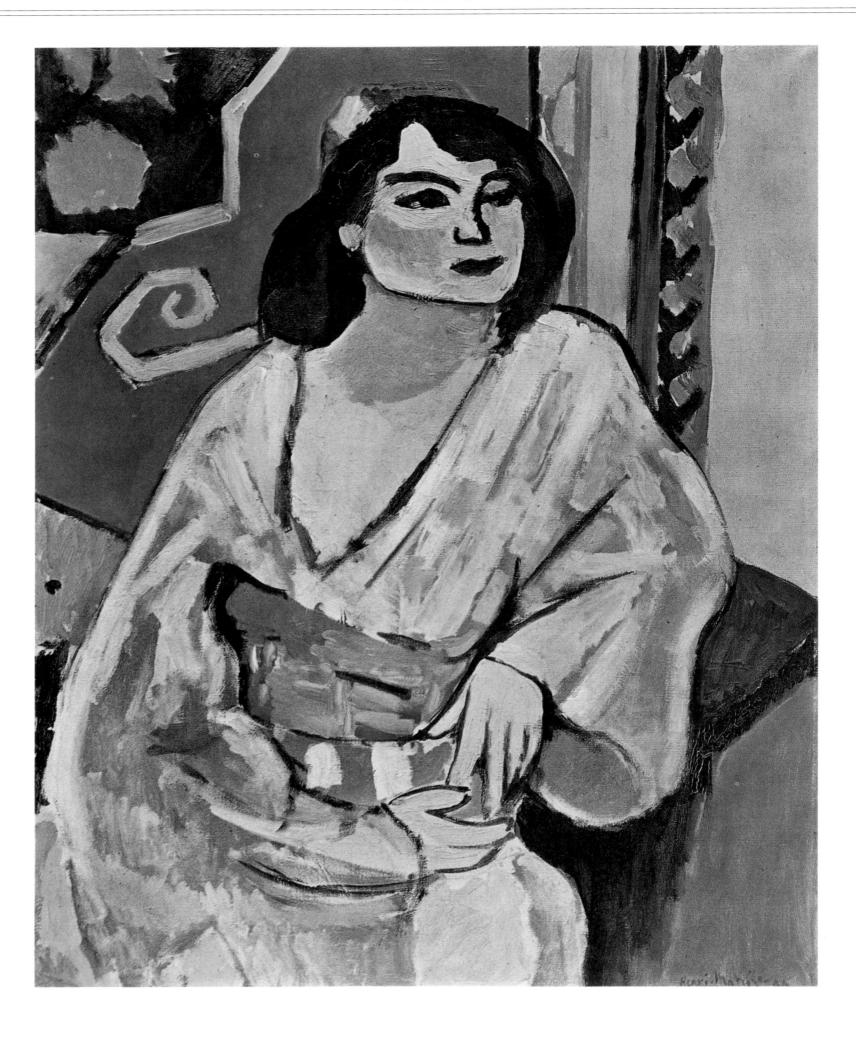

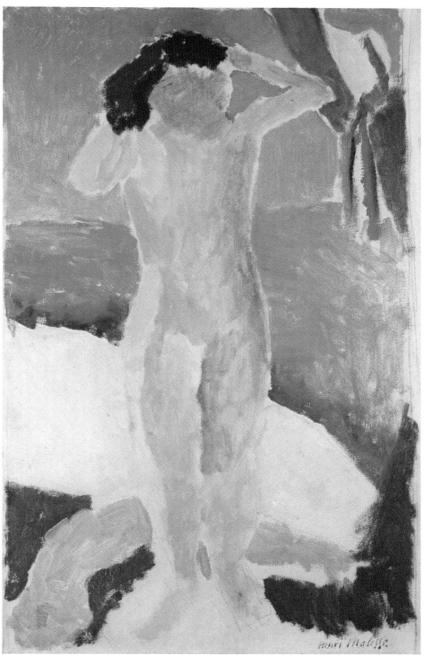

Opposite: Algerian Woman, *Paris, Hôtel Biron, spring 1909; oil on canvas; 81 × 65 cm (31⅞ × 25½ in); Musée National d'Art Moderne, Centre Georges Pompidou, Paris. Matisse made several journeys to Algeria, which provided him with motifs and especially formal elements that were decisive to the development of his vision.*

Above left: Portrait of Pierre, *Cavalière, summer 1909; oil on canvas; 41 × 33 cm (16⅛ × 13 in); Private Collection. Born in Bohain in 1900, Pierre Matisse spent his childhood at Toulouse, and then studied at Noyon and Vanves, later becoming one of the best known art gallery owners in the period between the two World Wars.*

Above right: Nude by the Sea, *Cavalière, Cavalière, 1909; oil on canvas; 46.5 × 29 cm) 18 × 11¼ in); whereabouts unknown.*

Above: Barbizon,
*Barbizon, 1909; oil
on canvas; 73 × 50 cm
(28 × 19½ in); Private
Collection. Depicting
one of the most
historic sites of
nineteenth-century*

*painting, this work is
a highly original re-
elaboration of
impressionist tones
in which the subject is
totally dominated by
colour.*

Opposite: Still Life
with an African
Statuette, *Paris (?),
1908–9; oil on
canvas; 105 × 70 cm
(40 × 27 in); Private
Collection. The
statuette in this*

*painting dates from
the nineteenth
century and belonged
to Matisse, whose
collection of African
art included some
noteworthy sculpture
pieces.*

116

Still Life with "The
Dance," *Issy-les-
Moulineaux,
autumn–winter 1909;
oil on canvas;
87 × 116 cm (35 × 45⅝
in); Hermitage*

*Museum, St
Petersburg. The motif
of the painting within
a painting runs
throughout Matisse's
oeuvre from this
period onwards.*

Still Life with Blue
Tablecloth, *Paris,
Hôtel Biron, end
1908-beginning
1909; oil on canvas;
88 × 118 cm
(34³/₈ × 46¹/₂ in);
Hermitage Museum,
St Petersburg. Once*

*again the subject is a
still life, but the
invasion of the
decorative element
obliges the onlooker to
interpret it in a
totally untraditional
key.*

118

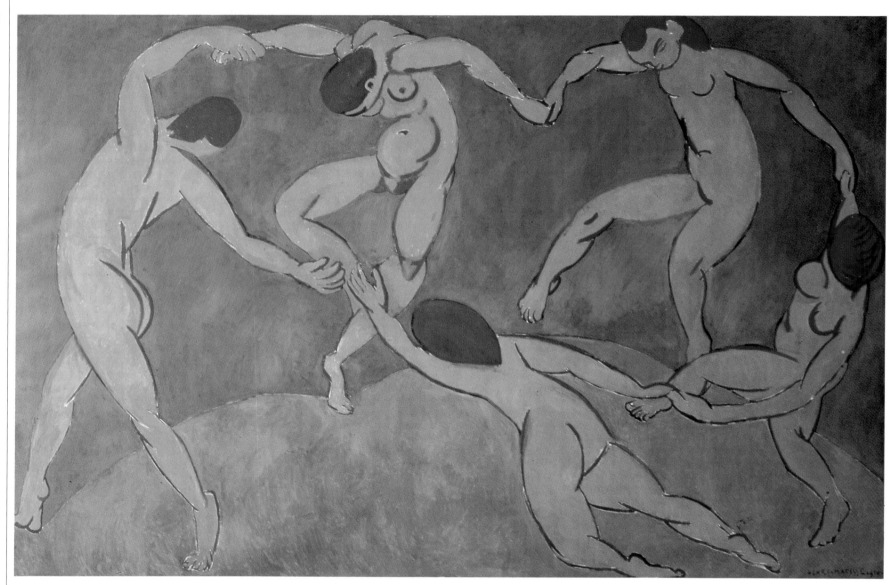

The Dance, *Issy-les-Moulineaux*, 1909–10; oil on canvas; 260 × 391 cm (102½ × 154½ in); Hermitage Museum, St Petersburg. This is, arguably, Matisse's most famous work and is certainly one of the most well known paintings of the twentieth century. It was commissioned by the Russian art collector Sergei Shchukin to decorate his home in Moscow.

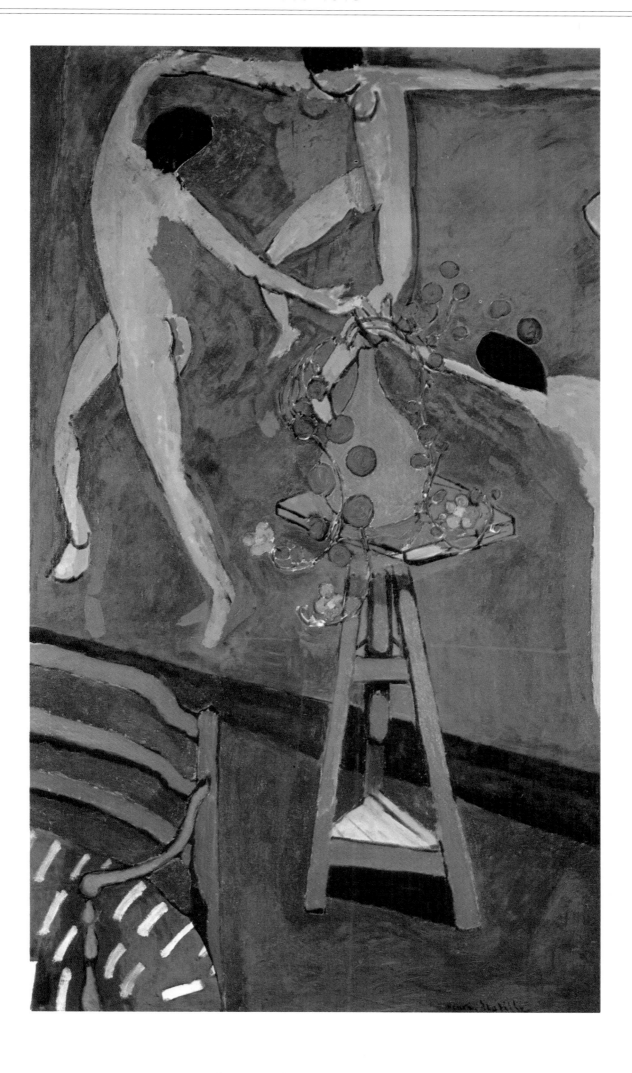

Nasturtiums and "The Dance II," *Issy-les-Moulineaux, spring-summer 1912; oil on* *canvas; 190.5 × 114.5 cm (74¼ × 44¾ in); Pushkin Museum of Fine Arts, Moscow.*

120

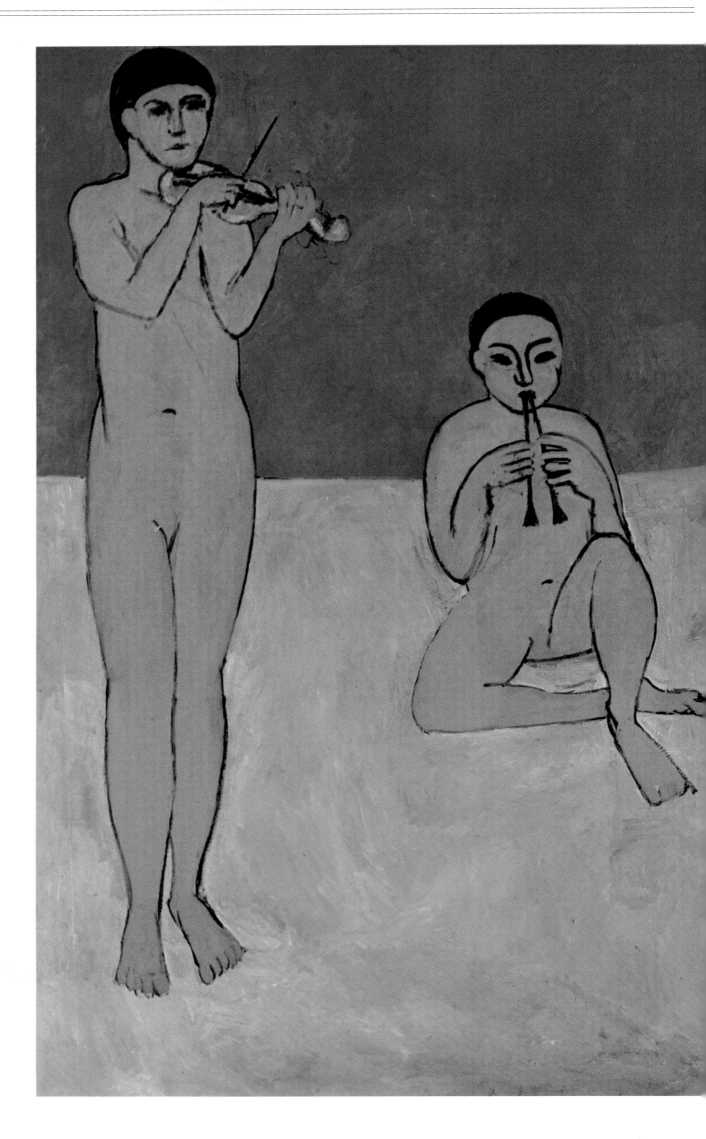

Music, *Issy-les-Moulineaux, end 1909-beginning 1910; oil on canvas; 260 × 389 cm (102¼ × 153 in); Hermitage Museum, St Petersburg. This work was also commissioned by Sergei Shchukin as the second part of a diptych (the first part being* The Dance) *that can be considered the synthesis of the various images of the Golden Age that Matisse painted in this period.*

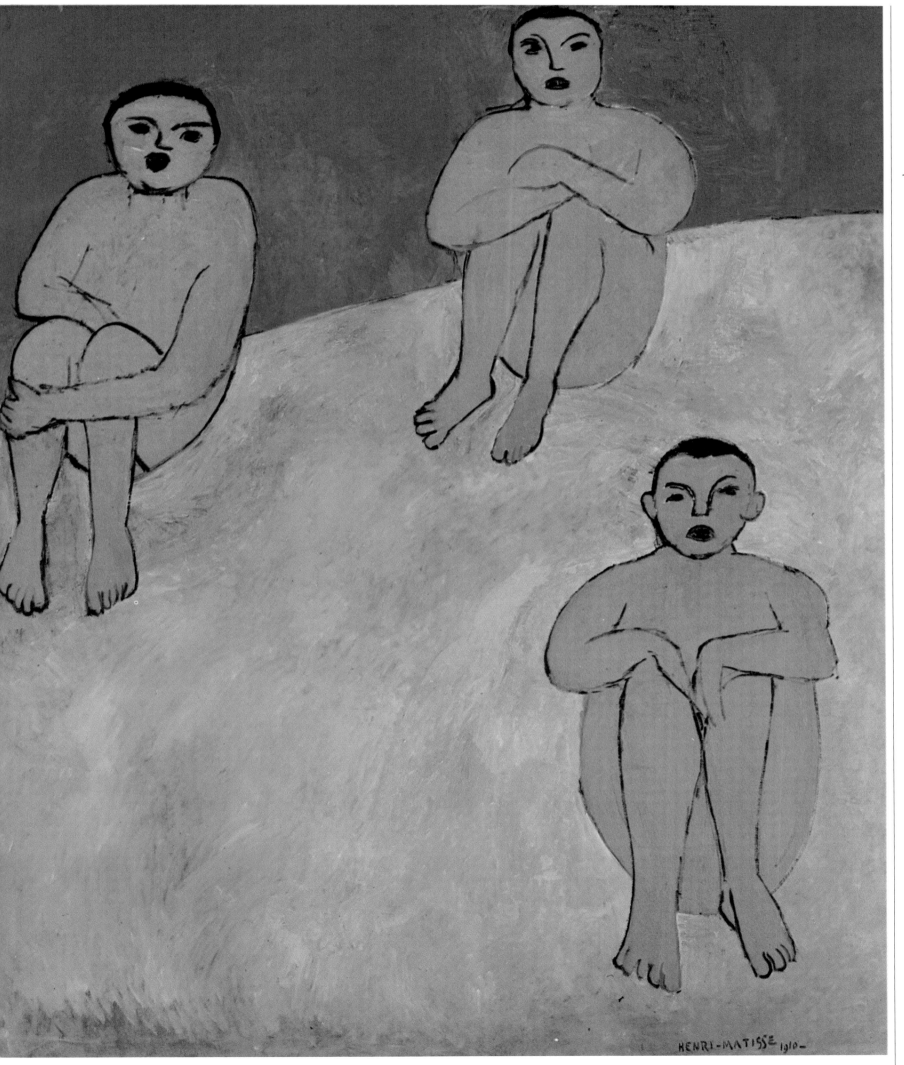

122

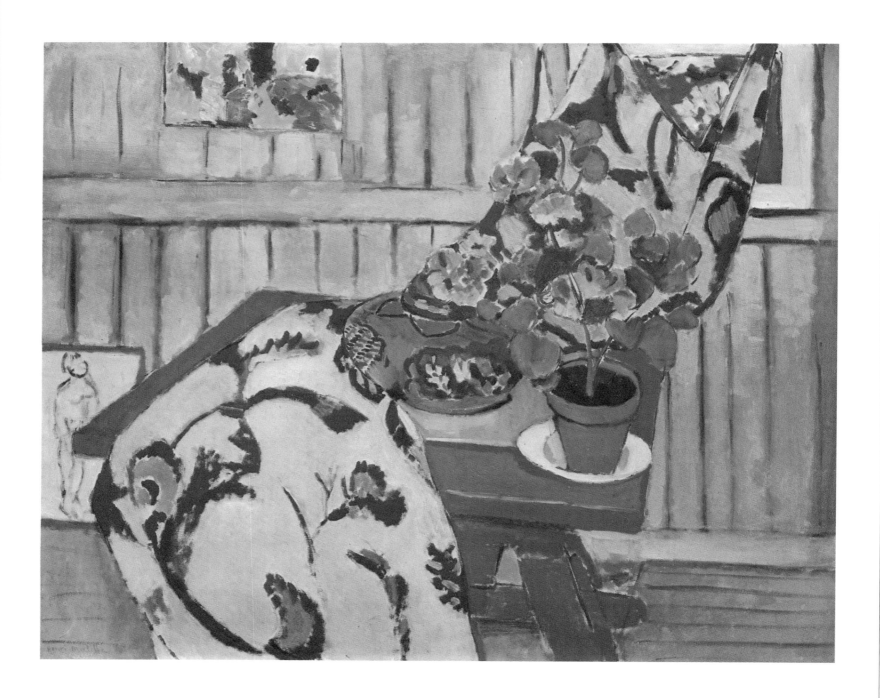

Above: Still Life with Geraniums, *1911; oil on canvas; 94.5 × 116 cm (36¾ × 45½ in); Neue Pinakothek, Munich. Note the flow of the tablecloth and* the perspective of the table, which bear witness to Matisse's concern at this time with the rendering of three-dimensional space. *Opposite:* Moroccan Landscape, Tangier *(?), 1911; oil on canvas; 116 × 81 cm (45¼ × 31½ in); Moderna Museet,* Stockholm. "My trips to Morocco have put me in more direct contact with nature [..]," Matisse wrote.

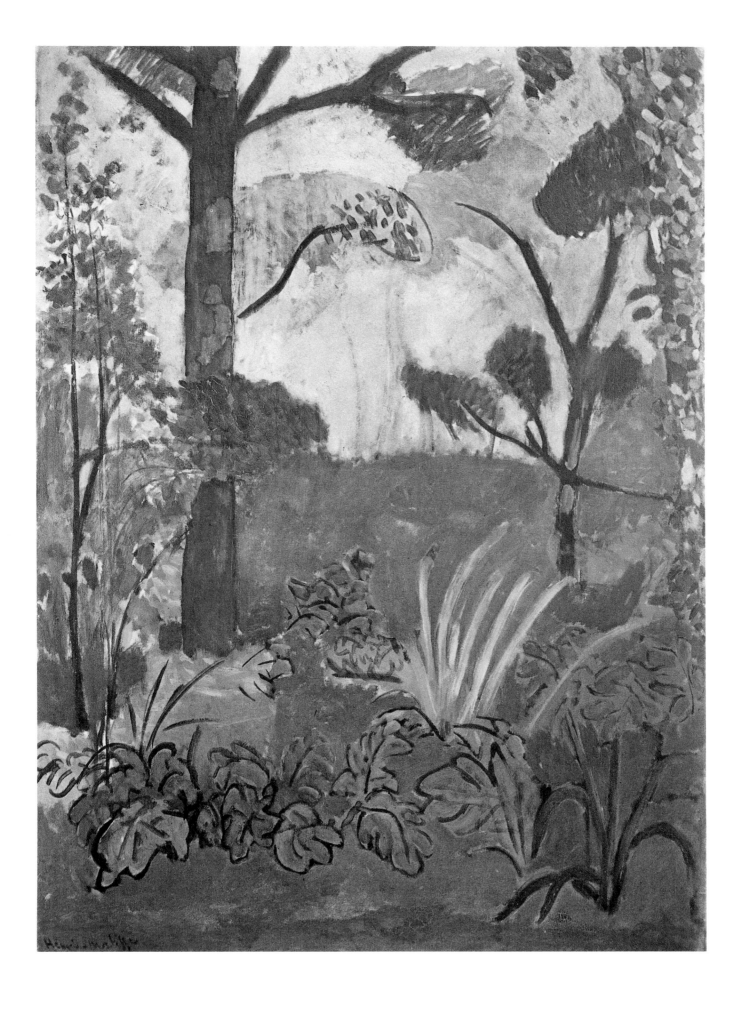

124

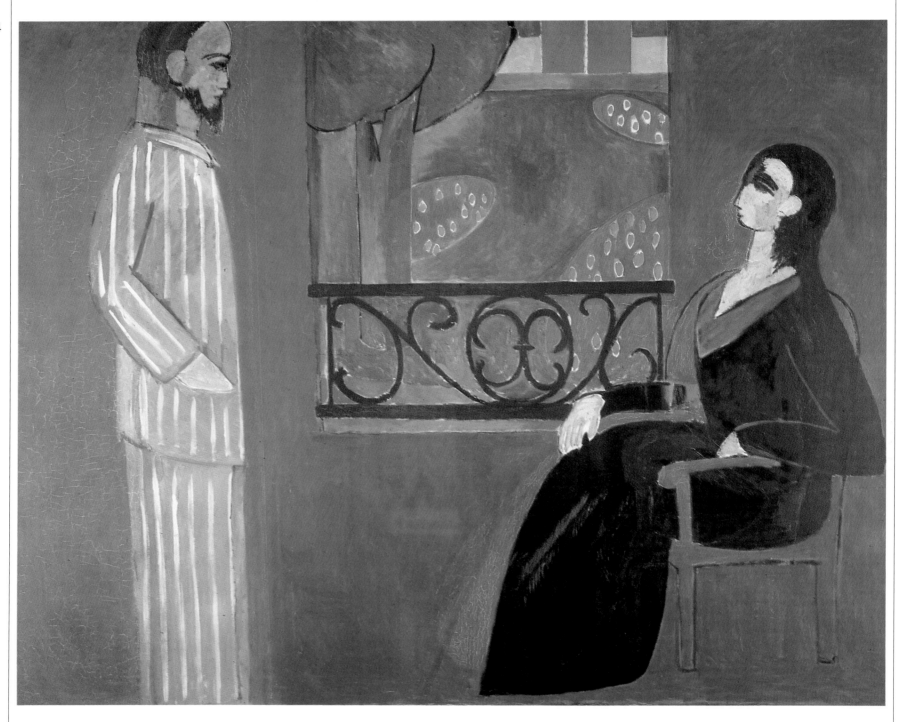

Above: The
Conversation, *Issy-les-
Moulineaux, 1911; oil
on canvas; 177 × 217
cm (69⅓ × 85½ in);
Hermitage Museum,
St Petersburg.*

Opposite: Goldfish and
Sculpture, *Issy-les-
Moulineaux, spring-
summer 1911; oil on
canvas; 116.2 × 100.5*

*cm (46 × 39⅝ in);
Museum of Modern
Art, New York, gift of
Mr and Mrs John Hay
Whitney.*

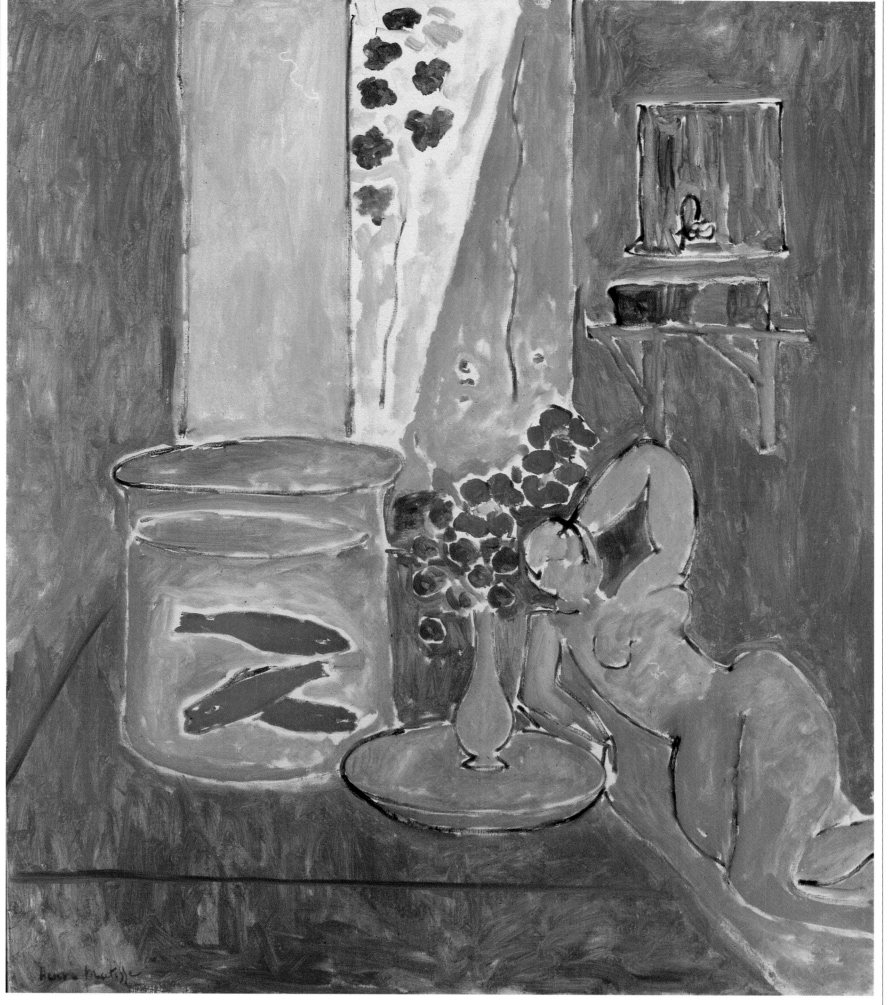

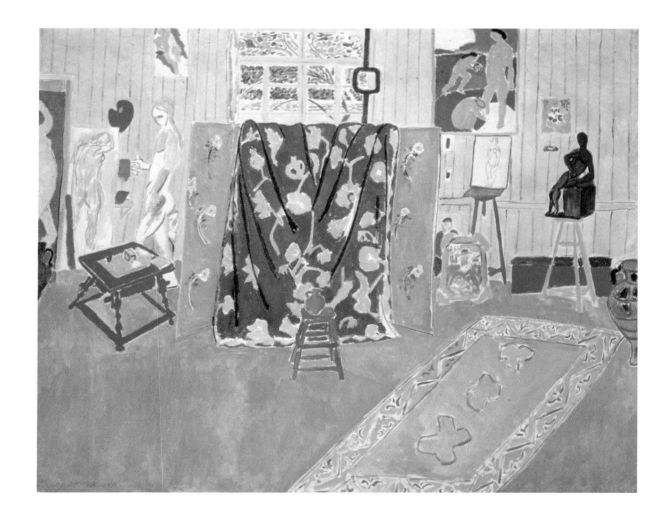

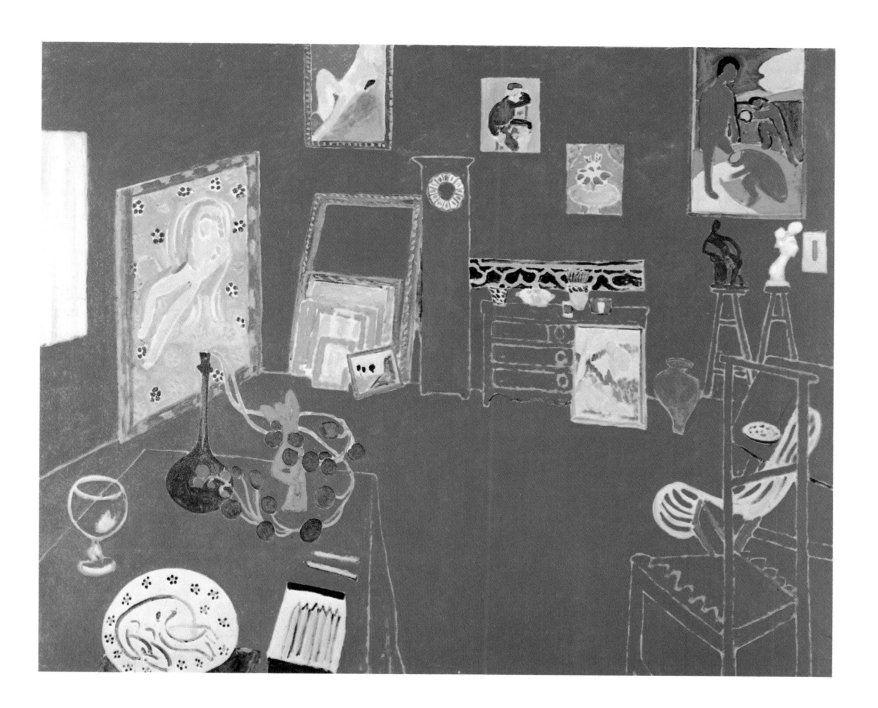

Opposite above: Flowers and Ceramic Plate, *Issy-les-Moulineax, spring-autumn 1913; oil on canvas; 93.5 × 82.5 cm (36¾ × 32½ in); Städelsches Kunstinstitut, Frankfurt.*

Opposite below: The Pink Studio, *Issy-les-Moulineaux, autumn 1911; oil on canvas; 179.5 × 221 cm (70⅝ × 87 in); Pushkin Museum of Fine Arts, Moscow.*

Above: The Red Studio, *Issy-les-Moulineaux, autumn 1911; oil on canvas; 181 × 219.1 cm (71¼ × 86¼ in); Museum of Modern Art, New York, Mrs Simon Guggenheim Fund. The two studios can be considered self-portraits of the artist because his* paintings are represented in the very place in which they were created. Note Matisse's extraordinary capacity to render space without utilizing the canonical elements of perspective.

128

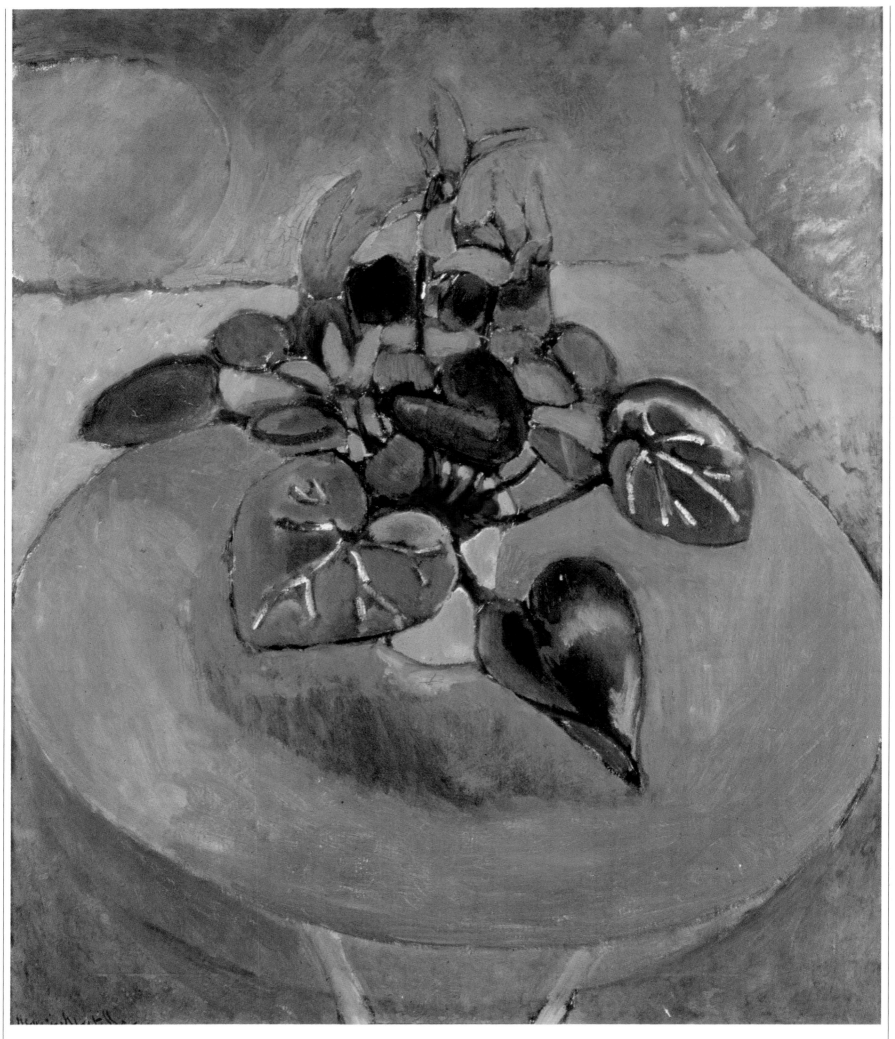

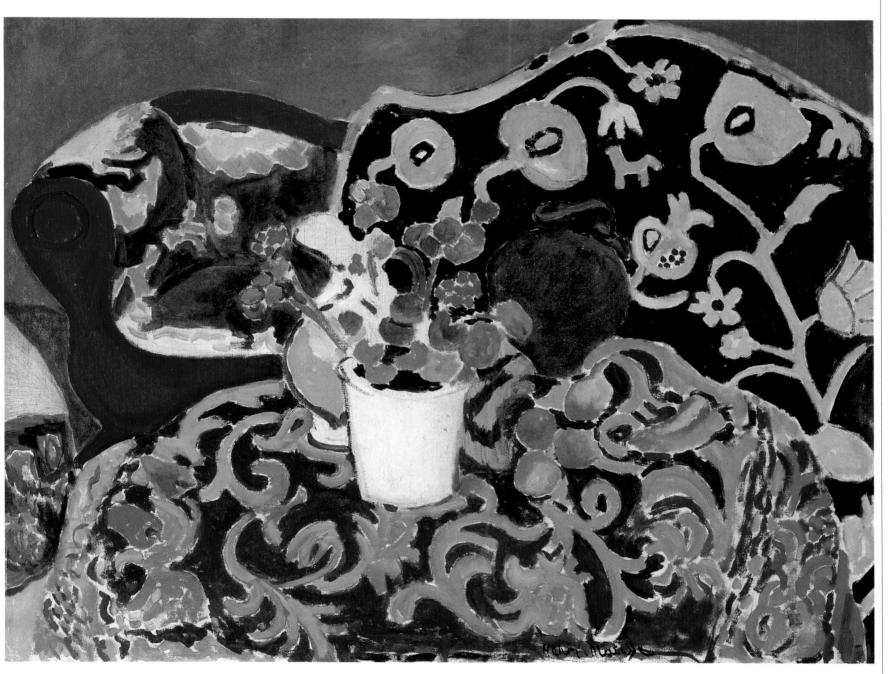

Opposite: Purple Cyclamen, *Issy-les-Moulineaux, early 1911 and spring 1912 or 1913; oil on canvas; 73 × 60 cm (28¾ × 23⅝ in); Private Collection.*

Above: Spanish Still Life, *Seville, winter 1910–11; oil on canvas; 89 × 116 cm (35 × 45⅝ in); Hermitage Museum, St Petersburg. In late 1910-early 1911 Matisse worked in a studio in Seville.*

130

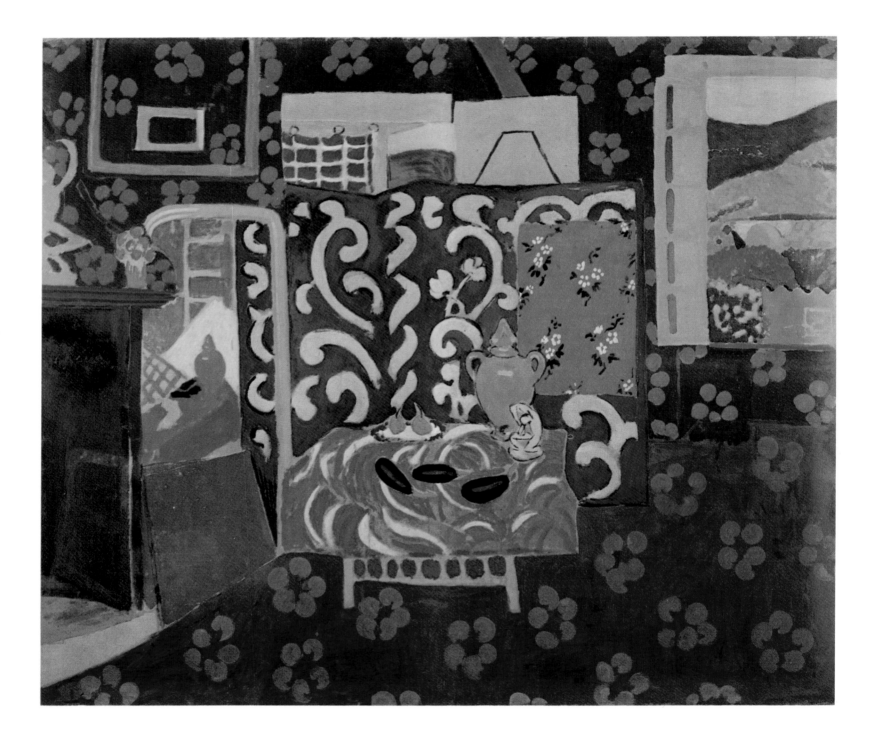

Interior with Aubergines, *Collioure, summer 1911; distemper on canvas; 212 × 246 cm (82⅜ × 96⅞ in); Musée des Beaux-Arts, Grenoble. Note how the objects lose their substance, transforming themselves into pure colour without interrupting the decorative continuity of the work. Matisse donated this painting to the Grenoble Museum in 1922.*

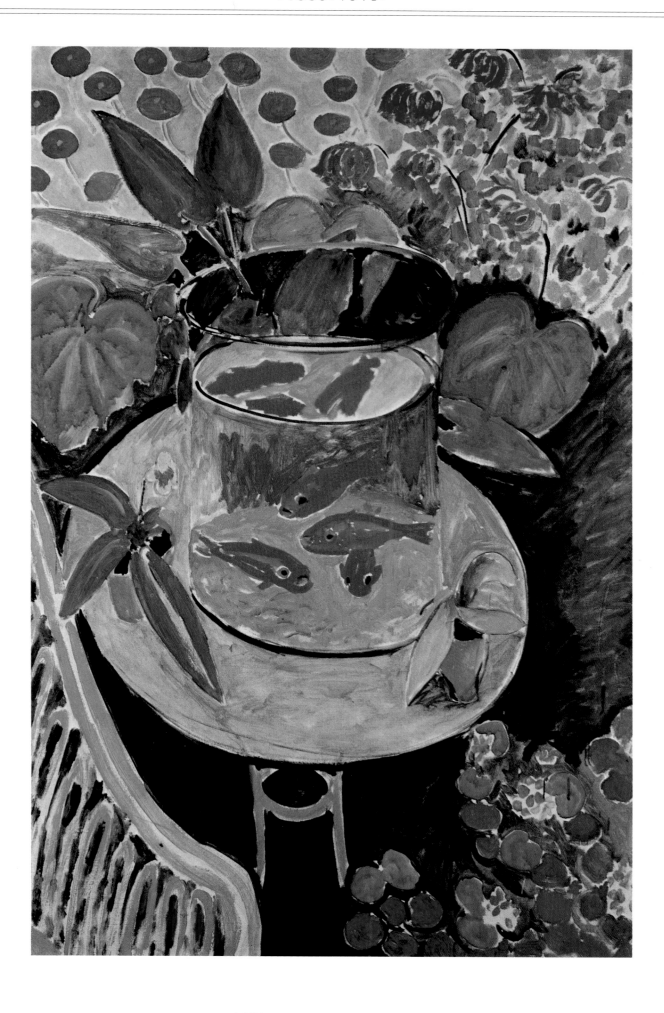

Goldfish, *Issy-les-Moulineaux, spring-summer 1912; oil on canvas; 147 × 98 cm (57½ × 38⅝ in); Pushkin Museum of Fine Arts, Moscow. The motif of the fish bowl allows* Matisse to delve into the relationships of light among the objects, the transparency and reflections it produces, and the images created by these.

132

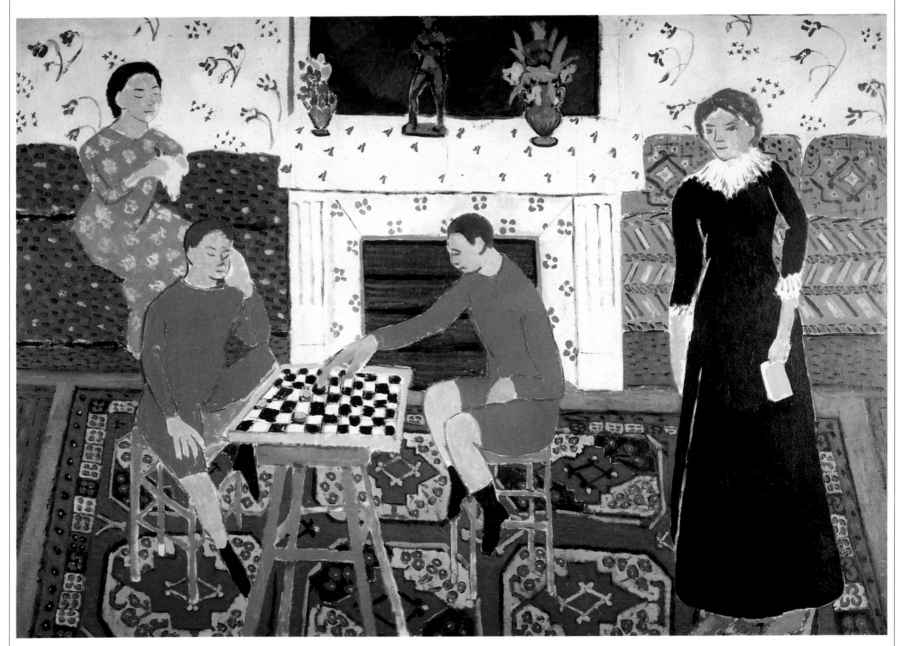

The Painter's Family,
Issy-les-Moulineaux,
spring 1911; oil on
canvas; 143 × 194 cm
(56¼ × 76⅜ in);
Hermitage Museum,
St Petersburg.
Matisse's family (his
wife and three
children, Pierre, Jean
and Marguerite)

functions here as
another decorative
motif within the
composition, as can
be clearly seen in the
figure of Marguerite
on the left, whose
dress is perceived
solely as a fabric
without a body
inside.

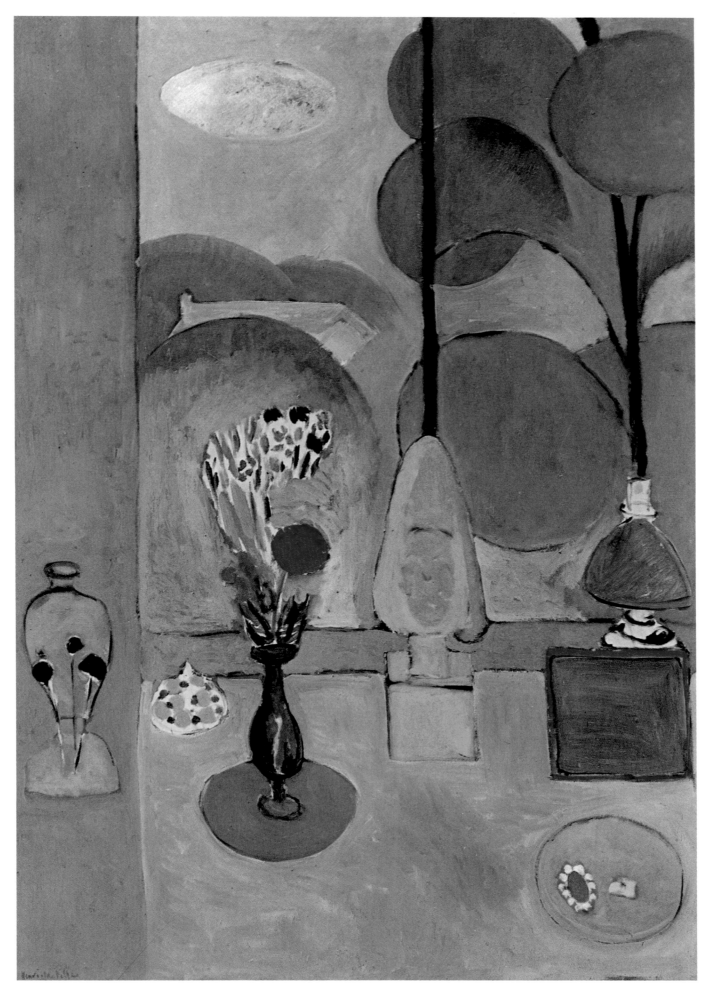

The Blue Window,
Issy-les-Moulineaux,
summer 1913; oil on
canvas; 130.8 × 90.5
cm (51½ × 35⅝ in);
Museum of Modern
Art, New York, Abby
Aldrich Rockefeller
Fund. As in the
preceding studies
and the windows that
were to follow this
work, the primacy of
colour penetrates the
very essence and
sense of the
composition. The tree
on the right is a clear
reference to
analogous synthetic
renderings of nature
that were
characteristic in this
phase of Matisse's
development.

134

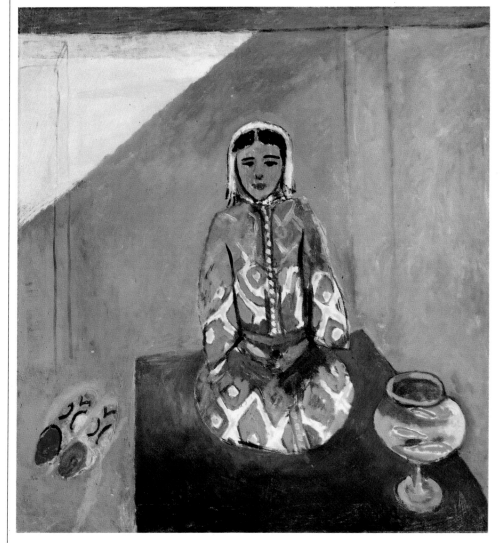

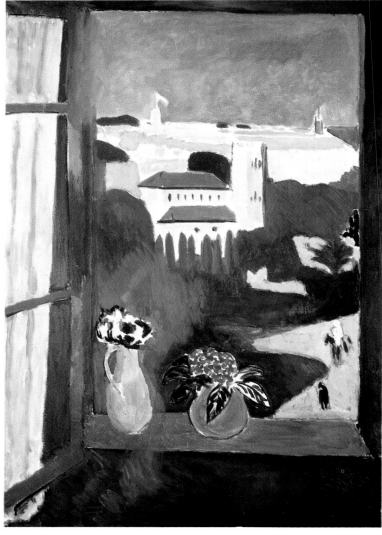

Above left: Zorah on the Terrace, *Tangier, winter 1912–13; oil on canvas; 115 × 100 cm (45¼ × 39⅜ in); Pushkin Museum of Fine Arts, Moscow. Matisse wrote of this painting to his friend Camoin: "I wanted to do a decorative work, and I really think it is one; but I would have liked it to be even more so."*

Above right: Window at Tangier, *Tangier, spring 1912; oil on canvas; 115 × 80 cm (45¼ × 31½ in); Pushkin Museum of Fine Arts, Moscow. Executed during one of his stays in Tangiers, this view takes up a motif Matisse was very fond of, in which he works out the relationship among the objects and among the colours that were a hallmark of his entire oeuvre.*

Opposite: Fatmah the Mulatto, *Tangier, 1913; oil on canvas; 147 × 61 cm (57¼ × 23¾ in); Private Collection. Pierre Schneider comments on the figure paintings of this periods as follows: "While the costumes of his models spread out in bright colours, their heads are effaced in neutral ocher, in a near-absence of expression."*

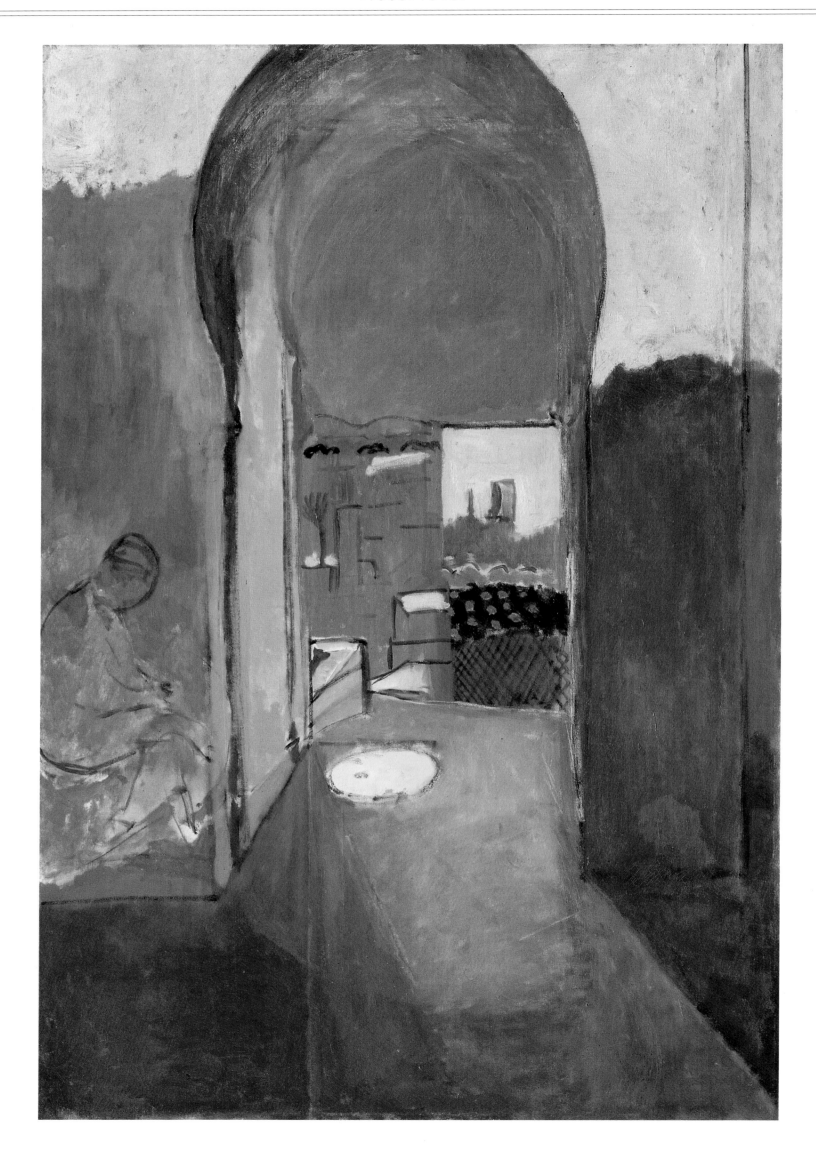

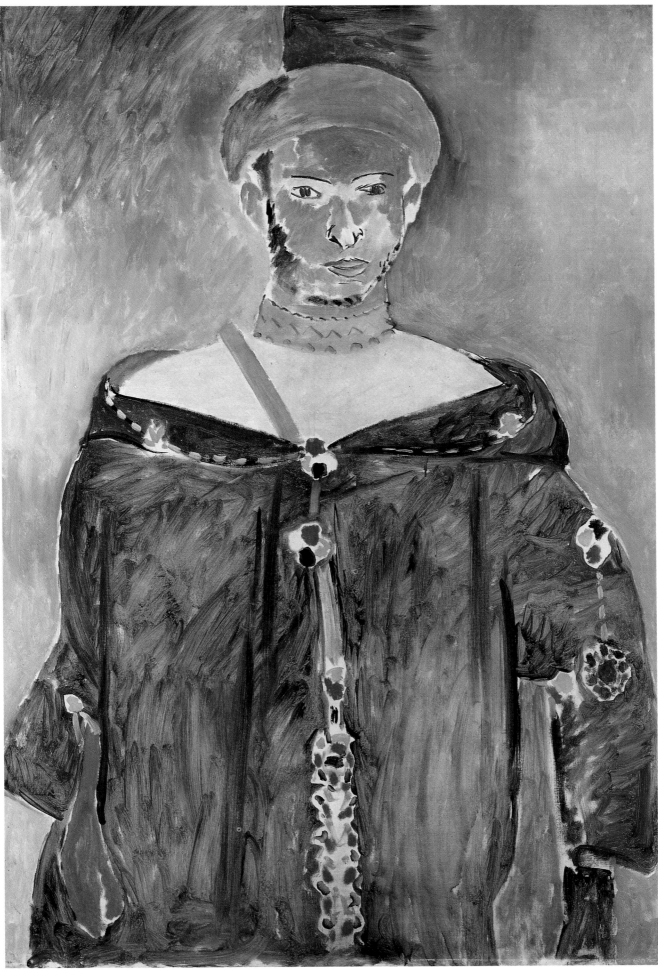

Opposite: Entrance to the Casbah, *Tangier, winter 1912–13; oil on canvas; 116 × 80 cm (45⅝ × 31½ in); Pushkin Museum of Fine Arts, Moscow. This work, together with* Window at Tangier *and* Zorah on the Terrace, *was once part of the Russian Morosov's collection. The three paintings make up Matisse's "Moroccan triptych," one of the high points of his production.*

Opposite: The Standing Riffain, *Tangier, late 1912; oil on canvas; 146.5 × 97.7 cm (57⅝ × 38½ in); Hermitage Museum, St Petersburg. Note how the decoration of the tunic plays the same role as the floral motifs in Matisse's still lifes with vases.*

Left: Moroccan Garden – Periwinkles, *Tangier, 1912; oil on canvas; 116.8 × 82.5 cm (46 × 32¼ in); Museum of Modern Art, New York, gift of Florene M. Schoenborn.* "We're enjoying fine weather and the vegetation, which is truly luxuriant. I've begun to work and am not too displeased with it, though it is difficult. The light is so soft, it's quite different from the Mediterranean." *(Matisse in a letter to* Camoin in 1912).* "I found the landscapes of Morocco just as they had been described in the paintings of Delacroix and in Pierre Loti's novels. One morning in Tangier I was riding in a meadow; the flowers came up to the horse's bridle. I wondered where I had already had a similar experience – it was in reading one of Loti's descriptions in his book* Au Maroc.*" *(Matisse in 1951).*

Right: Palm Leaf, Tangier, *winter-spring 1912; oil on canvas; 117.5 × 81.9 cm (46¼ × 32¼ in); National Gallery of Art, Washington D.C., Chester Dale Collection.*

Open Window at
Tangier, *Tangier,
1913; oil on canvas;
145×94 cm
(56½×36½ in);
Private Collection.*

140

Left: Calla Lilies, Irises and Mimosas, *Tangier, early 1913; oil on canvas; 145.7×97 cm (57¼×38¼ in); Pushkin Museum of Fine Arts, Moscow.*

Right: Basket of Oranges, *Tangier, spring-winter 1912; oil on canvas; 94×83 cm (37×32⅝ in); Musée Picasso, Paris.*

This work, part of Picasso's private collection which included a wealth of canvases, gouaches and drawings, is now kept in the Picasso Museum in Paris. Among these works are some masterpieces by Matisse such as Marguerite *(1906) and* Tulips and Oysters on a Black Background *(1943).*

The Moorish Café, Tangier, 1912–13 and/or Issy-les-Moulineaux, spring 1913; distemper on canvas; 176 × 210 cm (69¼ × 82⅝ in); Hermitage Museum, St Petersburg. This painting can be considered the ideal conclusion of the Golden Age triptych Matisse began in 1910 with The Dance and Music by elaborating upon the elements of his earlier La joie de vivre. The sense of ease and idleness, a theme typical of the Golden Age, is here depicted in the exotic colours of an Orient that is transfigured to the point of becoming a sort of state of mind expressed by means of colour.

The Confrontation with other Avant-Garde Art

142

View of Notre-Dame, French Window at Collioure and *The Yellow Curtain* are the inevitable result of the process that Matisse pursued in the early 1910s of paring down form to make it essential and of emphasizing the primary role of colour in the creation of the expressive tone of his oeuvre. A merely superficial reading of these three works executed in 1914 might lead one to consider them a demonstration of how Matisse was avoiding any direct confrontation with reality and of his turning to a purely abstract aesthetic quite close to the tendencies rapidly spreading throughout European art in the wake of Kandinsky's first experiments in this direction in this same period. However, a careful analysis of these paintings and of the very meaning of the word "abstraction" will immediately confute this hypothesis. We have already seen how Matisse's research tended to render objective data in an extremely synthetic manner, leaving the onlooker the task of completing them by means of imagination, feeling and memory. This is therefore a process which always has as its inevitable starting point the external world and which – both through adding or removing elements – can attain a final configuration in which the formal and expressive order prevails over the purely descriptive, narrative one.

What links Matisse's work with that of the historical abstract artists is the affirmation of the autonomy of artistic creation from any sort of imitative procedure and its constituting itself as a language that adheres to its own rules, the only ones the artist must obey. What irreconcilably differentiates the two approaches is their attitude towards external reality, which disappears from the speculative horizon of abstract painting and is replaced by forms and colours the meaning of which lies totally in themselves, without any reference to the "outside world." Therefore these three works should be approached from this viewpoint, bearing in mind that they all employ the same figurative "pre-text" – the image of the window. This is a recurring motif in Matisse's oeuvre and poetics and deserves special attention, both as concerns the way it appears in his works and the meaning it takes on in his overall approach to reality and its pictorial translation. The window is a natural frame in which a portion of reality is set and in the realist tradition represents the very metaphor for painting, which is understood in fact as a "window looking on to the world." At the same time the window is a filter separating the interior from the exterior world, the artist's arena from that of nature, and therefore lends itself to reflection that affects the very bases

of Matisse's aesthetic on various levels. It is certainly no accident that in his cardinal works, from *Harmony in Red* to *Interior with Aubergines*, Matisse uses the window as the conceptual pivot of the composition. By means of windows the landscape enters the scene and becomes a part of the still life, so that a single image sums up the antithetical aims and destiny of painting. By means of the window the landscape is presented to the onlooker as a framed entity that thus belongs to the domain of painting even more than it does to the world of nature. The window is one of the main expedients – and on a visual level perhaps the most evident one – that Matisse uses to formulate his conception of the basic autonomy of the painted image without, however, failing to reaffirm its link with the world of objects and forms known through our visual experience. All these elements are to be found in the three 1914 paintings and lead to the maximum stage of the invention of form, the two-dimensionality of the surface and the expressive quality of colour: the reformulation of reality in an intellectual key is wedded to the emotional intensity of the chromatic sensation in an extreme definition of the painting surface as a field in which to experiment with and re-invent the world through painting.

This is truly the maximum Matisse

attained in his quest for balance between intellect and feeling; this balance is epitomized and sustained in the first place precisely by the multiple registers of colour, which by this time had become the expressive focal point around which the entire sense of the composition revolved.

This simplification of his means would probably have led Matisse in a short time to deal with the theme of pure abstraction; if this did not occur it is because his work was so solidly anchored to a classical vision of the work of art that it did not allow him to relinquish totally the prime mover of pictorial creation, that is, the confrontation with objective reality. Such a confrontation, after the decorative experience of the preceding years and the radical formal changes he made in 1914, could no longer take place on the basis of the Fauve and Symbolist poetics that had marked the breaking point with the imitative convention of Western art: these poetics had been absorbed and at the same time surmounted exactly by Matisse's most recent artistic experiments. He therefore had to return to the roots of his creative career without abandoning the accomplishments he had made in the meantime.

Two thoughts Matisse expressed may help us to understand his mood at the

time, the path his painting took from 1914 to 1917, and the atmosphere in Paris in those years, which was throbbing with extraordinary intellectual fervour and artistic experimentation. "A great modern accomplishment is to have found the secret to expression by means of colour, to which has been added, with what is called Fauvism and with the movements that followed, expression through drawing; outline, lines and their direction. In the main, tradition was carried forward by new mediums of expression and augmented as far as was possible in this direction. It would be wrong to think that there has been a break in the continuity of artistic progress from the early to the present-day painters. In abandoning tradition, the artist would have only a fleeting success and his name would soon be forgotten."

Matisse's view of the continuity of artistic development testifies to the central role always played by the past in Matisse's aesthetic, even when his oeuvre might appear to deny those values. Matisse sought to regenerate these values and prune away the rhetorical and descriptive aspects that were obscuring their true pictorial and ideal worth. This is confirmed by the attention Matisse paid to the tools of his craft, by his interpretation of the innovations of the first years of this century as the expressive liberation of colour and drawing.

Matisse described the heart of the problem he faced in this period thus: "Cubism is the descendant of Cézanne, who used to say that everything is either cylindrical or cubical. In those days we were not imprisoned in uniforms, and a bit of boldness that could be found in a friend's picture, belonged to everybody. Cubism had a function in fighting against the deliquescence of Impressionism. The investigation of the plane carried out by the Cubists depended on reality. In the case of a lyric painter, however, it depends on the imagination. It is the imagination that lends space and depth to a picture. The Cubists forced on the spectator's imagination a rigorously defined space between each object. From another point of view, Cubism is a sort of descriptive realism."

These few lines contain all the elements we need to understand works such as *The Moroccans, Bowl of Oranges, Gourds, Bathers by a River* and *The Piano Lesson*, all executed in 1916, in what is commonly called Matisse's "Cubist" period. It was above all a return to Cézanne, to his intellectual reconstruction of reality, his creation of space that makes use of geometric figures in order to reduce structural elements and then transfer them on to reality. The echo of Cézanne was a constant feature and reference point during the critical moments of Matisse's artistic endeavour. He realized he had to return to the roots of his aesthetic because Cézanne's oeuvre confronts all the aspects of what Matisse himself called "the pictorial problem."

Alongside this towering figure is the Cubist structure of breaking down the painting into planes determined by drawing, in the attempt to render the image known by the intellect and by pre-existing ideas rather than the one perceived by the eye. It is important in this regard to note how Matisse refers to Cubism as an antidote not to Impressionism, but to its decadence, and how he fully grasps the substantial realism of Picasso and Braque's Cubist works. These considerations clearly reveal that the example of Cubism was useful to Matisse in that it allowed him once again to confront reality, without its gaining supremacy over the imagination, and without his abandoning his conception of a space that is invented and suggested both emotionally and chromatically and which resides in the decorative tradition.

The works executed in 1916 testify to the compromise Matisse was able to evolve: the simplification of form is accompanied – especially in works depicting figures such as *The Moroccans, The Piano Lesson* and *Bathers by a River* – by considerable articulation of space within the painting which, in *Variation on a Still Life by De Heem*, actually becomes an exercise on the creation of planes within a painting surface.

The way in which these problems are resolved in works such as *Gourds, Bowl of Oranges* and *The Rose Marble Table* appears to be different. Here the articulation of space is effected through the weight given to the forms and colours in the composition. In these cases this is not a question of creating planes by means of drawing, but of inventing space by means of light, a characteristic that was to become the core of Matisse's later work.

The works painted in 1916–17 can thus be considered the conclusion of Matisse's first, lengthy experimental phase, the origins of which date from the beginning of the century. This phase coincides with the heroic period of the avant-garde movements, one of whose leading figures was certainly Matisse himself.

The works that were executed in the period between the two World Wars represent the crystallization of the extraordinary achievements and innumerable subjects of inspiration and meditation that Matisse realized in the previous period and their transposition into his new system of representation.

144

View of Notre-Dame,
Paris, 19 quai Saint-
Michel, spring 1914;
oil on canvas;
147.3 × 94.3 cm

(58 × 37⅛ in);
Museum of Modern
Art, New York,
acquired through the
Lillie P. Bliss Bequest

and the Henry
Ittleson, A. Conger
Goodyear, Mr and
Mrs Robert Sinclair
Funds, and the Anna

Erikson Levene
Bequest given in
memory of her
husband, Mr Phoebus
Aaron Leven.

French Window at
Collioure, *Collioure,
winter 1914; oil on
canvas; 116.6 × 89 cm
(45⅞ × 35 in); Musée*

*National d'Art
Moderne, Centre
Georges Pompidou,
Paris. In order to
understand how far*

*Matisse's artistic
quest led him, we
need only compare
these two works with
the views from*

*windows he painted
at the beginning of
the century.*

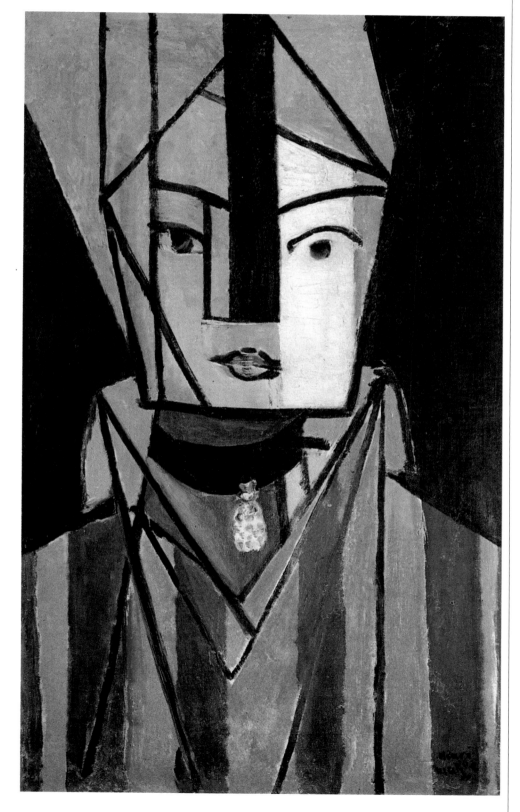

Opposite: The Yellow Curtain, *Issy-les-Moulineaux, c. 1915; oil on canvas; 146 × 97 cm (57½ × 38⅛ in); Stephen Hahn Collection, New York. This is one of Matisse's most radical paintings, which is based on the extraordinary interaction between colour and form and in which the narrative element is totally lacking.*

Above: Greta Prozor, *Paris, 19 quai Saint-Michel, autumn-winter 1916; pencil; 55 × 36 cm (21½ × 14 in); Private Collection.*

Right: White and Pink Head, *Paris, 19 quai Saint-Michel, autumn 1914–15; oil on canvas; 75 × 47 cm (29½ × 18½ in); Musée National d'Art Moderne, Centre*

Georges Pompidou, Paris. These two works exemplify this new phase in Matisse's art, in which his confrontation with Picasso and Braque led him once again to attach more importance to drawing. In White and Pink Head *the features of his most "abstract" style still prevail.*

148

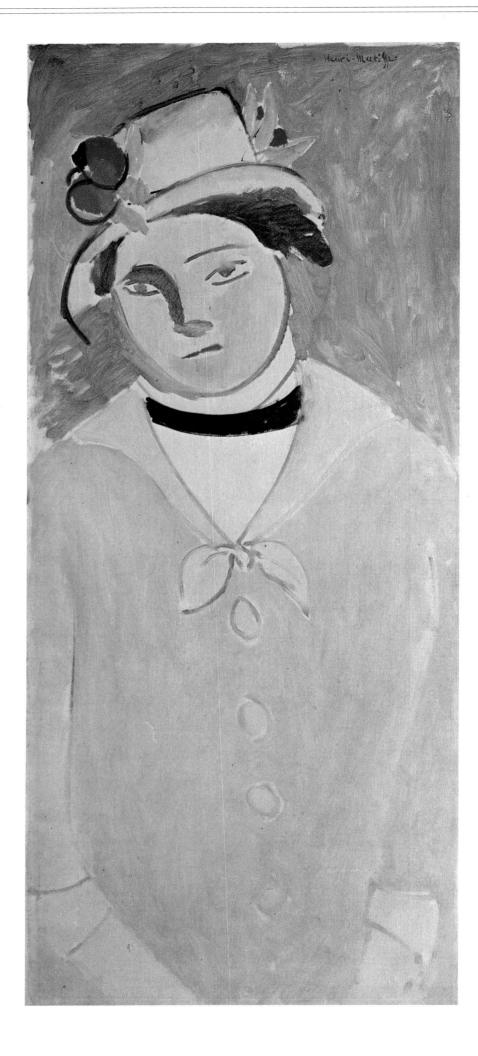

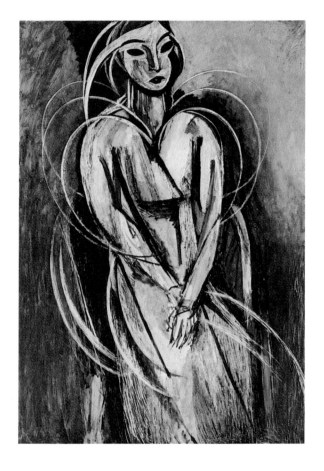

Marguerite in a Hat
with Roses, *1914; oil
on canvas; 112 × 49
cm (43½ × 19 in);
Private Collection.*

Portrait of
Mademoiselle Yvonne
Landsberg, *Paris, 19
quai Saint-Michel,
1914; oil on canvas;
147.3 × 97.5 cm*

*(58 × 38⅜ in); The
Philadelphia Museum
of Art, Louise and
Walter Arensberg
Collection.*

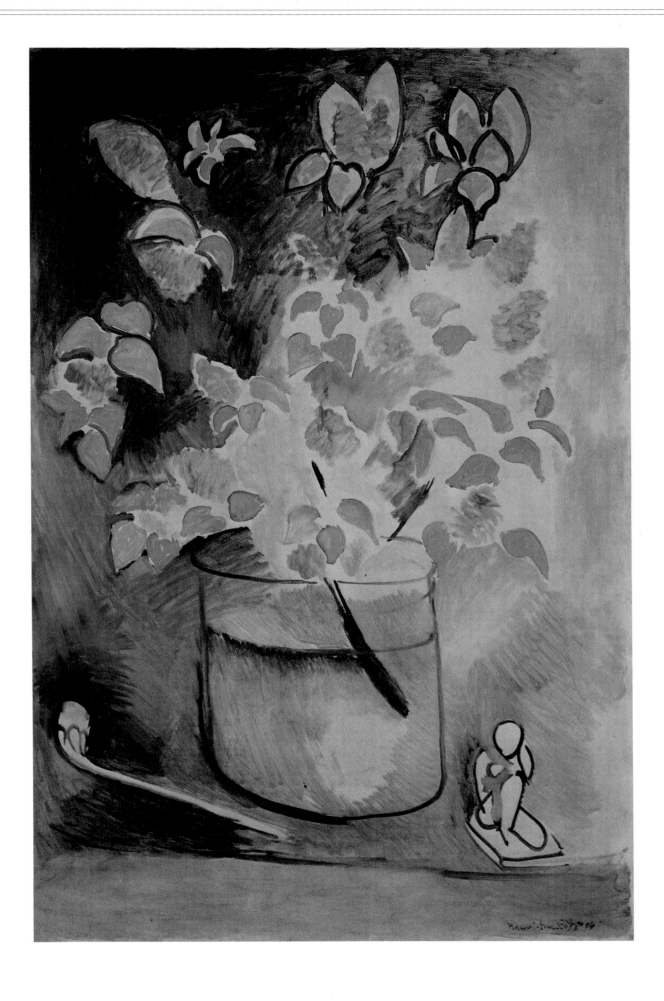

The Branch of Lilacs, Paris or Issy-les-Moulineaux, spring 1914; oil on canvas; 146 × 97.2 cm (57½ × 38¼ in); Private Collection. In 1914 Matisse's paintings were executed in Paris, Issy-les-Moulineaux and also in Collioure, where he moved with his family at the outbreak of World War One. Speaking about the influence of the war on his works, Matisse declared: "Despite pressure from certain conventional quarters, the war did not influence the subject-matter of painting, for we were no longer merely painting subjects."

150

Left: Still Life with Lemons Which Correspond in Form to a Drawing of a Black Vase on the Wall, *Paris, 19 quai Saint-Michel, 1914; oil on canvas; 70.5 × 55.2 cm (27⅞ × 21¾ in); Museum of Art, Rhode Island School of Design, Providence; gift of Miss Edith Wetmore.*

Right: Interior with a Goldfish Bowl, *Paris, 19 quai Saint-Michel, 1914; oil on canvas; 147 × 97 cm (57⅞ × 38⅛ in); Musée National d'Art Moderne, Centre Georges Pompidou, Paris.* Matisse said in 1925: *"There are two ways of expressing things. One is to show them crudely, and the other is to evoke them through art. By removing oneself from the literal representation of movement one attains greater beauty and grandeur. In order to succeed in this, I try to come close to these objects, define their specific character and the interrelations of their components; these interrelations exist both among the combinations of colours and among the combinations of forms."*

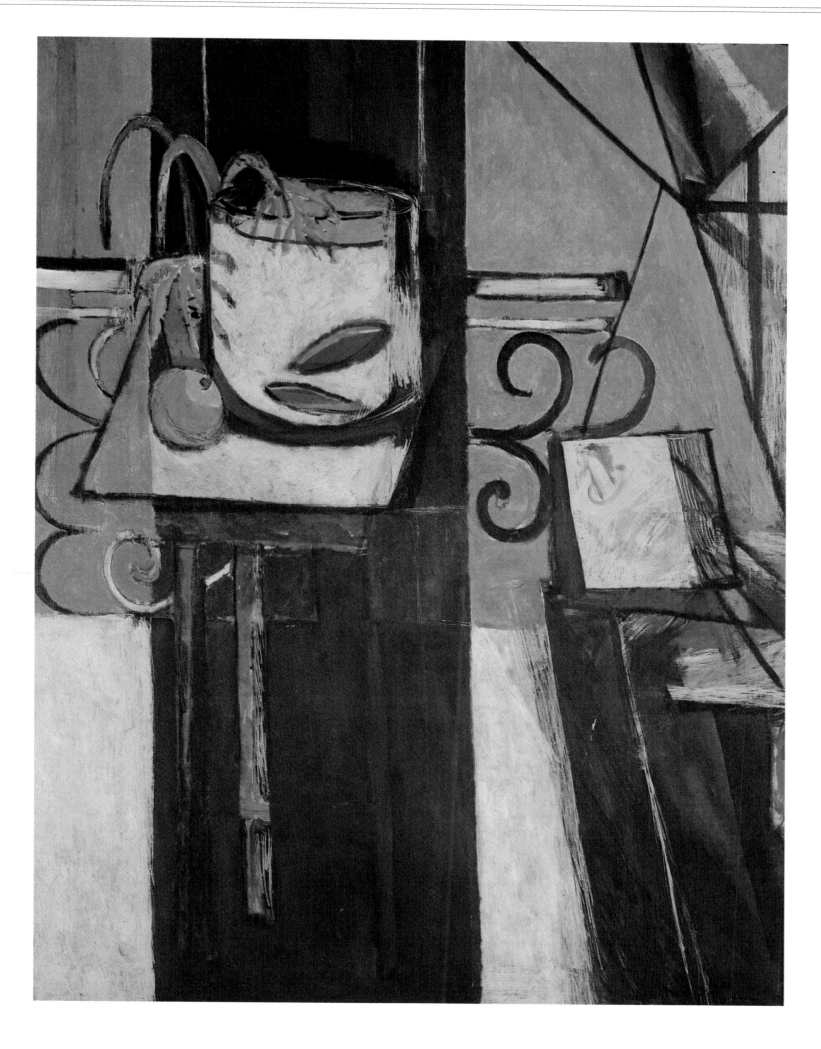

Goldfish and Palette,
Paris, 19 quai Saint-
Michel, 1914; oil on
canvas; 146.5 × 112.4
cm (57¾ × 44¼ in);

Museum of Modern
Art, New York, gift of
Florene M.
Scheonborn and
Samuel A. Marx.

152

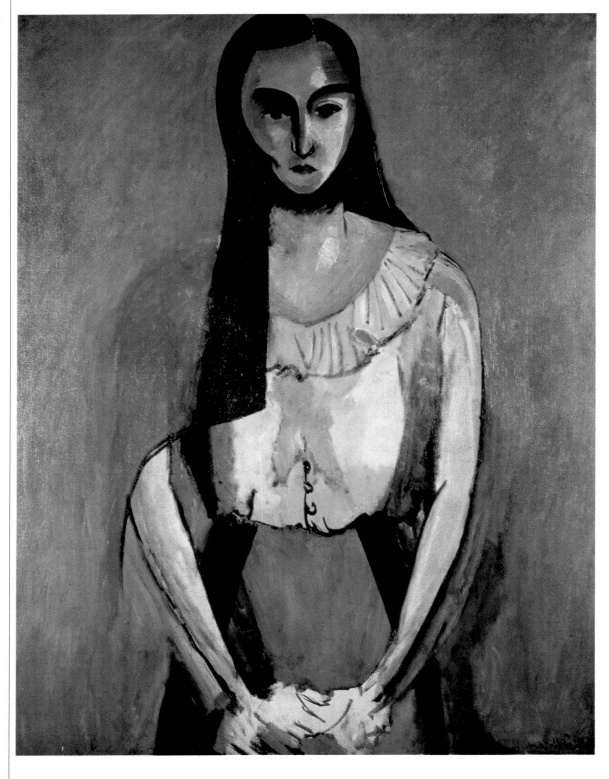

The Italian Woman,
Paris, 19 quai Saint-
Michel, autumn-
winter 1916; oil on
canvas; 116.7 × 89.5
cm (46 × 35¼ in);
Solomon Guggenheim
Museum, New York.
Matisse made his first
trip to Italy in 1917,
when he visited
Venice, Padua,
Florence, Arezzo and
Siena. He returned in
1915, 1931 and 1933.
He was particularly
enthusiastic about the
Sienese school,
Giotto's frescoes in
the Scrovegni chapel
in Padua, and the
murals at Pompeii, as
they were akin to his
own perception of
space and colour.

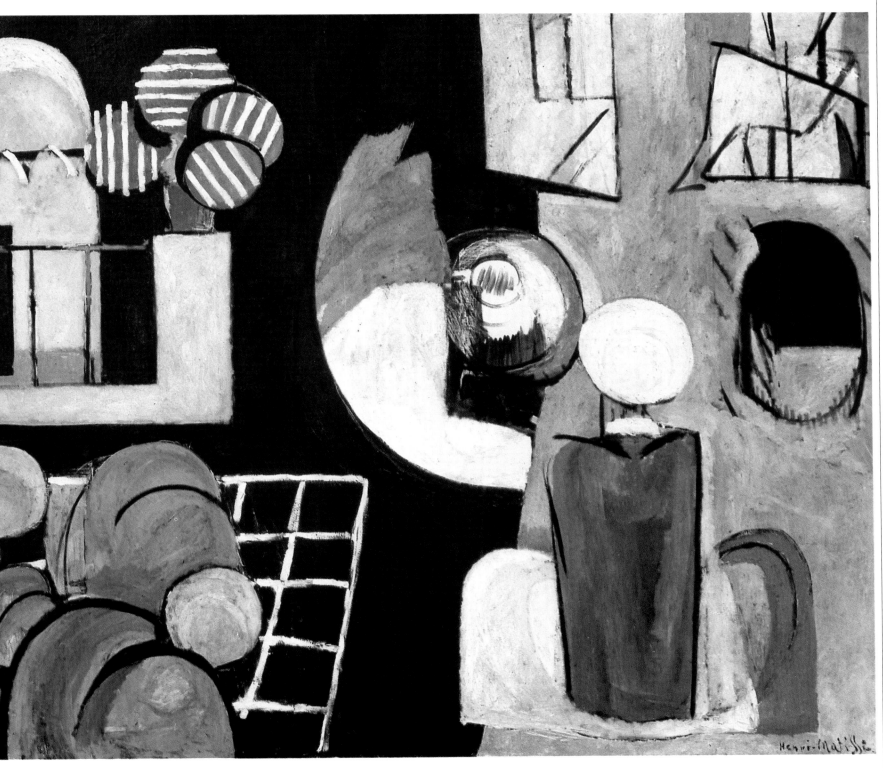

The Moroccans, *Issy-les-Moulineaux, 1915–16; oil on canvas; 181.3 × 279.4 cm (71⅜ × 110 in);* *Museum of Modern Art, New York, gift of Mr and Mrs Samuel Marx.*

154

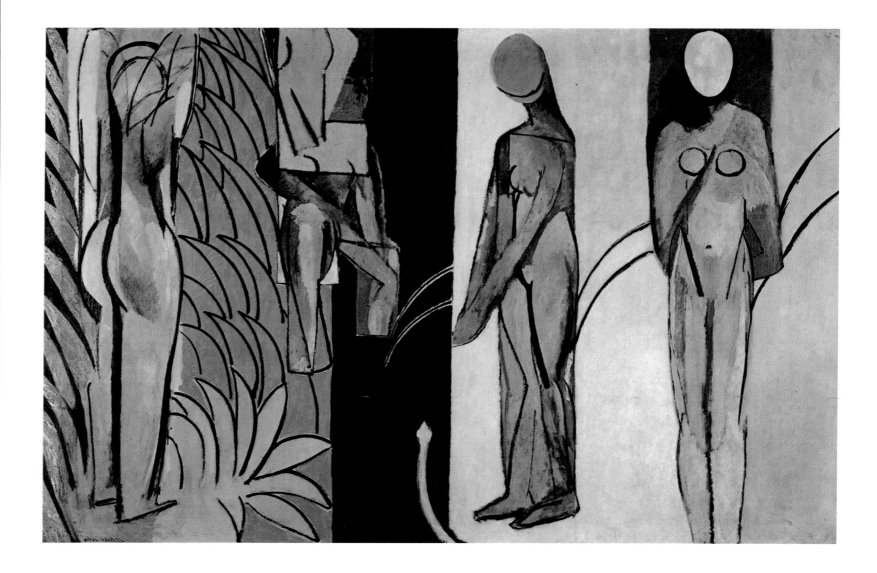

Bathers by a River, Issy-les-Moulineaux, 1910–10, spring-autumn 1913, spring-autumn 1916; oil on canvas; 261.8 × 391.4 cm (103 × 154 in); Art Institute of Chicago, Charles H. and Mary F.S. Worcester Collection. Painted during the war, this work takes up, with a new pictorial language, the themes of Matisse's "sacred" paintings of preceding years. As he himself said: "I have resumed work on a canvas five meters in width that depicts bathers [. .] Here are the important things in my life. I can't say it isn't a struggle, but this is not the real battle, I know that quite well, and it is with the utmost respect that I think of the French soldiers ["poilus"] who modestly say 'We have to do it.'"

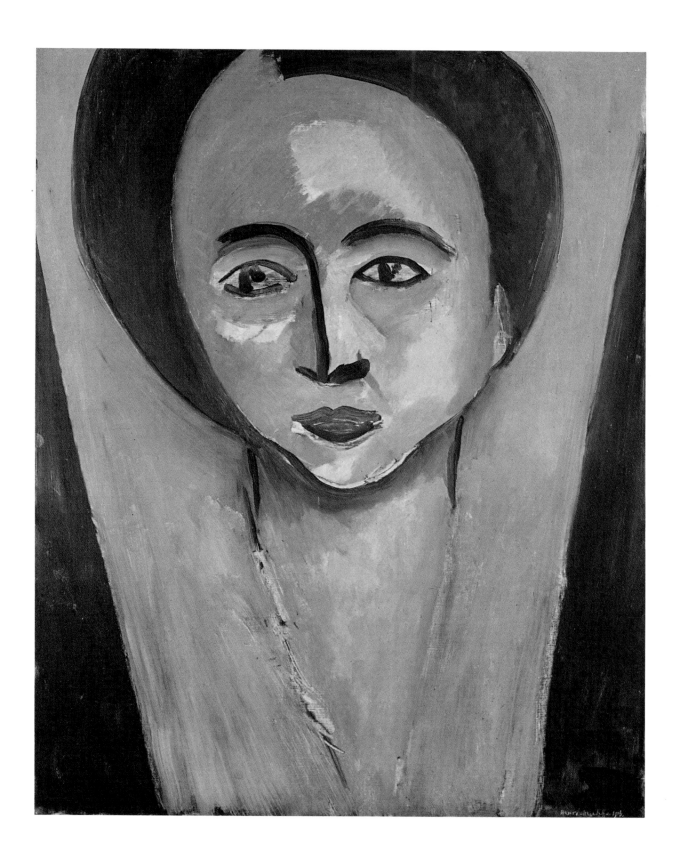

Portrait of Sarah Stein, Paris, 19 quai Saint-Michel, 1916; oil on canvas; 72.4 × 56.5 cm (28½ × 22¼ in); San Francisco Museum of Modern Art, Sarah and Michael Stein Memorial Collection, gift of Elise S. Haas. Michael and Sarah Stein were the first collectors of Matisse's Fauve works; on the last day of the 1905 Salon they bought his The Woman with the Hat. Sarah Stein was not only an art collector but also a close friend of Matisse's and a student at his school, which she helped to organize in 1907.

156

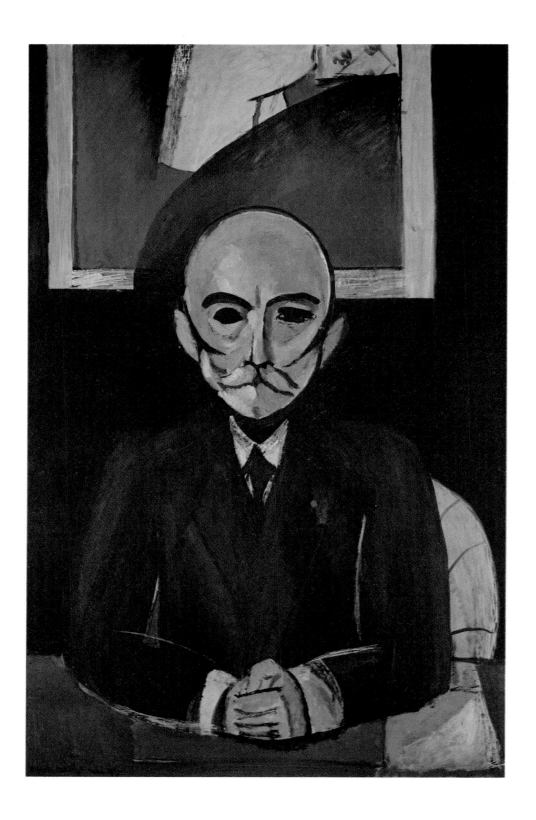

Portrait of Auguste Pellerin II, *Paris, winter-spring 1917; oil on canvas; 150.2 × 96.2 cm (59 × 37⅞ in); Musée National d'Art Moderne, Centre Georges Pompidou, Paris. The first version of this portrait is in a private collection; the one reproduced above is more synthetic, as often occurred when Matisse produced two versions of the same subject.*

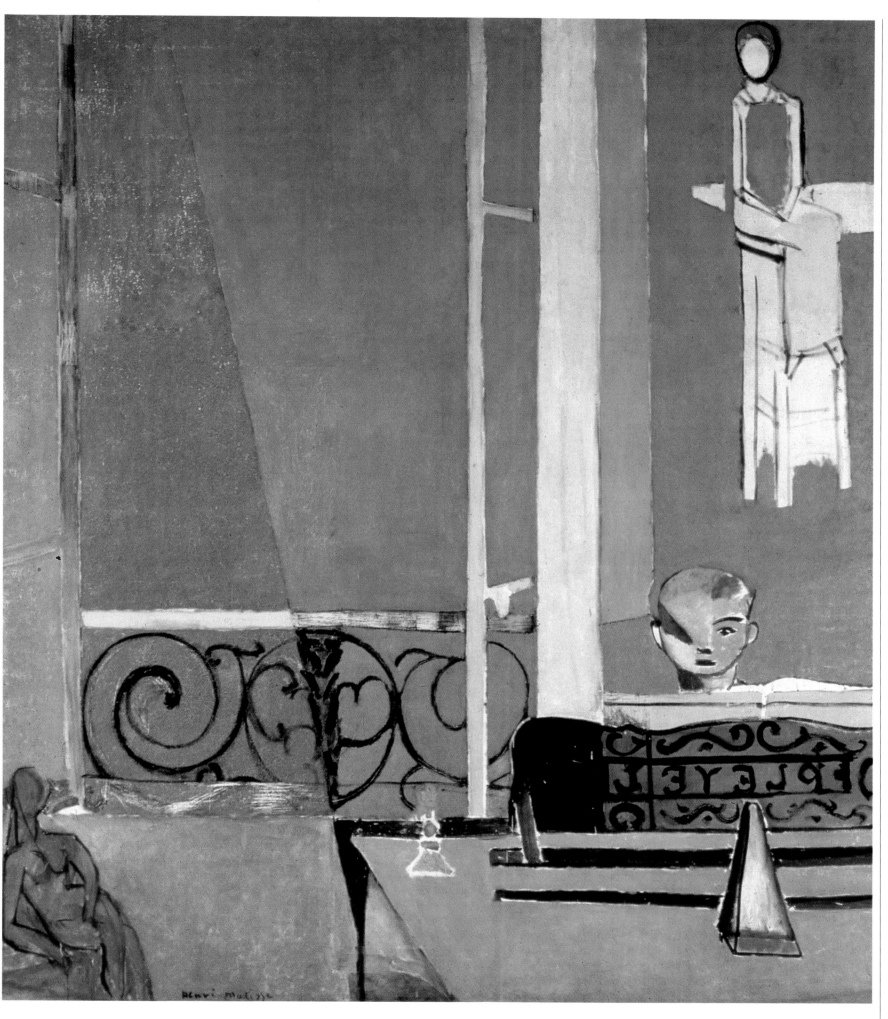

The Piano Lesson,
Issy-les-Moulineaux,
summer 1916; oil on
canvas; 245.1 × 212.7
cm (96½ × 83¾ in);
Museum of Modern
Art, New York, Mrs
Simon Guggenheim
Fund. The following
year Matisse painted
The Music Lesson,
whose structure was
basically the same
but rendered in a
more conventionally
realistic style.

158

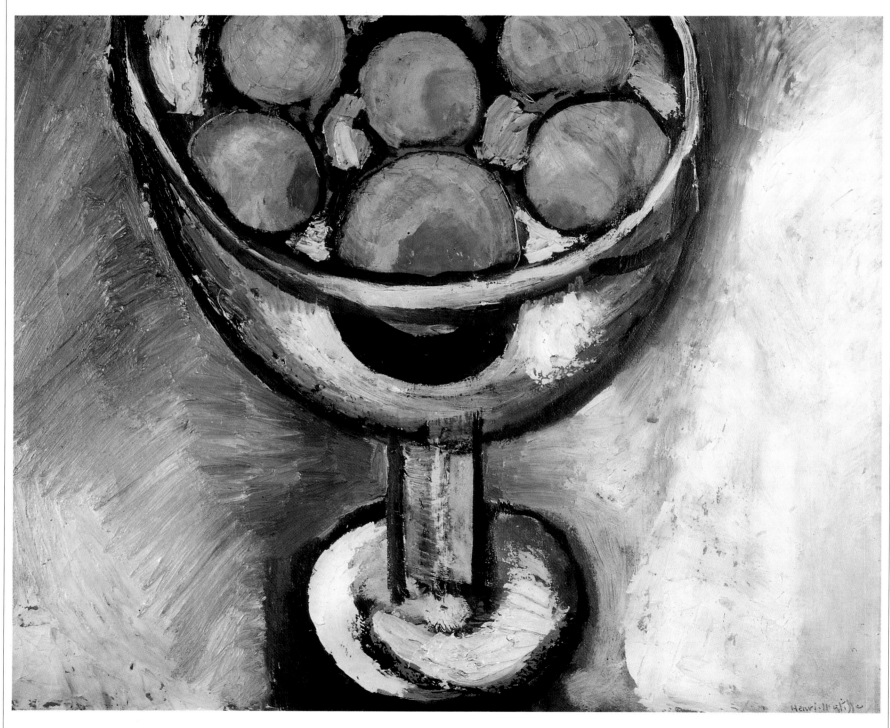

Bowl of Oranges,
1916; oil on canvas;
54 × 65 cm (21 × 25
in); Private
Collection. Matisse
wrote to Hans
Purrmann, one of his
pupils and best
friends, on 1 June

1916: "The still life
with oranges you
asked me to put aside
for you is finished."
In the same letter he
said he was working
on Bathers by a River
(reproduced on page
154).

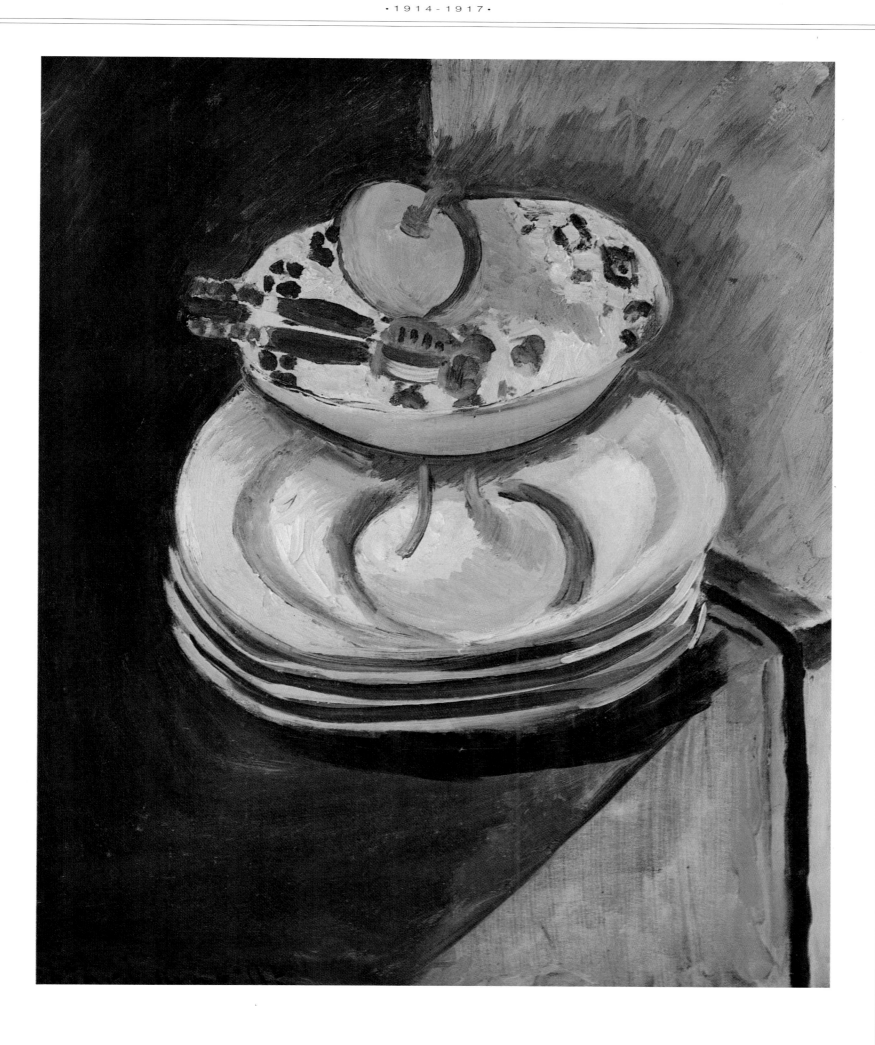

Still Life with a
Nutcracker, *Issy-les-
Moulineaux, 1916; oil
on canvas; 61 × 49.6*
cm (23 × 19¼ in);
*Statens Museum for
Kunst, Copenhagen.*

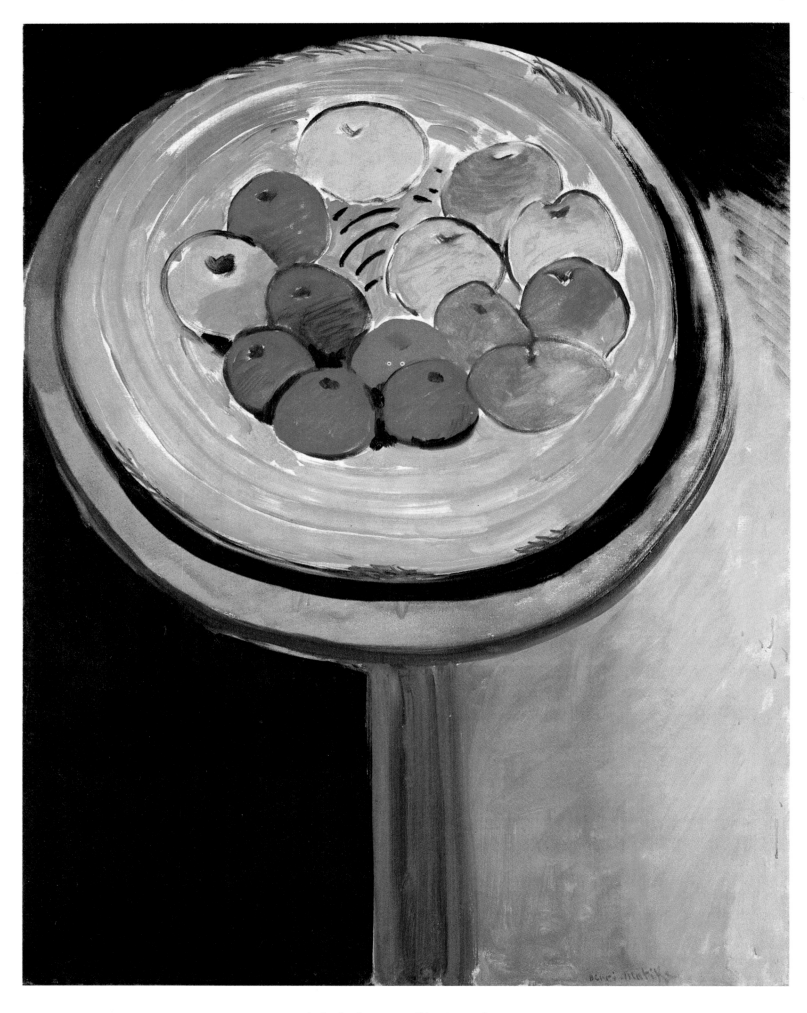

Apples, *Issy-les-*
Moulineaux, 1916; oil
on canvas;
116.9 × 88.9 cm
(46 × 35 in); Art
Institute of Chicago,
gift of Florene May

Schoenborn and
Samuel A. Marx.
Matisse often worked
in series, which
shows the importance
the idea of variations
played in his oeuvre.

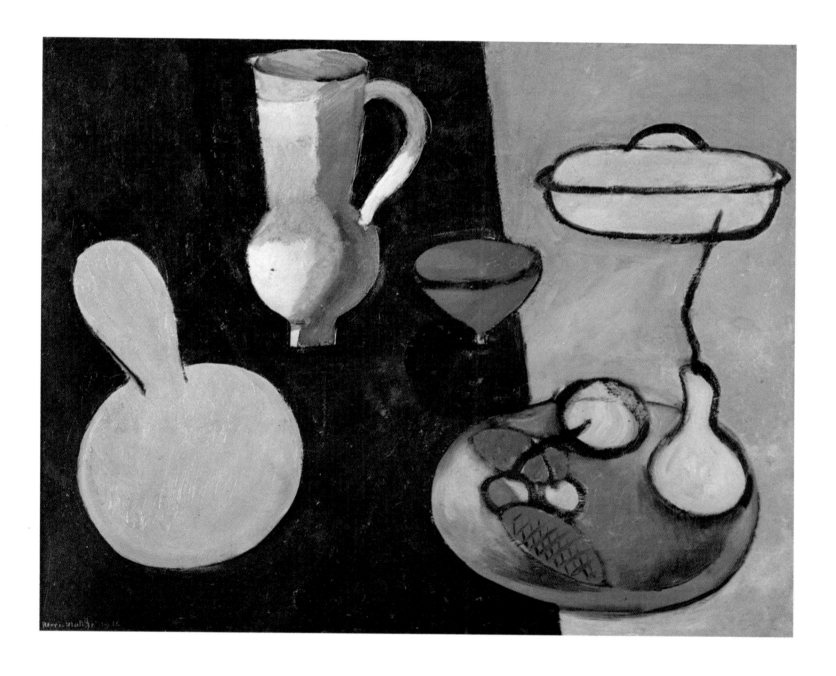

Gourds, *1916; oil on canvas; 65.1 × 80.9 cm (25⅝ × 31⅞ in); Museum of Modern Art, New York, Mrs Simon Guggenheim Fund. Matisse had the following to say about this work: "[...] a composition of objects that do not touch one* another and yet participate in the same intimacy." *Black was of particular importance to Matisse, who once said: "Black is a force: I depend on black to simplify the construction."*

162

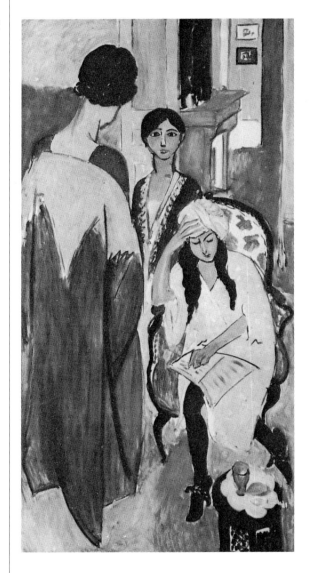

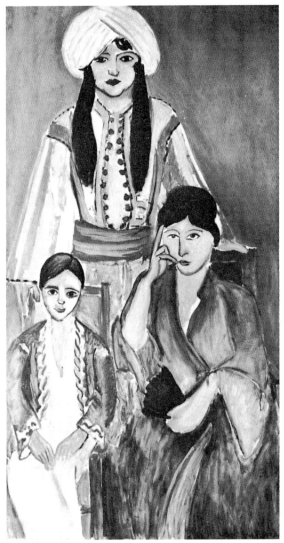

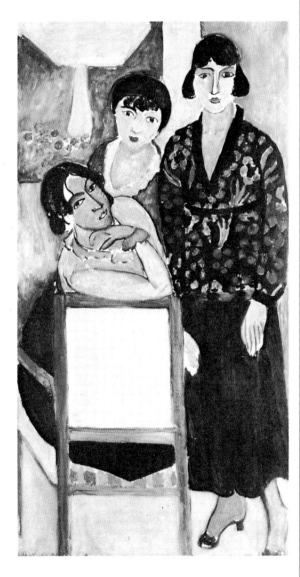

Above: The Three Sisters Triptych (Three Sisters with an African Sculpture, Three Sisters with a Grey Background, Three Sisters and "The Rose Marble Table"), *Issy-les-Moulineaux, 1016–17; oil on canvas; each panel 195 × 97 cm (77 × 38 in); The Barnes Foundation, Merion, Pennsylvania. This is a variation on the theme of the portrait in an interior that plays on the changes brought about by the different poses and clothing of the three models.*

Opposite: Interior with a Violin, *Nice, Hôtel Beau-Rivage, 1918; oil on canvas; 116 × 89 cm (45¾ × 35 in); Statens Museum for Kunst, Copenhagen. "This is one of my best canvases. To the degree that it is not Fauve", Matisse said, indicating the black and green surfaces of the work: "Do you see the red here that is physically evoked by this harmony?"*

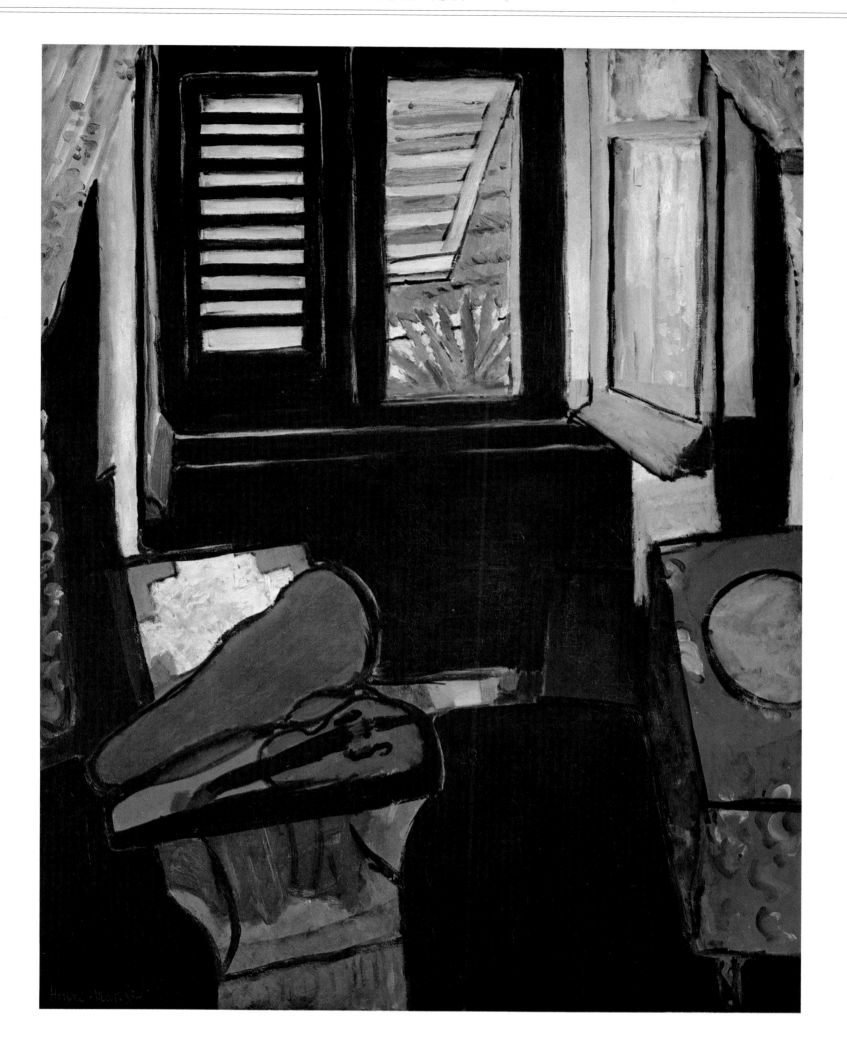

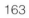

164

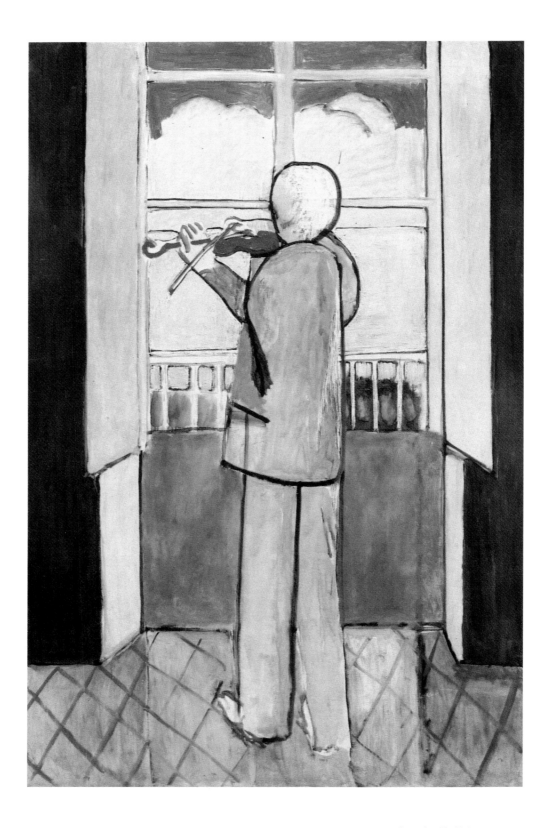

166

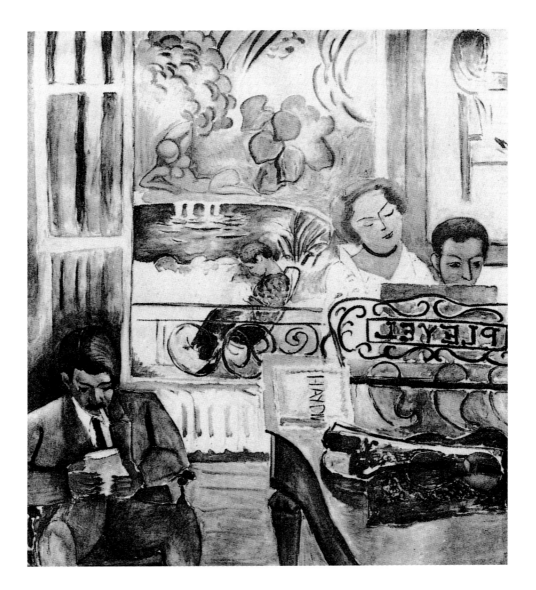

Above: The Music Lesson, *Issy-les-Moulineaux, 1917; oil on canvas; 243.8 × 209.5 cm (96 × 82½ in); The Barnes Foundation, Merion, Pennsylvania. Matisse wrote the following note concerning the relationship between this work and* The Piano Lesson *(see page 157): "I have finished a large canvas, more than two meters by two meters – based on one that was in my living room with Pierre at the piano, and adding his brother, sister and mother."*

Opposite: Shaft of Sunlight, The Woods of Trivaux, *Issy-les-Moulineaux, spring-summer 1917; oil on canvas; 91 × 74 cm (36 × 29⅛ in); Private Collection. Matisse painted this subject only rarely during The First World War, but executed numerous views of woods and trees in the early years of his career.*

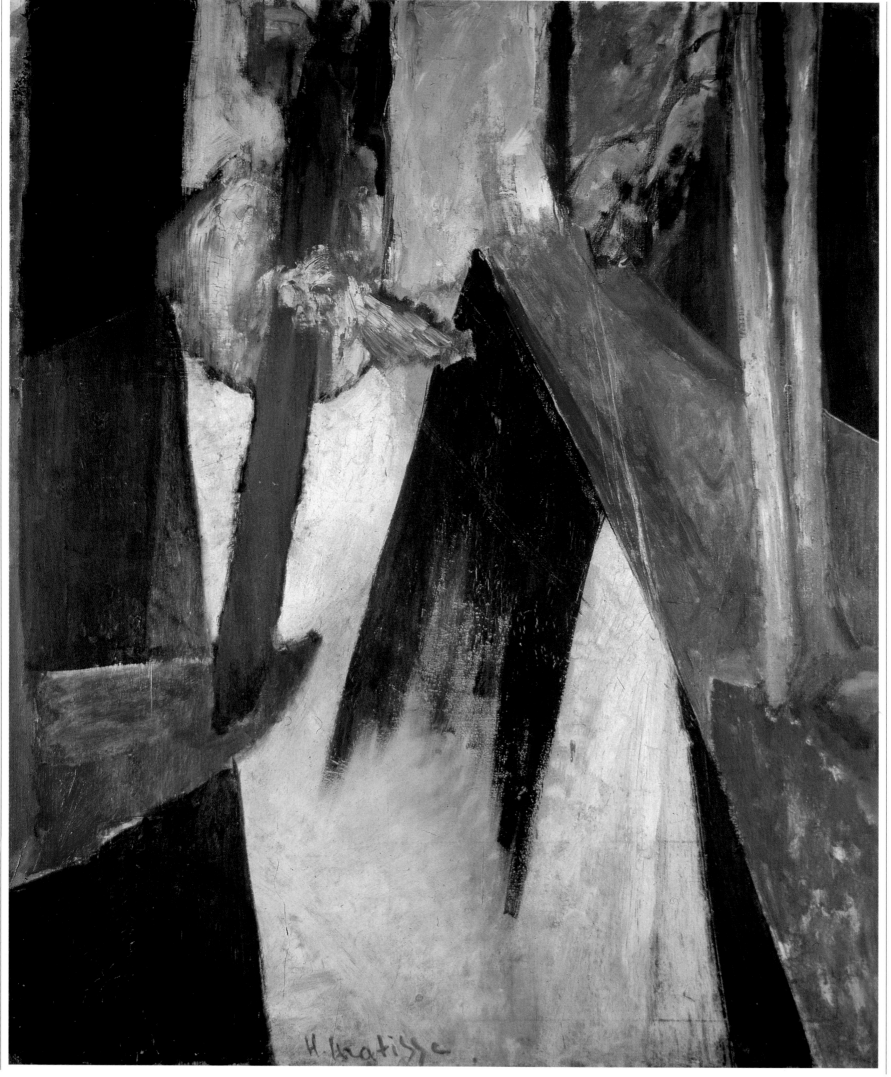

168

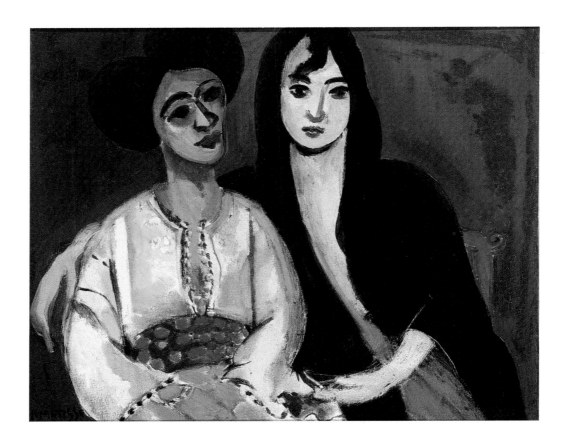

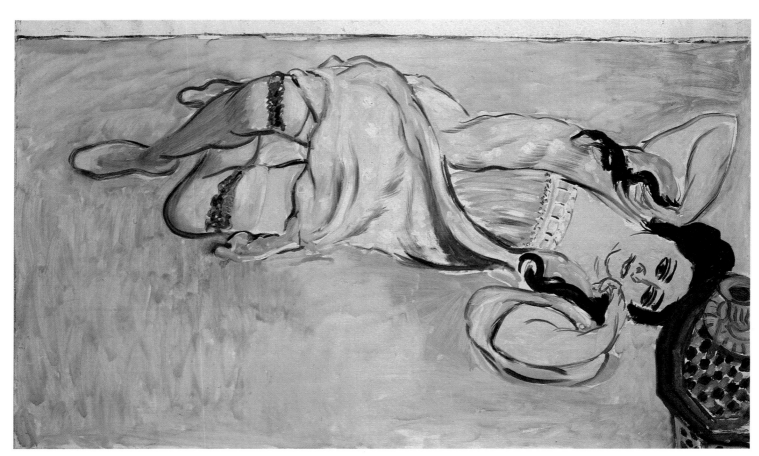

Above: Aïcha and Lorette, *Paris, 19 quai Saint-Michel, 1917; oil on canvas; 38 × 46 cm (14 × 17¾ in); Private Collection.*

Below: Lorette with a Cup of Coffee, *1917; oil on canvas; 89 × 146 cm (34¾ × 56¾ in); Private Collection. Lorette was one of the main subjects of the works Matisse produced in 1917; he executed around 40 canvases with this model. The only thing we know about her is that she was Italian.*

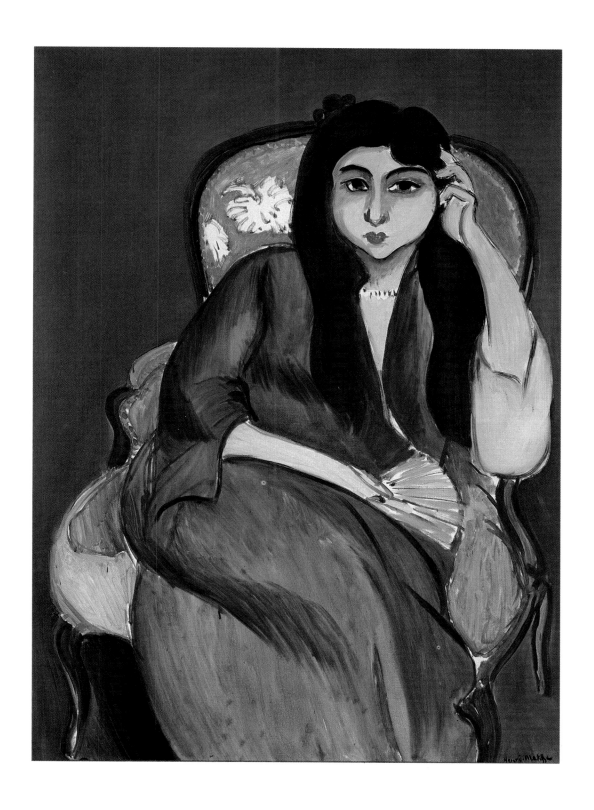

Lorette in Green in a
Pink Chair, *Paris, 19
quai Saint-Michel,
1917; oil on canvas;
100 × 73 cm
(39⅜ × 28¾ in);*

*Private Collection.
Lorette is also one of
the sisters in the
Three Sisters Triptych
(see page 161).*

The Period Between The Two Wars: From Nice To Vence

"From 1920 to 1925 Matisse worked indefatigably, producing numerous paintings and hundreds of drawings. In general the paintings are rather small, pleasant in subject and more conventionally realistic than the preceding works he painted from 1904 on; however, none of their decorative fascination is sacrificed. The combination of diverse elements in a single canvas, already employed in certain paintings dating from 1909–11, is now further elaborated, almost excessively so [...] According to many critics this is the most felicitous and convincing period of Matisse's entire production [...] But some of the master's admirers do not fail to note that the period from 1920 to 1925 is more a moment of pause, of transition, during which even the best works, despite their fascination and calm happiness, are still a far cry from the quality of the masterpieces painted from 1905 to 1916, and even from the best works of the period of new experimentation that began in 1926."
In 1951, Alfred Barr, one of the most important Matisse critics, expressed the embarrassment of art criticism and of the entire artistic community over Matisse's production in the so-called Nice period. This embarrassment is due to what seemed to be his sudden shift toward a traditional, anti-experimental style. The feeling is not without justification: Matisse had been the standard-bearer of early twentieth-century avant-garde art and, as late as 1951, with his paper cut-outs, he was once again (perhaps despite himself) the center of attention of art criticism

and viewed as an avant-garde artist. From this standpoint, how can we justify a Matisse caught up in the "call to order" atmosphere that dominated the 1920s? In effect, the seeds of change can already be found in the works executed in 1917, in particular *The Music Lesson*, which is one of those "manifesto-paintings" that often recur in his production. Begun almost together with *The Piano Lesson* and finished the following year, *The Music Lesson* represents, at first glance, a concession to realist taste as opposed to the abstract invention of *The Piano Lesson*. However, taking into consideration the fact that Matisse filtered his encounter with Cubism through Cézanne and that this Cubist experience was precisely the means whereby he could again approach the reality that was at risk of being lost in the "windows" of his 1914 paintings, it is not surprising that one of the possible consequences should be a work based on traditional figurative criteria.
We cannot therefore use an external necessity, a cultural clime, as a justification for this stage in Matisse's oeuvre, but must rather ascribe it to an inner need deriving from his poetics to fulfil a procedure which is basically linear and coherent, even though it may not appear to be so if considered from a purely mechanical, evolutionary standpoint.
The Music Lesson corresponds much less to realistic conventions than one might at first suppose: by observing the position in the pictorial space and the relative proportions of the five figures

(the four members of Matisse's family and the sculpture in the background) we realize that the spatiality here is pure invention, another attempt on the artist's part to render not objective space, but his reactions to space. The resultant image is most certainly at opposite poles from the essentiality of *Gourds* and *French Window at Collioure*, but the principle that pervades Matisse's conception of painting is the same, which he on more than one occasion expressed in the following terms. "My aim is to render my emotion. This state of soul is created by the objects which surround me and which react in me: from the horizon to myself, myself included. For very often I put myself in the picture and I am aware of what exists behind me. I express as naturally the space and the objects that are situated there as if I had before me only the sea and the sky, that is, the simplest things in the world."
Space is again populated with figures, objects, curtains, and vegetation. A decorative saturation emerges that undermines from within the realism of the composition, setting it on the level of fiction, of a pictorial *mise en scène*. Thus there are quite a few rather important elements that induce one to consider the above works – and those that were to follow, up to the mid 1920s – as manifestations of continuity rather than of rupture with respect to Matisse's period of experimentation. Decoration, the relationships among the objects and among the colours and the suggestion of an emotional rather than descriptive space, remain the focal

points around which Matisse's pictorial imagination and procedure revolve. The accusation of his having given in to a more conventional type of realism should perhaps be reversed, since indeed Matisse never moved so far away from reality as in the series of *Odalisques* he painted in the 1920s. The odalisque motif is in fact a representation, a *mise en scène* whose aim is to create a situation in which the constitutive elements of Matisse's aesthetic – colour and decoration – stand out to the utmost.
This was not a totally invented subject with a symbolic meaning such as *The Dance* and *Music*, for example, nor a subject belonging to the realist tradition to which he could confer new pictorial values, as was the case with the still lifes executed in the preceding decade; it was instead an exotic subject treated along apparently conventional compositional lines but actually stripped of all meaning except the purely pictorial one.
There is therefore no rupture between this period and the previous ones. There is merely a different approach to the already consolidated themes and pictorial procedures, an approach that is less conceptual and perhaps more attractive to the general public. The series of *Odalisques* could be considered variations on a theme and with the passing of time this manner of dealing with the subject became ever more central to Matisse's art and was best expressed in drawing – a technique that took on an importance it had never before had in his oeuvre. To confirm this hypothesis we need only take a

quick glance at a sequence of these paintings: it is clear that these are in effect variations on the same image, which gradually loses its original figurative meaning and becomes the pretext for a sort of "review" of the relationship among the colours, among the spaces, between the physicality of the figure and the objects on the one hand and the decorative dissolution of form on the other.

Matisse later said: "Look closely at the *Odalisques*: the sun floods them with its triumphant brightness, taking hold of colours and forms. Now the Oriental decor of the interiors, the array of hangings and rugs, the rich costumes, the sensuality of heavy, drowsy bodies, the blissful torpor in the eyes lying in wait for pleasure, all this splendid display of a siesta elevated to the maximum intensity of arabesque and colour should not delude us. I've always rejected the anecdote for its own sake. In this atmosphere of languid relaxation, under the torpor of the sun washing over people and objects, there is a great tension brewing, a tension of a specifically pictorial order, a tension that comes from the interplay and interrelationship of elements."

The culmination of this decorative tension, and the symptom of a revival of the values of surface and the essentiality of form, is his *Decorative Figure on an Ornamental Background* (1925), the very title of which is extremely indicative. Here the sumptuous wallpaper and richly decorated rug, a veritable paragon of arabesques and chromatic harmony, are blended with the almost geometric composition of the figure, which relinquishes the softness and sensuality that characterizes the *Odalisques* in favour of a more abstract and structural linearity. The space, formerly defined by complex relationships of planes and light, also becomes openly two-dimensional, so much so that the sculptural concreteness of the figure stands out sharply.

From this time on Matisse once again approached form by progressively increasing the linear components of the drawing; this procedure reached its peak in the two versions of *The Dance* he created for the Barnes Foundation, in the two versions of *The Dream* (1935 and 1940), as well as in the important book illustrations he began in 1930. These works, and the others executed in the 1930s, herald the large paper cut-outs of the 1940s and 1950s, marking the beginning of a process of rarefaction and distillation of the pictorial elements that Matisse would explore with new means in his final works. Line and colour came to be accentuated in an expressive key; the palette was quantitatively reduced in each single work and the lines defining the figure were also reduced so these elements could heighten each other, thus reinforcing their qualities of light and form. Such further strengthening of the luminosity of the work and simplification of space – no longer consisting of different planes re-established on the surface but now manifestly two-dimensional right from the first glance – is a result both of Matisse's experience with Polynesian light during his trip to Tahiti in 1930 and of his revival of the symbolic mode (which is evident in the Barnes Foundation *Dance* and in *The Dream*) he had abandoned in the preceding period.

Tahitian light had a great impact on Matisse. A passage from Louis Aragon's *Henri Matisse, roman*, a book based on the conversations between this poet and Matisse, illustrates this: "The water of the lagoon, grey and jade green, coloured by the very close ocean floor, the tufted corals and their variety of tender, 'pastel' colours, around which pass schools of little sky-blue, yellow and brown-striped fish, of a material comparable to enamel. Everything studded with the black truffles of the almost inert, languishing sea cucumbers [...] This lagoon allows the person diving into it, the painter on vacation, to analyze the particular luminosity of the landscape, underwater and above water, through successive impressions, dipping his head into the water and suddenly raising it above water, to find the relationship between the pale gold of the former and the soft green of the latter."

If we compare this description with the one of the three paintings *The Dream*, *Still Life with a Shell* and *Still Life with Oysters*, all dating from 1940, we will clearly see how the unifying element of each experience of Matisse is colour, and how the apparent facility of these works conceals a great deal of thought and labour that allows the painting to transcend its material and figurative pretext in order to attain the expression of sensations and thoughts of a universal character.

Matisse wrote the following in two successive letters. "Therefore this painting [*The Dream*], begun in a very realistic mode with a lovely brunette asleep on my marble table among different kinds of fruit, has become an angel sleeping on a violet surface – the flesh is rosy, pulpy and warm like a flower – and as for the clothes, the blouse is a pale and very very sweet periwinkle blue, and the skirt a caressing emerald green (with a bit of white in it), all sustained by a shiny jet black." "But rather a still life of a shell, a vase of blue flowers, a cup of coffee, a coffee pot and three green apples on a black and green marble table – a painting I worked on (transformed) during 30 sittings – I think I have arrived at the limit of what I can do in the abstract direction, by dint of meditation, of trying to work on different levels of elevation, and of pruning [...] For the moment I can't go any further, and I cannot even repeat myself, there's no question of it. So I have been schooling myself to keep within the bounds of a less extraordinary, less spiritual conception, and I have moved closer to the substance of things. To accomplish this I've painted some oysters – there, my dear friend, tasty sensations are necessary – it's essential that in a picture an oyster be itself a little, that it be a bit the Dutch rendering."

172

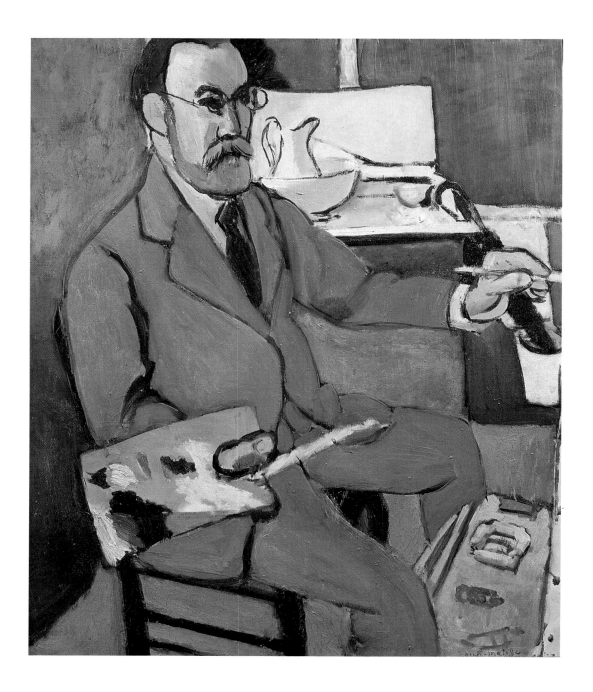

Self-Portrait, *Nice,
Hôtel Beau-Rivage,
early 1918; oil on
canvas; 65 × 54 cm
(25½ × 21¼ in);
Musée Matisse, Le
Cateau Cambrésis.
This work belongs to* the museum in Henri
Matisse's town of
birth in northern
France; it was
inaugurated in 1952,
two years before the
artist's death.

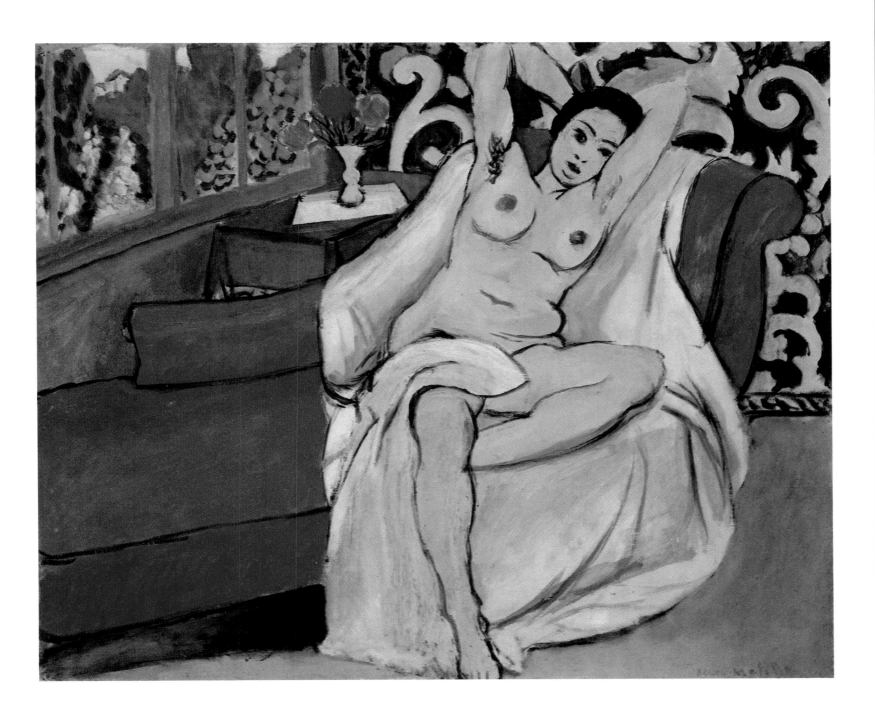

Draped Nude on a Red
Couch, *Nice,*
1918–19; oil on
canvas; 54 × 65 cm
(21 × 25¼ in); Private
Collection. The so-
called Nice period
was characterized by
Matisse's return to a
more conventional
approach, although
the decorative
element always
played a central role
in the definition of the
image.

174

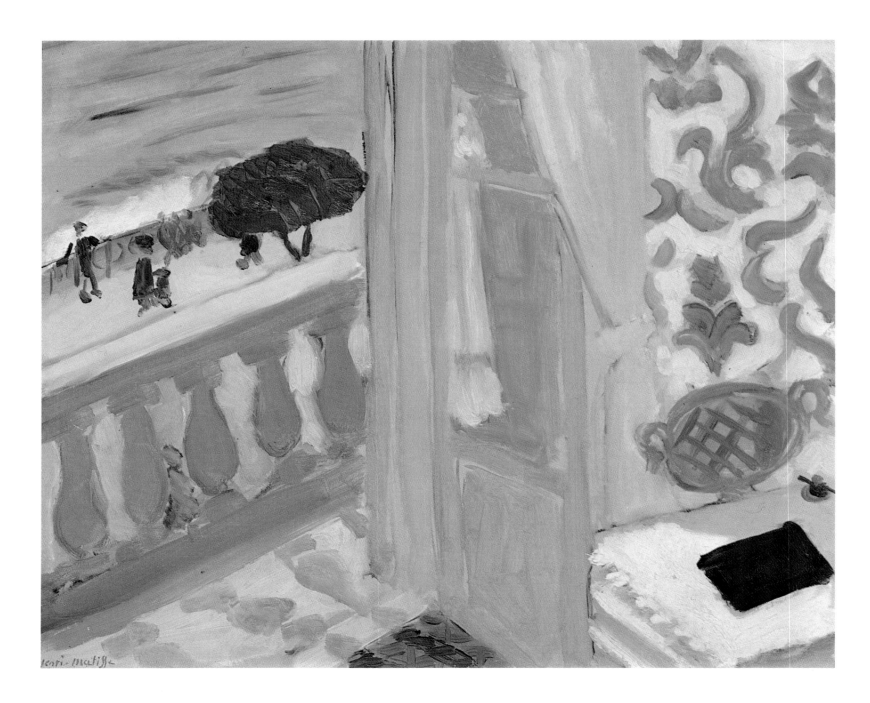

Above: Interior with a Black Notebook, *Nice, Hôtel de la Méditerranée, 1918; oil on cardboard; 32.5 × 40 cm (12½ × 39½ in); Private Collection. Note how the space, rendered without respecting the rules of* Renaissance *perspective, is still extremely ample; this is due to the relationship that is established between the various colours. In this regard the effect of the black notebook sinking into space is exemplary.*

Opposite: Grey Nude, *Nice, Hôtel Beau-Rivage, winter 1918; oil on canvas; 56 × 34 cm (21¾ × 13¼ in); Private Collection. The motif of the figure in an interior, always part of Matisse's oeuvre, becomes in this period almost an obsession that is repeated in numerous variations that revolve around the relationship between the figure, the decoration and the exterior.*

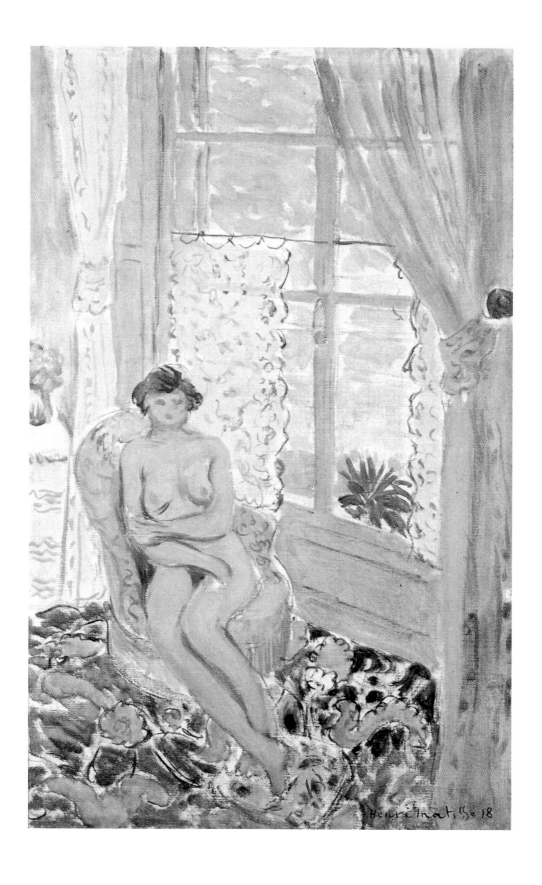

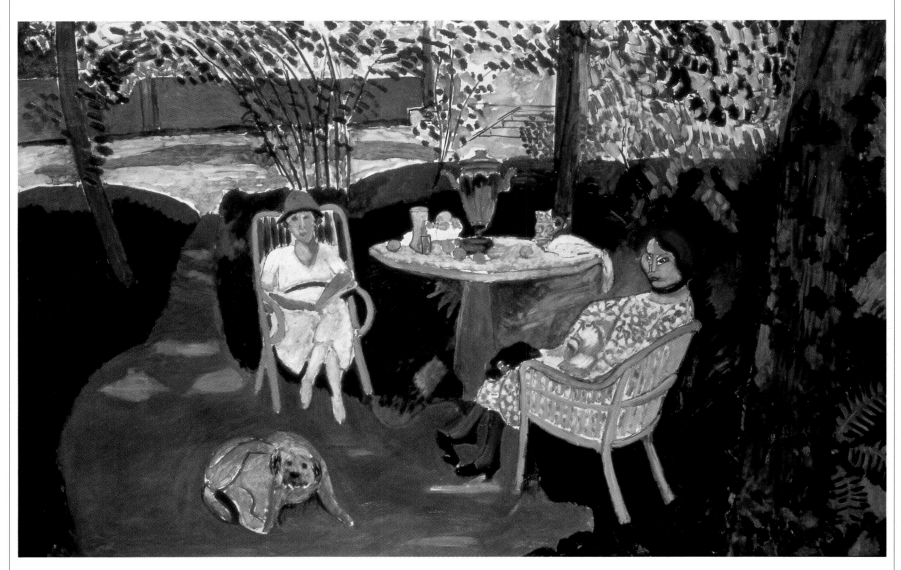

Tea in the Garden,
Issy-les-Moulineaux,
1919; oil on canvas;
140.3 × 211.5 cm
(55¼ × 83¼ in); Los
Angeles County
Museum of Art,
bequest of David L.
Loew in memory of
his father Marcus
Loew. One of the
largest works of
Matisse's Nice period,
this is ideally linked
to the large symbolic
compositions he
executed in the first
years of the twentieth
century, even though
now the subject is
obviously a domestic
scene. The table in the
middle was the motif
of a famous canvas,
The Rose Marble Table
(1917), now in the
Museum of Modern
Art in New York.

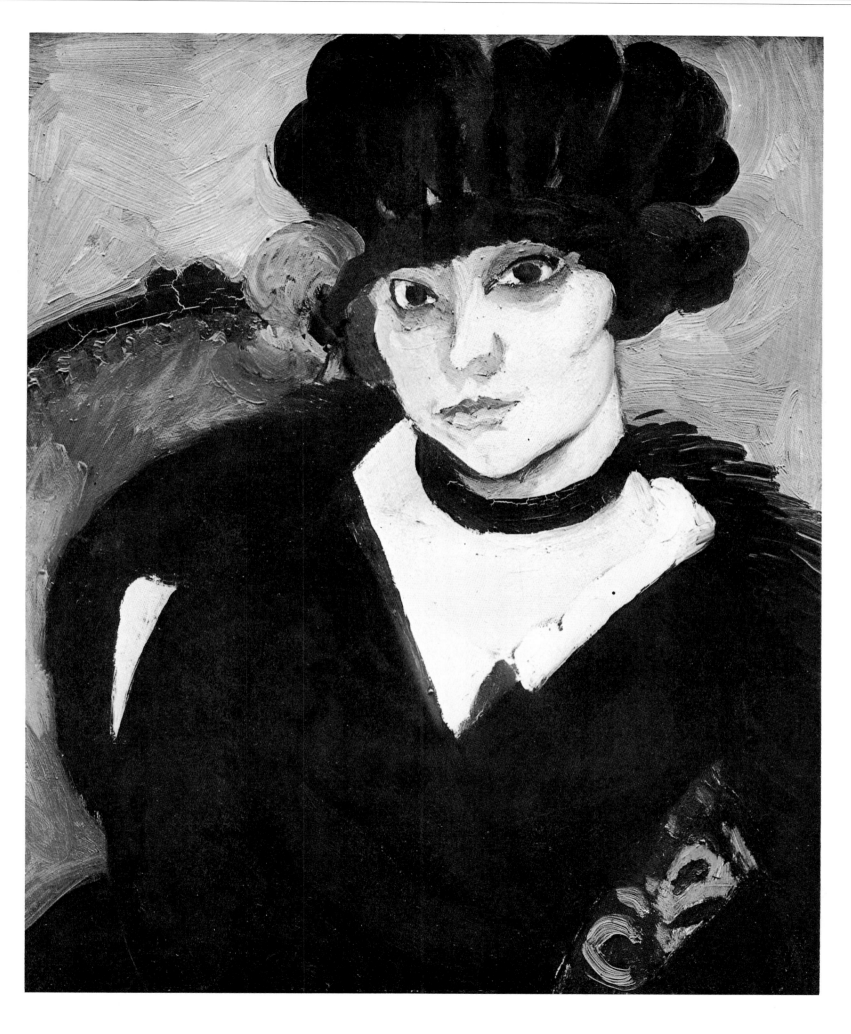

Marguerite with a Hat,
1919; oil on canvas;
46 × 38 cm (17¾ × 14¾
in); Galerie
Bernheim-Jeune,
Paris. The hats, like
the tunics, screens
and rugs, act as
decorative focal
points in this
composition.

178

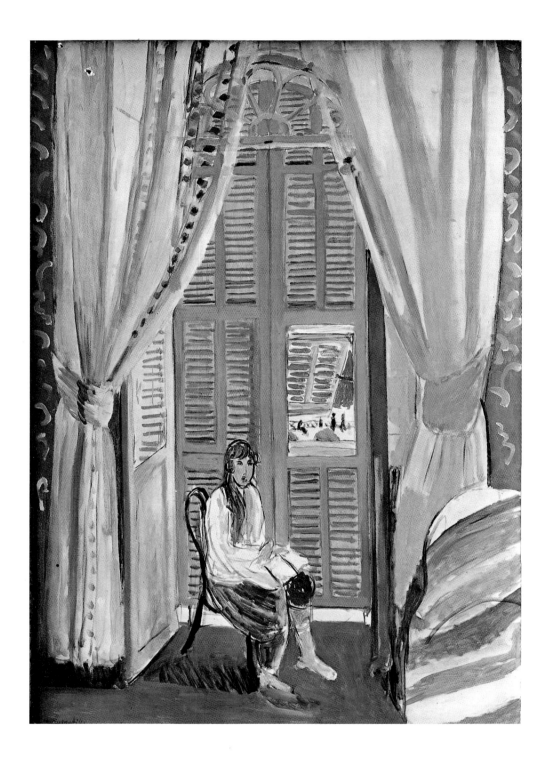

Above: The Shutters,
Nice, Hôtel de la
Méditerranée, 1919;
oil on canvas;
130 × 89 cm
(50¾ × 34¾ in); The
Barnes Foundation,
Merion,
Pennsylvania. The

*motif of shutters often
recurs in Matisse's
oeuvre; they filter the
light and lend a
geometric rhythm to
the composition.*

Opposite: The Lorrain
Chair – Chair with
Peaches, 1919; oil on
canvas; 130 × 89 cm
(50¾ × 34¾ in);
Private Collection.
Traces of Cézanne
can be noted in the
still life on the chair,

*while the
background, clearly
divided into
chromatic and
decorative areas, are
the most recognizable
elements of Matisse's
style.*

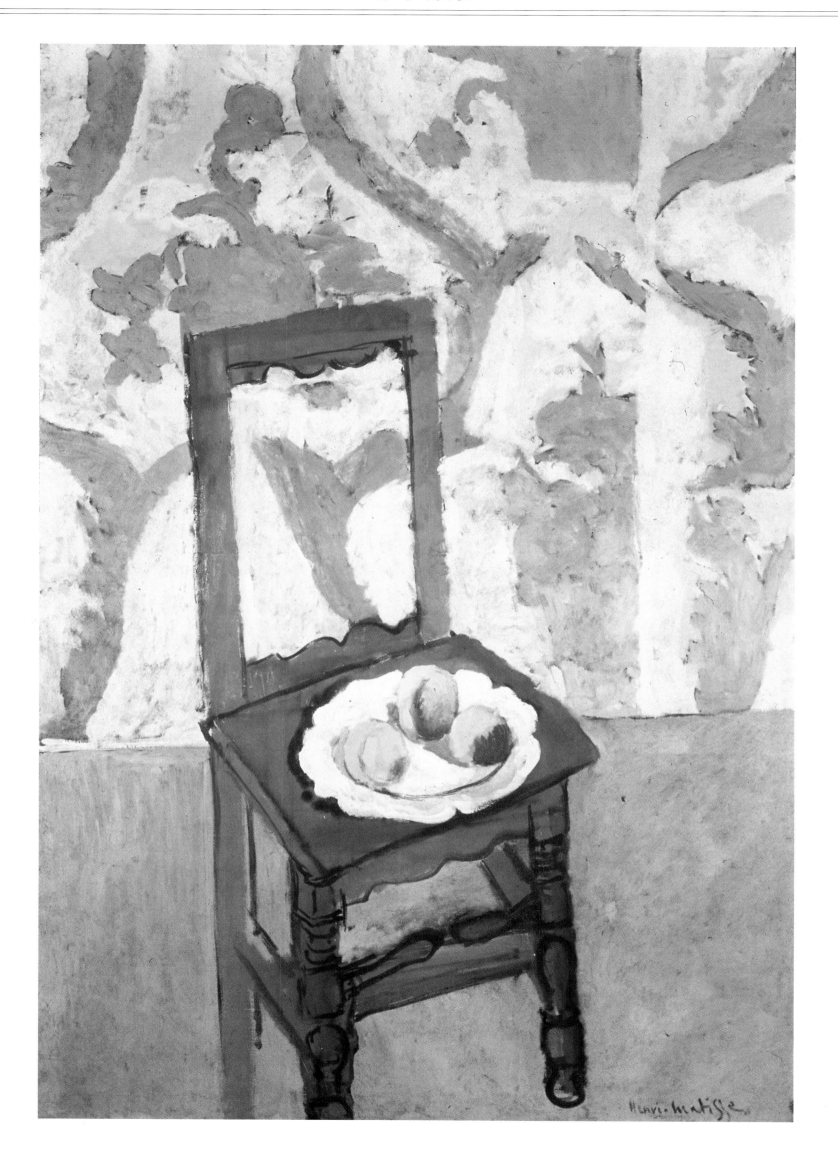

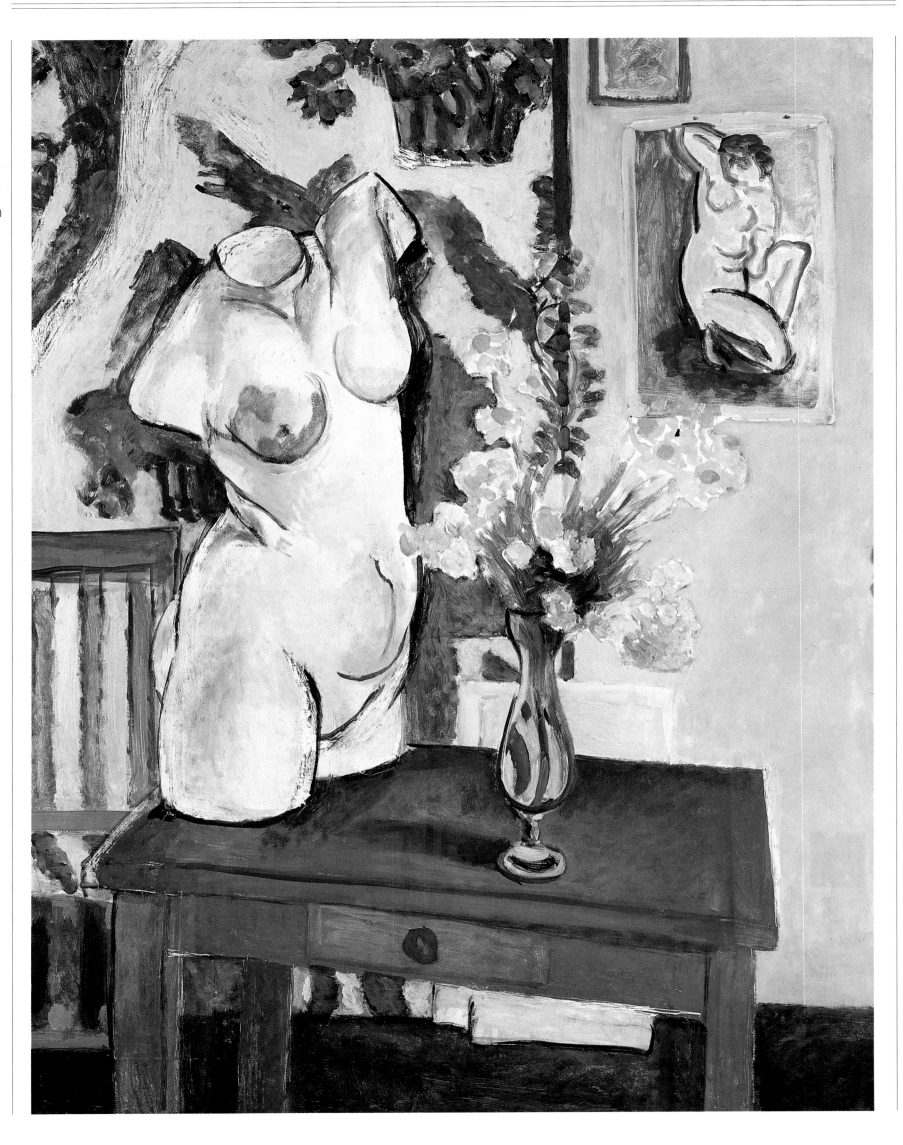

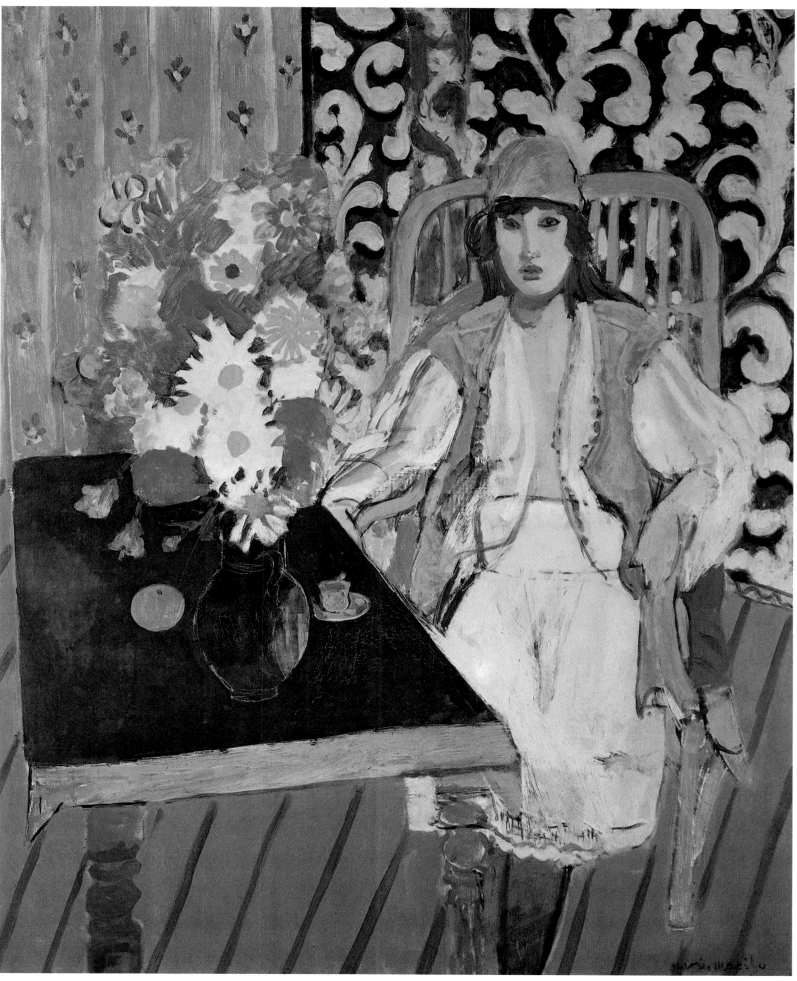

Opposite: Plaster
Figure, Bouquet of
Flowers, *Issy-les-
Moulineaux, summer
1919; oil on canvas;
113 × 87 cm
(45½ × 34½ in);
Museu de Arte, Sao
Paolo.*

Above: The Black
Table, *1919; oil on
canvas; 100 × 81 cm
(39⅜ × 31½ in);
Private Collection.
Matisse moved to
Nice in 1916, first
living in hotels and
then, from 1912 on, in*

*an apartment on the
fourth floor at place
Charles-Félix.*

182

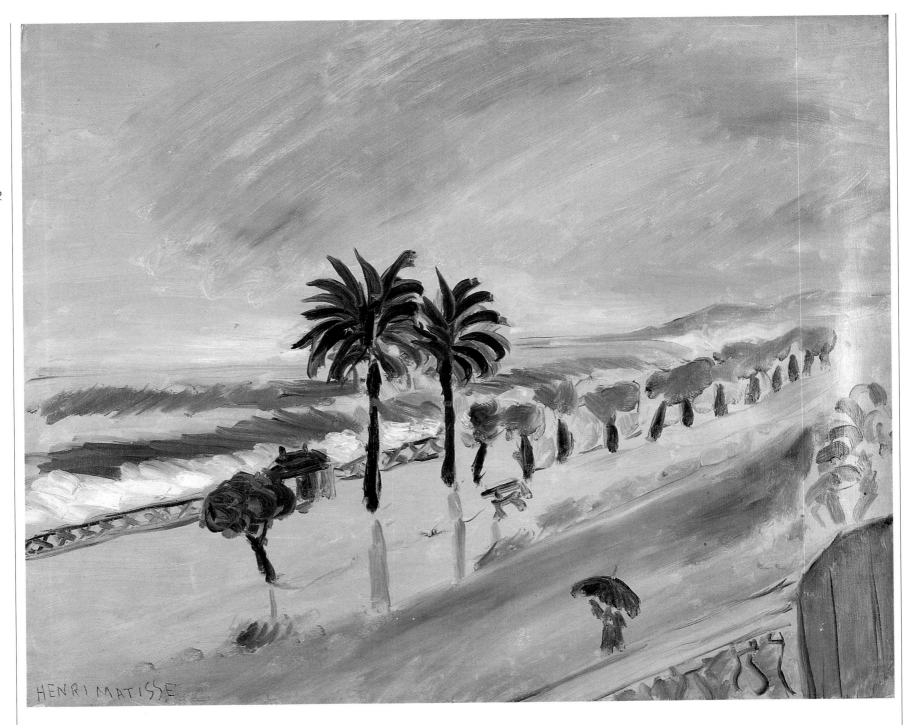

Above: Storm in Nice, Nice, Hôtel de la Méditerranée, 1919–20; oil on canvas; 60.5 × 73.5 cm (23¹⁄₄ × 28¹⁄₂ in); Musée Matisse, Nice. This is one of the views of the Bay of Angels, which Matisse could see from his window at the Hôtel de la Méditerranée, where he went to live in November 1918.

Opposite above: Marguerite among the Rocks, Etretat, 1920; oil on canvas; 37.7 × 45.7 cm (14³⁄₄ × 17³⁄₄ in); Private Collection.

Opposite below: The Red Sail, Etretat, Etretat, 1920; oil on canvas: 37.5 × 46 cm (14¹⁄₂ × 17⁷⁄₈ in); Private Collection.

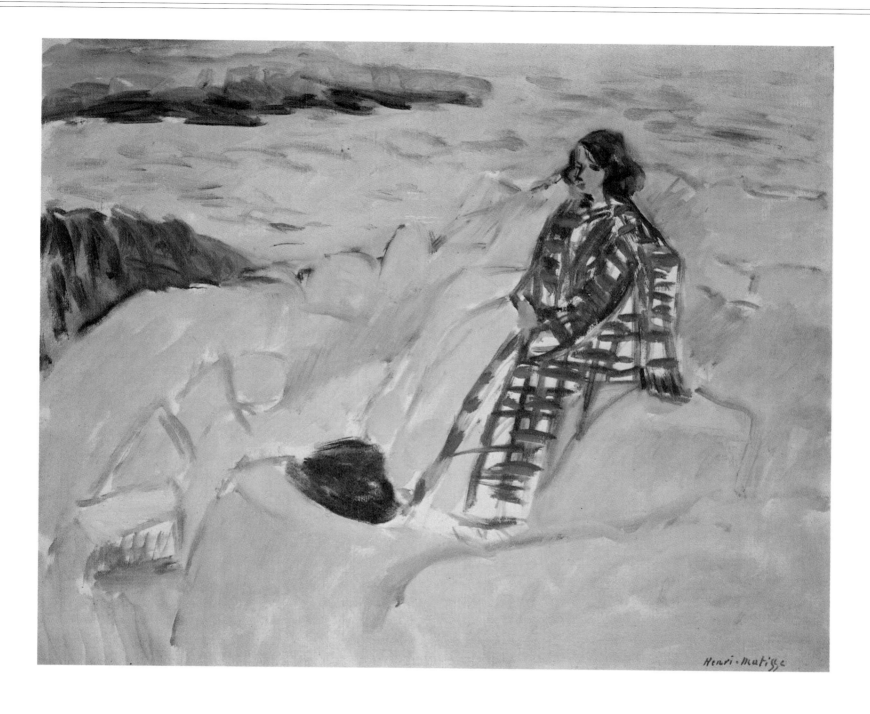

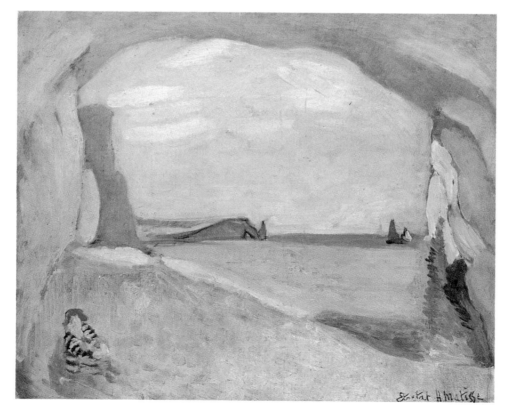

184

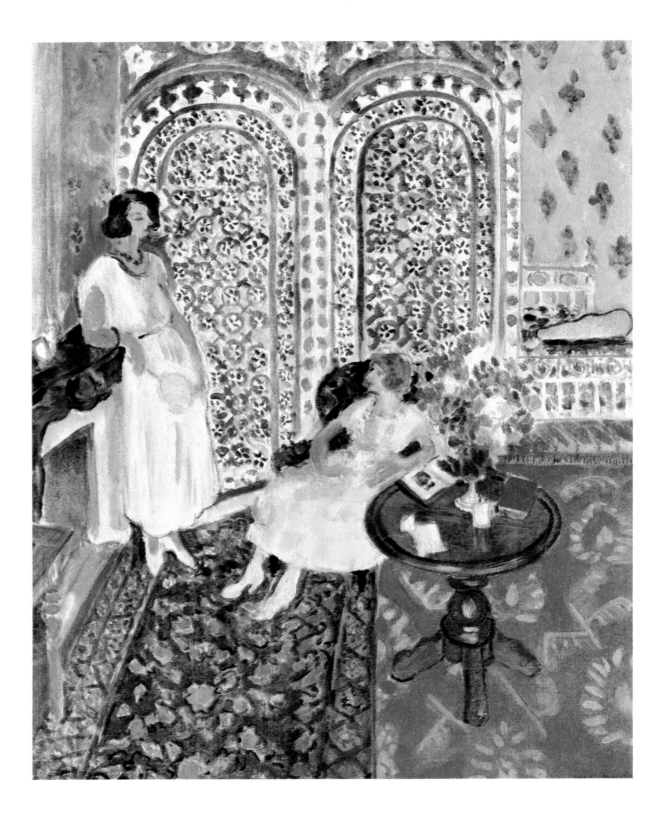

The Moorish Screen,
Nice, place Charles-
Félix, 1921–22; oil on
canvas; 98.8 × 74.3
cm (36¼ × 29¼ in);

The Philadelphia
Museum of Art,
bequest of Lisa Norris
Elkins. One of
greatest works of this

period, this canvas
also displays some
recurring
iconographic
elements in Matisse's

oeuvre, such as the
violin case on the
right and the books on
the table.

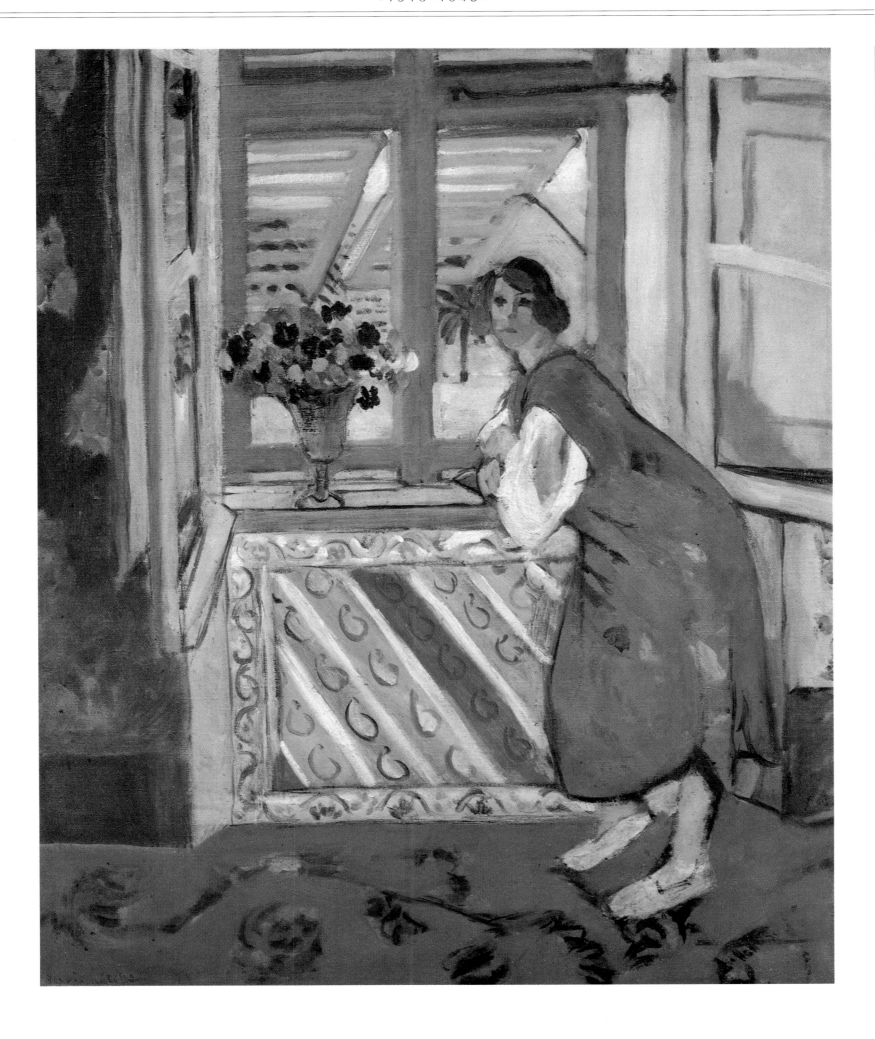

Interior at Nice: Young
Woman in a Green
Dress Leaning at the
Window, *Nice, place
Charles-Félix, 1921;*
*oil on canvas; 65 × 55
cm (25½ × 21⅝ in);
Colin Collection, New
York.*

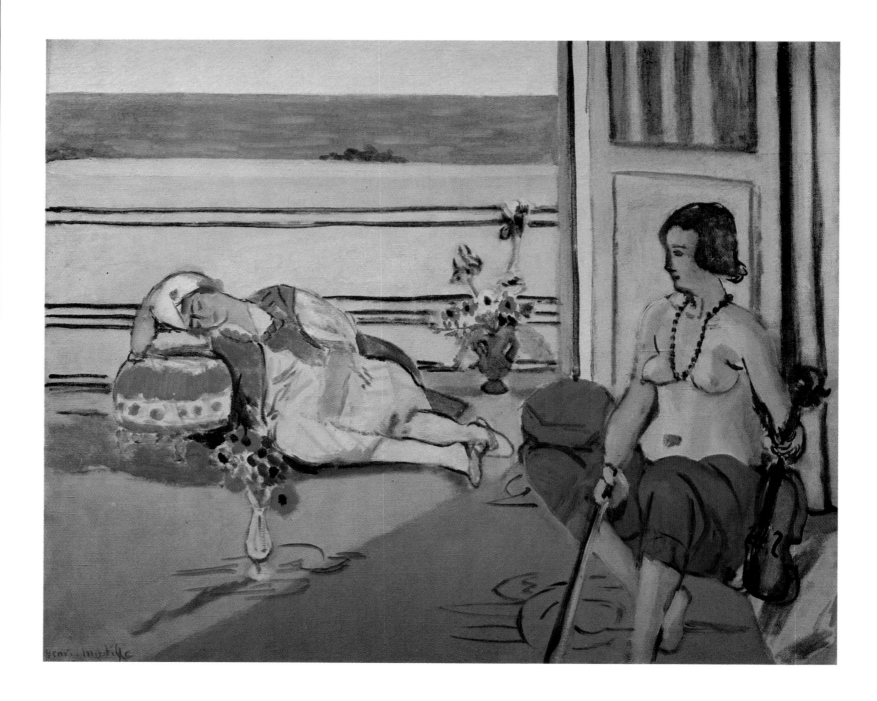

Two Odalisques (The Terrace), *Nice, 1921; oil on canvas; 81.3 × 101.6 cm (31¾ × 39½ in); Hester Diamond Collection.* "I do odalisques in order to do nudes. But how does one do the nude without it being artificial? And then, I do them because I know that they exist. I was in Morocco. I have seen them." *(Matisse's statements to Tériade, 1929).*

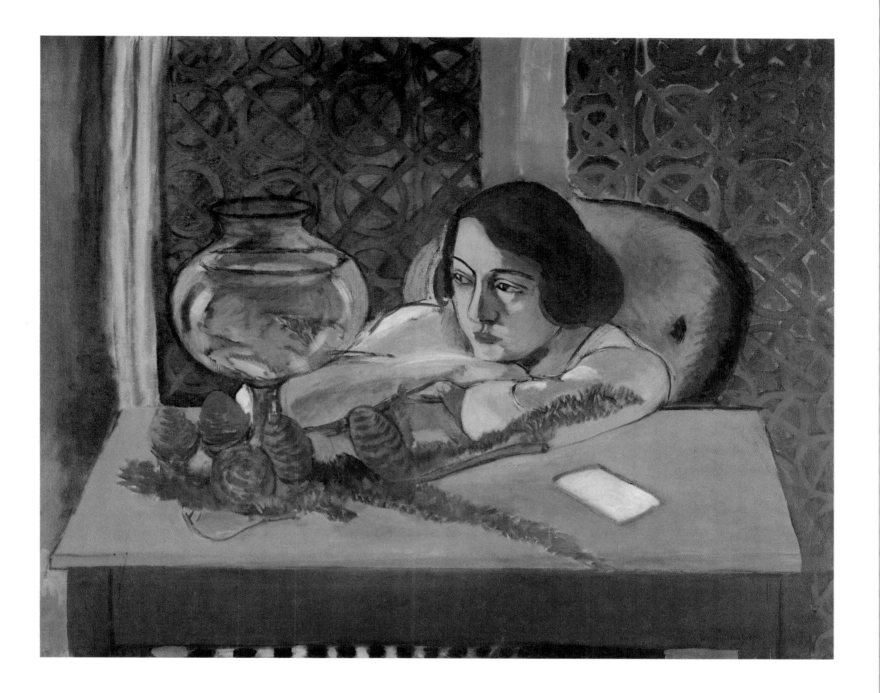

Woman before an Aquarium, *Nice, place Charles-Félix, 1921; oil on canvas; 81.3 × 100.3 cm (32 × 39½ in); The Art Institute, Chicago, Helen Birch Bartlett Memorial Collection. One of the chief events of this period was* *Matisse's meeting with Renoir, which took place in 1917. Matisse's return to a more consolidated pictorial tradition is without a doubt partly due to his admiration for the old Impressionist master.*

188

Woman Reading with
Peaches, *Nice, place
Charles-Félix, 1923;
oil on canvas;*
*12.7 × 17.2 cm
(4¾ × 6¾ in); Stephen
Hahn Collection.*

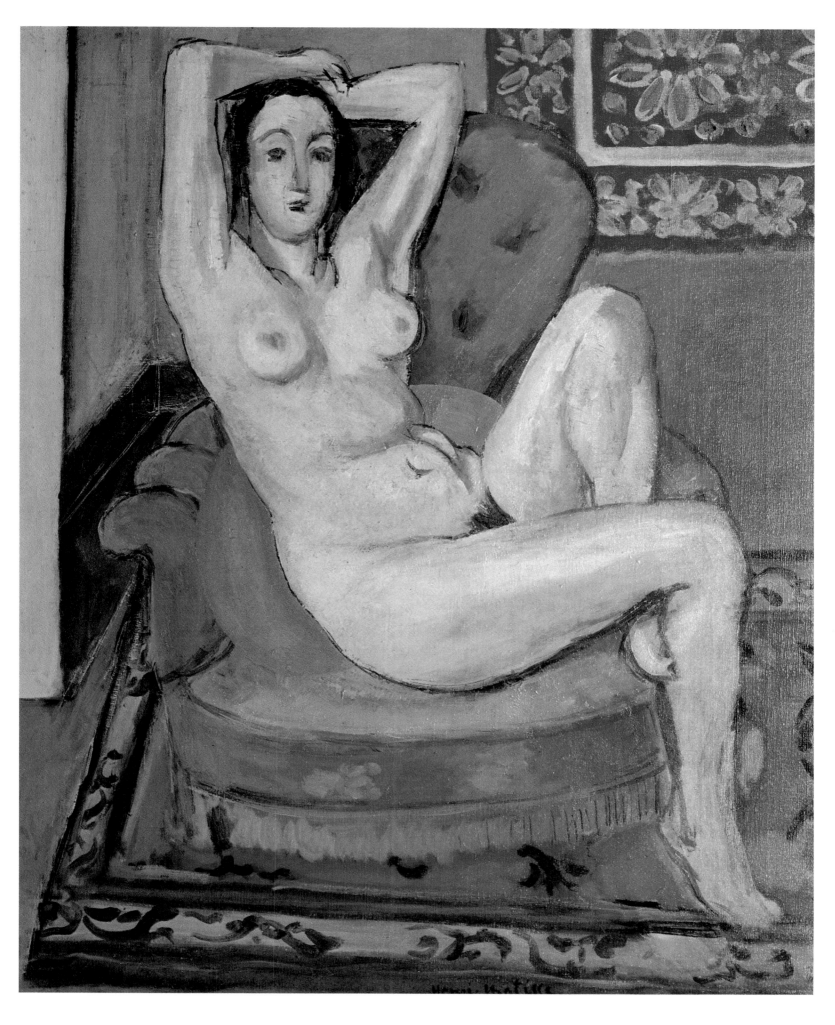

Nude with a Blue
Cushion, *Nice, place
Charles-Félix, 1924;
oil on canvas; 72 × 60
cm (28⅜ × 23¼ in);
Mr and Mrs Philip F.*

*Brody Collection, Los
Angeles. A female
nude with her arms
raised over her head
is a frequently
recurring motif in*

Matisse's oeuvre,
*depicted in
particular in
numerous drawings
and some sculptures,
such as* Standing

Nude, Arms on Head
(1904) and Venus in a
Shell I *(1930).*

190

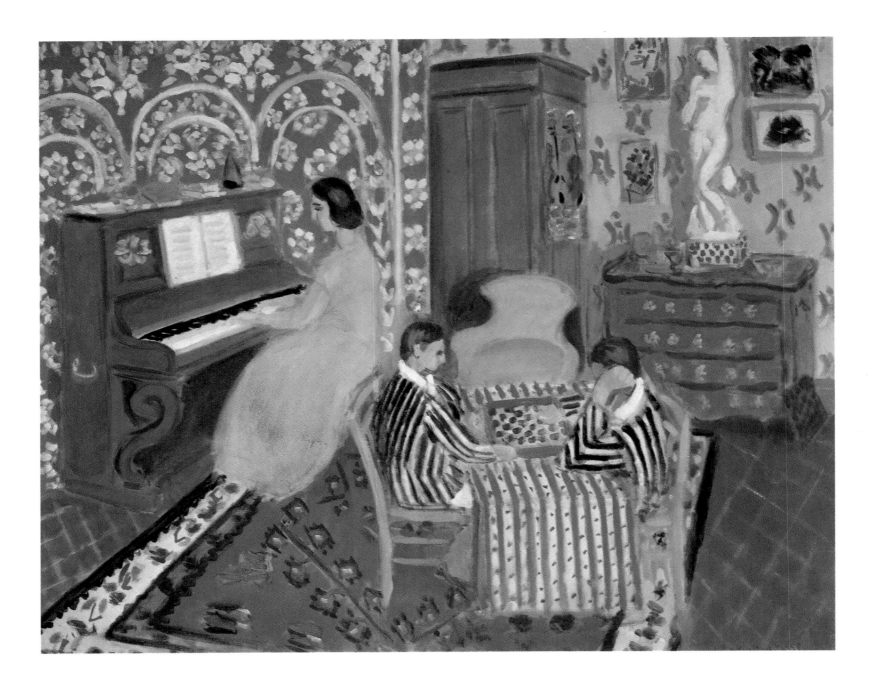

Pianist and Checker
Players, *Nice, place
Charles-Félix, 1924;
oil on canvas;
73.7 × 92.1 cm
(29¼ × 36⅜ in);
National Gallery of
Art, Washington D.C.,*
*Mr and Mrs Paul
Mellon Collection.
This interior he
recalls numerous
works Matisse
executed previously,
such as* The Piano
Lesson, The Music
Lesson *(1916 and
1917 respectively)
and* The Painter's
Family *(1911)*. Pianist
and Checker Players
*could even be
considered a
variation of* The
Painter's Family,
*which demonstrates
the evolution of
Matisse's concept of
décoration.*

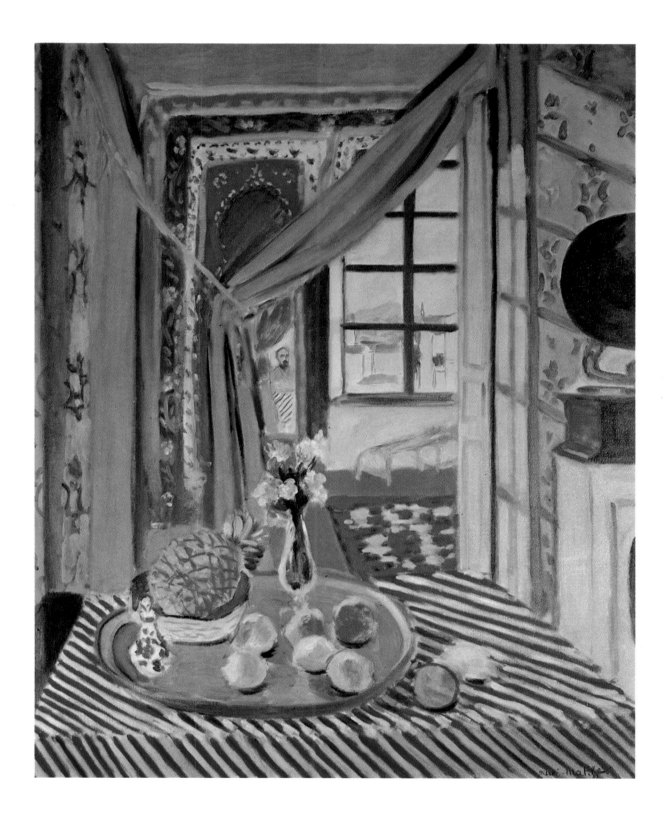

Interior with Phonograph, *Nice, place Charles-Félix, early 1924; oil on canvas; 100.5 × 81 cm (39⅝ × 31½ in);* *Private Collection. Matisse said in 1949: "The canvas must possess the power to generate light. This power exists when the* composition, placed in shadow, maintains its quality, and, placed in direct light, resists the sun's splendour." It is not difficult to find these qualities in the works executed in this period.

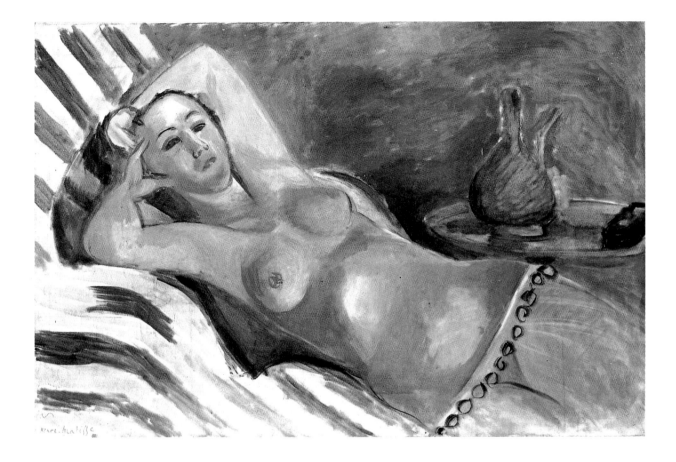

Above: Reclining Odalisque, *Nice, place Charles-Félix, 1925; oil on canvas; 81 × 117.5 cm (31½ × 45¾ in); Jan Krugier Gallery, Geneva.*

Opposite: Decorative Figure on an Ornamental Background, *Nice, place Charles-Félix, 1925–16; oil on canvas; 130 × 98 cm (51⅛ × 38⅝ in); Musée National d'Art Moderne, Centre Georges Pompidou, Paris. Besides its obvious qualities and* the fact that it marks the onset of a new phase in Matisse's development, this work also distinguishes itself because, as its title suggests, the figure itself is a decorative motif on an equal level with the fabric and its flowers.

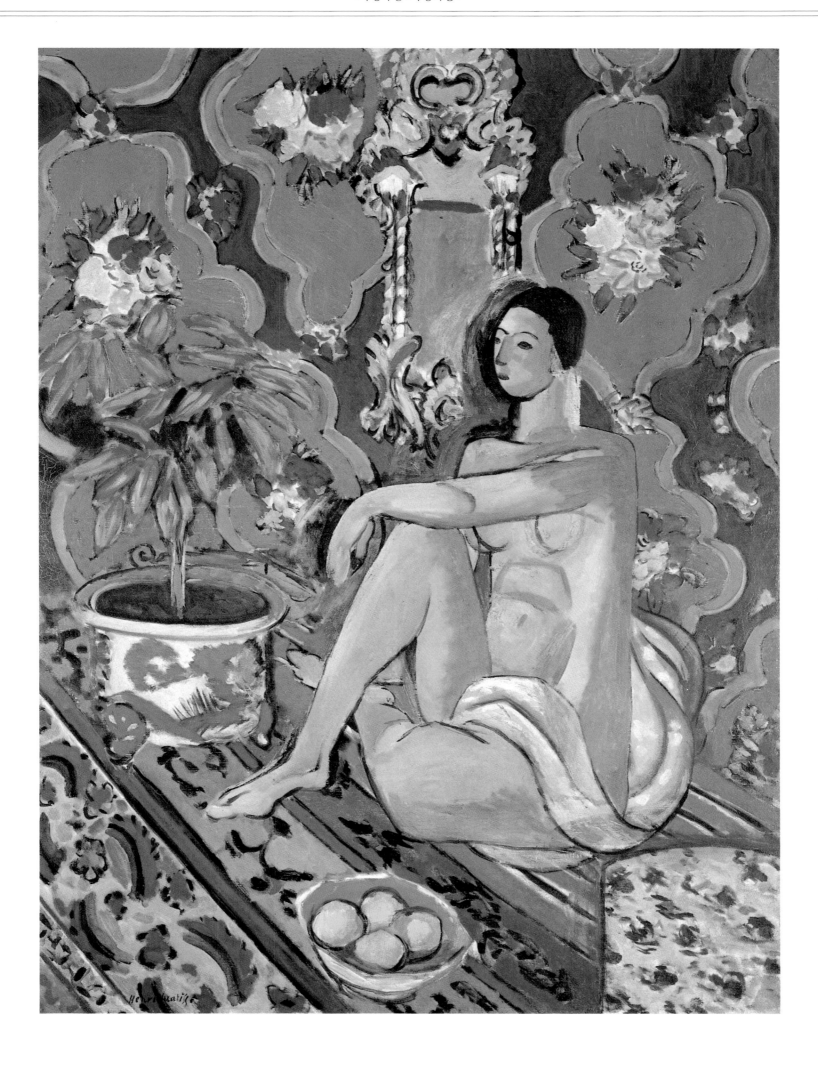

194

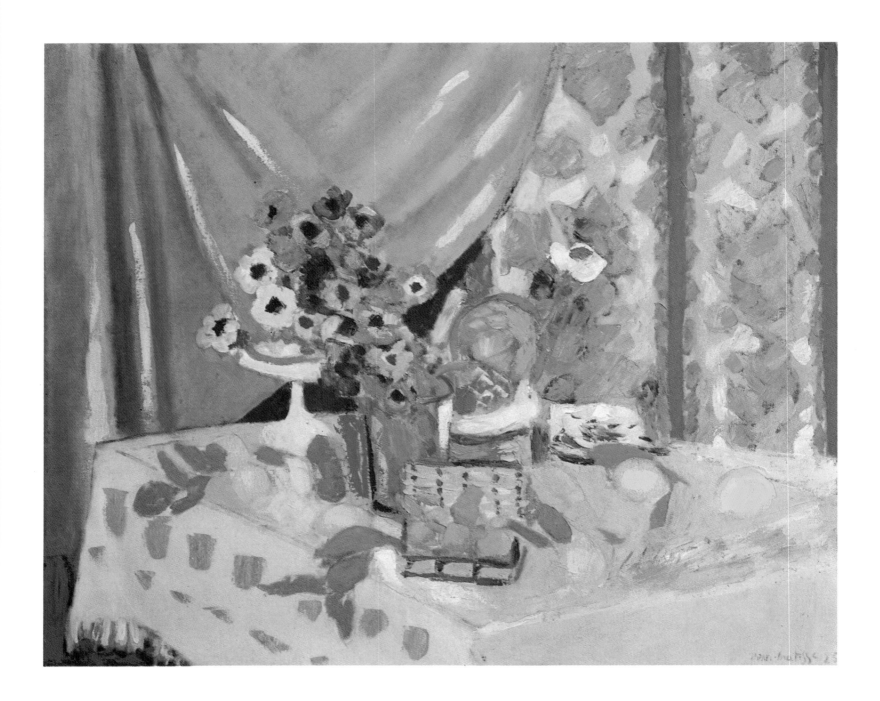

Above: Still Life: Pink Tablecloth, Vase of Anemones, and Pineapple, *Nice, place Charles-Félix, 1925; oil on canvas; 80 × 100 cm (31½ × 39⅜ in); Private Collection. In this work the apparent fidelity to* traditional sense perception is contradicted by many details that *show how Matisse used the subject as a mere pretext. Note also how the paintings executed in this period are extremely well* balanced; there are no areas in which the colour predominates over the other elements and the composition is rendered by means of the extraordinary relationship between the colours.

Opposite: Odalisque with a Tambourine, *Nice, place Charles-Félix, 1926; oil on canvas; 74.3 × 55.7 cm (29¼ × 21⅞ in); Museum of Modern Art, New York, The William S. Paley Collection.*

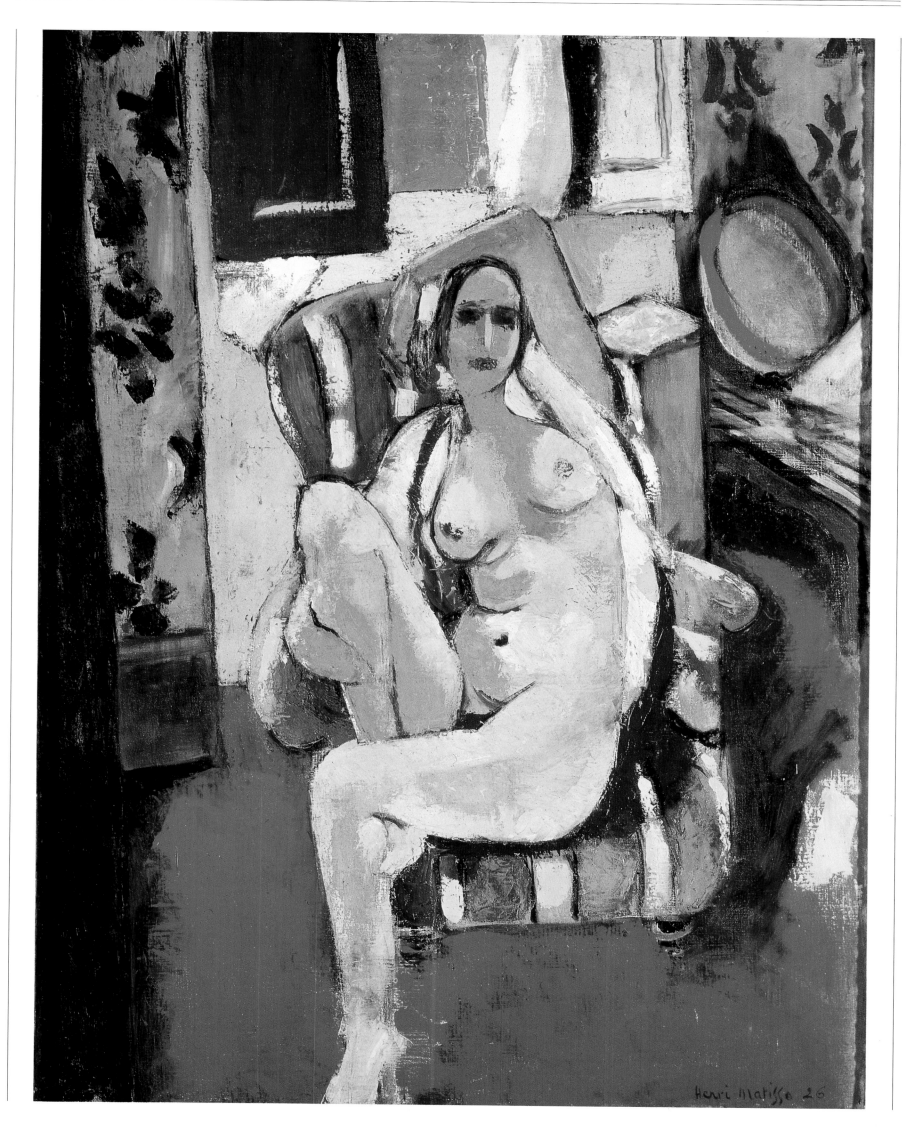

196

Opposite above:
Odalisque with a Red
Coffer, *Nice, place
Charles-Félix, 1927;
oil on canvas; 50 × 65
cm (19½ × 25⅓ in);
Musée Matisse, Nice.*

Opposite below:
Reclining Nude, Seen
from the Back, *1927;
oil on canvas; 65 × 92
cm; Private
Collection. Matisse
made the following
statement to the art
critic Florent Fels in
1925: "The simpler
the means, the easier
it is for the artist to*

meet the needs of his
temperament, and
together with this, of
his plastic ideal.
Because the role of the
artist is solely that of
taking in current
truths, of isolating
commonplaces which,
through him, take on
a profound, new and
definitive meaning."

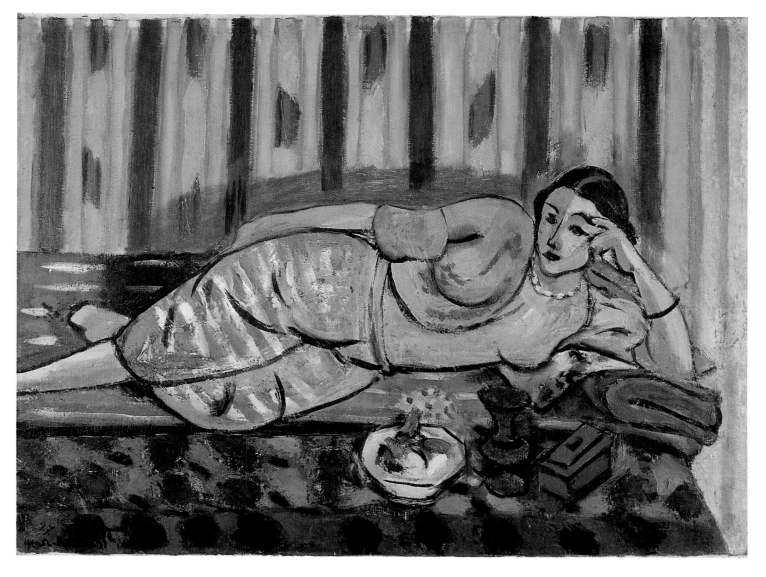

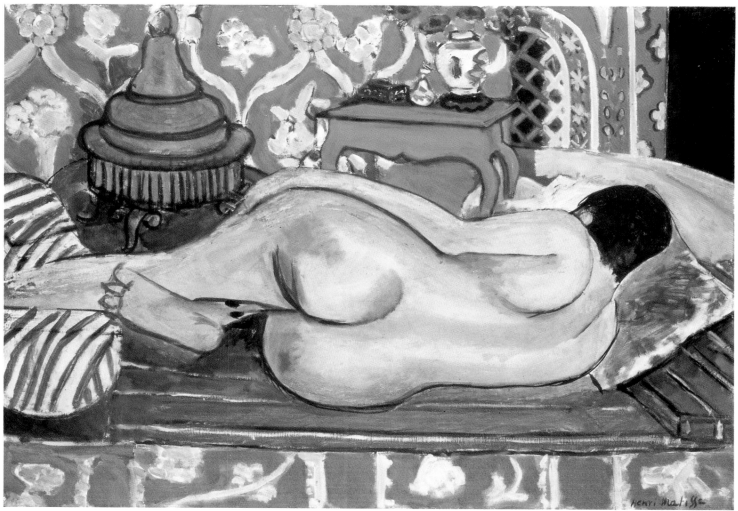

198

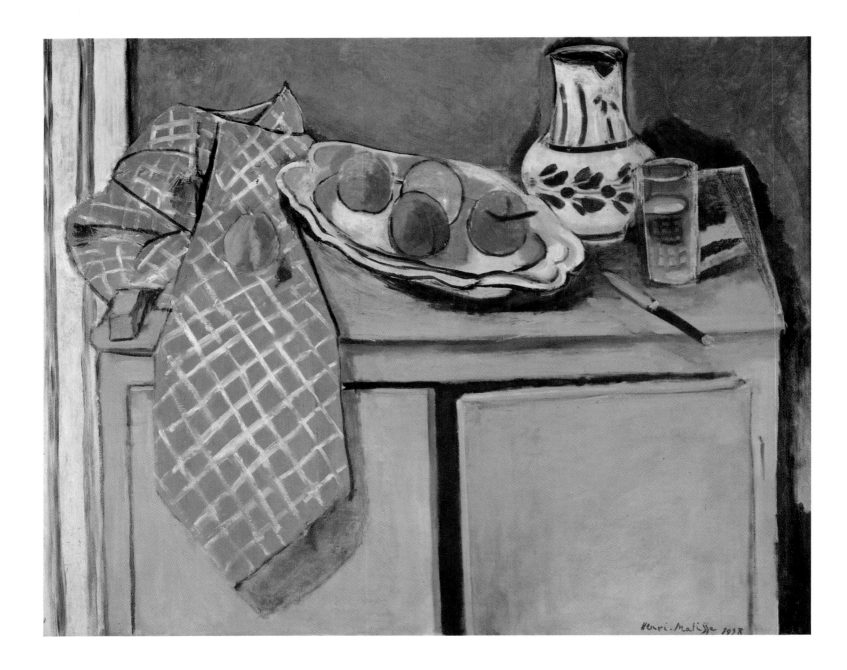

Above: Still Life on a
Green Sideboard, *Nice,
place Charles-Félix,
1928; oil on canvas;
81.5 × 100 cm
(32⅛ × 39⅜ in); Nusée
National d'Art
Moderne, Centre
Georges Pompidou,
Paris. This is new
conception of the
theme of still life: the*
cloth on the left and
the plate of apples are
still inspired by
Cézanne, or rather,
by a filtering of his
influence; the carafe
seems to hark back to
the one in Pink Onions
(1906), while the
knife in an homage to
traditional still lifes.

Opposite: Woman with
a Madras Hat, *Nice,
place Charles-Félix,
1929–30; oil on
canvas; 180 × 152 cm
(70⅞ × 59⅞ in);
Private Collection.*

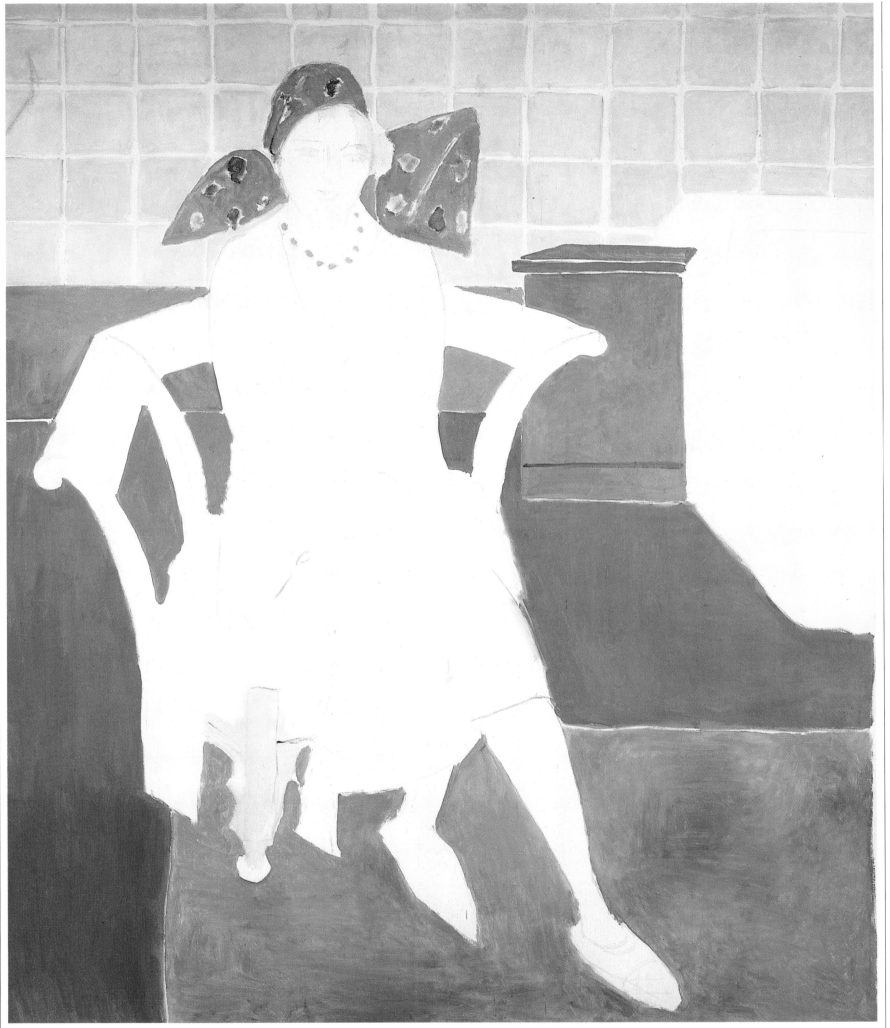

200

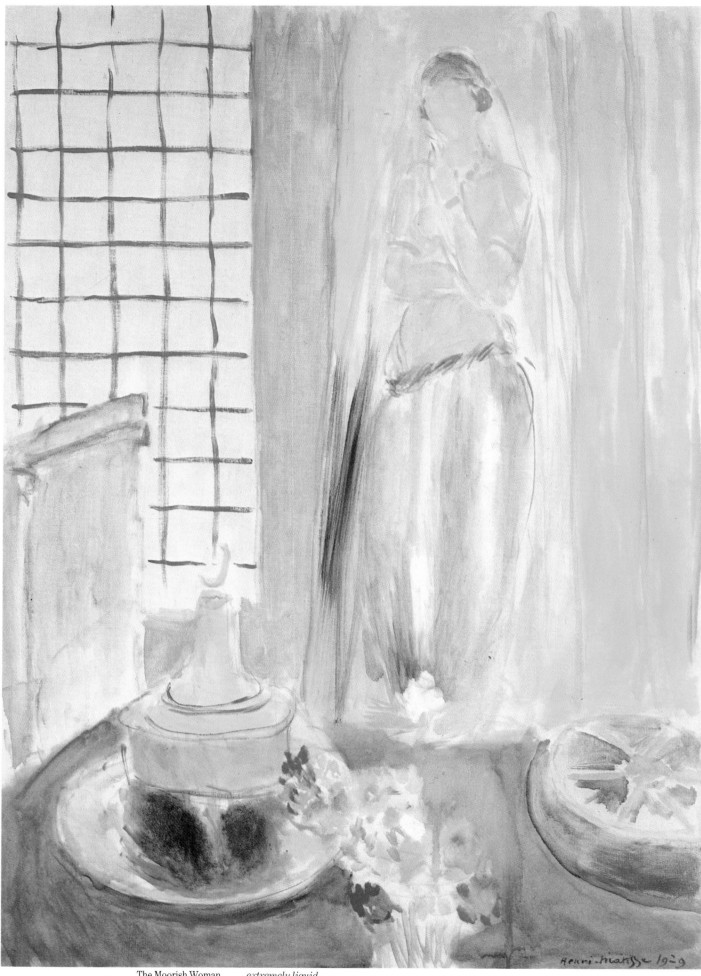

The Moorish Woman,
Nice, place Charles-
Félix, 1929; oil on
canvas; 92 × 65 cm
(35¾ × 25¼ in);
Private Collection. In
the second half of the
1920s certain works
of Matisse have
extremely liquid
colours and are
characterized by a
synthesis of forms
that almost seems to
act as a contrast to
the exaggerated
ornamental nature of
the Nice paintings.

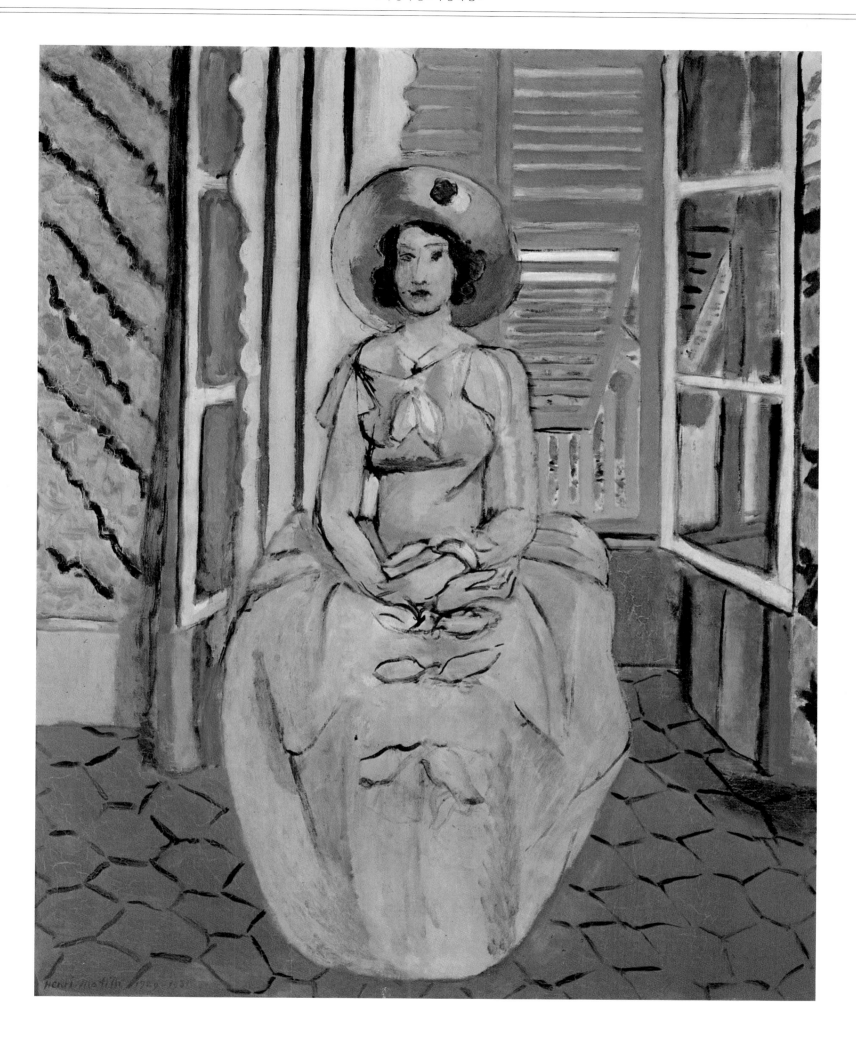

The Yellow Dress,
Nice, place Charles-
Félix, 1929; oil on
canvas; 99.7 × 80.7
cm (39¼ × 31¾ in);

*The Baltimore
Museum of Art, The
Cone Collection,
formed by Dr Claribel
Cone and Miss Etta*

Cone of Baltimore,
Maryland. The Cones
were among the most
important collectors
of Matisse's works,

and their collection
greatly enhanced the
Baltimore Museum.

202

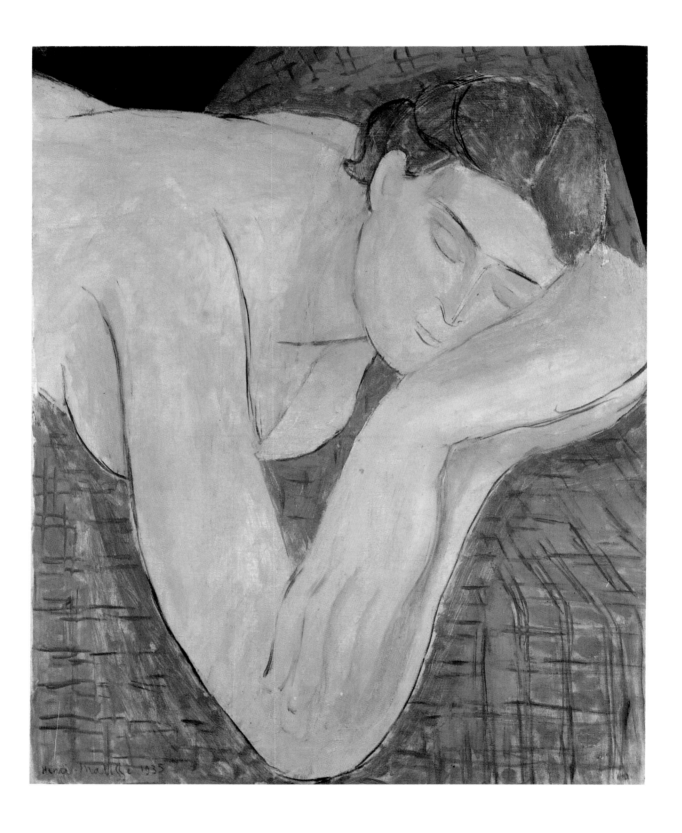

The Dream, *Nice,*
place Charles-Félix,
early April-mid May,
1935; oil on canvas;
81×65 cm (31⅞×25⅝
in); Musée National
d'Art Moderne,
Centre Georges
Pompidou, Paris.

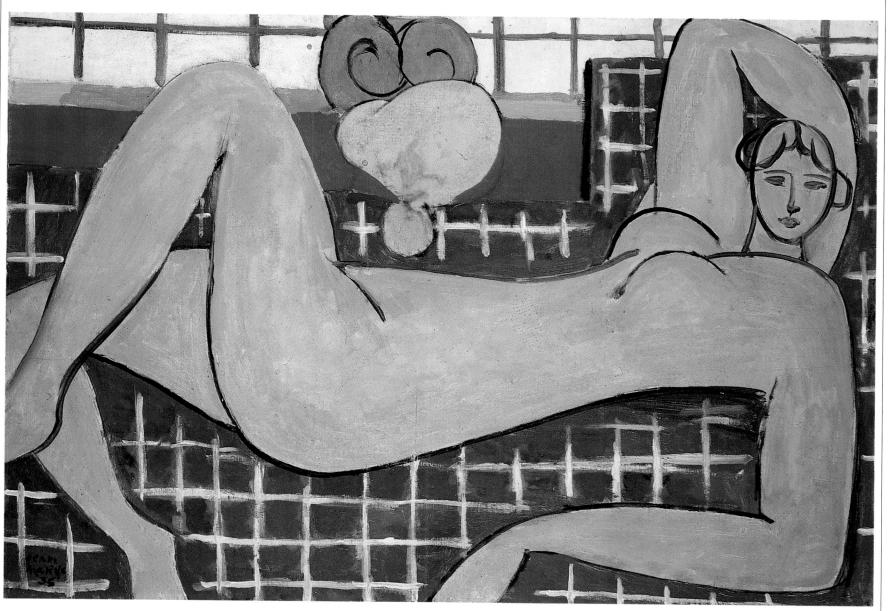

Large Reclining Nude/ The Pink Nude, *Nice, place Charles-Félix, April-October 1935; oil on canvas; 66 × 92.7 cm (26 × 36½ in); The Baltimore Museum of Art, Cone Collection, formed by Dr Claribel Cone and Miss Etta Cone of Baltimore, Maryland. After* The Dance, *executed from 1930 to 1933 for the Barnes Foundation, Matisse once again moved into a new phase characterized by markedly synthetic forms, the flat application of colours and clear-cut drawing that reached its height in the paper cut-outs.*

204

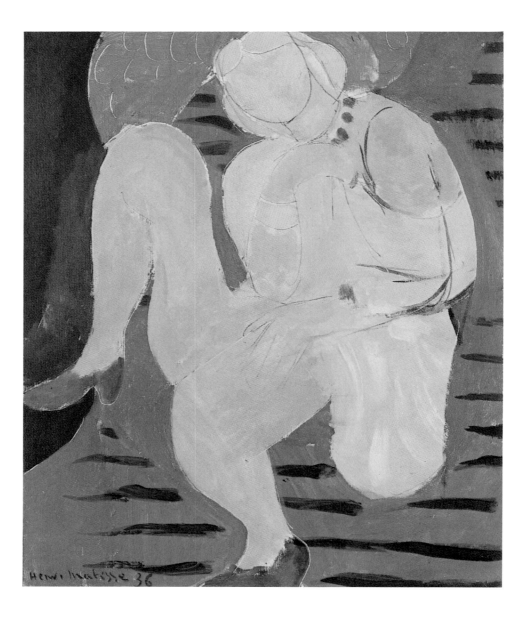

Above: Nude Woman
on a Blue Background,
*Nice, 1936; oil on
canvas; 46 × 38 cm
(17¾ × 14¾ in);
Private Collection.
The forms of the body
and face here become
a pretext for a pure
play of arabesques; in
this period Matisse
was "drawing in
colour," which he saw
as one of the aims of
his work.*

Opposite: Seated Pink
Nude, *Nice, place
Charles-Félix, 1935;
oil on canvas; 92 × 73
cm (17¾ × 28½ in);
Private Collection.
The various stages of
Matisse's oeuvre are
often documented by
photographs taken
while he was working
which show the
difficulty and labour
involved in the
creation of such
apparently simple
paintings.*

206

Nymph in the Forest, Nice, place Charles-Félix, and Nice-Cimiez, Hôtel Régina, 1935–42; oil on canvas; 242 × 195 cm (92¼ × 76¾ in); Musée Matisse, Nice. The subject of this work was inspired by a poem by Mallarmé. In 1931 Matisse did some etchings to illustrate an edition of Mallarmé's Poésies that was published the following year.

Reclining Nude Seen from the Back, *Paris, July 1938; charcoal on paper; 60 × 81 cm (23⅝ × 31⅞ in); Private Collection. Drawing always played a central role for Matisse; he used it to experiment with the relationships between the forms and the two-dimensional surface. Drawings were therefore not mere studies, but self-sufficient creations, as can be seen in the one reproduced above.*

208

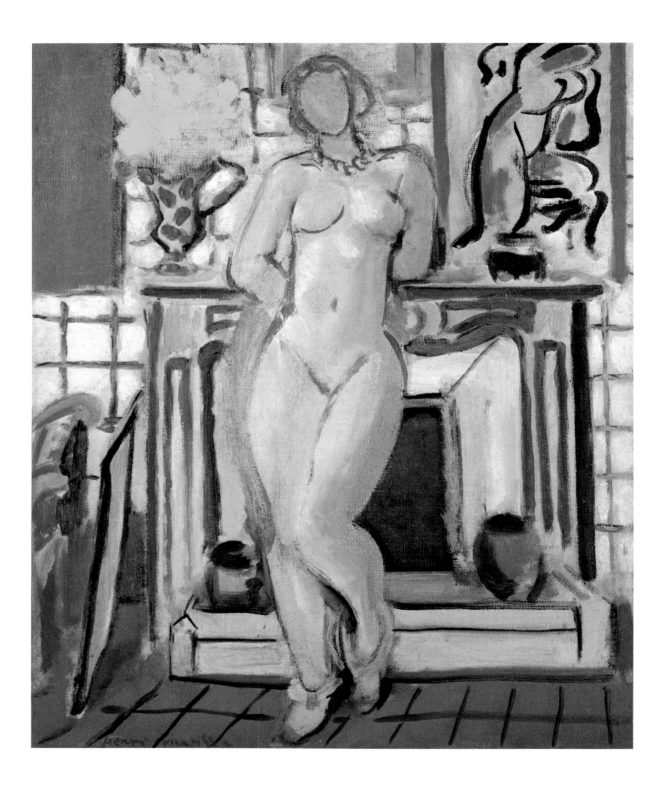

Above: Nude Standing at the Mantelpiece, *Nice, place Charles-Félix, 1936; oil on canvas; 46 × 38 cm (17⅞ × 14¾ in);* Private Collection. *This work could be considered a synthesis of Matisse's pursuit of essentiality* during this period coupled with the wealth of pictorial motifs that characterized his works in the 1920s.

Opposite: Window at Tahiti, *Nice, 1935–36; oil on canvas; 225 × 172 cm; Musée Matisse, Nice. This painting was based on an etching Matisse did in 1931. He had planned to use the same image for a tapestry, but the* project was abandoned. Matisse went to Tahiti in 1930, but only many years later did he manage to transfigure the extraordinary light of the island in his works.

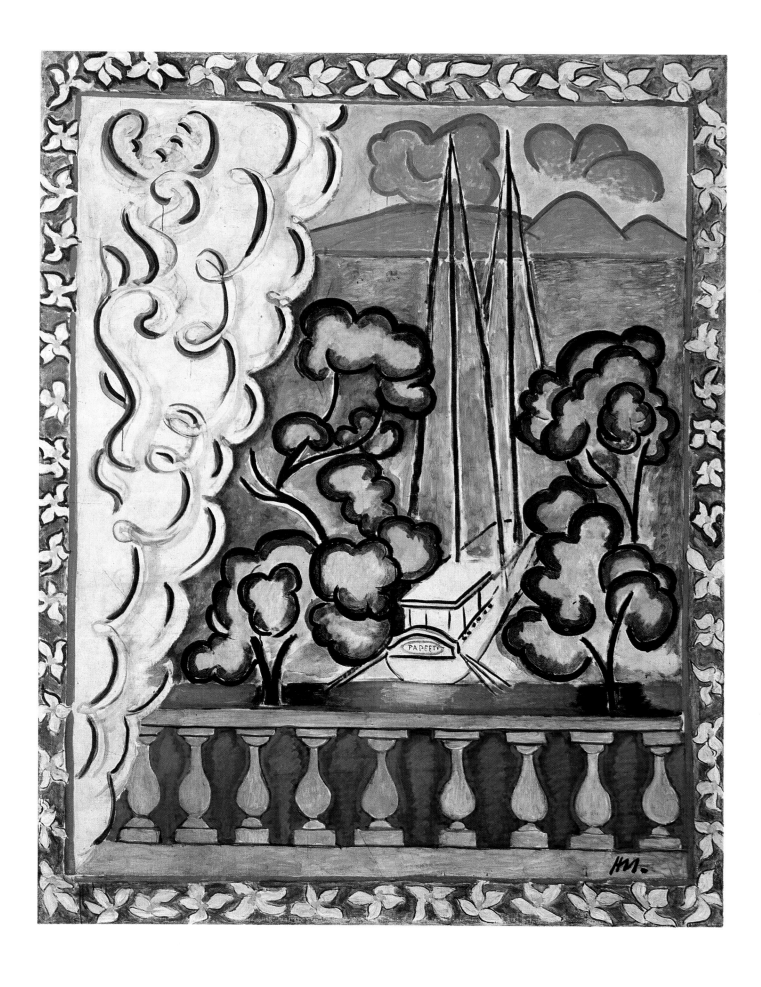

210

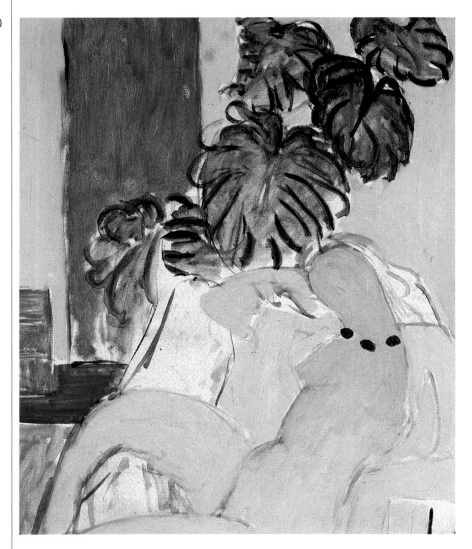

Above left: Nude with Armchair and Foliage, Sketch, *Nice-Cimiez, Hôtel Régina, 1936–37; oil on canvas; 72.5 × 60.5 cm (28¼ × 23½ in); Musée Matisse, Nice.*

Above right: Nude, *1942; charcoal on paper; Private Collection. One can still note the transition from the odalisques of the 1920s to the nudes of this period. The* subject is virtually the same, as are the poses and, presumably, the setting and furniture; what has changed is Matisse's approach to representation.

Opposite: The Striped Dress, *Nice, place Charles-Félix, 15 and 26 January 1938; oil on canvas; 46 × 38 cm (18⅛ × 14⅞ in); Private Collection, Liechtenstein.*

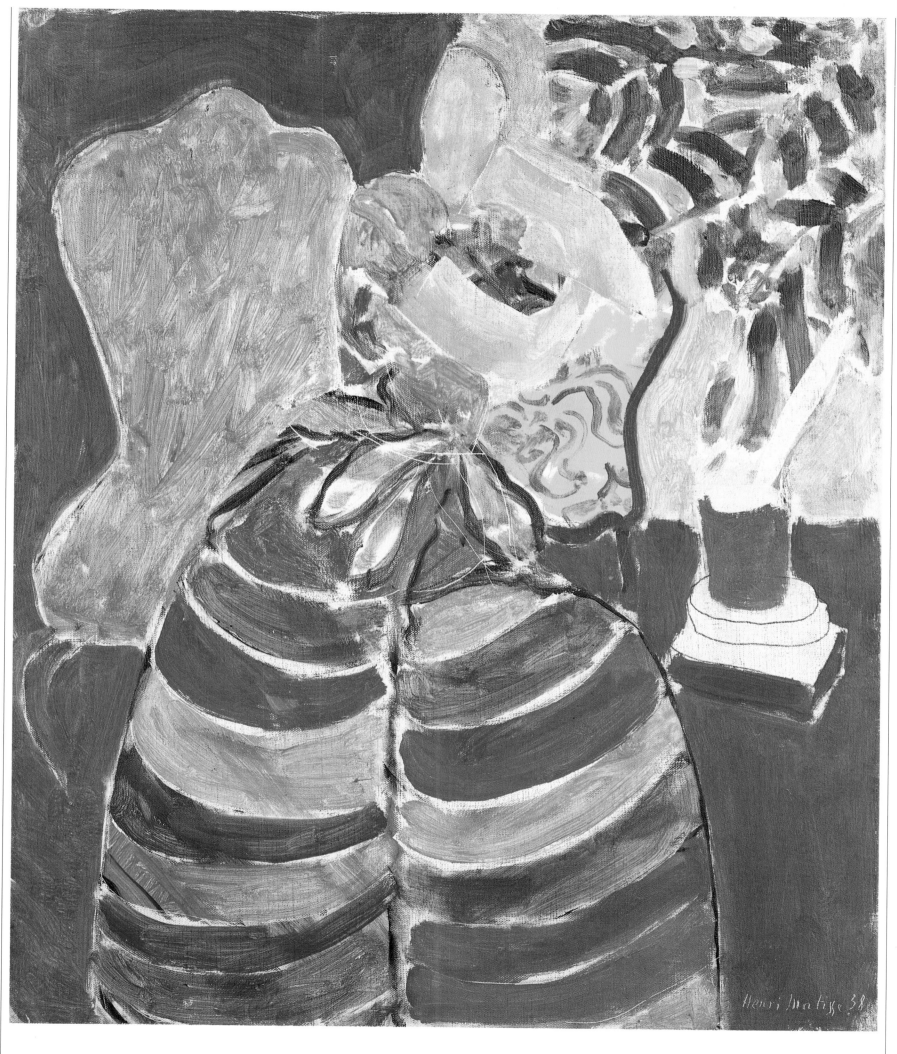

212

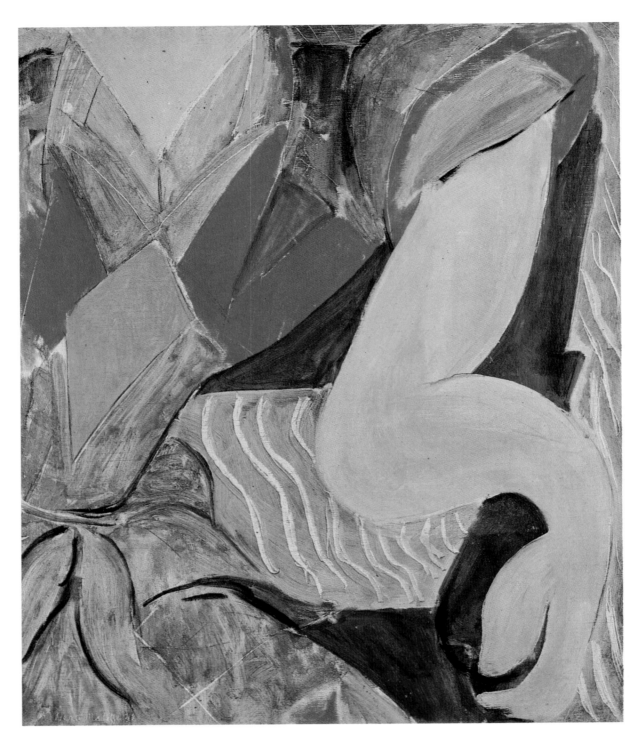

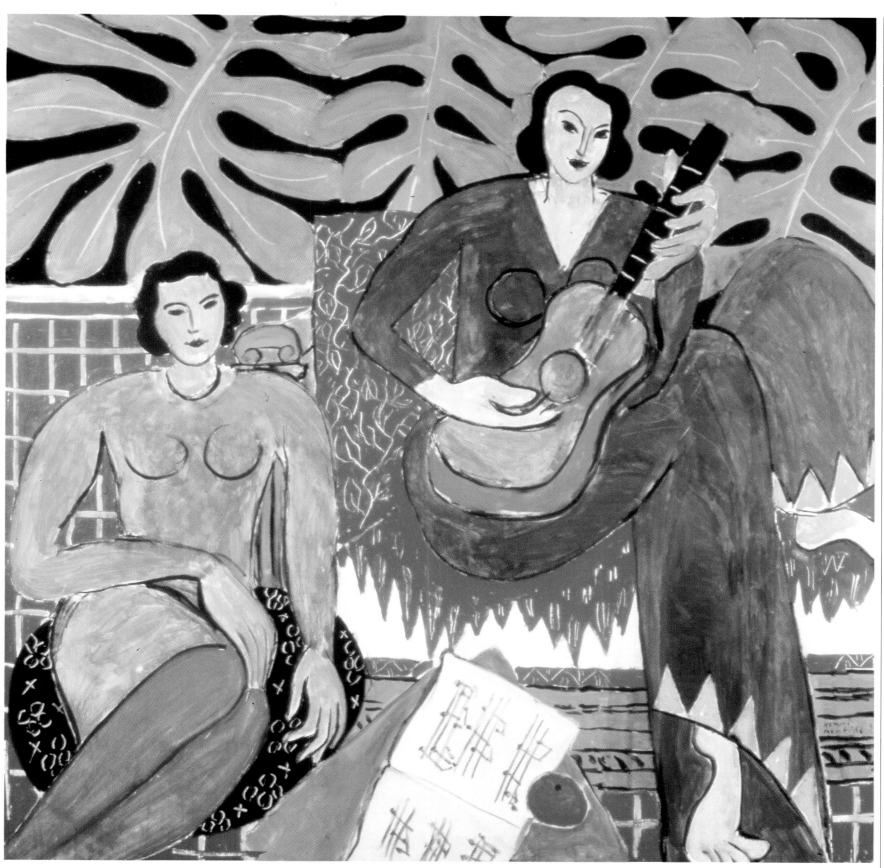

Opposite above: The Arm, *Nice, place Charles-Félix, January-June 1938; oil on canvas; 46 × 38 cm (18¹⁄₈ × 14⁷⁄₈ in); Private Collection, Switzerland.*

Opposite below, left: Legs with Anklets, *1925; pen on paper; 25.2 × 31.5 cm (9¾ × 12¼ in); Private Collection.*

Opposite below, right: Legs, *1935; pencil on paper; 26 × 32.7 cm (10 × 12¾ in); Private Collection.*

Above: Music, *Nice-Cimiez, Hôtel Régina, March-April 1939; oil on canvas; 115.2 × 115.2 cm (45⅜ × 45⅜ in); Albright-Knox Art Gallery, Buffalo, Room of Contemporary Art Fund. The theme of music is a veritable leitmotiv in Matisse's oeuvre. Compare this work with the others of the same title executed in 1910 and 1916–17.*

214

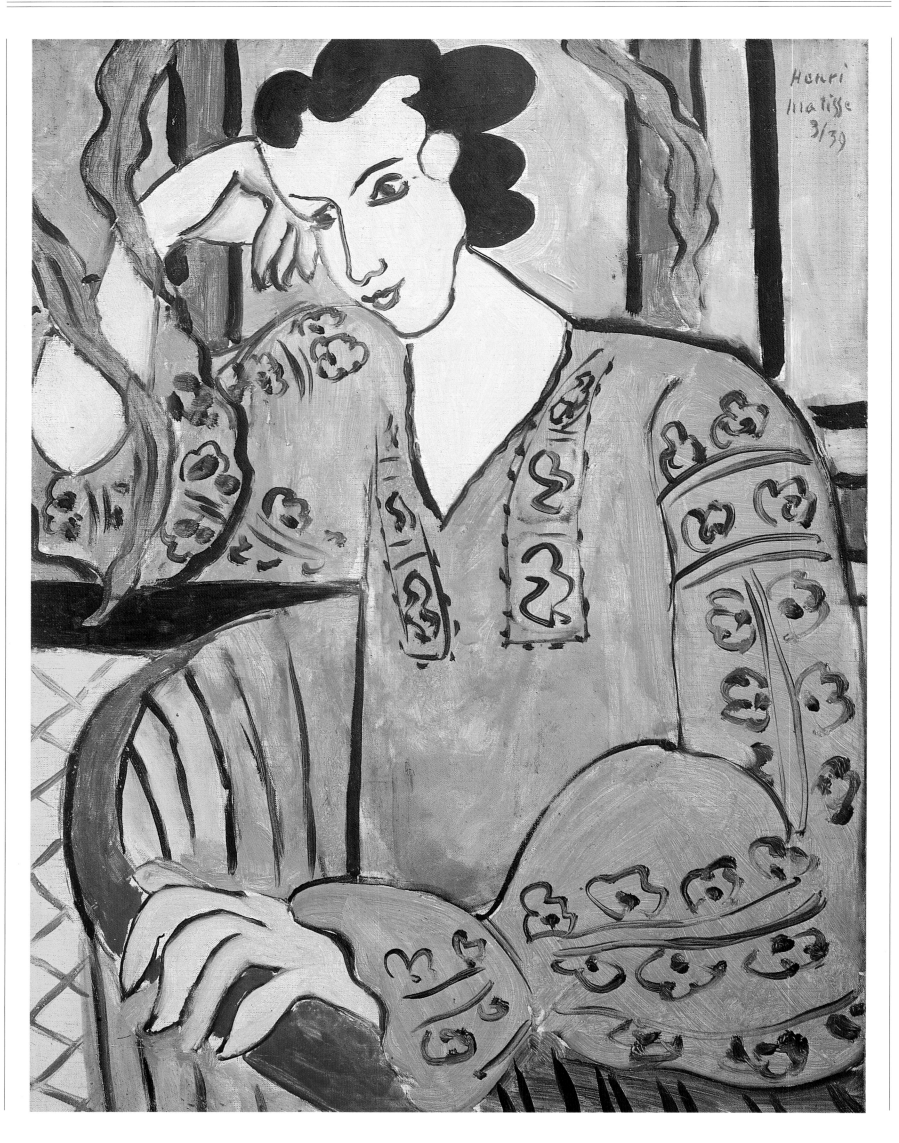

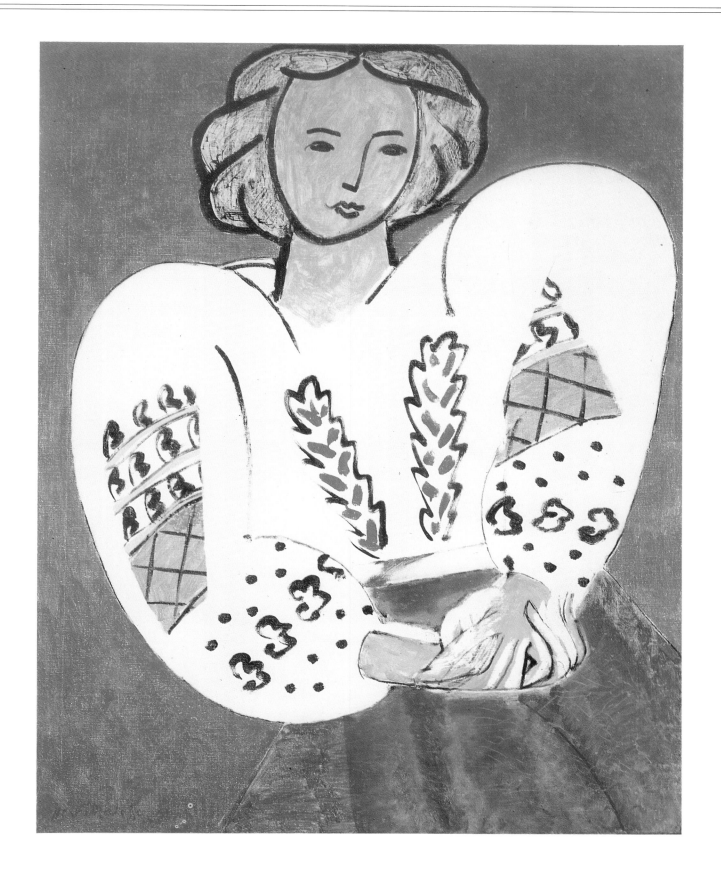

Opposite: Green
Rumanian Blouse,
*Nice-Cimiez, Hôtel
Régina, March 1939;
oil on canvas; 61 × 46
cm (24 × 18⅛ in);
Private Collection,
Switzerland.*

Above: The Rumanian
Blouse, *Nice-Cimiez,
Hôtel Régina, 1940;
oil on canvas; 92 × 73
cm (36¼ × 28¾ in);
Musée National d'Art
Moderne, Centre
Georges Pompidou,
Paris.*

216

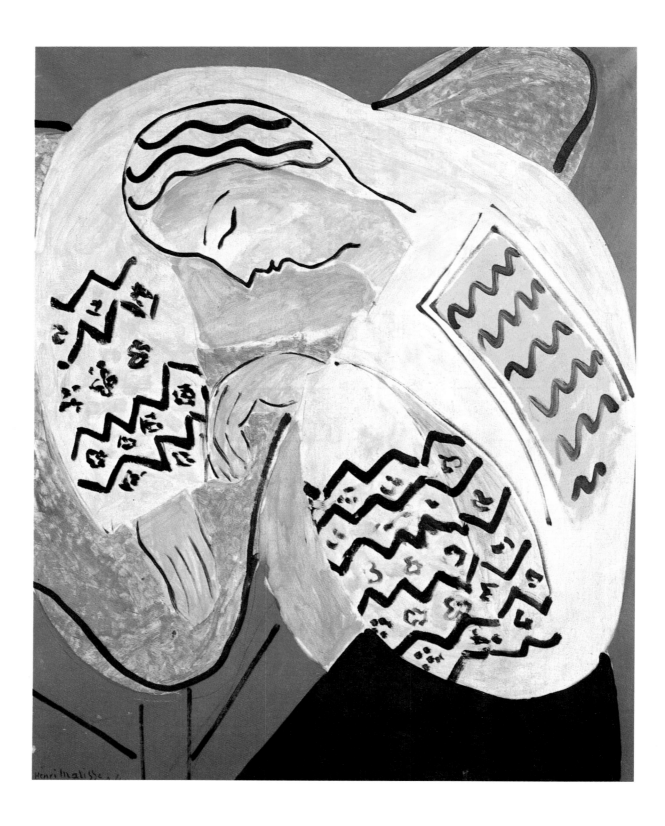

The Dream, *Nice-Cimiez, Hôtel Régina, 1940; oil on canvas; 81 × 65 cm (31⅞ × 25½ in); Private Collection. Matisse wrote the following to* his son Pierre in 1940: "So this picture [. .] has become an angel sleeping on a violet surface – the loveliest violet I've ever seen – her flesh is pink, pulpy and warm like a flower – and as for the clothes, the blouse is a pale and very very tender periwinkle blue, and the skirt a caressing emerald green (with a bit of white in it), all sustained by a shiny jet black."

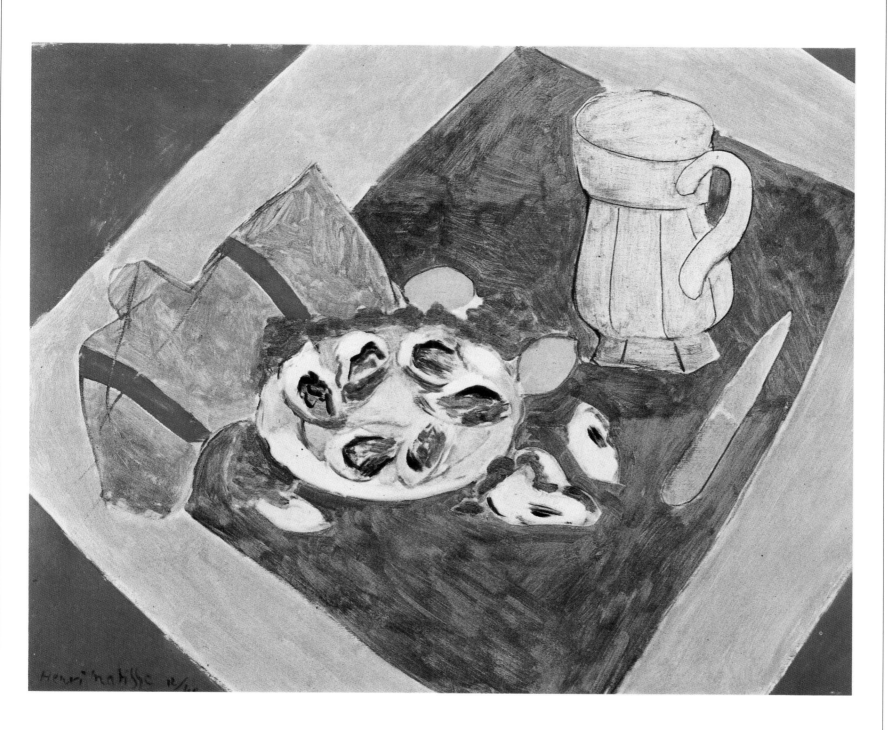

Still Life with Oysters, Nice-Cimiez, Hôtel Régina, December 1940; oil on canvas; 65.5 × 81.5 cm (25¾ × 32 in); Kunstmuseum, Basle. Matisse said to Pallardy in 1940: "[..] So I have been schooling myself to keep within the bounds of a less extraordinary, less spiritual conception, and I have moved closer to the substance of things. To accomplish this I've painted some oysters – there my dear friend, tasty sensations are necessary – it's essential that in a picture an oyster be itself a litte, that it be a bit the Dutch rendering."

218

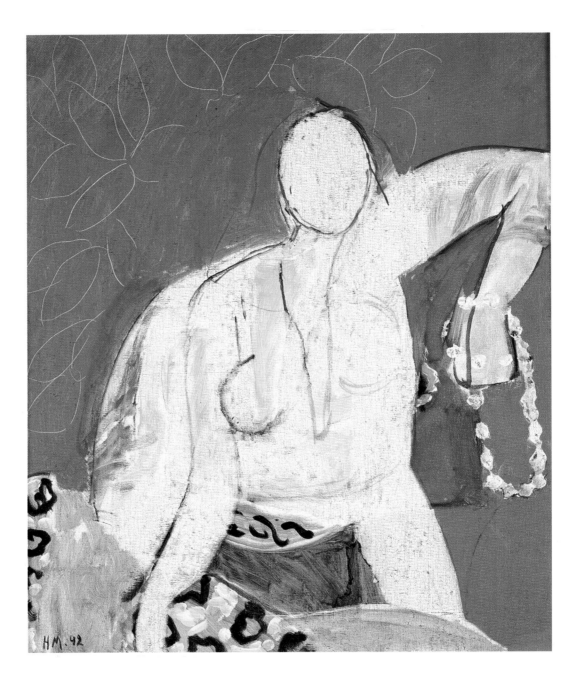

Young Woman with a Pearl Necklace, *Nice-Cimiez, Hôtel Régina, 1942; oil on canvas; 62 × 50 cm (24 × 19½ in); Private Collection. In 1942 Matisse said* that he wanted to achieve in painting what he had already managed to achieve in drawing: "a blossoming after fifty years of effort."

Sleeping Woman,
Nice-Cimiez, Hôtel
Régina, 1941; oil on
canvas; 59 × 72.5 cm
(23 × 28 in); Musée
Matisse, Nice. This
motif recurs in
Matisse's works from
the mid 1930s on.
Here we have a
demonstration of the
remarkably felicitous
results Matisse was
able to achieve by
merging drawing
and painting.

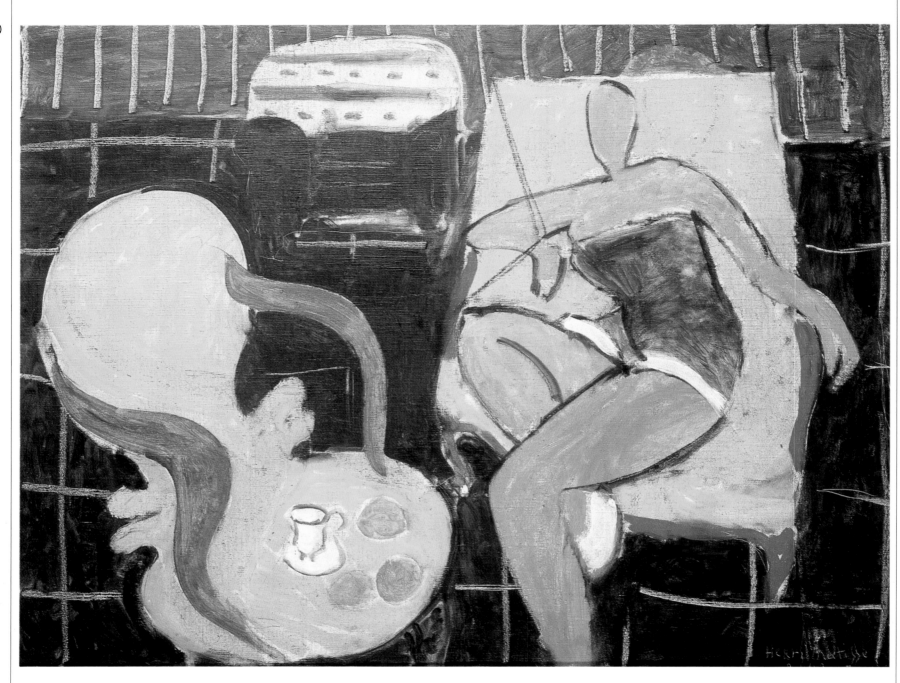

Above: Dancer and Rocaille Armchair on a Black Background, *Nice-Cimiez, Hôtel Régina, September 1942; 50.8 × 65 cm (20 × 25½ in); Private Collection. This work is part of a series in* which the human figure and the armchair play equally important roles in the overall rendering. It once belonged to Marcel Duchamp.

Opposite above: The Painting Session, *1942; oil on canvas; 54 × 73 cm (21 × 28½ in); Private Collection.*

Opposite below: The Drawing Session, *1944; pen on paper; 40.5 × 57.5 cm (15⅞ × 22¼ in); Matisse Archives.*

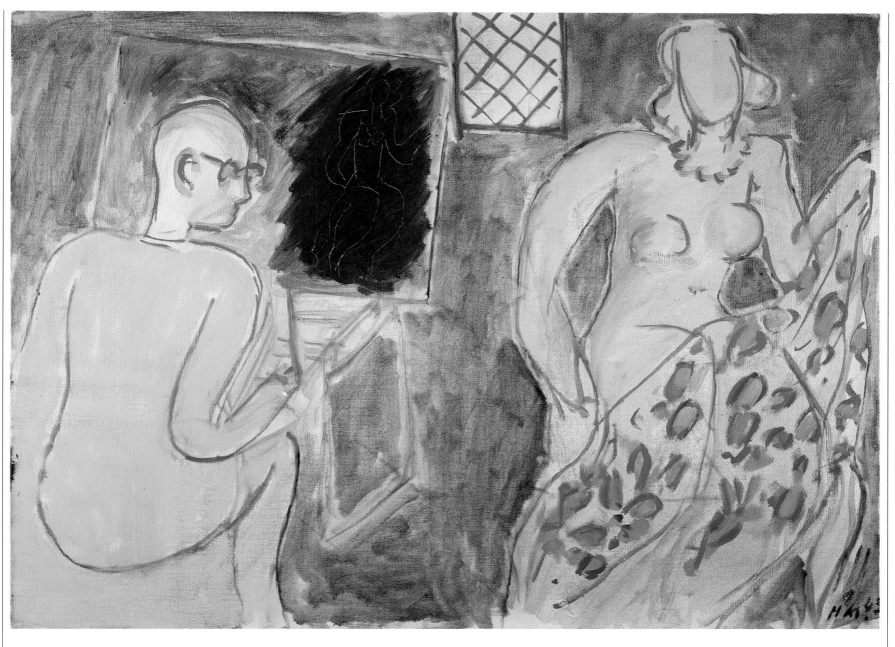

Paper Cut-Outs and Large Decorations

The final phase of Matisse's oeuvre is far from being a summing up and a celebration of a highly eventful career that, from the 1930s on, was marked by unanimous recognition and acclaim from art critics and a vast public. On the contrary, these were years of new discoveries that were carried through in a relatively short time, years characterized by an extraordinary, impassioned quest for new and original techniques. This creative outburst was solitary, far removed from the most important artistic movements of the time, but so far-reaching and meaningful that it proved to be a vital influence for them.

Two events characterize this period: Matisse's "discovery" of the paper cut-out and his investigation into its expressive potential, and the decoration of the Chapel of the Rosary at Vence, which can be considered as a kind of spiritual testament.

The paper cut-out medium made its appearance in the late 1930s, when Matisse was designing the costumes for the ballet *Red and Black (The Strange Farandole)*, which was first performed in 1939. It developed through the fundamental experience of the book *Jazz*, which Matisse conceived in 1930, composing both the texts and images, and which was published only in 1947. And this new art form reached its peak in the *gouaches découpées*, produced between 1944 and 1947.

The paper cut-out technique seems to be related to that of collage, but Matisse's aims and the results he obtained were quite different. For by means of this medium, which one could say he invented since there are no historical precedents, Matisse set

himself the basic goal of "drawing in colour." That is to say, he wanted to reduce his artistic tools to a minimum in order to avoid interfering with the purity of colour through the natural subjective, individualistic nature of drawing rooted in the realistic tradition of art. This elementary technique – which, in its simplicity and return to a childlike procedure, may be conceptually compared not so much to the collage as to the frottage that Max Ernst utilized in the 1920s – allowed Matisse to make a clean break: he could now treat the surface and the composition in total freedom and seek the correct balance between colours, lights and forms without being bridled by the action of the hand on the canvas. In its purity of colour and outline – so alien to the procedures of shading and modelling characteristic of traditional painting – this medium also takes into account an extremely common aspect of contemporary visual and graphic art: the "symbolic" communicability typical of posters, including commercial ones. If one of the principal aims of Matisse's career was to bring painting back to the surface and affirm its basic two-dimensional nature, the gouaches were undoubtedly the culminating point of this endeavour. It is the absence of pictorial material, the placing of flat forms on to the surface like pieces of a jigsaw puzzle and the consequent lack of any indication that might lead us to think that the artist intended to render depth to the individual forms, that bespeak the necessity of this technique and its perfect correspondence to Matisse's aesthetic. His vision was based on another fundamental concept – the relationship among the individual

elements of the composition. This aspect is also highlighted in the paper cut-outs, since it is only through the essential balance between form and colour that the work can express all the aspects of painting that seem to be negated by the very choice of this expressive means.

The last feature that allows us to consider *The Swimming Pool*, *The Wave* and the *Blue Nudes* the zenith and at the same time the summing up of Matisse's art, is the accentuation and definition, through new procedures, of their decorative value. This is perhaps the most explicit feature of these works, and here again we must refer to the basic elements in Matisse's conception of decoration, its potentially infinite development over the surface, and those dialectical pairs he plays with on a parallel level, alternating their importance as the occasion demands: movement and immobility, simplicity and redundancy, reality and abstraction. These are dialectical, not opposing pairs. Matisse's entire oeuvre clearly demonstrates this, as do these last works, in which the concept of continuity of the decorated surface is carried to an extreme level. We need only note the size of some cut-outs to see Matisse's desire to create new space and to lead the viewer into a situation much like that of a person surrounded by the walls of a mosque, a dimension of the uninterrupted development of form and colour, without narration but – and this is the point on to which Matisse grafts the reference to Western tradition that he always reasserted – with the fantastic and essential (but no less recognizable) figurative memory of reality. Even in the paper cut-outs,

which are among the works by Matisse that come closest to abstraction, the reference to reality is most clearly manifested in the definition of the form, even when it is only referred to, as in the case of *The Wave* or *Acrobats*. This abstraction and essentiality of the form reveal how Matisse, in the final phase of his career, preferred purity and decorative simplicity to the abundance that, from *Interior with Aubergines* to the *Odalisques*, had been such an important feature of his vision. A precise reason also lies behind this choice and should probably be linked with the dance motif, which is present in the pivotal works of this period: *The Swimming Pool*, the various versions of *Acrobats*, and *Creole Dancer* draw inspiration from the dancing figures painted in 1910 and 1933 and are the last descendants of that amazing movement on the walls in Shchukin's house and in the Barnes Foundation, although the symbolic aura that still prevailed in those compositions is lacking here. The paper cut-outs are therefore pure rhythm and pure painting, executed without any traditional pictorial means, fundamental works for a new generation of artists that was coming into being and that was supremely indifferent to the dispute concerning figurative and non-figurative art – just as Matisse himself had always been. Although he had avoided this particular controversy, he could not help becoming involved in the one over the social significance of art when he embarked on the decoration of the Chapel of the Rosary in Vence. Attacked by Picasso and other artists who affirmed that art should serve the

masses, Matisse merely replied: "All art worthy of the name is religious. Be it a creation of lines, or colours; if it is not religious, it doesn't exist. If it is not religious, it is only a matter of documentary art, anecdotal art . . . which is no longer art." He thus testified to the continuity of his thought and above all of his attitude towards the work of art and its significance in society.

The Vence chapel presented Matisse with a problem much like the one he had come to grips with years before with the Barnes Foundation mural: the need to create greater space, artificially through painting, for the relatively small chapel. If in the case of *The Dance* he had opted for a solution involving the very architecture of the building, on this occasion he entrusted this task to the light, especially that coming from the stained-glass windows. As all the elements in the Chapel of the Rosary were conceived by Matisse, it is only natural that its most notable feature should be the amazing unity of the whole; from the development of the decoration on the walls to the paraments and liturgical objects, everything is articulated along the lines of the utmost expressive simplicity and of a desire to respect rather than force the architectural character of the site. This character is violated only ideally by the light which, filtered through the stained-glass windows, penetrates the chapel and permeates the decorative panels with the episodes of the *Stations of the Cross* and the figures of St Dominic and the Virgin. The windows are the real core of the entire decoration, as Matisse brought to bear his old passion for

stained-glass windows in Gothic cathedrals and was finally able to achieve, without any conceptual or procedural filters of any kind, the transformation of colour into light that he had been seeking for years and years, and which he had realized through pictorial transposition in his paper cut-outs.

This is Matisse's description of the stained-glass windows and of their role in the visual and emotional structure of the chapel: "These stained-glass windows consist of three carefully chosen colours of glass–ultramarine blue, bottle green and lemon yellow, used together in each part of the stained-glass window. These colours are of quite ordinary quality; they exist as an artistic reality only with regard to their quantity, which magnifies and spiritualizes them. In addition to the simplicity of these three constructive colours there is a differentiation in the surface in some of the pieces of glass. The yellow is roughened and becomes only translucent, while the blue and green remain transparent and thus absolutely clear. This lack of transparency in the yellow arrests the spirit of the spectator and keeps it in the interior of the chapel, thus forming the foreground of a space that begins in the chapel and then passes through the blue and green to lose itself in the surrounding gardens. In this way, when someone inside can see through the glass a person going to and fro in the garden, only a meter away from the window, he seems to belong to a totally separate world from that of the chapel. I speak of these stained-glass windows – I don't think one can dispute the spiritual expression of their colour –

simply in order to establish the difference between the two long sides of the chapel which, decorated differently, sustain themselves by their mutual opposition." Three times in a few lines Matisse uses terms belonging to the domain of the "spirit," so that it is not difficult to see, on the one hand, that his endeavours totally correspond to the needs of the commission, and on the other hand the possibility of inserting this aspect into his poetics, which in any case always fed upon secular spirituality.

In the paper cut-outs and Vence chapel the fusion of symbolic and decorative aims achieves, through different procedures, a sublime synthesis. It would, however, be wrong to ignore, among Matisse's last works, the canvases executed with more traditional means and of a more "normal" size. Some of these are certainly among his masterpieces and sum up all the preceding experiences that characterize this final, extremely fertile creative period of Matisse's art. Among these works, particularly worthy of mention are *The Rocaille Armchair* (1946), *The Silence Living in Houses* (1947) and *Interior with an Egyptian Curtain* (1948).

These three paintings reveal the diverse themes that accompanied Matisse throughout his career, from the attempt to pacify "the eternal contrast between drawing and colour" to his love of still lifes and interiors; from his love for non-Western art to his dreams of "an art of balance, of purity, of serenity [. . .] something like an armchair [. . .]," the figurative symbol of which is *The Rocaille Armchair*; lastly, there is the concept of variation which he often put

to use. In 1952 Matisse explained this last-mentioned theme as follows: "Thus I have worked all my life before the same objects which continued to give me the force of reality by engaging my spirit towards everything that these objects had passed through for me and with me. A glass of water with a flower is different from a glass and a lemon. The object is an actor: a good actor can have a part in ten different plays; an object can play a different role in ten different pictures. The object is not taken alone, it evokes an ensemble of elements." It is easy to grasp the meaning of *The Silence Living in Houses* by considering objects as "characters" in a play, the director of which is the artist, and one understands to an even greater degree the value Matisse attached to the relationship between the various components of the painting. *The Rocaille Armchair* recalls the innumerable divans on which Matisse's odalisques lay for years, as well as the armchairs so often found in his works from the 1930s on; *The Silence Living in Houses* evokes other moments of meditation and conversation in the family scenes such as *Pianist and Checker Players* or *The Piano Lesson*; *Interior with an Egyptian Curtain* refers to the many rugs and carpets Matisse painted from 1909 on and the tablecloths and fabrics spread over the surface, from *Harmony in Red* to *Window at Tahiti*, in a series of equally intense and meaningful references and implications.

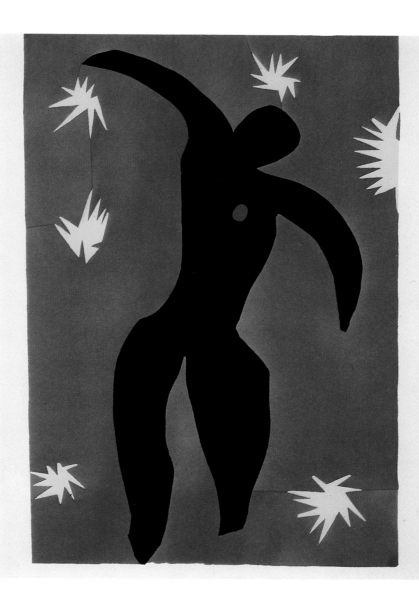

un moment di libres.
Ne devrait-on
pas faire ac.
complir un
grand voyage
en avion aux
jeunes gens
ayant terminé
leurs études.

54

Opposite above:
Forms (Jazz),
1943–44; paper cut-
out; 42.2 × 65.1 cm
(16½ × 25¼ in);
Private Collection.

Opposite below:
Destiny *(maquette for*
plate XVI of Jazz),
1943–44; gouache on
paper, cut and
pasted; 42.2 × 65.1 cm
(16½ × 25¼ in);
Private Collection.

Above: Icarus
(maquette for plate
VIII of Jazz),
1943–44; gouache on
paper, cut and
pasted; Private
Collection.

226

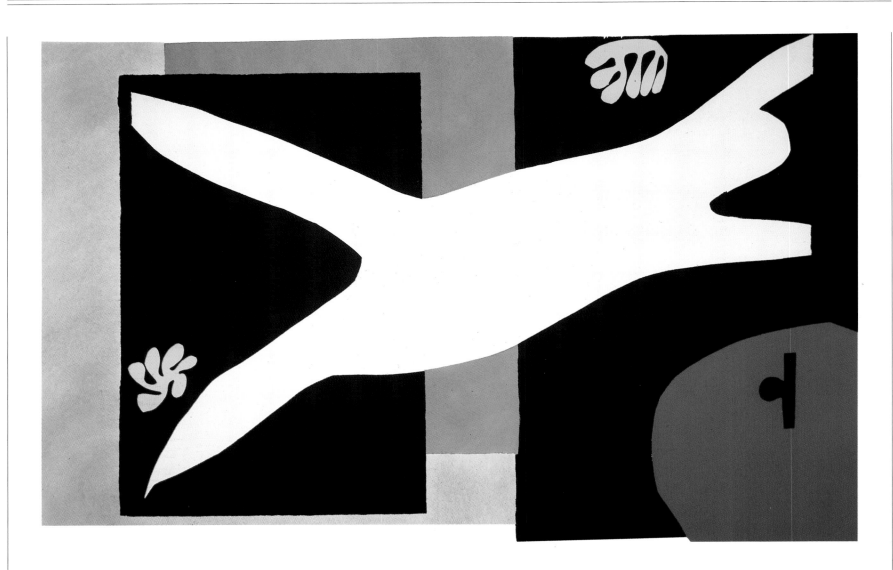

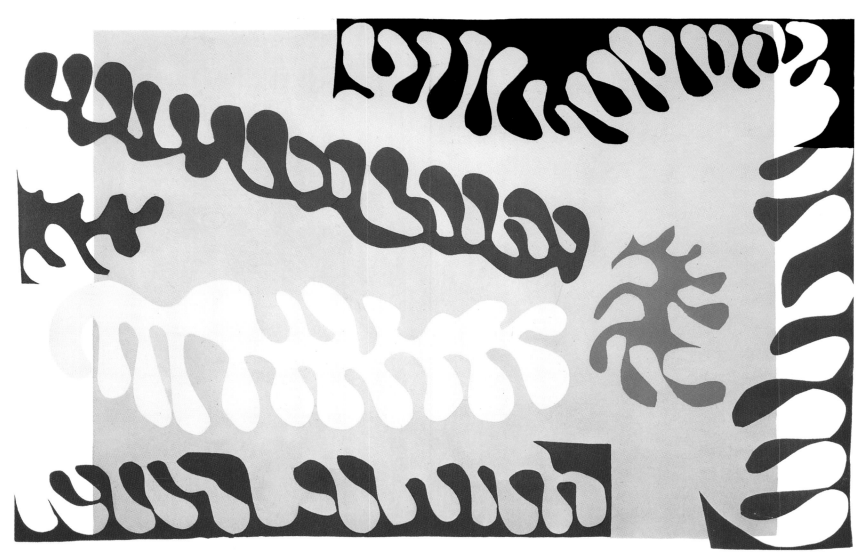

Opposite above: The Swimmer in the Aquarium *(maquette for plate XII of Jazz), 1943–44; gouache on paper, cut and pasted; 42.2 × 65.1 cm (16½ × 25¼ in); Private Collection.*

Opposite below: Lagoon *(maquette for plate XVII of Jazz), 1943–44; gouache on paper, cut and pasted; 42.2 × 65.1 cm (16½ × 25¼ in); Private Collection.*

Above: The Rocaille Armchair, Vence, villa Le Rêve, 1946; oil on canvas; 92 × 73 cm (36¼ × 28¾ in); Musée Matisse, Nice. This work, one of Matisse's most famous, transfigures a chair that belonged to Matisse (this is now kept in the Musée Matisse in Nice) in a pure play of lines and colours.

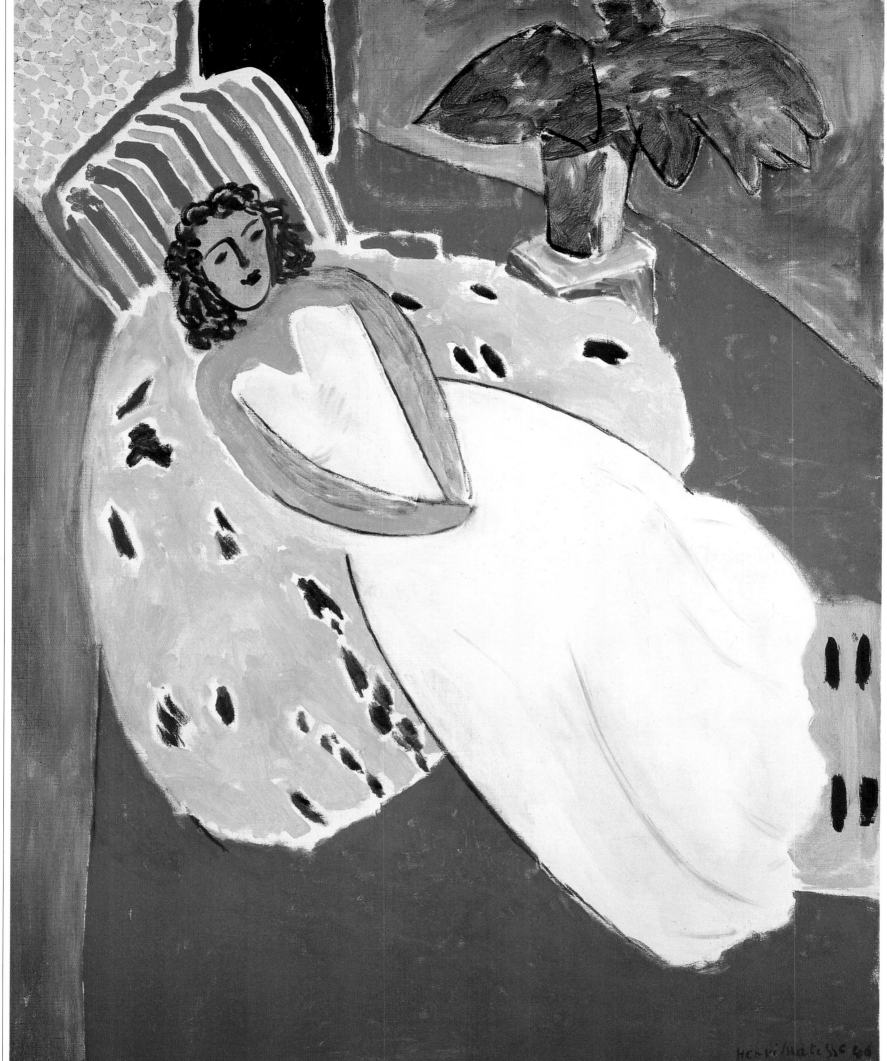

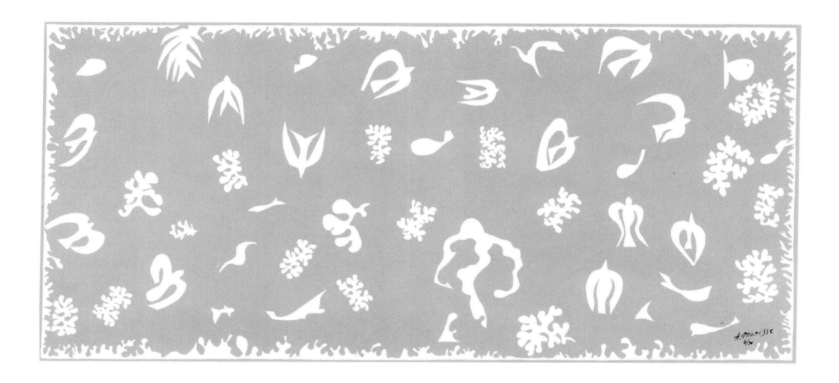

Opposite: Young Woman in White, Red Background, *Vence, villa Le Rêve, 1946; oil on canvas; 92 × 73 cm (36¼ × 28¾ in); Musée National d'Art Moderne, Centre Georges Pompidou, Paris.* "I feel through colour, so that my canvas will always be organized by means of colour. However, the sensations must be condensed and the means employed must be taken to their utmost expression." (*Matisse in 1943*).

Above: Oceania – The Sky, *1946; stencil on linen; 177 × 370 cm (69⅝ × 145⅝ in); Musée National d'Art Moderne, Centre Georges Pompidou, Paris.*

230

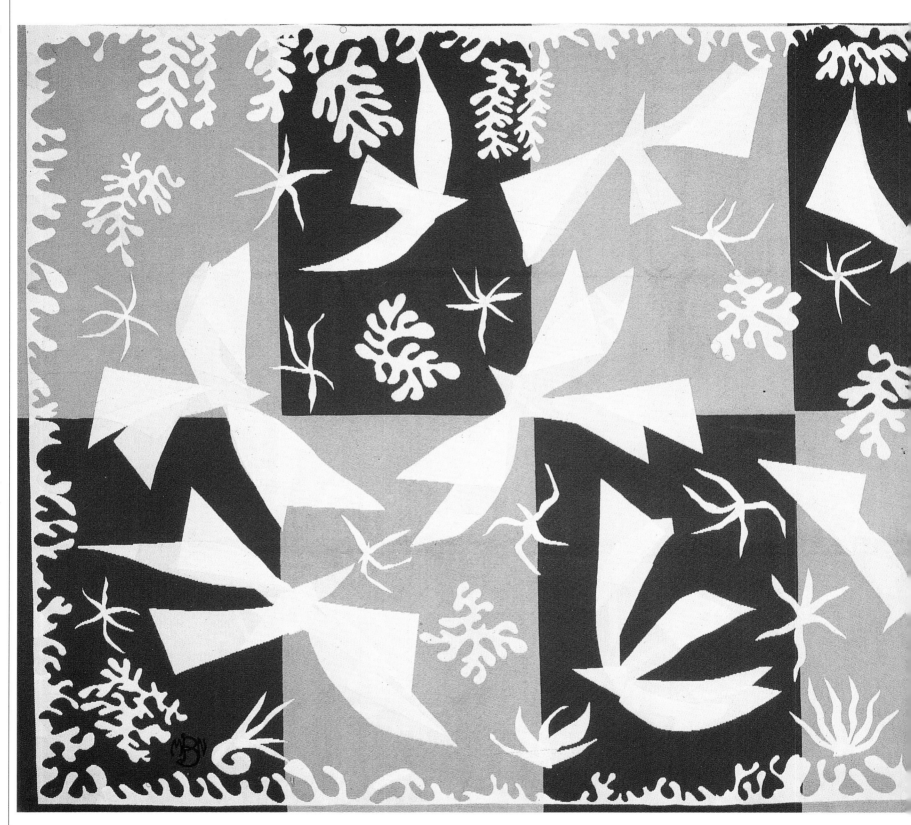

Polynesia – The Sky, 1946; gouache on paper, cut and pasted; 200 × 314 cm (78¾ × 123⅝ in); Musée National d'Art Moderne, Centre Georges Pompidou, Paris. When he made the trip to Polynesia, Matisse declared that the sensations he felt in that place could be translated only in banally descriptive painting. Years later he achieved the transfiguration of those landscapes in this extraordinary decorative series.

Five Red Circles and
a Black Losenge,
c. 1947–48; gouache
on paper, cut and
pasted; 60 × 45.5 cm
(23½ × 17¾ in);
Private Collection.

232

Above: Still Life with Pomegranates, *Vence, villa Le Rêve, 1947; oil on canvas; 80.5 × 60 cm (31½ × 23½ in); Musée Matisse, Nice. This work is part of a series of interiors Matisse executed in* Vence, including *some of his last masterful paintings. Thus, at the end of his painting career, he returned to the initial motif, the interior and still life of French and northern tradition.*

Opposite: The Silence Living in Houses, *Vence, villa Le Rêve, summer 1947; oil on canvas; 61 × 50 cm (24 × 19⅝ in); Private Collection. This subject recalls* Interior with a Young Girl *(1905–06), the* numerous family portraits, and the piano and music lessons and motifs. Note how Matisse makes the black actually permeate the walls and curtains.*

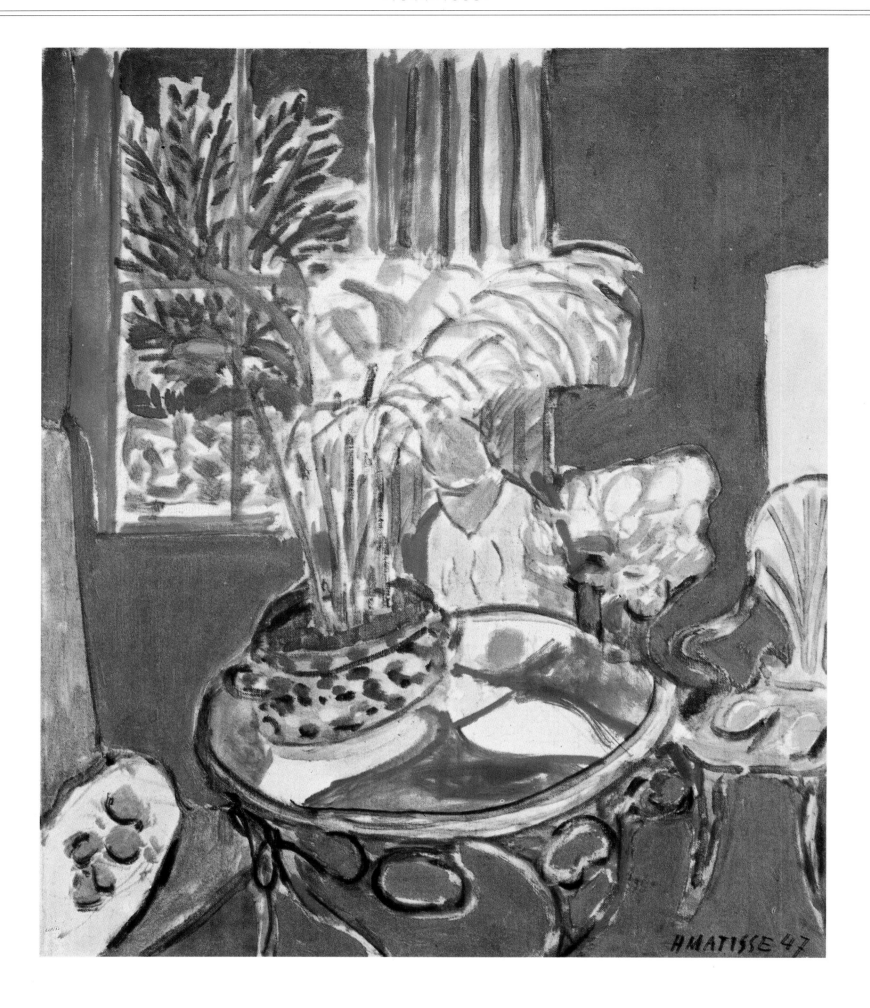

Small Blue Interior,
Vence, villa Le Rêve,
1947; oil on canvas;
55 × 45 cm (21½ × 17½
in); Staatsgalerie,
Stuttgart. This is one
of the many small
paintings of interiors
Matisse executed in
1947 that usually
have two figures and
a landscape seen
through a window.

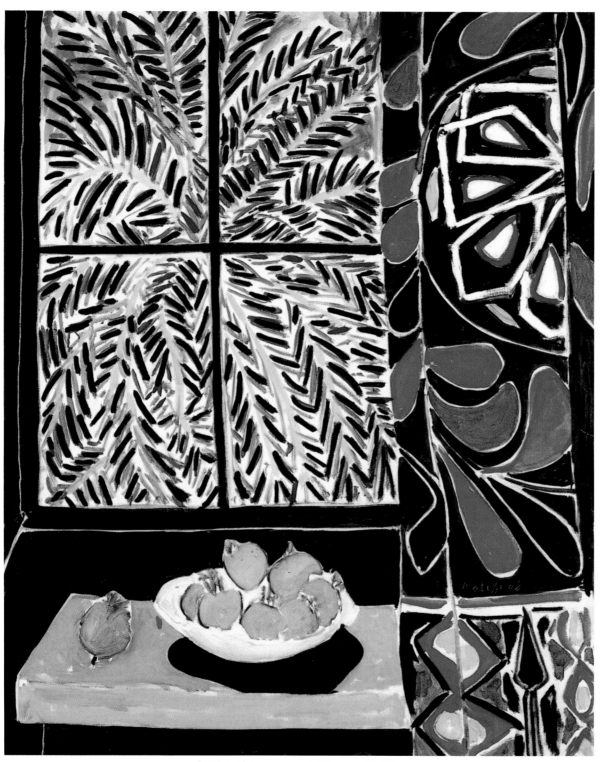

Interior with an
Egyptian Curtain,
Vence, villa Le Rêve,
winter-spring 1948;
116.2 × 88.9 cm
(45¾ × 35⅛ in); The
Phillips Collection,
Washington D.C.
"I'm definitively
committed to colour
because drawings no
longer interest me.
I've cleared my brain
in this respect [. .] I'm
full of curiosity, as
when one visits a new
country. For I've
never before
advanced this far in
the expression of
colours. Up to now
I've been merely
dillydallying at the
temple gates."
(Matisse to André
Rouveyre, 1947).

236

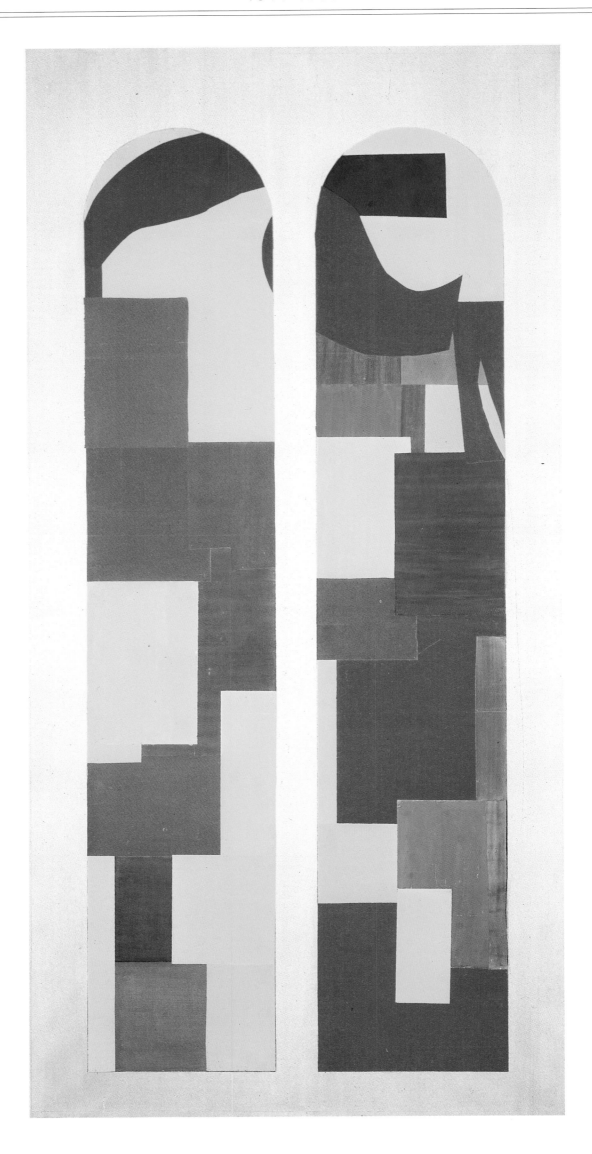

Celestial Jerusalem,
Vence, villa Le Rêve,
winter-spring 1948;
gouache on paper, cut
and pasted; 270 × 130
cm (106⅜ × 51⅛ in);
Private Collection.
Matisse often spoke of
the religious meaning
of his art, which is to
be understood as the
desire to surmount
the limited barriers
of sensory reality to
arrive at a more
spiritual vision.

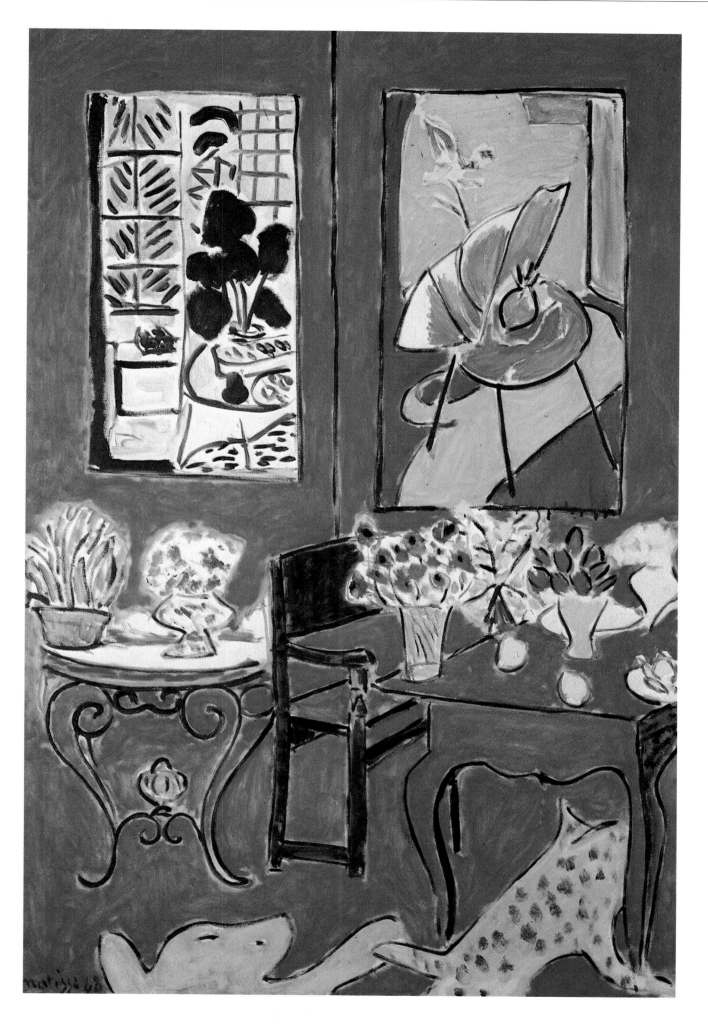

Large Red Interior,
Vence, villa Le Rêve,
winter-spring 1948;
oil on canvas;
146 × 97 cm
(57½ × 38¼ in);

Musée National d'Art
Moderne, Centre
Georges Pompidou,
Paris. The "painting
within a painting" on
the wall is The

Pineapple, which
Matisse executed the
same year and which
is reproduced on the
following page. The
same idea is

elaborated in The Red
Studio, executed in
1911.

238

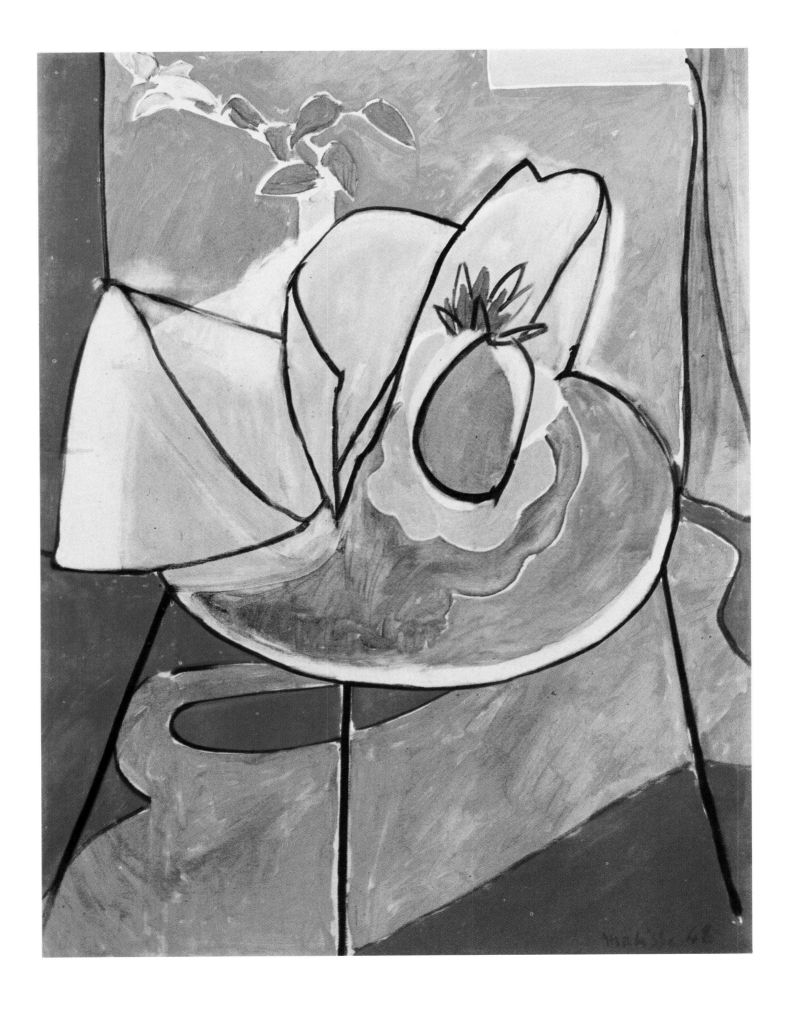

Opposite: The Pineapple, *Vence, villa Le Rêve, winter-spring 1948; oil on canvas; 116 × 89 cm (45¾ × 35 in); Alex Hillman Family Foundation, New York. Matisse drew numerous studies of this work in which the treatment is much more realistic; in translating it on to the canvas he stressed the essentiality of form so as to increase the chromatic expression.*

Above: The Bees, *1948; gouache on paper, cut and pasted on wrapping paper, on white cardboard covered with cloth; 101 × 241 cm (39¼ × 93¾ in); Musée Matisse, Nice. The reference to the great Gothic stained-glass tradition and decorative Oriental art is quite evident here; in fact this was one of the maquettes for the stained-glass windows in the Chapel of the Rosary at Vence.*

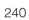

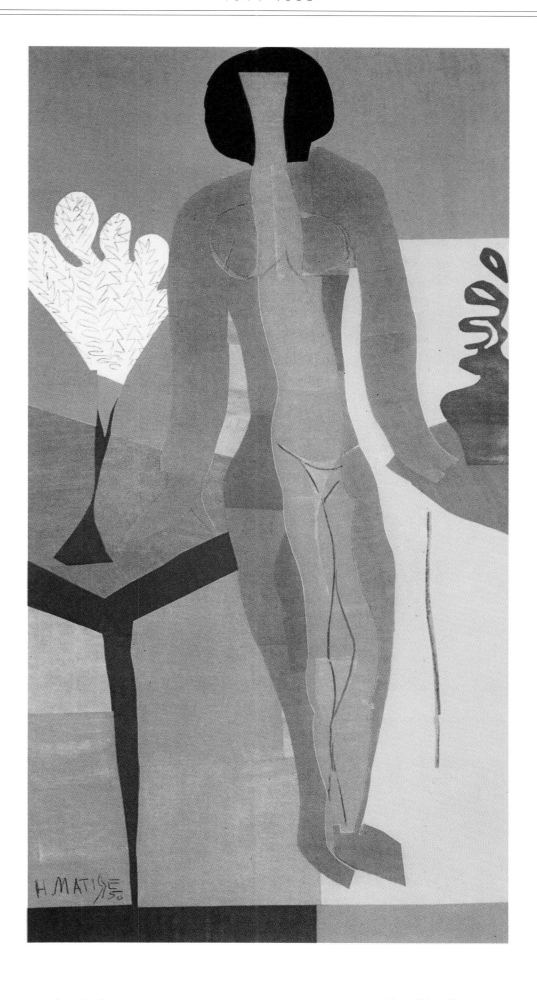

Opposite: Creole
Dancer, *Nice-Cimiez,
Hôtel Régina, 1951;
tempera on paper,
cut and pasted on
white Canson paper
pasted on cloth;
205 × 120 cm
(79¾ × 46¾ in);
Musée Matisse, Nice.*

Above: Zulma, *Nice-
Cimiez, Hôtel Régina,
1950; gouache on
paper, cut and
pasted, and crayon;
238 × 133 cm
(93¾ × 52⅜ in);
Statens Museum for
Kunst, Copenhagen.*

242

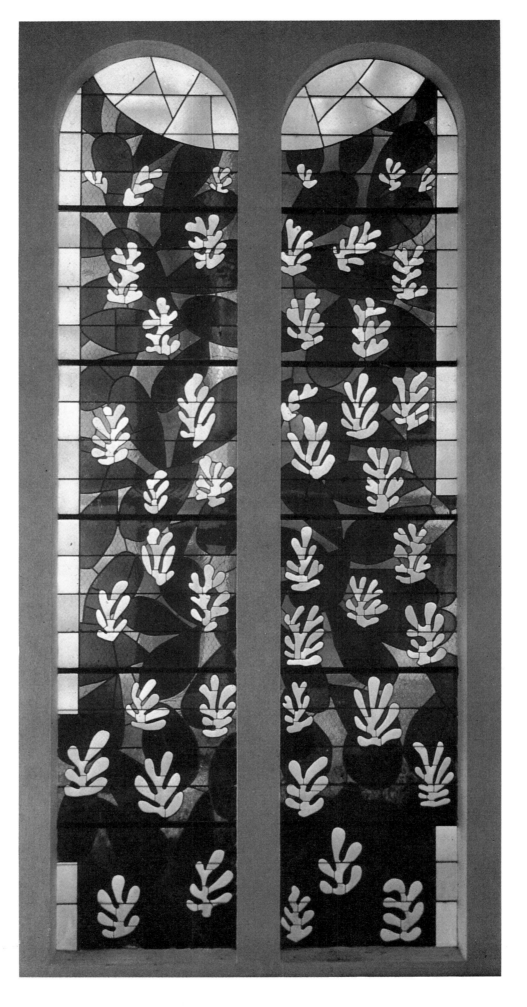

The Tree of Life, *1950;*
stained-glass
window; 515 × 252
cm (202³/₄ × 99¹/₈ in);
Chapel of the Rosary,
Vence. The result of
Matisse's research
into stained-glass led
to the resumption of
floral forms, the
image of which
attains a heraldic
clarity and meaning.

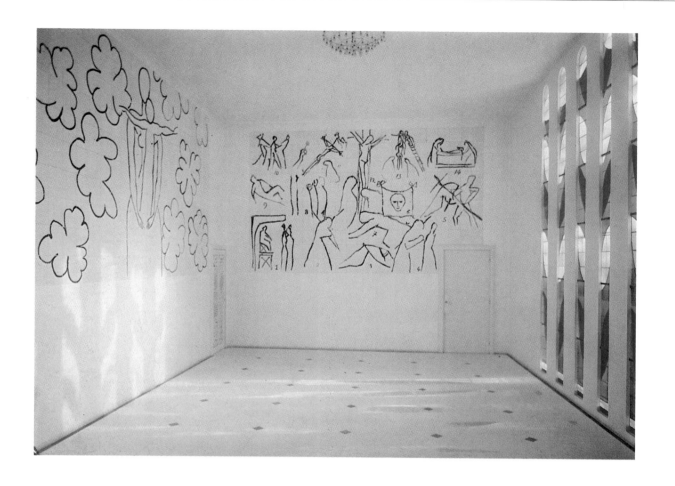

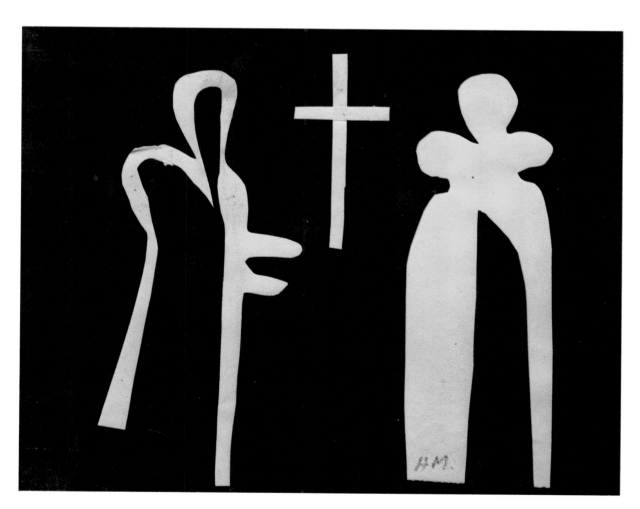

Top: interior of the
*Chapel of the Rosary
at Vence. On the left,
Virgin and Child,
ceramic tile; on the
right,* The Tree of Life,
*stained-glass
window.*

Above: Study for the
Tabernacle in the
Chapel of the Rosary,
*1950; gouache on
paper, cut and
pasted; Private
Collection.*

244

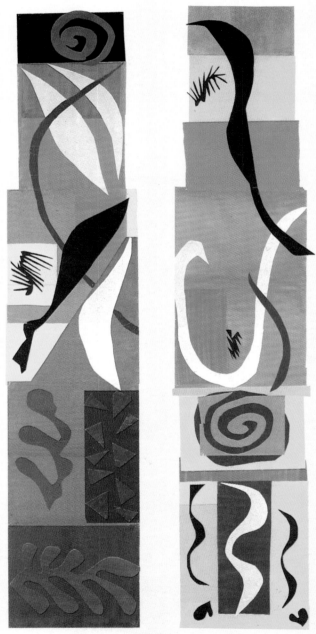

les bêtes de la mer...
H. matisse 50

The Beasts of the Sea,
*Nice-Cimiez, Hôtel
Régina, 1950;
gouache on paper, cut
and pasted, on white
paper; 295.5 × 154 cm
(116⅝ × 60⅝ in);
National Gallery of
Art, Washington D.C.,
Ailsa Mellon Bruce
Fund.*

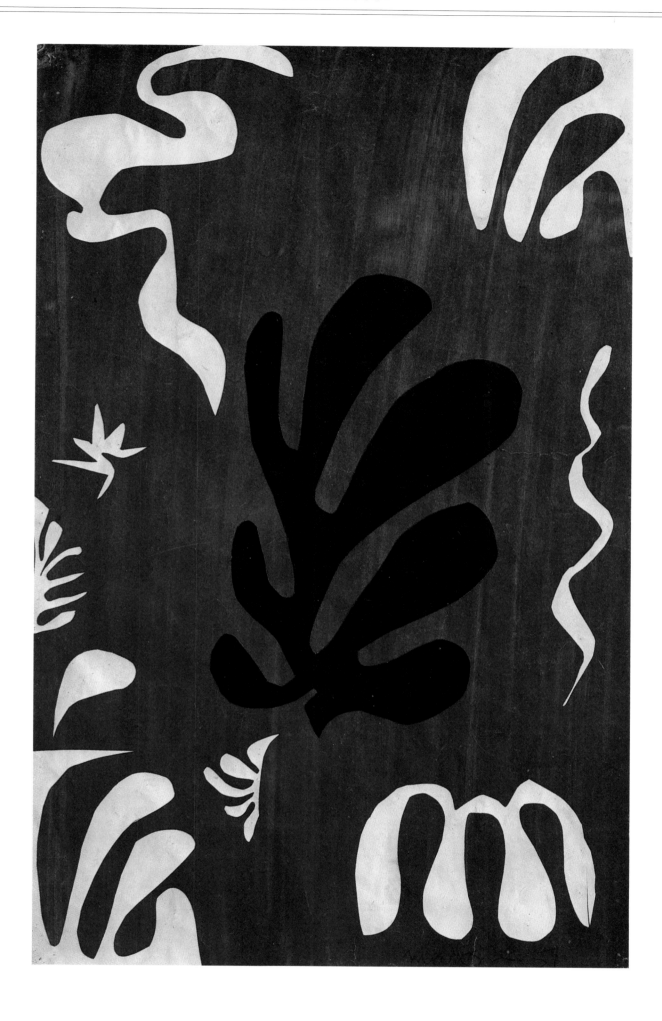

Composition, Blue
Background, *Nice-
Cimiez, Hôtel Régina,
1951; gouache on
paper, cut and
pasted; 80 × 50 cm
(31¼ × 19½ in);*

*Private Collection.
Matisse made many
statements on the
theme of the tree,
which he expressed in
a letter to his friend
André Rouveyre in*

*the 1940s. He also
executed a great
number of drawings
of leaves, again in the
1940s.*

246

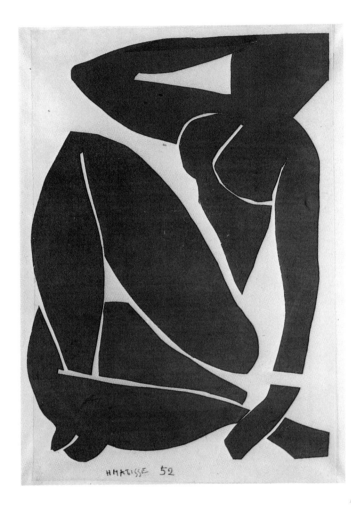

Above left: Blue Nude III, *Nice-Cimiez, Hôtel Régina, 1952; gouache on paper, cut and pasted, on white paper; 112 × 73.5 cm (44 × 29 in); Musée National d'art Moderne, Centre Georges Pompidou, Paris. Matisse continuously worked on and elaborated his "favourite" motifs and forms: here is a figure with one arm raised behind her head, a pose that was often represented in paintings and drawings in the 1920s and 1930s.*

Above right: Nude in Profile, *1951; pencil on paper; 26 × 20 cm (10 × 7¾ in); Private Collection. Matisse said in 1939: "Once my emotive line has modelled the light of my white paper without its precious whiteness, I can neither add nor take anything away. The page is written; no correction is possible."*

Opposite: Blue Nude IV, *Nice-Cimiez, Hôtel Régina, 1952; gouache on paper, cut and pasted, and charcoal on white paper; 103 × 74 cm (40½ × 29⅛ in); Musée Matisse, Nice, gift of Jean Matisse, State deposit.*

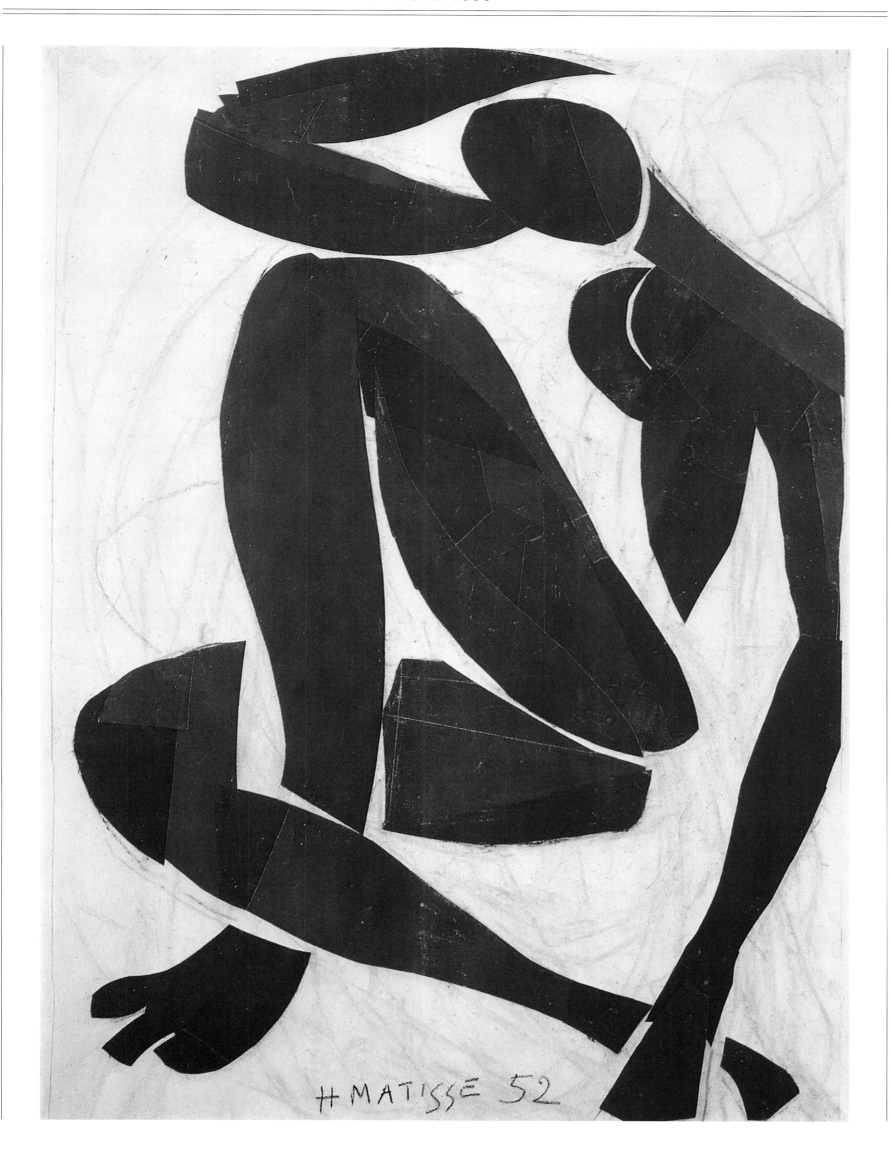

248

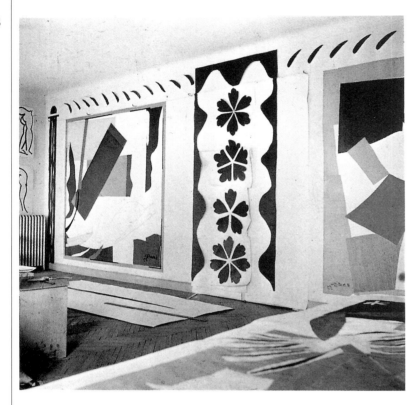

Above: a room in Matisse's apartment at the Hôtel Régina in Nice-Cimiez, 1952. Photograph by Hélène Adant.

Right: The Black Woman, *Nice-Cimiez, Hôtel Régina, 1952–53; gouache on paper, cut and pasted; 453.9 × 623.6 cm (177 × 243¼ in); National Gallery of Art, Washington D.C., Ailsa Mellon Bruce Fund. The idea of the large-scale decoration, which was central in the final phase of Matisse's artistic* career, took on form also in the very dimensions of the works, which became larger and larger. Naturally this increase in size was also due to the technique of the gouache cut-out, which allowed Matisse to act upon the surface of the work until it was totally balanced.

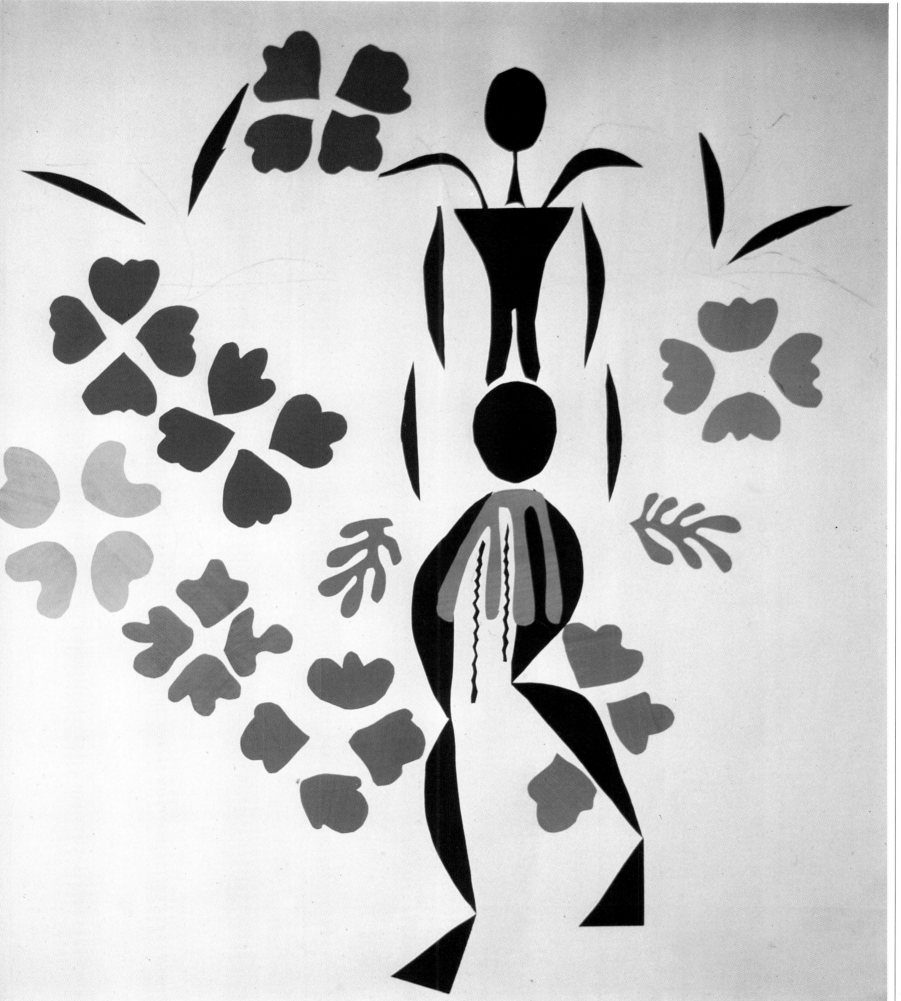

The Sails, *1952;*
gouache on paper, cut
and pasted; 72 × 60
cm (28 × 23½ in);
Private Collection.
The essentiality of
these final works
reminds one of the

most synthetic phase
in Matisse's career,
in the "distant"
period in which he
created The Yellow
Curtain *and* French
Window at Collioure,
among others.

Venus, *Nice-Cimiez,*
Hôtel Régina, spring-
summer 1952;
gouache on paper, cut
and pasted;
101.2 × 76.5 cm
(39½ × 29½ in);
National Gallery of

Art, Washington D.C.,
Ailsa Mellon Bruce
Fund. Note the
relationship between
this work and the
Forms Matisse
executed for Jazz *in*
1943 (see page 224).

252

Auguste Rodin, Nude
with Long Hair
Bending Backwards,
*1908–15; lead pencil
and watercolour on
paper; 27.5 × 21.4 cm
(10³⁄₄ × 8¹⁄₄ in); Musée
Rodin, Paris.*

Auguste Rodin, Nude
in Profile Doing a
Bridge Backbend,
*1908–15; lead pencil
and watercolour on
paper; 27.2 × 19.1 cm
(10¹⁄₂ × 7¹⁄₂ in); Musée
Rodin, Paris.*

Above: The Wave, Nice-Cimiez, Hôtel Régina, summer 1952; gouache on paper, cut and pasted; 51.1 × 158.5 cm (19¾ × 61½ in); Musée Matisse, Nice.

Few twentieth-century works of art have equalled the absolute harmony of formal invention and essentiality achieved in this work.

The Swimming Pool, 1952; nine-panel mural in two parts, gouache on paper, cut and pasted, on white paper mounted on burlap; 230.1 × 847.8 and 230.1 × 796 cm (90⅝ × 333½ and 90⅝ × 313½ in); Museum of Modern Art, New York, Mrs Bernard F. Gimbel Fund. Matisse said in 1952: "There is no separation between my old pictures and my cut-outs, except that with greater completeness and abstraction, I have attained a form filtered to its essentials and of the object which I used to present in the complexity of its space, I have preserved the sign which suffices and which is necessary to make the object exist in its own form and in the totality for which I conceived it."

256

Decoration, Flowers and Fruit, *Nice-Cimiez, Hôtel Régina, 1953; gouache on paper, cut and pasted; 410 × 870 cm (159⅞ × 339¼ in); Musée Matisse, Nice. Matisse's greatness lies in his capacity to translate in the language of Western* art the spirit of *Oriental forms by rejecting the supposed superiority of the former. His influence on future generations of artists lay mostly in this interpretation of the surface as a sort of infinite proliferation of forms and colours.*

Carla Accardi, Grey
Brown, *oil on canvas;*
160 × 130 cm (in);
property of the artist,
Rome.

Left. La Gerbe (The Sheaf), *maquette for ceramic tile, Nice-Cimiez, Hôtel Régina, 1953; gouache on paper, cut and pasted; 290 × 350 cm (62½ × 136½ in); UCLA Art Galleries, Los Angeles (this reproduction is of the stencil print of this work).*

Above: Leaves Cut into Arabesques, *1944–47; ink on paper; Musée National d'Art Moderne, Centre Georges Pompidou, Paris.*

260

The Snail, *Nice-Cimiez, Hôtel Régina, 1952–53; gouache on paper, cut and pasted, on white paper; 287 × 288 cm (112¾ × 113 in); The Tate Gallery, London. Matisse said in 1952: "In creating these coloured paper cut-outs, I seem to be proceeding happily* toward what is prefigured. I have never, I believe, achieved such equilibrium as in these paper cut-outs. But I know that only much later will people realize that what I am doing today is in harmony with the future."

Memory of Oceania, Nice-Cimiez, Hôtel Régina, 1952–53: gouache on paper, cut and pasted, and charcoal on white paper; 284.4 × 286.4 cm (112 × 112⅞ in); Museum of Modern Art, New York, Mrs Simon Guggenheim Fund. "Fine stay, good rest. I've seen all kinds of things. I'll tell you about it. I lived for 20 days in a "coral island"; pure light, pure air, pure colour: diamond sapphire emerald turquoise. Amazing fish. I've done nothing at all except take some bad photographs." (Matisse in a letter to Pierre Bonnard on his way back from Tahiti.)

Sculpture

262

With the exception of two pieces he produced while still an art student, Matisse began sculpting at the beginning of this century; his activity in this medium continued parallel to his painting well into the 1930s, when it slowed down considerably and then came to a halt in 1949. His sculpture coincides with the period of his greatest experimentation, declining when his pictorial language paused momentarily to enable him to distil his previous experiences. This coincidence between his sculpture and painting demonstrates the centrality of sculpting as a proving ground for the many doubts he experienced during the course of his artistic research – especially, of course, the problems of space and the plastic rendering of the figure, which were particularly pressing in the transition stages from his Fauve period to his "decorative" one, and from this latter to the phase in which he reconstituted an apparently realist pictorial space.

When considering the sculpture of Matisse (or indeed, sculpture pieces by other great painters such as Degas and Renoir) one inevitably tends to view this art as a mere support to their painting, almost a three-dimensional transposition of the results of painting – in other words, a basically secondary procedure with respect to the "primary" activity. If, however, we take into account both the continuity of Matisse's utter commitment to sculpture and the quality of his pieces, we should consider works such as *La Serpentine* and the various versions of *The Back* and *Jeannette* as wholly self-sufficient achievements that rank with

some of his paintings and are also capable of illuminating certain aspects of them.

This short-sighted interpretation of Matisse's sculpture led him to make some statements about his work in this medium: "I myself have done sculpture as the complement of my studies. I sculpted when I was tired of painting, for a change of medium. But I sculpted like a painter, I did not sculpt like a sculptor. Sculpture does not say what painting says, and painting does not say what music says. They are parallel ways, but you can't confuse them." Clearly, this statement stresses the subordinate role of sculpture. It also suggests, however, that every medium, from painting to etching, drawing and paper cut-outs, has its own well-defined language, its own specific problems that require specific solutions. It would be wiser, therefore, to underscore their specific qualities rather than their auxiliary character.

The first important sculpture by Matisse, both on a conceptual and operative level, is *The Slave*, executed in 1900. This was the period when Matisse was still searching for his own artistic identity and, in particular, when he was reflecting on Cézanne's oeuvre. At the time the towering figure of Auguste Rodin dominated sculpture, and in this work Matisse seems to be matching himself with the great French sculptor. We must not forget that when, in 1899, he bought Cézanne's *Three Bathers* from Vollard, he also purchased a plaster cast by Rodin, and the model who posed for *The Slave* was the same person who years before had posed for *The Burghers of Calais*.

Leaving aside these purely external coincidences, the structure of *The Slave* may be linked directly to Rodin's *Walking Man*, even though the plastic conception is quite different: Matisse's idea was to "strengthen the unity of the figure" in order to achieve a sense of monumentality, whereas Rodin was quite willing to sacrifice such wholeness in order to render detail and make his work more expressive. However, the analogy between *The Slave* and his *Male Model*, which he painted in the same year and which betrays such a strong Cézannesque influence, is extremely significant because it reveals that the basic problem for Matisse at this time, the construction of the human figure in relation to space, was tackled by means of different techniques so as to broaden the gamut of possible solutions, ranging from the constituent three-dimensionality of the sculpture to the illusory, mental evocation of three-dimensionality in the painting.

There are also analogies between two later works, the sculpture piece *Reclining Nude I* and the painting *Blue Nude*, both executed in 1907. Caught up in the exciting discovery of so-called primitive art, Matisse produced this piece by relating directly to black African sculpture, as can be seen in the rendering of the bent leg, which answers the need for construction in planes that is quite foreign to any realistic aesthetic. According to post-Renaissance canons, this sculpture is utterly wrong; it can be appreciated only by setting it in another cultural milieu, the same one that inspired Picasso, in the same year, to

create *Les demoiselles d'Avignon*. Yet the definition "black Venus" given to *Reclining Nude I* is quite apt, since Matisse also based this figure on one of the canonical models of ancient art, Ariadne, that Giorgio de Chirico later made so popular in his celebrated metaphysical plazas. As can be readily seen, during this period an entire artistic language was revolving around certain pivotal problems; in this respect special attention should be paid to the attempts to connect different, and often diametrically opposed, cultural traditions, and the passages from one to the other, effected above all by Matisse and Picasso. *Blue Nude* repeats the motif of *Reclining Nude I*, but the aesthetic of "expressive deformations" that Matisse was pursuing at this time (1907) appears to be more successfully brought into focus in the sculpture, and this is probably due to the fact that the examples of African art he owned and was studying at the time were sculpture pieces, so that the plastic impression of those "invented planes," which for Matisse were the most fascinating achievement of this artistic world, was even greater.

Two Women (1908) and *La Serpentine* (1909) are among the sculptures that best represent another meaningful aspect of Matisse's relationship with this medium: both were inspired not by models but by photographs. He adopted this expedient in order to avoid the excessive naturalistic effect of the human figure and its compromise with a reality which, from the time of Baudelaire's celebrated condemnation, had always been considered the factor

that prevented sculpture from reaching the ideal heights achieved by painting because it restricted it to the domain of purely imitative art. It is therefore only natural that the author of *Le luxe* and *Bathers with a Turtle* should emphasize in the field of sculpture his detachment from mere appearances, and his choice of the pose of *Two Women* is significant in this regard: they are seen in both back and front views at the same time, which emphasizes the artifice and self-conscious invention that characterizes this work. The forcing of an expressive element – in this case, line – and the resultant sacrifice of the anatomical likeness of the figure, is on the other hand the principal feature of *La Serpentine*, which is perhaps the work that best suits the definition of "painter's sculpture." Indeed, here Matisse almost totally abandons the search for volume and the definition of mass in the body, in favour of a veritable drawing procedure in the material and in space that has few equals in coeval sculpture.

Back I was completed the same year as *La Serpentine*, and was followed by three other versions executed in 1913, 1916–17, and 1930–31. Here again it is not difficult to find similarities and differences with Matisse's paintings. The first and most obvious is the serial principle that informs these sculptures, as well as the busts of *Jeannette* and *Henriette*. In sculpture, too, Matisse utilized the motif of theme and variations, forcing the subject to play "a different role in ten different pictures." The progressive abstraction of this motif is quite evident – from the

apparent realism of *Back I* to the apparent abstraction of *Back IV*. However, this process is to be interpreted not as a mechanical evolution, but as a slow formal elaboration that therefore ranges from the complexity of the formal elements in the first version to their final distillation, without any of the essential characteristics of all four versions being sacrificed. The choice of the low-relief form for the *Backs* is probably due to the need to tackle in a different artistic medium the problems of line, light and the relationship among the planes that Matisse was facing in his painting of this period, without forgoing the rapport with the surface and while at the same time avoiding the more specific sculptural problems of rendering volume.

This interpretation is confirmed in another of Matisse's rather frequent statements concerning sculpture: "I took up sculpture because what interested me in painting was a clarification of my ideas. This means that sculpture was also made to clarify [...] It was done for the purpose of organization, to put order into my feelings, to seek a method that wholly suited me. Once I found it in sculpture, it helped me in painting. It was always done with a view to mental self-possession, with a view to a kind of hierarchy of all my sensations that would allow me to reach an ultimate method."

Over and above these considerations – and the historical significance of bas-relief, the cardinal moment of the fusion of sculpture and architecture that now belongs to remote ages – there

remains the supreme quality of this series, which represent one of the greatest sculpture works of the twentieth century, especially *Back IV*, in which the structural rigour, the total possession of space and the capacity to attain a monumental dimension without any traces of rhetoric, are merged with utter formal simplicity.

The series of five busts of *Jeannette*, executed from 1910 to 1913, is more problematical. Here one can readily detect Matisse's tormenting encounter with Cubism. The course of these works also seems to be a progressive detachment from the imitative conception of sculpture; but the theme, with its "subjective" implications, did not allow Matisse to follow the same path of the *Backs*. The cornerstone of the *Jeannette* series is probably to be found in the treatment of the woman's hair, where for the first time Matisse deals so directly with the relations between mass and volume, thus facing a problem he had temporarily set aside. The construction of these heads, especially in the third and fourth versions, seems to correspond to Matisse's search for formal equilibrium and weight totally free from any need for narrative or psychological features; the attainment of this balance by means of deliberate anatomical deformation lends expression to the figure and brings out its emotional quality.

The geometric breakdown of planes that had played such an important role in the Cubist approach to reality – and which Picasso himself was unable to render as effectively as Matisse in his most "academically" Cubist sculpture, *Head of a Woman* (1909) – is fully

achieved in this series because Matisse manages to re-establish expressive and emotional unity out of the various motifs that go to make up the woman's head. He realized that a mere transposition of the Cubist faceting into three dimensions was not possible, and that it was necessary to restore unity to the piece by meditating on the relationship among the different volumes. For that matter, the major accomplishments in the most orthodox Cubist sculpture are in the bas-relief medium, where the relationship with the surface is greatest; Matisse's mastery here lies in his having offered an eminently sculptural solution to a problem that was originally pictorial. During the 1920s and 1930s, Matisse again took up sculpture, with works such as *Reclining Nude II*, *Reclining Nude III*, *Tiari* and *Venus in a Shell*, in which he virtually brought his research to a conclusion by re-elaborating plastic themes and motifs he had already dealt with in the past. These too are remarkably intense works, but the passion for research and experimentation has "mellowed" somewhat, becoming a more explicit quest for clarity and palpitating sensuality of the form.

A clear example of this is *Tiari*, the translation into sculpture of the spirals and arabesques that dominated his paintings in this period, the three-dimensional incarnation of reality placed in a "stage set" amongst exotic drapery and clothing.

264

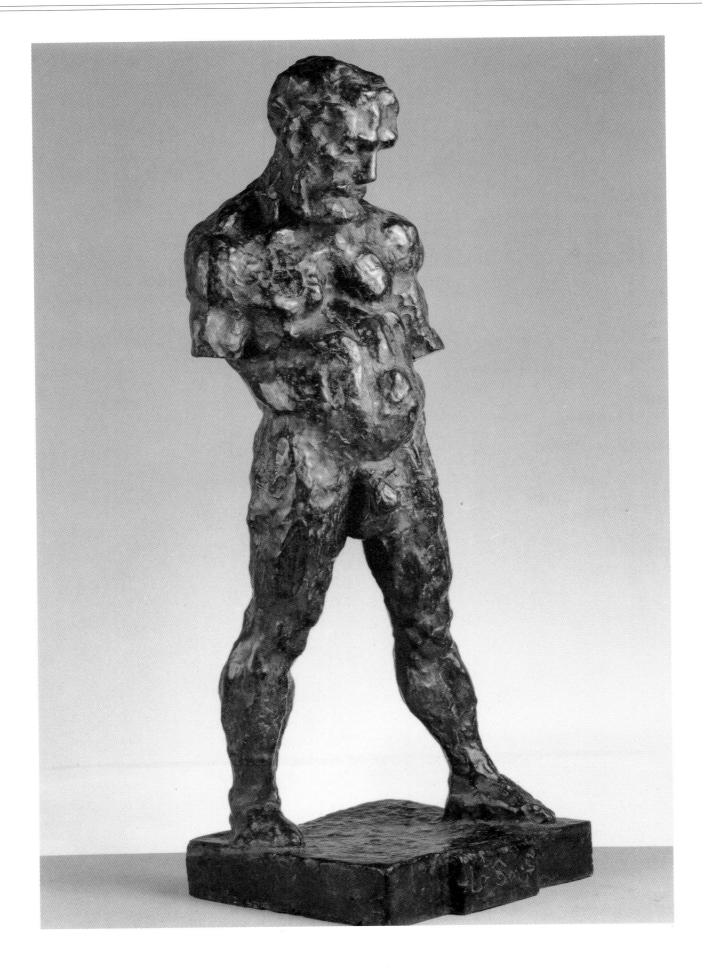

The Serf, *Paris,
1900–04; bronze;
height 92.3 cm (37⅛
in); Museum of
Modern Art, New
York, Mr and Mrs
Sam Salz Fund. This
sculpture piece was
executed during one
of the most complex
phases of Matisse's
artistic formation* and is a testament to
his meditation on
Rodin's art. The
model was the same
as the one Rodin used
for his Walking Man,
Pignatelli, who
together with
Bevilacqua was
perhaps the best
known model of the
time.

Torso with Head – La Vie, *Paris or Collioure, c. 1906; bronze; height 23.2 cm (9⅛ in);* *Metropolitan Museum of Art, New York, The Alfred Stieglitz Collection, 1949.*

266

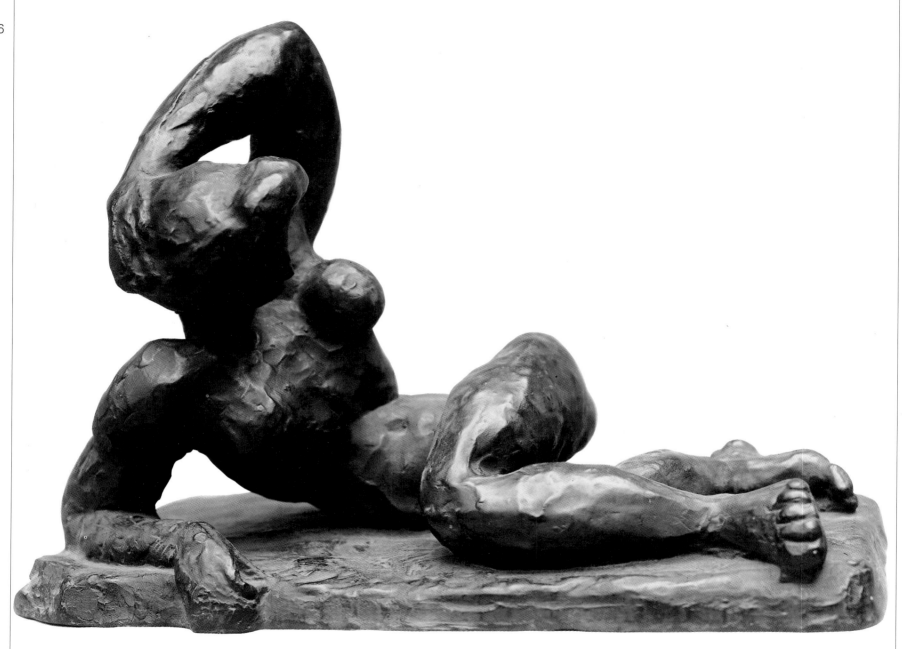

Above: Reclining Nude I – Aurora, *Collioure, winter 1906–07; bronze; height 34.3 cm (13½ in); Private Collection. One can note obvious analogies and references between Matisse's sculpture and painting by comparing this work with* Blue Nude – Memory of Biskra, *which was executed in 1907. The influence of black African art led Matisse to organize his figures in unrealistic planes by accentuating the torsion of the bust and setting the left leg in the foreground.*

Opposite: Little Crouching Nude, *1908; bronze; height 16 cm (6¼ in). 1908 was one of the crucial years in Matisse's entire career, both from the point of view of public recognition of his greatness and from an artistic standpoint, as is testified by the strikingly different works he executed during this time.*

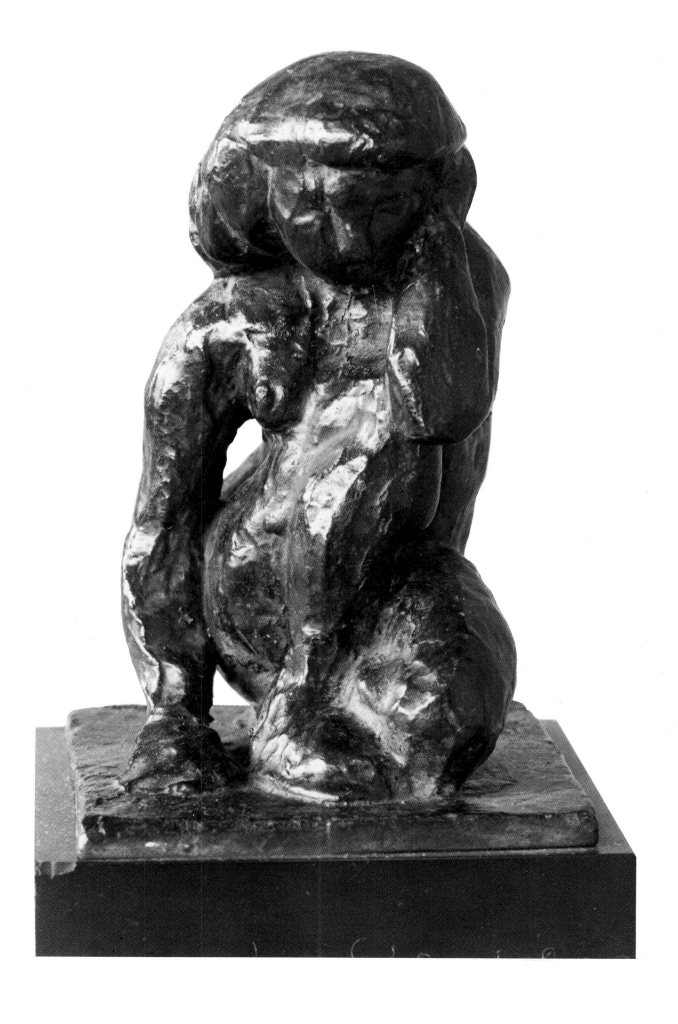

268

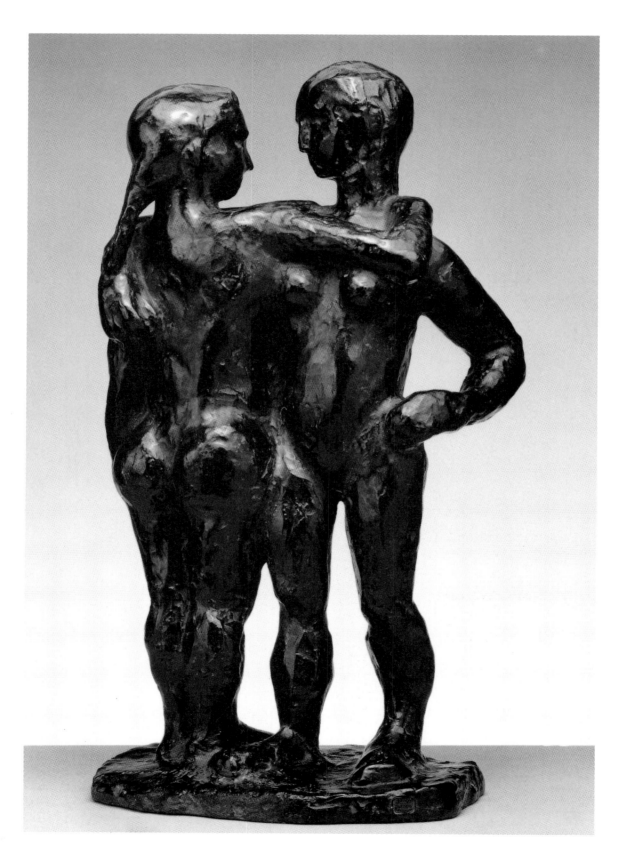

Two Women,
Collioure, summer
1907; bronze; height
46.6 cm (18⅜ in);
Hirshhorn Museum
and Sculpture

Garden, Smithsonian
Institution,
Washington D.C., gift
of Joseph H.
Hirshhorn, 1966. As
was often his custom,

Matisse used a
photograph as a
model for this
sculpture instead of a
live model.

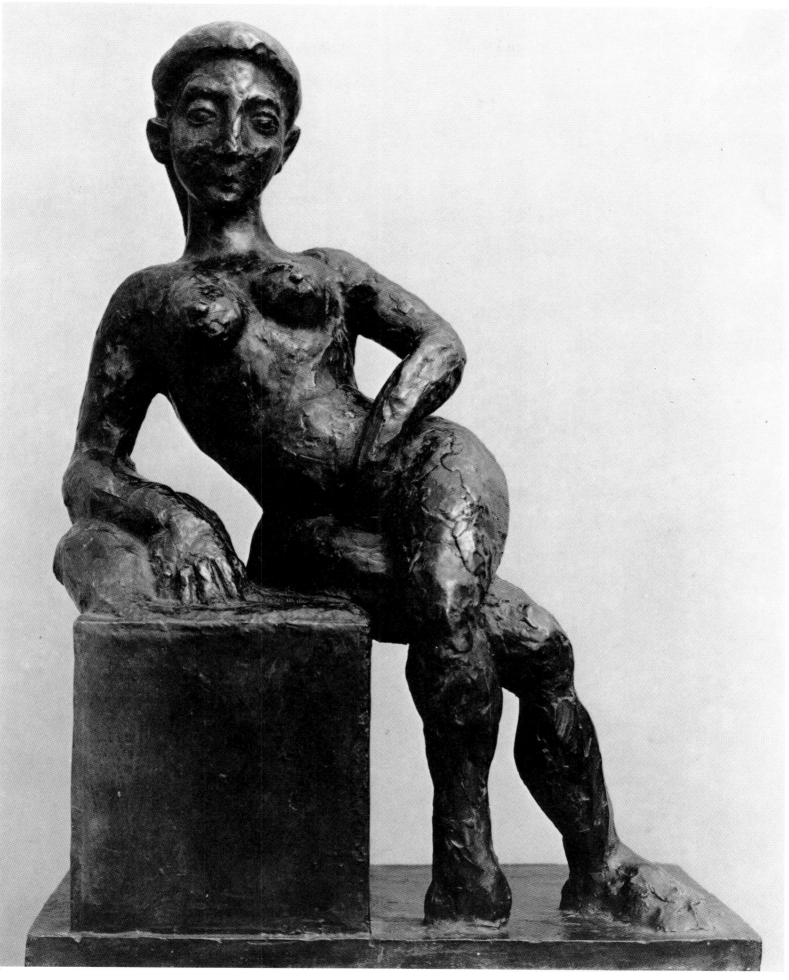

Decorative Figure,
Paris, Hôtel Biron,
spring-summer 1908;
bronze; height 72.1
cm (28⅜ in);
Hirshhorn Museum
and Sculpture
Garden, Smithsonian
Institution,
Washington D.C., gift
of Joseph H.
Hirshhorn, 1966.

270

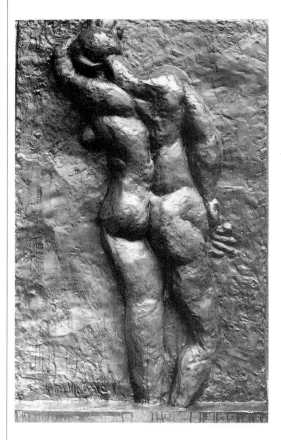

Above: The Back I,
*Paris, Hôtel Biron,
and Issy-les-
Moulineaux, spring
1908-late 1909;
bronze; height 188.9
cm (62⅜ in); Museum
of Modern Art, New
York, Mrs Simon
Guggenheim Fund.*

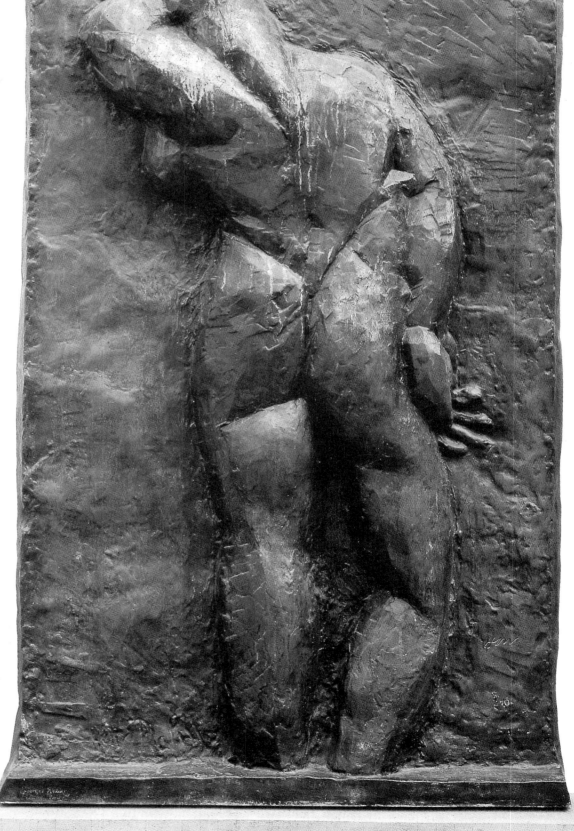

Right: The Back II,
*Issy-les-Moulineaux,
spring-early autumn
1913;bronze; height
188.5 cm (74⅜ in);
Museum of Modern
Art, New York, Mrs
Simon Guggenheim
Fund.*

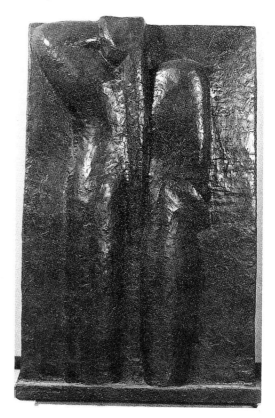

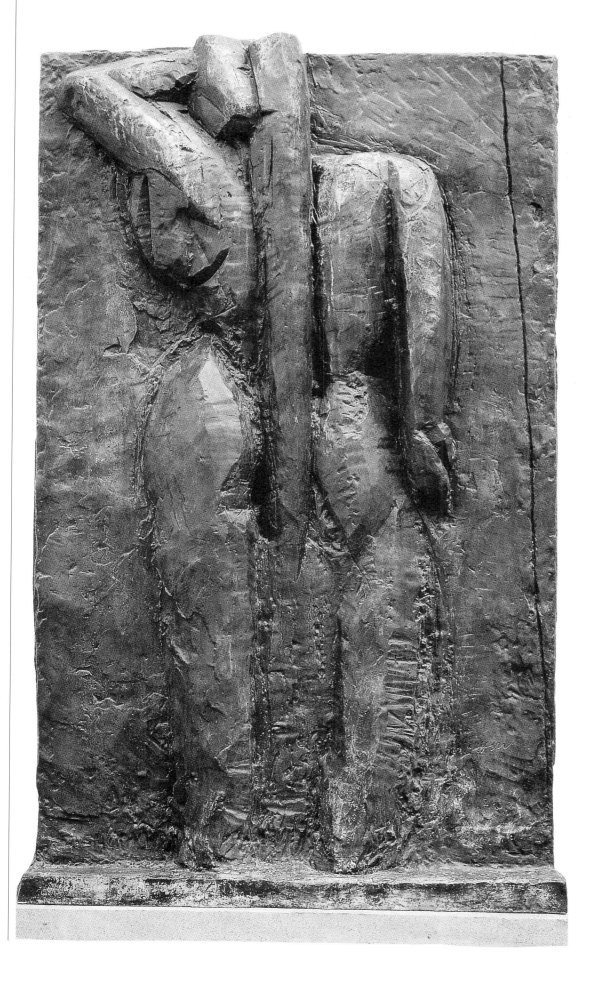

Above: The Back III,
*Issy-les-Moulineaux,
spring-summer 1916;
bronze; height 189.2
cm (74½ in); Museum
of Modern Art, New
York, Mrs Simon
Guggenheim Fund.*

Left: The Back IV,
*Nice, place Charles-
Félix, 1930–1931;
bronze; height 188 cm
(74 in); Museum of
Modern Art, New
York, Mrs Simon
Guggenheim Fund.*

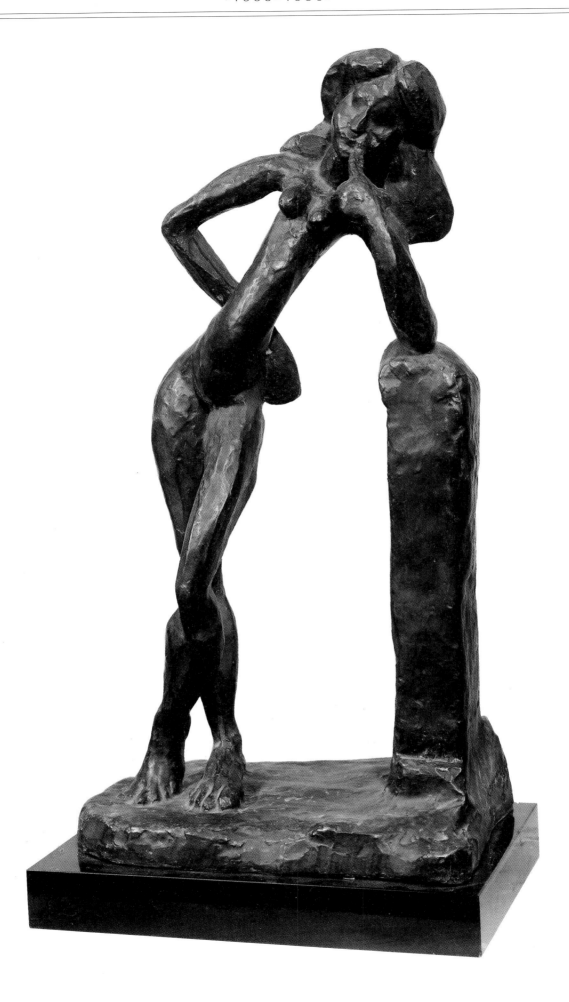

La Serpentine, *Issy-les-Moulineaux, autumn 1930; bronze; height 56.5 cm (22¼ in); Museum of Modern Art, New York, gift of Abby Aldrich Rockefeller. This* sculpture was inspired by a photograph taken from the magazine "Mes Modèles." There is also a famous photograph taken by Edward Steichen of Matisse working on this piece. The model was rather stout, quite different from the linear, arabesque-like quality of Matisse's work. The principle of drawing in space, always used by Matisse in his painting, here takes on a purely plastic meaning.

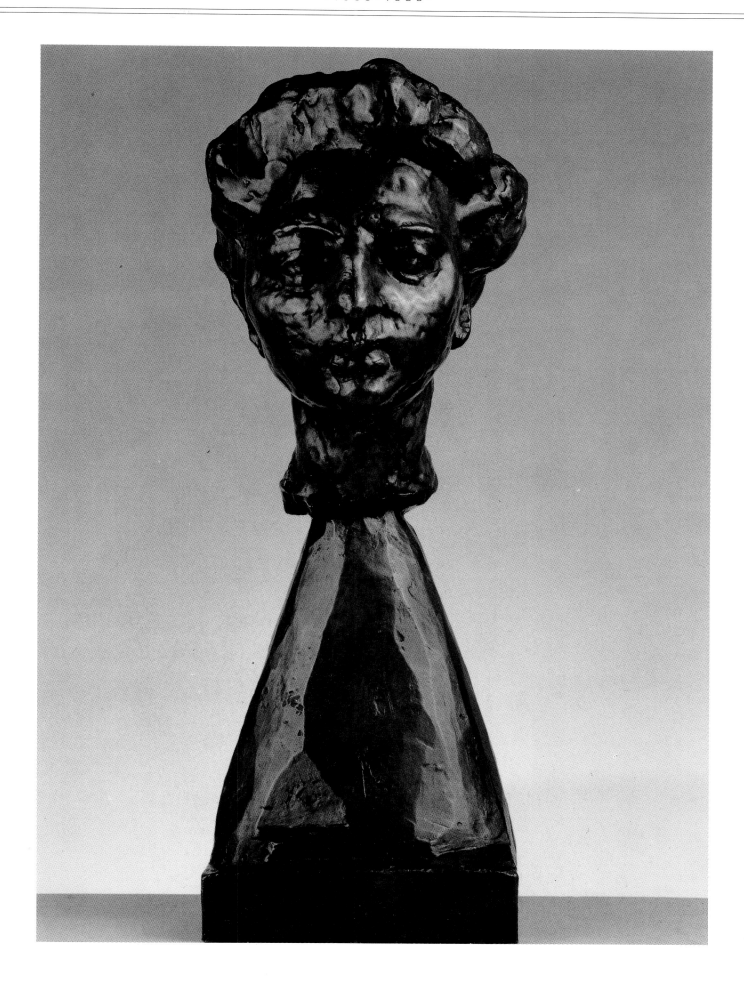

Jeanette I, *Issy-les-Moulineaux*, early 1910; bronze; height 33 cm (13 in); Museum of Modern Art, New York, acquired through the Lillie P. Bliss Bequest. The first work in the extraordinary series of five sculptures of this subject, this piece is also the closest to the traditional imitative canons of sculpture. Note the anomalous relationship between the head and the pedestal.

274

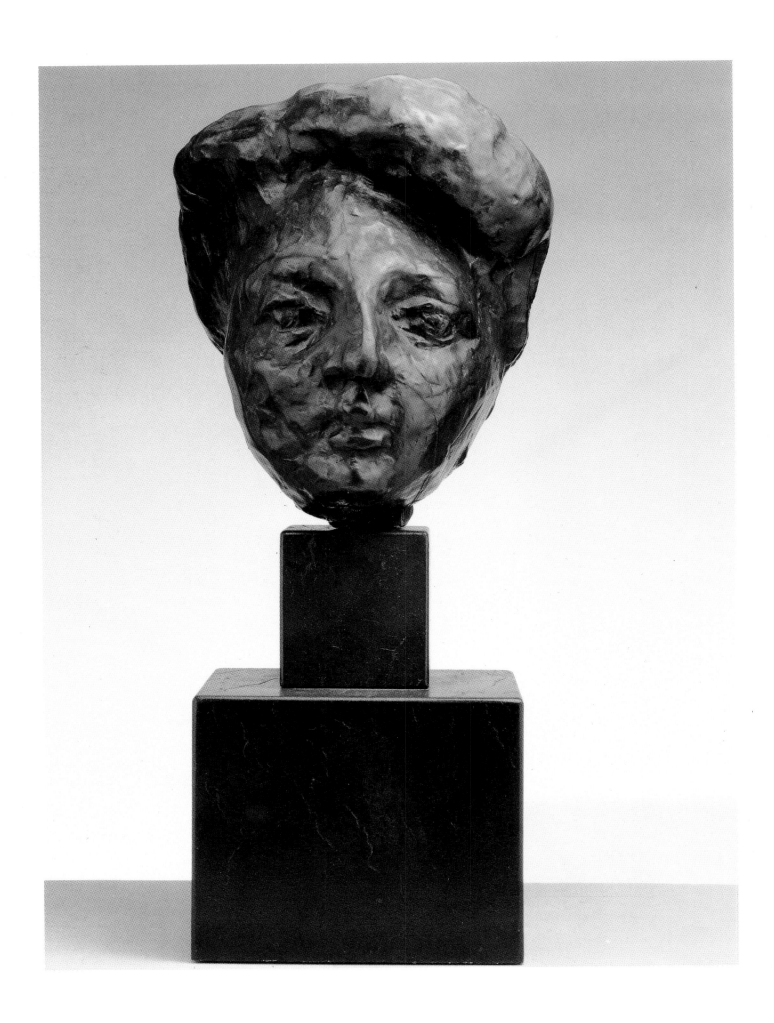

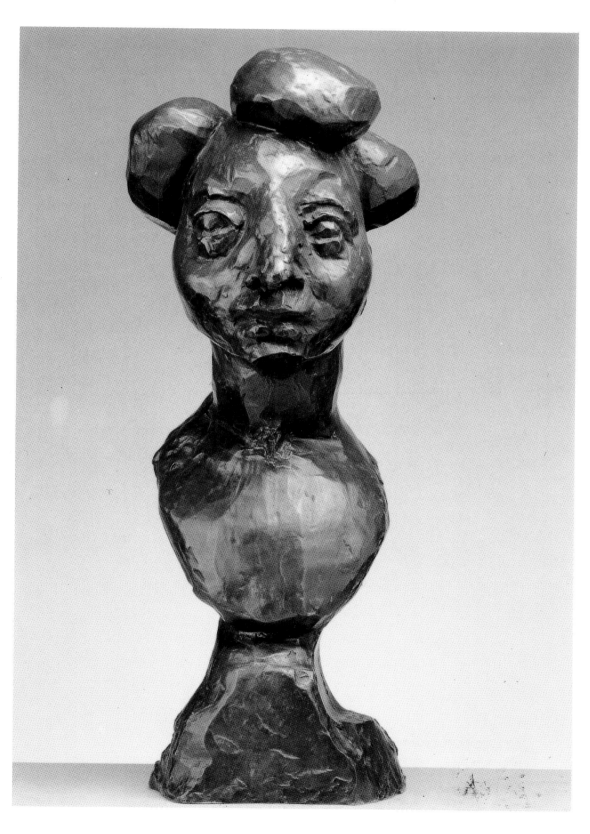

Opposite: Jeanette II, Issy-les-Moulineaux, early 1910; bronze; height 26.2 cm (10⅛ in); Museum of Modern Art, New York, gift of Sidney Janis. According to Alfred Barr Jr., the model for this sculpture piece was a young woman Matisse had met at Clamart.

Above: Jeanette III, Issy-les-Moulineaux, spring 1910–autumn 1911; bronze; height 60.3 cm (23¾ in); Museum of Modern Art, New York, acquired through the Lillie P. Bliss Bequest. Beginning with this piece, Matisse used the preceding sculpture as his model for the other Jeannettes instead of a live model.

276

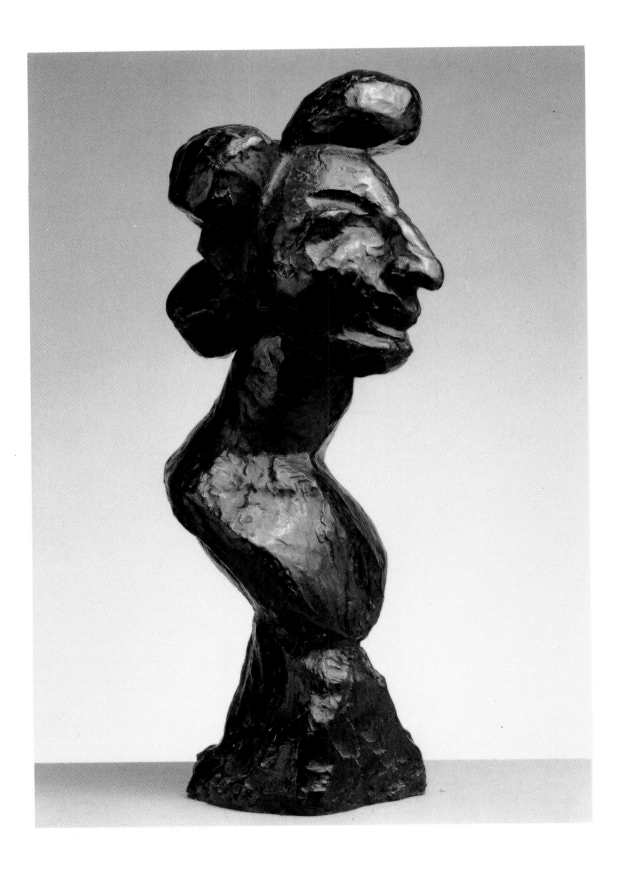

Jeanette IV, *Issy-les-Moulineaux, 1911; bronze; height 61.3 cm (24⅛ in); Museum of Modern Art, New York, acquired* *through the Lillie P. Bliss Bequest. The progressive deformation of the facial features is wedded to the* *increasing importance attached to the rapport between the volumes. Matisse achieved this partly thanks to his* *study of African sculpture, which in fact influenced the entire European artistic community in the early 1900s.*

277

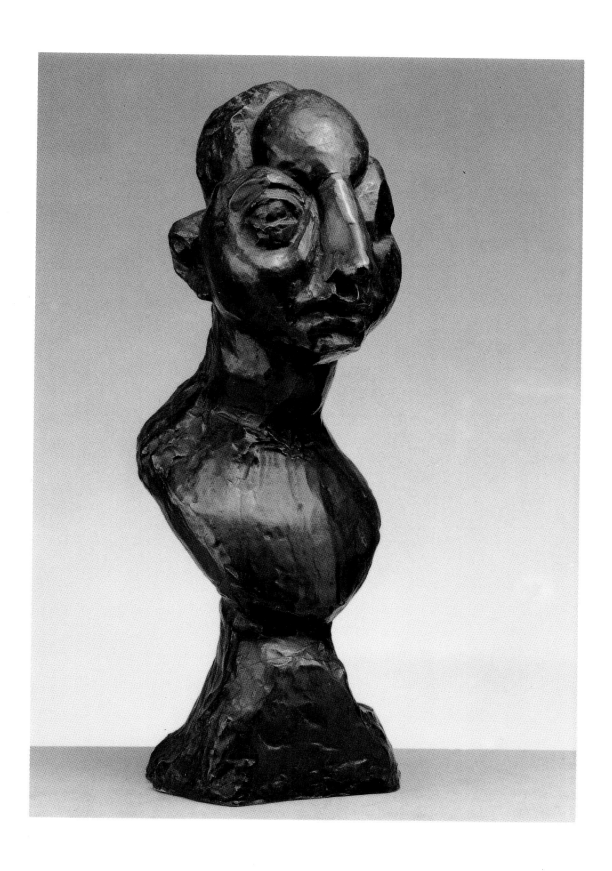

Jeanette V, *Issy-les-Moulineaux, 1916; bronze; height 58.1 cm (22⅞ in); Museum of Modern Art, New York, acquired* *through the Lillie P. Bliss Bequest. The almost total absence of hair and the asymmetry of the eyes mark the* *extreme point of transfiguration that Matisse was able to achieve in his distillation of and meditation on the* *Cubist aesthetic. Note the articulation of the sculpture into three clear-cut volume areas.*

278

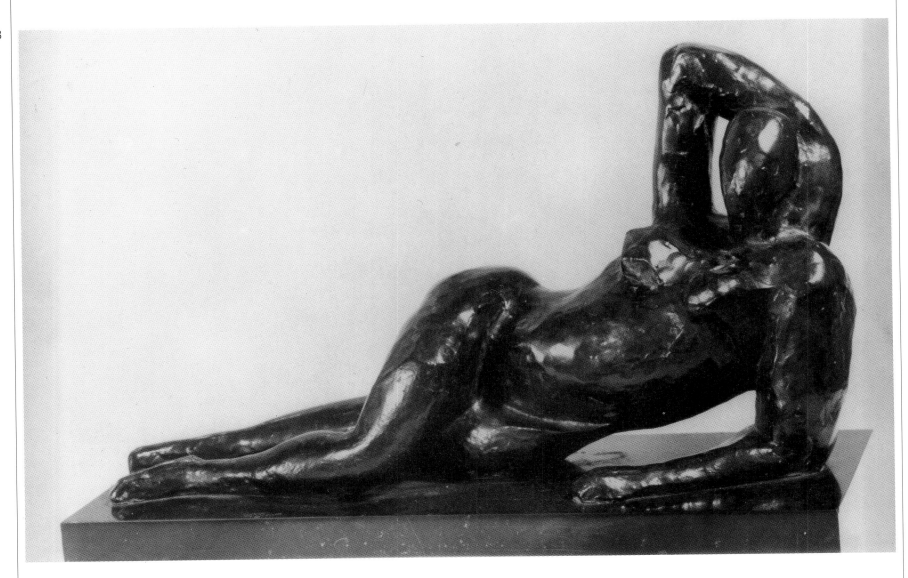

Reclining Nude II,
Nice, place Charles-
Félix, 1927; bronze;
height 28.5 cm (121¼
in); The Minneapolis
Institute of Arts, gift
of the Dayton Hudson
Corporation,

Minneapolis. This is
yet another variation
of the reclining nude
motif that takes its
cue from Reclining
Nude I – Aurora,
executed in 1907.

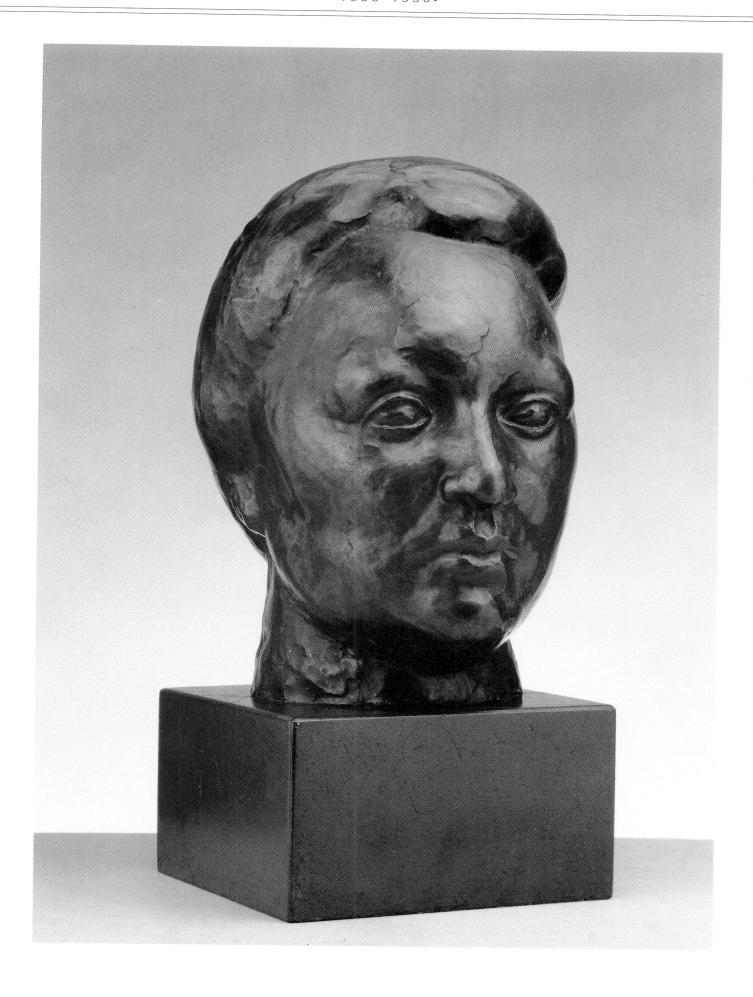

Henriette I, *Nice,
place Charles-Félix,
1925; bronze; height
29.5 cm (11⅝ in); Jan
Krugier Gallery,*
*Geneva. The model
for this sculpture
triptych was
Henriette
Darricarrère, who*
*also posed for many
of Matisse's drawings
in this period. The
return to more
traditional forms has*
*led some critics to say
that Matisse was
influenced by Maillol.*

280

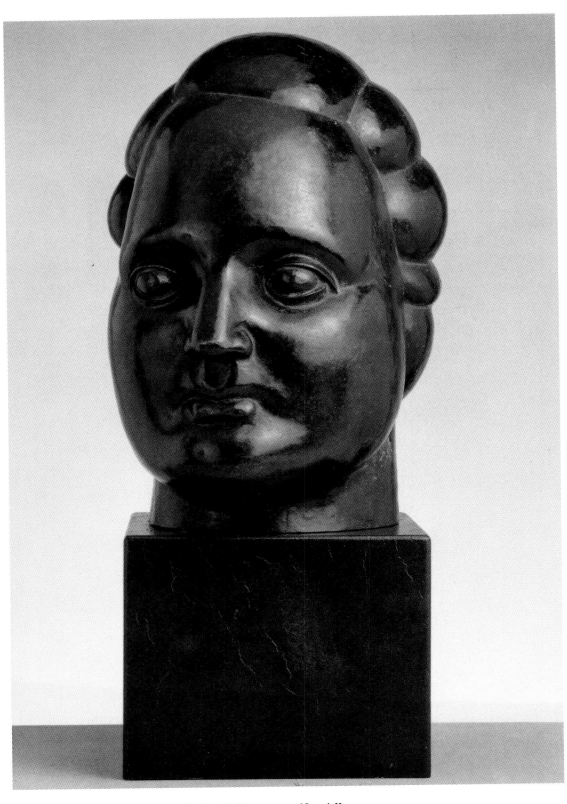

Henriette II, *Nice, place Charles-Félix, 1925–26; bronze; height 41.8 cm (16½ in); Hirshhorn Museum and Sculpture Garden, Smithsonian Institution, Washington D.C., gift of Joseph H. Hirshhorn, 1966. In this second version, Matisse seems to pose the problem of the geometrical treatment of the face, the exemplification of the features to the point of abstraction.*

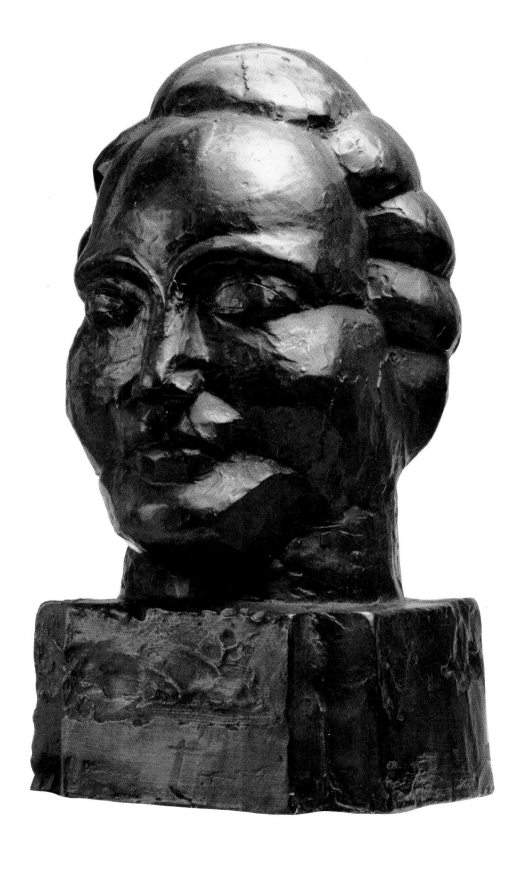

Henriette III, *Nice, place Charles-Félix, 1929; bronze; height 32.5 cm (13 in); Jan Krugier Gallery, Geneva. The Henriette series could also be considered the final phase in Matisse's dedication to sculpture. Although he did not abandon this art after this time, it became a purely secondary activity in the 1940s and 1950s.*

282

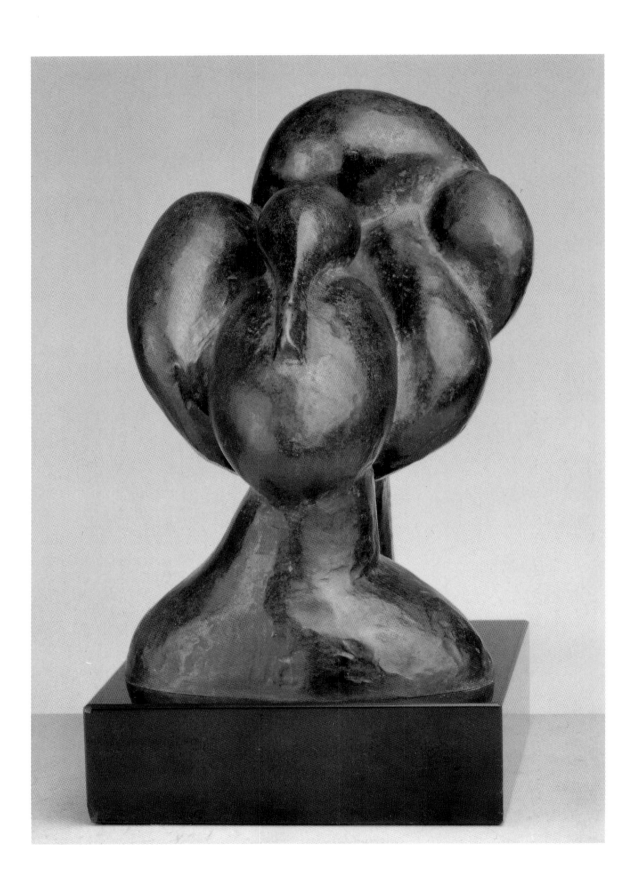

Tiari, *Nice, place Charles-Félix, 1930; bronze; height 20.3 cm (8 in); Museum of Modern Art, New York, A. Conger Goodyear Fund. This is a remarkable work, in which Matisse succeeds in* wedding the decorative motifs of his painting and a purely sculptural approach to volume, thus achieving an image that revolves entirely around the rhythm of the forms.

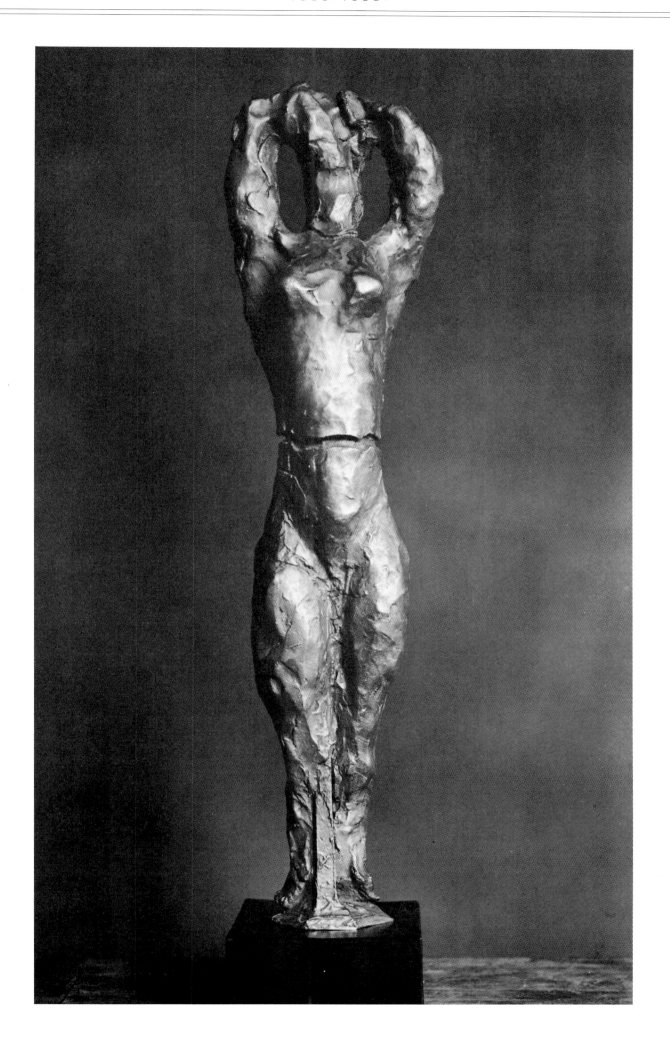

Standing Nude – Katia,
1950; bronze; height
45 cm (17½ in); The
paper cut-outs such
as Forms *(see page
224) and* Venus *deal
with the same formal
theme.*

BIBLIOGRAPHY

Various authors, *Henri Matisse: Retrospective Exhibition of Paintings, Drawings and Sculpture*, Museum of Art (catalogue), Philadelphia, 1948

Various authors, *Henri Matisse: Retrospective Exhibition*, (catalogue) UCLA Art Galleries, Los Angeles, 1966

Various authors, *Matisse, 1869–1954*, (catalogue) Arts Council of Great Britain, London, 1968

Various authors, *Henri Matisse: Exposition du centenaire*, (catalogue) Musée du Petit Palais, Paris, 1970

Various authors, *Henri Matisse: Paper cutouts*, (catalogue) The Saint Louis Art Museum, 1977

Various authors, *Henri Matisse*, (catalogue) Kunsthaus, Zurich, 1982

L. ARAGON, *Henri Matisse: roman*, 2 vols., Gallimard, Paris, 1971

A. C. BARNES-V. DE MAZIA, *The Art of Henri Matisse*, Scribners, New York and London

A. BARR JR., *Matisse, his Art and his Public*, (catalogue), The Museum of Modern Art, New York, 1951

F. BRILL, *Matisse*, London 1967

CAHIERS D'ART, vol. V., nos. 5–6, Paris, 1931

J. CASSOU, *Henri Matisse*, Berlin, 1959

J. CLAIR (ed.), *Bonnard-Matisse: Correspondance 1924–1946*, Gallimard, Paris, 1991

P. COURTHION, *Le visage de Matisse*, Marguerat, Lausanne, 1942

G. DIHEL, *Henri Matisse*, Pierre Tisné, Paris, 1954

C. DUTHUIT, *Catalogue raisonné des ouvrages illustrées*, Paris, 1987

M. DUTHUIT-MATISSE-C. DUTHUIT, *Henri Matisse: Catalogue raisonné de l'oeuvre gravée*, 2 vols., Paris, 1983

J. ELDERFIELD, *Matisse in the collection of The Museum of Modern Art*, Museum of Modern Art, New York, 1978

J. ELDERFIELD, *Matisse in Morocco: The Paintings and Drawings*, National Gallery of Art, Washington D.C., 1990

J. ELDERFIELD, Henri Matisse: A Retrospective, (catalogue) The Museum of Modern Art–Thames and Hudson, New York, 1992

A. E. ELSEN, *The Sculpture of Henri Matisse*, New York, 1972

R. ESCHOLIER, *Henri Matisse*, Floury, Paris, 1937

J. FLAM, "Matisse and the fauves" in W. RUBIN (ed.), *Primitivism*, vol. 1 (catalogue), The Museum of Modern Art, New York, 1984

J. FLAM, *Matisse: the Man and his Art, 1869–1918*, Cornell University Press, Ithaca and London, 1986

J. FLAM, *Matisse: a Retrospective*, Levin, New York, 1988

D. FOURCADE, *Henri Matisse: Ecrits et propos sur l'art*, Hermann, Paris, 1972

D. FOURCADE, *Matisse au Musée de Grenoble*, Musée de Grenoble, 1975

J. FREEMAN *et al.*, *The fauve landscape*, Abbeville, New York, 1991

J. GOLDING, *Matisse and Cubism*, University of Glasgow Press, Glasgow, 1978

L. GOWING, *Matisse*, Oxford University Press, New York and Toronto, 1979

C. GREENBERG, *Henri Matisse*, New York, 1953

"HOMMAGE A HENRI MATISSE", *XX^e siècle*, Paris, 1970

R. HUYGE, *Henri Matisse*, Flammarion, Paris, 1953

J. JACOBUS, *Henri Matisse*, New York and London, 1973

J. LASSAIGNE, *Matisse*, Geneva, 1959

J. LEYMARE, *Henri Matisse*, Sansoni, Florence, 1964

M. LUZI-M. CARRA`, *L'opera di Henri Matisse dalla rivolta fauve all'intimismo*, Rizzoli, Milan, 1972

G. MARCHIORI, *Henri Matisse*, La Bibliothèque des Arts, Paris, 1967

I. MONOD FONTAINE, *The sculpture of Henri Matisse*, Arts Council of Great Britain, London, 1984

I. MONOD FONTAINE, *Matisse*, (catalogue), Musée National d'Art Moderne, Centre Georges Pompidou, Paris, 1989

R. NEGRI, *Matisse e i fauves*, Milan, 1969

S. ORIENTI, *Henri Matisse*, Sansoni, Florence

P. SCHNEIDER, *Matisse*, Flammarion, Paris, 1984

P. SCHNEIDER, *Matisse et l'Italie*, Arnoldo Mondadori Editore, Milan, 1987

P. SCHNEIDER, *Henri Matisse: capolavori dal Museo di Nizza*, (catalogue) Accademia di Francia, Rome, 1991

M. SEMBAT, *Henri Matisse*, Nouvelle Revue Français, Paris, 1920

M. VALSECCHI, *Disegni di Matisse*, Milan, 1944

A. VERDET, *Prestiges de Matisse*, Emile Paul, Paris, 1952

INDEX

Numbers in italics refer to captions.

Accardi, Carla 31, *257*
– *Grey Brown 257*
Acrobat (1952) *28*
Acrobats 222
Adant, Hélène *248*
Aïcha and Lorette 168
Ajaccio *50*
Alcoforado, Mariana 23
Algeria 15, 34, *113*
Algerian Woman 113
Angelico, Fra 15, 110
Apollinaire, Guillaume *17*, 18, 34, 35
Apples 160
Aragon, Louis 25, *29*, 171
Arcueil 58, 78
Arezzo 152
Arm, The 213
Aurora see *Reclining Nude I*

Back I, The, 13, 15, 263, *270*
Back II, The, 270
Back III, The 271
Back IV, The 271
Ballets Russes 24, 35
Baltimore 35
Banyuls *26*
Barbizon 114
Barbizon *114*
Barnes, Dr Albert C. 14, *24*, 25, 35
Barnes Foundation 24, 35, *203*, 222, 223
Barr, Jr. Alfred 35, 170, *275*
Basket of Oranges 140
Basle Kunsthalle 26, 35
Bathers by a River 20, 143, *154, 158*
Bathers with a Turtle 16, *16, 104*, 263
Baudelaire, Charles 10, 262
Beasts of the Sea, The 244
Bees, The 239
Bell Tower, The see *View of the Kasbah*
Belle-Ile *11, 45*
Berlin 34
Bernheim-Jeune (Gallery) 18, 26, 34
Bevilacqua *12, 66, 264*
Black Table, The 181
Black Woman, The 248
Blinding of Polyphemus, The 23, 25
Blue Nude (Memory of Biskra) 16, 65, *99, 107*, 262, *266*
Blue Nude III 246
Blue Nude IV 246
Blue Window, The 133
Bohain-en-Vermandois 34, *38, 66*, 71, *72, 113*
Bonnard, Pierre 25, *261*
Bouguereau, Adolphe William 34
Bouquet on a Bamboo Table 64, *72*
Bowl of Oranges 143, *158*
Bunch of Lilac, The 18, *149*
Braque, Georges 10, 20, 21, 143, *147*
Brassaï 23
Brazil 35
Brittany 9, *11*, 12, 34, 36, *42, 43, 44, 46*
Brücke, Die *14*
By the Sea (Gulf of Saint-Tropez) 77

Caillebotte, Gustave 34
Calla lilies, Irises and Mimosa 111, 140
"Camera Work" 17
Camoin, Charles 19, 25, 35, *134, 138*
Capa-Magnum, Robert *30, 31*
Carmelina *69*
Cartier-Bresson, Henri *27*
Cassatt, Mary 9
Cassirer, Paul 34
Cateau-Cambrésis, Le 34, 35
Cavalière *113*

Celestial Jerusalem 236
Cézanne, Paul 11, *12*, 13, 14, 15, 20, 22, 34, 37, *58*, 64, 65, 143, *198*, 262
– *Three Bathers* 11, *12*, 13, 34, 37, 262
Chair with Peaches see *Lorraine Chair, The*
Champaigne, Philippe de *9*
Chant du rossignol, Le 24
Chapel of the Rosary, Vence 28, *29*, 30, *30, 31*, 35, 223, *239*
Char, René 25
Chardin, Jean-Baptiste 11, 36
Christ on the Cross 30
Cimiez 35
Clamart 275
Collioure 84
Collioure 14, *15*, 18, 19, 34, 35, 64, *76, 78, 79, 82, 83, 84, 86, 90, 92, 93, 95, 97, 98, 99, 100, 101, 102, 130, 145, 149, 265, 266, 268*
Composition, Blue Background 245
Cone Collection 35, *201*
Conversation, The 110, *124*
Copenhagen Statens Museum 26, 35
Corot, Jean-Baptiste 36
Corsica 12, 34, 37, *48*
Costume design for the ballet *Red and Black 24*
Courbet, Gustave 11, 13
– *Bathers, The 13*
Courtyard of the Mill, The 50
Creole Dancer 222, *241*

Dance, The (1909–10) 14, 15, 16, 18, *18, 21*, 29, 34, 110, *118, 120, 141*, 170
Dance, The (1932–33) 12, 24, *24*, 25, 29, 30, 35, 171, *203*
Dancer and Rocaille Armchair on a Black Background 220
Darricarrère, Henriette *24, 279*
D'Eugène Delacroix au néoimpressionisme 13
De Chirico, Giorgio 262
Dead Christ 9
Decoration, Flowers and Fruit 29, *256*
Decorative Figure 269
Decorative Figure on an Ornamental Background 171, *192*
Degas 262
Delacroix, Eugène, 10, 19, *138*
Delktorskaja, Lydia *24*
Denis, Maurice, 10, 14
Derain, André 15, *15*, 22, 34, *82*
– *Trees, Collioure 15*
Destiny 225
Diaghilev, Sergei 18, 24
Dinner Table, The 12, 34, 36, *47*, 64
Door to Signac's Studio, The 73
Draped Nude on a Red Couch 173
Drawing Session, The 220
Dream, The (1935) 171, *202*
Dream, The (1940) *31*, 171, *216*
Duchamp, Marcel *220*

El Greco 14
Entrance to the Kasbah 14, 19, *137*
Ernst, Max 222
Etretat 182
Evenepoël, Henri 12, 34, 36

Fatmah the Mulatto 134
Fels, Florent *196*
Five Red Circles and a Black Losenge 231
Florence 152
Florilège des amours 23

Forain, Jean-Louis 9
Forms (Jazz) 225, 251, 283
Fragonard, Jean-Honoré 22
France 15, 19, 35
French Window at Collioure 18, 19, 35, 142, *145*, 170, *251*

Game of Bowls 20, 108
Gauguin, Paul 9, 10, 11, *11*, 13, 16, 34
– *Head of a Boy 34*
– *White Horse, The 11*
Gérard Matisse, Héloïse 34, 35
Gerbe, La (The Sheaf) 259
Giacometti, Alberto *21*
– *Matisse in his Studio 21*
Giotto 29, 110, *152*
Goldfish 17, *131*
Goldfish and Palette 151
Goldfish and Sculpture 124
Gourds 143, *161*, 170
Goya y Lucientes, Francisco de 27
Green Line, The see *Portrait of Mme Matisse*
Green Rumanian Blouse 215
Greta Moll *104*
Greta Prozor *147*
Grey Nude 174
Gris, Juan 9, 20, 35
Guillaume, Paul 18, 35
Guillaume Apollinaire 17
Gustave Moreau's Studio 36, 40

Hare, The 55
Harmony in Red 15, 65, *108*, 111, 142, 223
Head of Hair, The 24
Heem, Jan Davidsz de *9*
– *Dessert, The 9*
Henri Matisse Engraving 10
Henriette I 279
Henriette II 280
Henriette III 281
Hokusai *18*
– *View of Mt Fuji during a Storm 18*

Icarus 225
"Illustration, L' " *13*
Ingres, Jean-Dominique 19
– *Odalisque with Slave 19*
Interior at Collioure, The Siesta 84
Interior at Nice: Young Woman in a Green Dress Leaning at the Window 185
Interior with a Black Notebook 174
Interior with a Goldfish Bowl 150
Interior with a Top Hat 36, 41
Interior with a Violin 162
Interior with a Egyptian Curtain 223, *235*
Interior with Aubergines 34, 35, 111, *130*, 142, 222
Interior with Harmonium 37, *58*
Interior with Phonograph 191
Interior with Young Girl 64, *81, 232*
Invalid, The 52
Irène Vignier 19
Issy-les-Moulineaux *17*, 18, 35, *116, 118, 119, 120, 124, 127, 129, 131, 132, 133, 141, 147, 149, 153, 154, 157, 159, 160, 161, 166, 176, 181, 270, 271, 272, 273, 275, 276, 277*
Italian Woman, The 152
Italy 15, 34, *152*

Javor, Wilma *24*
Jazz 23, 28, 29, 222
Jeanette I 15, *273*
Jeanette II 275
Jeanette III 275
Jeanette IV 276
Jeanette V 277
Joie de vivre, La 10, 14, 16, *17*, 19, *19, 21*, 25, 27, 64, 65, *91, 95*, 110, *141*
Joyce, James 23, *23*

Kahnweiler, Daniel-Henry 18
Kandinsky, Wassily 142

Lagoon, The 28, *227*
Landscape at Arcueil 58
Landscape at Collioure 83
Landscape at Saint-Tropez 15
Large Pine Tree, The see *Road at Cap d'Antibes*
Large Reclining Nude/The Pink Nude 203
Large Red Interior 237
Lausanne *24*
Leaves Cut into Arabesques 259
Legs 213
Legs with Anklets 213
Lemons and Bottle of Dutch Gin 36, *43*
Letters of a Portuguese Nun 23
Little Crouching Nude 266
London 12
Lorette 168, *169*
Lorette in Green in a Pink chair 169
Lorette with a Cup of Coffee 168
Lorraine Chair, The – Chair with Peaches 178
Loti, Pierre *138*
Lucerne 35
Lund 35
Luxe I, Le 16, *100*
Luxe II, Le 101
Luxe, calme et volupté 10, 13, 34, 64, *74, 77, 91*, 263

Mme Matisse in a Japanese Robe 64, 66
Maillol, Aristide 14, 25, *26, 270*
Male Model 13, 37, *62*, 66, 262
Mallarmé, Stéphane 10, 23, 24, *24, 206*
Manet, Edouard 11, *20*, 36
– *Old Musician, The 20*
Manguin, Henry 15, 34
Marguerite 97, 140
Marguerite among the Rocks 182
Marguerite in a Hat with Roses 148
Marguerite with a Hat 177
Marquet, Albert *10*, 13, 15, 25, 34, *60*, 64, 82
– *Matisse Painting in Marguin's Atelier 10*
Marx, Samuel A. *160*
Master of the Middle Rhine *21*
– *Garden of Paradise, The 21*
Matisse, Emile 34
Matisse, Jean 34
Matisse, Marguerite 35
Matisse, Pierre 16, *26*, 34, *113, 166*, 216
Memory of Biskra see *Blue Nude*
Memory of Oceania 261
Merion 24, 30
"Mes Modèles" *272*
Miró, Joan *26*
Monet, Claude, 12, 27, 36
Monte Carlo 24
Montherlant, Henry de 23
Moorish Café, The 19, 110, 111, *141*

286

Moorish Screen, The 23, *184*
Moorish Woman, The 200
Moreau, Gustave 10, *10*, 11, 12, 13, 15, 16, *16*, 34, 36, 37, 47, 104
– *Life of Humanity, The* (detail): *The Golden Age. Sleep. Adam 10*
– *Orpheus* 16, *16*
Morisot, Berthe 9
Moroccan Garden – Periwinkles 138
Moroccan Landscape 122
Moroccans, The 20, 143, *153*
Moroccans on the Terrace see *Zorah on the Terrace*
Morosov, Ivan 14, 35, *137*
Moscow, 14, 18, *20*, 34, 35
Moulade, Collioure, La 79
Munich 19, 35
Music (1909–10) 14, 15, 16, 18, *18*, 19, 34, 110, *120*, *141*, 170
Music (1939) *26*, *213*

Nasturtiums and "The Dance II" 119
Nee York *17*, 26, 34, 35
Newman, Barnett 31
Nice *23*, 24, *25*, 26, 35, *162*, 164, 172, 173, *174*, 178, 181, *182*, 184, 185, 186, 187, *188*, 189, *190*, 191, 192, 194, 196, 198, 200, 201, 202, 203, 204, 206, 208, 210, 213, 271, 278, 279, 280, 281, 282
Nice-Cimiez 210, 213, 215, 216, 217, 218, 219, 220, 241, 244, 245, 246, 248, 251, 254, 256, 259, 260, 261
Notre-Dame de Paris 57
Notre-Dame with Tugboat 13
Notre-Dame with Violet Wall 70
Noyen 113
Nude 210
Nude – Back View 29
Nude, Black and Gold 102
Nude by the Sea, Cavalière 113
Nude in Profile 246
Nude Seated on a Blue Cushion 22
Nude Standing at the Mantelpiece 208
Nude with a Blue Cushion 189
Nude with Armchair and Foliage, Sketch 210
Nude Woman on Blue Background 204
Nymph in the Forest 206

Oceania 26
Oceania – The Sky 229
Odalisque with a Moorish Chair 24
Odalisque with a Tambourine 194
Odalisque with Red Coffer 196
Odalisque with Red Culottes 24, 35
Olive Tree, The 48
Open Window, Collioure, The 64, *86*
Open Window at Tangier 14, *139*
Orléans, Charles de 23
Ovid 10

Padua 29, 110, *152*
Paitner in his Studio, The 164
Painter's Family, The 110, *132*, *190*
Painting Session, The 220
Pallardy, Theodor *217*
Palm Leaf 138
Parayre, Amélie 34
Paris, 11, 12, 14, *14*, 15, 18, 19, 25, 26, 34, 35, *38*, 40, 41, *42*, 43, *47*, 52, 55, 56, 57, 58, 60, 61, *62*, 66, 69, 70, 74, 81, 88, 89, *91*, 93, 101, *102*, 104, 107, 108, 113, *114*, *117*, 143, 144, *147*, 148, 149, 150, *151*, 152, 155, 156, 164, 168, *207*, 264,
265, 270
Pasiphaé: Chant de Minos 23
Pastoral 76
Path in the Bois de Boulogne, The 64, 68
Periwinkles see *Moroccan Garden*
Perpignan 12, 34
Philadelphia 35
Pianist and Checker Players 190
Piano Lesson, The 20, 22, 35, 143, *157*, *166*, 170, *190*, 223
Picasso, Pablo *10*, 15, *17*, 18, *18*, 20, 21, 22, 24, 30, 65, *91*, *140*, 143, *147*, 223, 262, 263
– *Demoiselles d'Avignon, Les 17*, *91*, 262
Piero della Francesca 10
Pignatelli *264*
Pineapple, The 237, *239*
Pink Nude (1906) *95*
Pink Nude, The see *Large Reclining Nude*
Pink Onions 14, *15*
Pink Studio, The 18, 34, 111, *127*
Pissarro, Camille 10, 12, 34
Pittsburgh 25, 35
Plaster Figure, Bouquet of Flowers 181
Poèmes 23
Poésies 23, 24, *24*
Polynesia 9, 10, *26*, 230
Polynesia – The Sky 230
Pont-Aven *11*
Pont Saint-Michel 60
Port of Abaill, The 81
Portrait of Auguste Pellerin II 156
Portrait of Bevilacqua 66
Portrait of Mme Matisse – The Green Line 14, 64, *88*
Portrait of Mademoiselle Yvonne Landsberg 35, *148*
Portrait of Michael Stein 18
Portrait of Nono 65, *102*, 110
Portrait of Pierre 113
Portrait of Sarah Stein 155
Portrait of Shchukin 18
Poussin, Nicolas 11
Purple Cyclamen 129
Purrmann, Hans *158*
Puvis de Chavannes, Pierre 10, 11, 16, 65, *91*
– *Girls by the Seashore* 11
– *Happy Land, The* 10, 11
– *Summer 91*
Puy, Jean 14, 34

Rape of Europa 25
Raphael 10
Rayssiguier, Brother 30
Reclining Nude, Seen from the Back (1927) *196*
Reclining Nude I – Aurora 16, *16*, 17, *107*, 262, *266*, *278*
Reclining Nude II 278
Reclining Nude Seen from the Back (1938) *207*
Reclining Nude with Large Foliage 12
Reclining Odalisque 192
Red and Black (The Strange Farandole) 24, 35, 222
Red Sail, Etretat, The 182
Red Studio, The 18, 34, 111, *127*, *237*
Redon, Odilon
– *Intelligence* 10
– *Salomé* 10
– *Secret, The* 10
– *Temptation* 10
Rembrandt, Harmenszoon van Rijn 10, 27
Renoir, Auguste 12, 14, 19, 25, 35, *187*, 262
Repli 23

Reverdy, Pierre 23
Road at Cap d'Antibes – The Large Pine Tree 196
Rocaille Armchair, The 29, 223, *227*
Rocks at Belle-Ile 45
Rodin, Auguste 12, 13, 34, 66, 252, 262, 264
– *Nude in Profile Doing a Bridge Backbend 253*
– *Nude with Long Hair Bending Backwards 252*
– *Walking Man* 12, 262, *264*
Rose Marble Table, The 21, *21*, 143
Rothko, Mark 31
Rouge et Noir see *Red and Black*
Rouault, George 15, 34
Rouveyre, André 9, 23, 25, 26, 35, *235*, *245*
Rue de Soleil 78
Rumanian Blouse, The 215
Rump 35

Sails, The 251
Saint Dominic 30
Saint-Jean-Cap-Ferrat 27, *27*
Saint-Quentin 11, 34
Saint-Tropez 15, *73*, *74*, *77*, 78
Salmon, André 18
Schneider, Pierre 13, 14, *20*, 27, 104, *134*
Schoenborn, Florence May *160*
Sculpture and Persian Vase 107
Seascape 86
Seaside, Collioure 95
Seated Nude 14
Seated Pink Nude 204
Self-portrait (1900) *61*
Self-portrait (1918) *172*
Self-portrait (1934–35) *22*
Sembat, Marcel, 14, 35
Serf, The 12, 13, 262, *264*
Serpentine, La 16, 17, 262, 263, *269*, *272*
Seurat, Georges 10, 14
– *Sunday Afternoon on the Island of the Grande Jatte* 10
Severini, Gino 22
Seville, *129*
Shaft of Sunlight, The Woods of Trivaux 166
Shchukin, Sergei 14, 18, *20*, 34, *108*, 110, *118*, *120*, 222
Sheaf, The see *Gerbe, La*
Shostakovich, Dimitri 24, *24*
Shutters, The 178
Sideboard and Table 13, 37, *54*
Siena *152*
Signac, Paul 10, 13, 34, 64, *73*, *74*, 81
– *Saint-Tropez 81*
Silence Living in Houses, The 223, *232*
Sketch 20
Skira, Albert 23, 24, *24*
Sleeping Woman 219
Small Blue Interior 234
Snail, The 260
Spain, 18, 35, *129*
Spanish Still Life 111, *129*
Stack of Gorse, The 46
Standing Nude 102
Standing Nude – Katia 29, *283*
Standing Riffain, The 137
Stations of the Cross 30, *30*
Steichen, Edward *17*, *272*
Stein (Family) 14, 18, 34
Stein, Gertrude 14, *18*, 34, *88*
Stein, Leo 14, *18*
Stein, Michael 14, *14*, *18*, 155
Stein, Sarah 14, *14*, *18*, 89, 155
Stella, Frank 31
Stieglitz, Alfred *17*, 18, 34

Still Life against the Light 37, *52*
Still Life in Venetian Red 106
Still Life on a Green Sideboard 198
Still Life: Pink Tablecloth, Vase of Anemones, and Pineapple 194
Still Life with an African Statuette 114
Still Life with a Geranium 90
Still Life with a Nutcracker 159
Still Life with a Red Rug 65, *98*
Still Life with a Shell 171
Still Life with Aubergines 18, 19, *232*
Still Life with Blue Jug 62
Still Life with Blue Tablecloth 17, 111, *117*
Still Life with Books 38
Still Life with Geraniums 122
Still Life with Lemons Which Correspond in Form to a Drawing of a Black Vase on the Wall 150
Still Life with Oysters 171, *217*
Still Life with Pewter Jug 90
Still Life with Pomegranates 232
Still Life with "The Dance" 116
Still Life with Two Bottles 42
Storm in Nice 182
Strange Farandole, The see *Red and Black*
Stravinsky, Igor 24
Striped Dress, The 210
Studio under the Eaves 64, *71*
Study after the Tomb of Lorenzo de' Medici 22
Study for "Antaeus" after Pollaiuolo 22
Study for Luxe, Calme et Volupté *74*
Study for "The Dance" 15
Study for the Tabernacle in the Chapel of the Rosary 243
Swimmer in the Aquarium, The 227
Swimming Pool, The 29, 222, *255*

Tahiti 26, 35, *208*
Tangier 122, *134*, *137*, *138*, *139*, *140*, *141*
Tea in the Garden 176
Tériade, Emmanuel 23, 27, *27*
Themes and Variations 12
Three Sisters Triptych, The 162
Tiari 263, *282*
Titian 27
Torso with Head – La Vie 265
Toulouse 12, 34, *54*, *113*
Tree, The 29
Tree of Life, The 242, *243*
Turner, Joseph 12, 34
Two Odalisques (The Terrace) 186
Two Women 15, 262, 263, *268*

Ulysses 23, *23*
United States, 18, 35

Vallotton, Félix 14
Van Gogh, Vincent 13, 34, 65
Vanves 113
Variation on a Still Life by De Heem 20, 143
Vase of Flowers 37, *56*
Vence 9, 12, 28, 29, 30, *31*, 35, *227*, 229, *232*, 234, 235, 236, 237, 239
Venice 152
Venus 251, *283*
Venus in a Shell 263
Veronese 11
Vie, La see *Torso with Head*
View of Collioure 17
View of Collioure (The Bell Tower) 82
View of Notre-Dame 13, 19, 142, *142*
View of the Kasbah 19

Villa La Rêve *31*
Villa Natasha 27
Village in Brittany 44
Violinist, The 20
Violinist at the Window 164
Virgil 10
Virgin and Child 30, *243*
Visages 23
Vlaminck, Maurice *14*, 15, *82*
Vollard, Ambroise *12*, 13, *14*, *22*, 34, 262

Wave, The 29, 222, *254*
Weil, Berthe 34
Wéry, Emile *11*, 12, 34, 36
White and Pink Head 147
White Chasuble 31
Window at Tahiti 208, 223
Window at Tangier 134, 137
Woman before an Aquarium 187
Woman by a Stream 97
Woman Reading 38

Woman Reading in a Purple Dress 50
Woman Reading with Peaches 188
Woman with a Madras Hat 198
Woman with a Hat 14, 64, *89*, 155

Yellow Curtain, The 19, 35, 142, *147*, 251
Yellow Dress, The 201
Young Sailor I, The 14, 22, 65, *92*
Young Sailor II, The 15, 16, 22, *93*, *101*

Young Woman in White, Red Background 229
Young Woman with a Pearl Necklace 218

Zorah on the Terrace 14, 19, *134*, 137
Zulma 241

PICTURE SOURCES